STILL MOVING

STILL

BETWEEN CINEMA AND PHOTOGRAPHY

MOVING

Karen Beckman and Jean Ma, eds.

DUKE UNIVERSITY PRESS

DURHAM & LONDON 2008

Printed in the
United States of America
on acid-free paper ∞

Designed by Jennifer Hill
Typeset in Adobe Jenson Pro
by Tseng Information Systems, Inc.

Library of Congress
Cataloging-in-Publication Data
appear on the last printed
page of this book.

PERMISSIONS/SUBVENTIONS:

Duke University Press gratefully
acknowledges the support of both
the University of Pennsylvania and
Bard College, which provided
funds toward the production
of this book.

Chapter 4 originally appeared in
The Event Horizon (1998), a catalog
published by the Irish Museum of
Modern Art and edited by
Michael Tarantino.

An earlier version of Chapter 9
was published in *The Lure of the Object*
(2005), edited by Stephen Melville and
published by the Sterling and
Francine Clark Art Institute
in 2005.

An earlier version of Chapter 13
was published in French for the catalog
of the "States of the Image—Instants
and Intervals" show, curated by
Raymond Bellour and Sergio Mah,
at the Biennial Lisboa Photo 2005.

CONTENTS

THREE
WORKING BETWEEN MEDIA

ACKNOWLEDGMENTS

The editors warmly thank all the contributors. We would also like to thank the four anonymous readers, whose comments helped us clarify our vision of what we wanted this collection to accomplish. Special thanks go to Nancy Davenport for generously granting permission for the use of the cover image. We are very grateful to Ken Wissoker for his unwavering tough love and eye-opening advice as we worked on the introduction, and to the editorial staff at Duke—it has been a pleasure to work with the Press. *Still Moving* is published with the assistance of subventions from the University of Pennsylvania Research Foundation and Bard College, and we gratefully acknowledge this support.

STILL MOVING

INTRODUCTION

Karen Beckman and Jean Ma

THE CHANGING FACE(S) OF THE FIELD

Anyone who arrived late at Princeton's recent symposium on Magic and Cinema might well have wondered what the heck was going on if they had walked in at the moment when P. Adams Sitney declared with great gusto: "The future of cinema lies with SPECIAL EFFECTS!" Even those of us who had arrived on time (and who were therefore aware that Sitney was in fact reading aloud the paper of another presenter who had fallen ill) had to pinch ourselves as we witnessed these words passing those lips. The event became a standing joke of the conference, but it can also be read as a comic symptom of changes that are currently taking place across the landscapes of film studies and art history, where many of the navigation points that once allowed us to recognize our disciplinary spaces and proper objects of study have either disappeared completely or changed dramatically, demanding of us a fairly radical reassessment of where we stand, as well as how and what we study. At this time when moving images seem to have permeated almost every field within the university setting (try counting how many different departments cross-list film courses with "homes" like cinema studies), one possible strategy for a volume like this, which tries to assess the state of a field, would be to gather together those who represent the "official" face of the field and ask them to outline coherent guidelines for the discipline. We, however, have chosen to resist segregating "official film scholars" from others involved in discussions

of photography and film. Instead, we have embraced the hybridity and promiscuity of film and photography by inviting contributions from film scholars, art historians, artists, filmmakers, and curators, believing that, at this time of transition and confusion, we might most usefully put these voices into conversation with each other. With this juxtaposition of contributors and subject matter, we hope to forge alliances and establish dialogues among practitioners and scholars working in a variety of institutional spaces with shared interests—to invent a community of the question as we struggle collectively to understand how encounters between photography and contemporary moving images emerge in response to, to provide us with models for thinking about, the world in which we live.

The diverse nature of the group we have brought together between these covers reflects both what we believe to be a shared, defining feature of film, photography, and digital media—their overlapping heterogeneity—and the variety of readers we hope to engage. We aim with this volume to make a specific critical intervention into a number of fields and practices at a moment when our objects and the methodologies with which we engage them strike us as simultaneously petrified and elusive or confused. We might have tried to formulate the contours of a new theory for our times, to bring clarity to the messy intersections among practices and discourses that at times seem to cloud our view of what we should be looking at. But this book starts from the premise that our absence of a clear theoretical paradigm reflects the complexity of our present moment and challenges us to develop questions and structures for thinking that will enable us to engage this complexity as productively as possible.

FILM STUDIES AND ART HISTORY: THE MEDIUM

In the midst of these recent anxieties about the messiness of objects and methodologies in visual arts–related fields—something Hal Foster has described as "the paradigm of no paradigm"[1]—the issue of medium specificity has become a central concern for scholars in the field of cinema studies (in response to new media), and in the field of art history (in contention with the ubiquity of film, video, and the projected image in contemporary art practice). In this context, the question of

what defines a medium is inextricably interwoven with questions regarding the object of the disciplinary gaze, the parameters of scholarship, and the relationship between art and technology.[2] The stakes of these questions, and the sense of disciplinary crisis by which they are driven, emerge most forcefully around photography and cinema, whose essential hybridity and interconnectedness present a challenge to homogeneous and reductive notions of medium specificity and open an important site of overlap between art history and cinema studies. While photography and film were once rarely studied in the same institutional spaces—with photography a province of art history, and film finding a home either in departments of literature, drama, or, from the 1960s on, programs devoted exclusively to film studies—this is clearly no longer true.

Hollis Frampton may have been overstating the case when he subordinated art to film by claiming that "the whole history of art is no more than a massive footnote to the history of film" (1983, 123); and yet it is undeniable that we write at a moment when scholars of art history and cinema studies have more in common than ever before: art history departments hire film scholars; graduate students in visual studies and fine arts programs study cinema and art in relation to one another; art journals frequently devote special issues to film-related questions, just as film journals publish articles on artists working with film and video. Yet in spite of this apparent overlap of interests, there has been a dearth of exchange between the two fields on the issue of medium specificity, even with the advent of visual studies programs, for which "the medium" as a question may have seemed too aligned with methodological approaches to the arts that the new field was trying to escape. With *Still Moving*, we hope to provoke explorations of the difference between these parallel approaches to film and photography and their respective and mutually implicated identities as media, and to develop the questions we need in order to enable new modes of intellectual exchange. Rather than leveling differences across fields and practices in search of "a happy medium," *Still Moving* works both to understand the separations that exist and to facilitate productive exchange between artists and film scholars, art historians and filmmakers, curators and photographers, all the while resisting the potential for a renewed interest in the medium to devolve into a regressive reassertion of eroded disciplinary borders. The resis-

tance to this unproductive model of medium-based inquiry emerges out of the media in question. For our work begins from the premise that as photographic and moving image media mutate, recombine, and migrate across disparate contexts—operating as fields and effects as well as simply objects—medium specificity in turn asserts itself anew as a necessarily *inter*disciplinary question.

While our focus on how artists' ever-increasing engagement with moving image technologies necessarily produces what Georges Didi-Huberman has recently described as "an art history turned towards cinema," as it attempts "to understand the temporality of images, their movements, their 'survivals,' their capacity for animation," it is important to remember that the question of the "still moving" is not new to art history but rather lies as a founding tension of the discipline (Michaud 2004, 12). But this volume suggests that we would do well to cultivate a parallel turn of cinema studies toward art history, to recognize that the transitions we now face in relation to modern media may well have roots or precedents in earlier moments of aesthetic change. At the opening of his *Aby Warburg and the Image in Motion,* for example, Philippe-Alain Michaud writes:

> In 1893 . . . Warburg tackled the age-old question of the Renaissance artists' return to and interpretation of Antiquity, giving it a paradoxical twist. In treating the presence of mythological figures in Florentine painting, he focused on how these artists represented movement. He argued that it was not the motionless, well-balanced body that served as the model for the imitation of Antiquity, as in Winckelmann's view of art history, but rather the body caught up in a play of overwhelming forces, limbs twisting in struggle or in the grips of pain, hair flowing, and garments blown back through exertion or by the wind. (28)

Though Warburg's reversal of Winckelmann's aesthetics may initially seem remote from the contemporary challenges facing cinema studies and art history as they try to account for both new moving-image technologies and for each other, the controversies surrounding Warburg's argument—which include the abandonment of a passive and contemplative viewer in favor of an interactive spectator drawn into the work itself through the representation of motion—could not be more pertinent to a present concerned with problems of immersive and spectacular environments that threaten to absorb the viewer and destroy

the distance many believe to be necessary for critical contemplation.[3] Furthermore, by framing the tension between stasis and motion we perceive in today's art and film historically, we recognize the extent to which the field of cinema studies does not, and cannot, exist solely within the century-long framework that is often assigned to it. While some deans and students may regard cinema studies as the love-child of the film industry and the ever-more-corporate university, a road to riches for all, fruitful intellectual exchange between art history and cinema studies allows these fields mutually to energize and strengthen, rather than undermine, each other, and to assert the continued primacy of creating spaces for historical, aesthetic, and theoretical reflection in both.

As the authors assembled here grapple with new manifestations of persistent issues surrounding the play of motion within still images and the insistence of stasis within moving images, they resist the amnesia implicit in Noël Carroll's polemic call to "forget the medium; watch the movement" (2003, 9). Rather, *Still Moving* argues for the impossibility of watching the movement without simultaneously watching the stasis *and* the media that produce these effects, and suggests instead that the hesitation between stasis and motion actually produces an interval in which rigorous thinking can emerge. Though wary of forgetting the medium altogether, the contributors to this volume are equally wary of confusing rigor with rigor mortis. We certainly intend this volume as an extension of the discussions of medium specificity that have emerged in the wake of G. E. Lessing, Clement Greenberg, Michael Fried, Hal Foster, Rosalind Krauss and others, but our interest here lies less in rehearsing debates that are either already familiar or easily available to our readers than in trying to map out strategies for analyzing and understanding emerging practices and problems at the intersection of cinema and art.

But what are the questions that emerge within the interval of stasis and motion, which Corrigan describes as a zone of thought, of an encounter between subjectivity and public culture, "creating space and time for thought between the images of a moving world"? What is the critical purchase of the "still-moving" paradigm offered here? Why privilege the intersection of cinema with photography in particular as the nexus through which to engage the present? Which questions come into focus at this crossroads, and which structures of thinking does it challenge or unveil? We hope that a range of possible answers to these

questions as well as avenues for further pursuit of them will emerge throughout the book. But before readers embark upon their exploration of the individual essays presented here, we will sketch out why the intersection of cinema and photography seems to us to be such a productive and necessary place to locate a consideration of these related fields at this time, and what we believe to be the intervention of our collection.

THE STILL-NESS OF FILM

At first glance, it would seem possible to punctuate the birth and death of cinema with the visible manifestation of this tension between still and moving images: the first public presentations of the Lumière *cinématographe* in 1895 began with the projection of a still photograph onto the screen that would subsequently spring into life with the cranking of the projector.[4] The sudden animation of the image, to the amazement of early film audiences, asserts at once the commonality of and difference between photography and cinema by highlighting the individual photographic frame as the basic unit of the filmstrip while, at the same time, contrasting its stillness with the cinematic illusion of movement. The vexed relationship of the static image and its animated counterpart, each differentiated from the other yet coexisting simultaneously as they are interwoven by the machinery of projection and the physiology of human perception, inheres within the cinematic medium as both a material attribute and a founding myth. Though the ensuing development of cinema as an art and industry of narrative storytelling may appear to have demanded a denial of its materiality along with a flattening of this dialectical interplay—serving the illusionism of a unitary fictional space and sequential temporal flow (an assumption that, as we will see momentarily, may itself need to be revised)—at the turn of our present century we are confronted with a reactivation of the bond between photography and film as these media fall under the shadow of obsolescence in the age of electronic reproduction, during a moment marked by "the end of film as we know it." If the "birth" of cinema set the stage for the digressing paths of the still and moving image, we now find them reunited in the purported "death" of cinema.[5]

Consider the number of recent exhibitions that have foregrounded contemporary artists' engagement with the spaces between film and photography, and with moving image and projection practices, includ-

ing "Projections: Les transports de l'image" (Studio national des arts contemporains, Tourcoing, France, 1997–98); "Into the Light: The Projected Image in Contemporary Art" (Whitney Museum of American Art, 2001); "Future Cinema: The Cinematic Imaginary after Film" (MIT, 2003), addressing in particular the intersections between pre-cinema and new media; "Slide Show: Projected Images in Contemporary Art" (Maryland Institute of Art, 2005); and "States of the Image: Instants and Intervals" (Biennial LisboaPhoto, 2005; see Raymond Bellour's catalog essay in this volume).[6] The proliferation of such exhibitions emphasizes not only that the path between the "filmmaker" and the "artist" is open but also that it is resolutely a two-way street. On the one hand, we see artists increasingly turning to projected and moving images through the channels of installation art, multimedia, and "time-based" work—whether in video, digital, or photographic formats—occasionally blurring the boundary between spaces of theatrical exhibition and museum or gallery spaces. On the other hand, narrative filmmakers like Ulrike Ottinger, Chris Marker, Chantal Akerman, Peter Greenaway, and Atom Egoyan have produced installations, photographs, and CD-ROMs that would find no home in the movie theater.

Similarly, the practitioners we invited to contribute to this book—Atom Egoyan, Rebecca Baron, Nancy Davenport, and Zoe Beloff—all juxtapose film and photography to illuminate one another, calling attention to the distinct practices and traditions at work within each individual medium. In doing so, they often revivify dormant memories and earlier practices within more recent media, as in Beloff's combined projections of slides and film; her CD-ROMs, which reveal the affinities between contemporary digital technology and nineteenth-century philosophical toys; or Baron's captivating exploration of the resemblance between the camera obscura and contemporary live-feed digital surveillance technologies. In various ways, the filmmakers and artists collected here unveil secret conversations between media that persist across decades and geographical realms, revealing difference between old and new without asserting its absoluteness, unveiling the question of the medium to be, among other things, a question of history, temporality, and relationality. In blurring the boundary between still and moving photographically-appearing images, these artists provoke us to articulate how media reflect or confound each other anew, and challenge us to revise our current thinking about the qualities that join or separate

them, why we care about such boundaries in the first place, and the temporal frameworks within which we articulate such questions. Taking our cue from contemporary practice rather than from existing theoretical models, our volume calls for a resolutely antilinear approach to the issues posed by "new" media and tries to mobilize the tension inherent in the idea of the still moving to create a pause for thought about these suspended moments of aesthetic transition. We consider such pauses not as evidence of our failure to progress (must thought progress like a train on a track?) but as proof that pausing for thought is still possible in a world where, as Susan Sontag stated shortly before her death, "space reserved for being serious is hard to come by," in a world "whose chief model of a public space is the mega-store (which may also be an airport or a museum)."[7] Discussions of this globalized world in which it is so hard to find time or space for thought often demonize film and photography for their participation in the ongoing process of turning life into nothing more than a stream of images, information, crisis, and spectacle. Though these aspects of the media in question cannot be denied, these somewhat rigid characterizations of them need to be refined and revised. *Still Moving* explores the extent to which these media may also be harnessed in the service of the critical dismantling of the structures that support such mindless living. But exactly what critical or political interventions could film and photography make available to us?

THE PROBLEM OF "POST-"

Benjamin once suggested that the utopian possibilities of a medium make themselves most visible at the moments of its birth and death, and this suggestion has undergirded and framed much of the recent discussion of the obsolescence of photochemical media, and what Rosalind Krauss has called "the post-medium condition."[8] Yet when we look closely at what this time of birth and death of film offers us—the stillmoving image—we are left with a paradox: the very quality that seems to mark the beginning and end of film also fundamentally destabilizes the teleologies that reify its identity and make beginnings and endings possible. Our aim in evoking the language of crisis surrounding cinema at the turn of this century, then, is not to dwell melancholically on past debates, bygone giants, and former heydays but rather to interrogate the

very notion of endpoints and technological progressions.[9] Faced with the predominance of digital technology, we suggest that the photochemical image may be too quickly coded as archaic, tinged with the patina of age, historicity, and nostalgia. By exploring the interplay between cinema's origins and twilight hours in contemporary art and cinema, this volume wants to liberate the utopian possibilities of the media in question, possibilities that, above all, open up new pathways for conceiving of temporality, memory, and history, including the history of the media themselves. *Still Moving* accepts and responds to the present moment as one of transition and transformation—of film and photography, of technology and art, of the very idea of the medium in its ontology and specificity. Our title foregrounds what we regard as a productive tension between two terms inherent to cinema and (less obviously) to photography, a tension that is at once material, philosophical, historical, and institutional in its implications, and we invite readers to follow the lines of flight that spin out of this generative and irresolvable encounter between stasis and motion.[10] The essays contained in this volume trace the shifting contours of this encounter across the realms of narrative and avant-garde film, photography, photo-essays, and installation art, from the spaces of page to screen and theater to gallery. These avenues of investigation do not cohere to produce a clear diagram of what contemporary visual practice is or will become but rather to suggest directions, revisions, problems, and possibilities for further exploration as we continue to adapt, invent, and recombine technologies of the image.

All of the contributors in this collection resist the reductive linear logic that often underpins notions of clear-cut beginnings and terminations, evolutionist understandings of history, and categorical distinctions between old and new media. Such a logic finds a culminating expression today in the predominance of the prefix "post-": if postmodernism has served as the primary descriptive rubric for contemporary, late capitalist culture, then the corollary idea that we have entered a post-photographic, post-referential, even post-medium age now permeates discussions of visual culture.[11] In the wake of technological innovation's apparently relentless forward drive, responses have run across a spectrum from breathless hyperbole around the newness of new media to apocalyptic pronouncements on the obsolescence of old media. Within such a critical climate, the intervention of returning motion

to stasis and film to photography might strike a discordant note with its suggestion of historical and intellectual inertia, of energy expended without result, of sweating scholars exerting themselves in the face of adversity while going nowhere, like Jack Deller on his Nordic Track in Yvonne Rainer's *The Man Who Envied Women*. But rather than simply turning away from such specters of intellectual paralysis, this volume illuminates how this moment marking the "obsolescence" of two of the twentieth century's most important media ultimately, and paradoxically, undoes the very paradigm that makes the concepts of novelty, progress, and obsolescence thinkable. Rejecting the more or less explicit institutional imperatives that scholars and artists must deliver novelty to students or spectators in an unending stream of the next best thing, *Still Moving* takes the idea of stillness as a starting point for a consideration of the multiple temporalities that arise at the intersection of still and moving image technologies, and which have yet to find expression through legible forms and conventions.

In heed of Trinh T. Minh-ha's assertion that "it is in stillness that one may be said to find true speed" (2005, 11), *Still Moving* celebrates recursive thinking, the act of being able to go over and over the same problem without moving forward—not because we like to be stuck in a rut, but because the ability, the right, to engage in thinking that does not necessarily have an obvious use value, and that may be held in stillness by its own internal contradictions, creates spaces that undermine and resist the reductive logic of a world shaped by global capitalism on the one hand, and the war on/of terror on the other. *Still Moving* asserts the importance of slow-paced thought at times of swift change, suggests that motion, action, and transformation may at times only be the impression of such, and maintains, in the wake of postmodernism, a commitment to and interest in grappling with the murky challenges of emerging visual paradigms through historically aware, cross-disciplinary intellectual exchange. In the suspended animation created by the intersection of photography and cinema we find a model for simultaneously looking forward and backward at the vicissitudes of the media in question, and see that new media do not simply displace what came before, but rather shine a light onto older media, permitting us to see them differently.

The consequences of shifting one's temporal paradigm away from a linear model of history are too numerous, complex, and, at times, unknown to outline in any comprehensive way, but we can at least begin to imagine what it would mean to think about these media and the methodologies through which we engage them in the light of the temporal paradigm made available to us by the concept of the still moving. First, consider the implications of the still moving on our film history courses. Could a film history course open to the disruptive temporal and epistemological effects of the still moving be adequately taught through a textbook that marches through a timeline and updates itself not by revising how we understand film history in the light of each new articulation of the medium but simply by adding on another chapter to reflect the latest thing in isolation (e.g., the use of digital technology)? Do we not rather consistently need to ask (and teach) how these latest manifestations of the medium might require us to revise what we thought we knew of the medium in its earlier incarnations? Imagine the logistical nightmares that will emerge if we continue to encourage the pedagogical and epistemological gestures of these cumulative textbooks through the financial support that is a direct consequence of our course requirements: How big will these books get? How many courses of ours will we have to assign to getting through them? What notion of learning are we transmitting to students through these additive books, and where is the time or model for thinking in all of this? The monstrous nature of the possibilities behooves us now to reframe our film historical imaginations and to create alternate models of film historical pedagogy that engage with, and are not blind to, film theory and its insights.

STILL MOVING: NARRATIVE/NONNARRATIVE FILM

As an example of how the recursive temporality of the "still moving" challenges conventions of film history, consider how this concept points directly to the instability of cinema as an object of knowledge, to an ambiguity that has yet to be dispelled in our understanding of its ontology. The questions of "what is cinema" and whether "cinema has not yet been invented"—first posed by Bazin and taken up by Barthes not long afterward—become all the more urgent as new media technologies

press upon the domain of the luminous image. Already in "The Third Meaning," Barthes had described film stills as a class of reproductions that need to be distinguished from the "simple photograph" by the "armature of a permutational unfolding," marked by the virtual movement of a "diegetic horizon" that hovers beyond its frame. The oxymoronic language used by Barthes here echoes the ambivalent status of the film still itself, yet the terms of his analysis further oscillate: if the filmic dimension troubles the immobility of the still, likewise "the still dissolves the constraint of filmic time" and demands a rethinking of what constitutes the essence of cinematic mobility. "Born technically, sometimes even aesthetically," he concludes, "film is yet to be born theoretically."[12] Indeed, as Laura Mulvey has recently pointed out, DVD technology has reactivated cinema's constitutive dialectic of stasis and mobility, with the still function making the photogram newly visible, forcing us to consider our readings of familiar films and their apparent continuity afresh: "Now, cinema's stillness, a projected film's best kept secret, can be easily revealed at the simple touch of a button, carrying with it not only the suggestion of the still frame, but also of the stillness of photography . . . the post-cinematic medium has conjured up the pre-cinematic" (Mulvey 2006, 22).[13]

Mulvey's attention to the new visibility of the photogram in narrative films whose commitment to continuity had previously worked against an awareness of the still moving reminds us that we have a tendency to associate the confrontation of cinema and photography primarily with avant-garde, and particularly structural cinema, and to see the concept as anathema to narrative cinema. Yet this assumption must also be questioned, and not only for the reason outlined by Mulvey above. There is, of course, a resonance between the problematic of still moving and practices that have emerged outside of mainstream narrative cinema, such as the work of Peter Kubelka, Tony Conrad, Paul Sharits, Hollis Frampton, Michael Snow, Wallace Berman, and Chris Marker, avant-garde filmmakers who call attention to the individual photogram through "flicker films" and strategies of single-frame montage, through photo-essays, slow zooms, or filmed still photographs.[14] But this volume aims to build upon the work already done by Garrett Stewart in his *Between Film and Screen* in tracing the encounter between film and photography within narrative as well as experimental films. For though there is an important connection to be recognized between the early

"cinema of attractions" and avant-garde film practices, as Tom Gunning has argued, we must be careful not to allow this insight to blind us to other kinds of resonances that may exist across narrative and nonnarrative films. Furthermore, as Juan Suárez's essay "Structural Film: Noise" makes clear, the narratives we have come to know well *about* avant-garde film may also be put under pressure by the concept and temporality of the still moving. Suárez, for instance, intervenes in commonplace understandings of the structural cinema of the 1970s as purely visual, as apolitical, and as primarily "films about film"—that is, films that reflect upon the material of their own making and the specificity of the apparatus—through a focus on sound. Not only do what Sharits calls the "operational analogues" between avant-garde music and cinema challenge the reductive notion that these works are only about film; they also point to the usefulness of *noise* as a conceptual rubric for the "obstreperous materiality" of structural film, for those interferences in the form of scratches, sprocket holes, splices, photograms, grain, and such, that hinder the clarity and transparency of the transmitted image, and that introduce a politically resonant registration of the unrepresentable or illegible within our social systems. With its connotations of static, illegibility, leakage, waste, accident, decomposition, meaninglessness, and enigma, noise opens up a dialogue between classical ontologies of the photochemical image and the discourse of cybernetics and information, and concomitantly reveals the ways in which the postanthropomorphic implications of mechanical reproduction first elaborated by Benjamin and Kracauer, on the one hand, and more contemporary discussions of the posthuman, on the other, might shed light upon one another.

THE POLITICS OF MOVEMENT

Alongside the questions of film aesthetics, history, and pedagogy, then, we need also to consider how the uneasy sense of being out of sync with the present evoked by the still moving—a belated relation to a time that passes too quickly, or an inability to catch up with a future that arrives too early—bears upon our social and political paradigms. For it seems that along with having arrived at the twilight of modernism, and of photography and cinema as modern media par excellence, we have also come up against the limits of the conventions of social intelligibility entrenched in older models of representation. And this brings

us back to the problematic logic of "post-." The encounter of the photographic and digital age, as Nancy Davenport demonstrates in *"Weekend Campus,"* takes place in a moment of "post-feminism, post-identity politics, post-community," with the reductively linear fashion in which this encounter is conceived reinforcing the sense of exhaustion that has overtaken politics. Our invocation of the paradox of standstill motion thus also serves as a call to rethink and resuscitate the politics of the image, with recourse neither to a "political modernist" hyper-emphasis upon the intransigence of form nor to a precritical appeal to the documentary certitude of content.[15] In an era of globalization and deterritorialization, contemporary photographers, filmmakers, and videographers increasingly foreground the identifications that are sustained and interrogated by the still-moving image, grappling with how we might conceive of collective political agency in terms other than "movement," and with the question of what film and photography, in Rebecca Baron's words, "can offer history in excess of language." Think, for example, of the theme of diaspora in *Calendar* (1993), encapsulated in the intermingling of recorded and remembered experiences in the mind of the main character; of the frozen icons of hands signaling the words for *nomad*, *exile*, and *refugee* in Ming-Yuen S. Ma's *Myth(s) of Creation* (1997); or of the tense energy produced by the juxtaposition of Jia Zhangke's expansive traveling panoramas of the Beijing global theme park in *The World* (2004) with the stories of the park's workers, local people who possess no passports and who never have left—most likely never will leave—the environs of Beijing. In such works, the still-moving image becomes a vehicle for the reflection of hybrid identities—minoritarian, diasporic, subcultural—that challenge the coherence of national constructs of subjecthood, helping us to understand the complexity of the modern nomadic subject whose mobility may well be experienced as a confining imperative as much as an ecstatic freedom.

While this challenge often receives articulation through tropes of movement, passage, and distance, as in the idea of border crossing or interstices, the question now arises as to whether these spatial tropes can continue to offer a conceptual handle on a world in which the speed and flow of peoples, images, information, and capital threaten to outpace our ability to evaluate and theorize our changing experiences. Indeed, as the very fixity and locational stability that would confer such a power disintegrates—that is, as it becomes more and more difficult to identify

a place in the world that is not in some respect already a borderland, begging the very idea of the border—it becomes all the more crucial to attend also to other forms of displacement wrought, at least in part, by the onslaught of mechanically reproduced images in contemporary media culture.

TRAUMA, MEMORY, INDEXICALITY

Under the weight of these multiplying images, fragments of the then-and-there transported to the here-and-now, the anomalous sense of temporality that has characterized modernity from its beginnings settles into a strange rhythm of rupture and repetition. So it seems that the currency of the concept of trauma today stems less from its specification of the singular horrors of history than from its crystallization of a more general paradox of ever-repeating crisis. The time of trauma is at once in motion and at a standstill, consisting of a recursive eventfulness, impervious to the linear rubrics of progress. Trauma stands for both the difficulty and imperative, as Davenport reminds us, of thinking through the possibilities of subjectivity and collectivity after the loss of faith in grand narratives. It augurs the triumph of the excesses of memory over the critical distance of history, rendered unthinkable not because we are cut off from the past but because we are inundated by it.[16]

If photography's arrest of the instant elicits comparisons to trauma on the basis of a shared logic of deferral and repetition, its estranging effects may be seen as a product of a similar confrontation with the unconscious. The notion of an "optical unconscious," first set forth by Benjamin and often registered in the form of accidents or details that are among the hallmarks of photographic media, suggestively opens onto a phenomenology of the photochemical image that calls into question the forms and conventions through which we know reality. Pointing to the image's elusion of intentionality and conscious signification, its tendency to exceed rather than uphold systems of meaning in its affiliation with contingency and indeterminacy, the optical unconscious negates the principle of photography as proof, and in doing so opens channels through which to explore how photography and film's ambiguity can map onto social configurations of alterity, difference, and otherness.

Driving the push-and-pull of oblivion and recollection associated with these media is the photochemical image, whose capabilities as a

medium of storage and mechanized memory stem from its indexical bond with the contingent reality it captures—that is, from the direct physical contiguity between the image and the thing it represents, in the manner of an imprint or trace. The quality of indexicality, common to film and photography, figures prominently in the recent critical reinvestment in the relationship of these media, after its longtime relegation to the margins of film theory's critique of illusionism—a critique that emphasized the deceptive nature of the photographic sign, aiming to shatter its claim to referentiality by interrogating its mimetic semblance of reality. In this context, the revival and reexamination of thinkers like Bazin and Kracauer—previously characterized as naive realists or technological determinists for their insistence upon the ontology of the photograph as a material trace of reality—denotes a shift away from semiotic methodologies as these prove inadequate to the task of accounting for the potentiality of film and photography.[17] Going further, Gunning asks whether we might even do away with the concept of indexicality itself, given its longstanding associations with photography's evidentiary functions and its origination in the semiotic theories of Charles Sanders Peirce; insofar as both Barthes and Bazin characterize the photograph as something of the same order as the reality it conveys, it may be said to ultimately circumvent what he calls "the sign's essential function of substitution." Divested of its baggage of referentiality and truth-value, the photochemical image remains compelling as it generates something along the lines of a natural disaster: "the flood of photos sweeps away the dams of memory," as Kracauer declares, and further on, "the blizzard of photographs" (1995, 58).

The paradigms for thinking about film and photography offered to us by the Frankfurt School critics were formulated, of course, at a moment when these media and their effects were described with repeated recourse to metaphors of novelty, speed, intensity, and shock, all consistent with modern mass culture's overall assault on the senses. But if these media once shone with the anticipation of the century to come, they now radiate its afterimage, the "immense, interminable fade" of the twentieth century, to borrow the words of Chris Marker. Just as speed may no longer be the most pertinent paradigm for our theoretical reflection on these media, so the most pressing consequences of the photochemical image for the present are now as much concerned with how it bears upon our understanding of the past, as it sweeps away

"the dams of memory," as with how it orients us toward the future. The uncanny rhythms of hesitation, interruption, delay, and return released by photographic technologies undoubtedly contribute to the disintegration of organic constructs of memory and temporality, to the attenuation of older modes of historicism; at the same time, however, they open onto new capacities for action and reflection in the interstitial zones of private and public remembrance, between individual subjectivity and a public sphere of collective memory.

Several of the contributors in this book—including Ma, Baron, and Gonzalez—investigate the political possibilities of photography and film, their connection to lost, forgotten, excluded histories, and to unfamiliar pasts brought into jarring juxtaposition with the present. These authors trace the interplay of still and moving images across different registers of history: official, vernacular, intimate. In doing so, they pursue what Baron calls the "details, digressions, tangents, the edges of the frame" that give lie to official history's claims to comprehension and totality.

Exploring the social, political, epistemological, as well as aesthetic potential of interstitial spaces, these essays offer new conceptions of the ontology of film and photography while at the same time challenging those traditional notions of medium specificity invested in clear, impenetrable borders and pure, uncontaminated identities. *Still Moving* maps out the critical and aesthetic potential of interstitial spaces and offers ways for us to think about these contested and provisional spaces without either returning to modernist notions of aesthetic purity or perpetuating an automatic celebration of intermediality. In spite of the understandable pessimism informing recent discussions of the state of theory, it may be useful to recall Maurice Blanchot's appeal in *The Writing of the Disaster*: "Let us not entrust ourselves to failure. That would only be to indulge nostalgia for success."[18] Responding to this call, *Still Moving* resists the temptation to dwell exclusively on the failure and inadequacy of contemporary critical paradigms and instead attempts to open a vibrant space in which artists, filmmakers, art historians, and film scholars can initiate a conversation regarding the medium and medium-specific discourse, the affinities and tensions that exist between cinema and photography, and the impact that these conversations may have on the disciplinary and interdisciplinary spaces in which we work.

NOTES

1 See Foster 2002.

2 The unresolved identity of the medium as an object of study is demonstrated by its lack of a standardized disciplinary appellation; a quick glance through the catalogs of various universities reveals a diversity of titles: cinema, film, media, video, television, digital technology, electronic arts, screen studies, visual culture, and so on.

3 On the representation of movement in painting, see also Hollander 1989.

4 To cite the well-known account of Maxim Gorky, "suddenly a strange flicker passes through the screen and the picture stirs to life." Maxim Gorky, review of the Lumière program at the Nizhni-Nobgorod Fair, *Nizhegorodski listok*, July 4, 1896. Translated by Leda Swan and Jay Leyda in Leyda 1983, 407–8.

5 Other works that have shaped this discussion about the relationship of film and photography are *Fugitive Images* (1995), ed. Patrice Petro; *The Image in Dispute* (1997), ed. Dudley Andrew; and Garrett Stewart's *Between Film and Screen* (1999). More recently, Laura Mulvey engages a similar set of concerns in her *Death 24x a Second* (2006). The relationship between film and photography is also the subject of *The Cinematic* (2007), a reader compiled by David Campany, which includes key texts by artists and critics.

6 Bellour's essay appears here in its first English-language publication. Dominique Païni's catalog essay for "Projections: Les transports de l'image," entitled "Should We Put an End to Projection?" has been reprinted in English in *October* 110 (Fall 2004). For further discussion, see also *October*'s roundtable on "The Projected Image in Contemporary Art" (2003).

7 Sontag 2003, 119.

8 See, for example, Krauss 1999.

9 Indeed, the sense of obsolescence and crisis overshadowing the cinema's centennial has in fact been one of film's defining attributes throughout its history, prompted by developments such as sound technology, television, video, and, more recently, digital systems of production and delivery.

10 The idea of still moving has been previously invoked by Scott Curtis in his essay "Still/Moving: Digital Imaging and Medical Hermeneutics" (2004).

11 For example, see Krauss 1999.

12 Barthes 1991 [1985], 60–61.

13 To look back to the prehistory of cinema is to take in not only photography as one immediate predecessor but also a broad spectrum of visual practices that engage the interrelatedness of the two media, such as optical toys, dissolving slide shows, the serial motion studies of Edwaerd Muybridge and Etienne-Jules Marey. For discussions of these earlier visual practices and their connection with cinema, see Musser 1990 and 1991, Braun 1992, Williams 1986, Doane 2002, Hansen 1997 and 1999, Gunning 1990 and 1995b, Crary 1990 and 1999, and Mulvey 2006.

14 Our use of photogram refers to the individual photographic image on the filmstrip, and not to an image produced by the imprint of an object directly onto a photosensitive plate, as the nineteenth-century usage of the term suggests.

15 On "political modernism," see Rodowick 1988.

16 Jameson first made this point in *Postmodernism, or, The Cultural Logic of Late Capitalism* (1991).

17 Some examples of this emerging body of scholarship include Hansen 1997, Rosen 2001, Mulvey 2006, and Morgan 2006. A special issue of *differences* (2007), edited by Mary Ann Doane, deals with the topic "Indexicality."

18 Blanchot 1995, 12.

beyond
referentiality

WHAT'S THE POINT OF AN INDEX? OR, FAKING PHOTOGRAPHS

Tom Gunning

f Freud had subjected one of the West's central ideologies—histori-
cal progress—to psychoanalysis, he might have discovered the pri-
mary psychic operation of displacement operating behind our con-
stant impetus toward ever-greater perfection. What passes for progress
(especially theoretical progress), I am claiming, often simply displaces
unresolved problems onto new material.

As a historian of early cinema (and of the even earlier visual and
sound technology that preceded the cinema, such as the magic lantern,
the phantasmagoria, the panorama, the phonograph, and the devices of
instantaneous and chronophotography), I am excited, but also a bit dis-
mayed, by the current discussion of newly emerging media, especially
when this discussion provides an account of the older media of cinema
and photography. There is no question in my mind that the recent inter-
est in early cinema and its technological antecedents springs partly from
the excitement the appearance of such new media generates (and my
friend and colleague Erkki Huhtamo has demonstrated this interrela-
tion of old and new most wonderfully).[1]

But, as Norman Mailer is supposed to have once said, ideals of progress
often depend on the anesthetization of the past. While I believe that the
possibilities and realities of new media invite us to (in fact, demand that
we) rethink the history of visual media, I also fear they can produce
the opposite: a sort of reification of our view of the older media, an
ignoring of the true complexities that photography, cinema, and other

visual media capturing light and motion presented, simply displacing their promises and disappointments onto a yet-to-be-achieved digital media utopia. Especially bothering to me is a tendency to cast the older media as bad objects, imbued with a series of (displaced) sins that the good objects of new media will absolve.

Let's tackle one of the largest problems first, the truth claim of traditional photography (and to some extent cinematography), which has become identified with Charles Peirce's term *indexicality*. Both aspects need investigation: the nature of the truth claim, and the adequacy of indexicality to account for it. This whole issue becomes even more obscure when critics or theorists claim (I hope less frequently as time goes by) that the digital and the indexical are opposed terms.

I will approach this last issue first, both because I think it is rather simple and because others have made the argument as well or better than I can (most recently Phil Rosen in his fine work *Change Mummified* [2001]). I have some difficulty figuring out how this confusion arose, but I imagine it went something like this: the indexicality of the photograph depends on a physical relation between the object photographed and the image finally created. The image on the photographic negative derives from the transformation of light-sensitive emulsion caused by light reflecting off the object photographed filtered through the lens and diaphragm. In a digital image, however, instead of light-sensitive emulsion affected by the luminous object, the image is formed through data about light that is encoded in a matrix of numbers.

But what problem does this change present and how does it challenge indexicality? Clearly a digital camera records through its numerical data the same intensities of light that a nondigital camera records: hence the similarity of their images. The difference between the digital and the film-based camera has to do with the way the information is captured—which does have strong implications for the way the images can be stored, transferred, and indeed manipulated. But storage in terms of numerical data does not eliminate indexicality (which is why digital images can serve as passport photographs and the other sorts of legal evidence or documents, which ordinary photographs supply).

Further, it would be foolish to identify the indexical with the photographic; most indexical information is not recorded by photography. Long before digital media were introduced, medical instruments and other instruments of measurement, indexical instruments *par excel-*

lence—such as devices for reading pulse rate, temperature, heart rate, and the like, or speedometers, wind gauges, and barometers—all converted their information into numbers. (Think, for instance, of that household item, the thermometer, in either its analogical or digital form.)[2]

Although a photograph combines both types of signs, the indexical quality of a photograph must not be confused with its iconicity. The fact that rows of numbers do not resemble a photograph, or what the photograph is supposed to represent, does not undermine any indexical claim. An index need not (and frequently does not) resemble the thing it represents. The indexicality of a traditional photograph inheres in the effect of light on chemicals, not in the picture it produces. The rows of numerical data produced by a digital camera and the image of traditional chemical photography are both indexically determined by objects outside the camera. Both photographic chemicals and the digital data must be subjected to elaborate procedures before a picture will result. Here we might grasp how the claim for digital uniqueness displaces a problematic issue within our conception of traditional photography, an especially pernicious one. The claim that the digital media alone transform their data into an intermediary form fosters the myth that photography involves a transparent process, a direct transfer from the object to the photograph. The mediation of lens, film stock, exposure rate, type of shutter, processes of developing, and of printing become magically whisked away if one considers the photograph as a direct imprint of reality.

Thus the very strong claim that digital images can be manipulated in ways that photographic images cannot must also be qualified. Indeed the much-heralded malleability of the digital image does not contrast absolutely with photography. I would not deny that the ease, speed, and quality of digital manipulation represent an important new stage in the technology of imagery. But we must carefully consider the situations in which such malleability becomes a value and the considerable debt such transformations owe to (although often displacing our attention from) the history of photography. Here especially, the intertwining of indexicality and iconicity must be observed.

Let us grant for the moment the ability of digital photography to transform absolutely the appearance of the object originally photographed. Doesn't this power of the digital destroy the indexical quality of the

image? If we grant that the original digital photograph of Uncle Harry was indexical (and therefore bears an important relation to the actual Uncle Harry), what happens when we then intervene on the data in a Photoshop program and transform his nose into a pronounced beak, his bald head into a shaggy wilderness, turn his brown eyes blue? Surely the indexical is being attenuated, if not absolutely destroyed! Two answers are relevant here, both of which include a qualified yes. Yes, but . . . film-based photography can also transform Uncle Harry's appearance, whether through retouching, use of filters or lenses, selection of angle of photography, exposure time, use of specially prepared chemicals in the developing stage, or adding elements through multiple printing. Traditional photography, therefore, also possesses processes that can attenuate, ignore, or even undo the indexical. No question digital processes can perform these alterations more quickly and more seamlessly, but the difference between digital and film-based photography cannot be described as absolute, only as relative.

But a more complex and, I think, more interesting answer would point out that the power of the digital (as well as the traditional photographic) to "transform" an image depends on maintaining *something* of the original image's visual accuracy and recognizability. I use this phrase ("visual accuracy and recognizability") to indicate the manner in which indexicality intertwines with iconicity in our common assessment of photographs. Our evaluation of a photograph as accurate (i.e., visually reflecting its subject) depends not simply on its indexical basis (the chemical process) but on our recognition of it as looking like its subject. A host of psychological and perceptual processes intervene here which cannot be reduced to the indexical process. The recognition of a photograph by a viewer as an image of its subject would not simply result from indexicality. Indeed, one could produce an indexical image of something or someone that remained unrecognizable. While the indexical relation may tie the photograph to its referent, the image must be recognizable for us to see it as a picture of the referent. More is involved here than simple indexicality.[3]

Let me get at this point via another route. If one of the great consequences of the digital revolution lies in the freedom it gives people to transform a photographic image, we could say that the digital aspires to the condition of painting, in which color, shape, texture, all the compo-

nents of an image, are decided by the painter, rather than determined by the original subject through an indexical process. But do users of Photoshop want an *absolute* freedom? Do they really want to *create* an image or, rather, is their purpose to *transform* an image that can still be recognized as a photograph (and maybe even as a photograph of Uncle Harry)?

The interest in transforming Uncle Harry's photograph is not quite the same as that of drawing a caricature of him. Admittedly one could point out that few of us have the depictive talent to produce a caricature, and that digital manipulation programs give us that power (interestingly this recalls the argument Fox Talbot gave for his invention of photography as a mechanical aid for those who lack drawing talent). But beyond the technical aid offered, it seems to me that the power of most digital manipulation of photographs depends on our recognizing them as *manipulated photographs*, being aware of the strata of the indexical (or perhaps better, the visually recognizable) beneath the manipulation.

The wonderful playfulness celebrated in the digital revolution remains parasitic on the initial claim of accuracy contained in some uses of photography. Just as I tried to untangle the idea of visual accuracy from simple indexicality, I would now like to consider the "truth claim" of photography that relies on both indexicality and visual accuracy but includes more (and perhaps less) than either of them. A great deal of the discussion of the digital revolution has involved its supposed devastating effect on the truth claim of photography, either from a paranoid position (photographs will be manipulated to serve as evidence of things which do not exist, thereby manipulating the population to believe in things that do not exist) or from what we might call a schizophrenic position (celebrating the release of photographic images from claims of truth, issuing in a world presumably of universal doubt and play, allowing us to cavort endlessly in the veils of Maya).

I use the term *truth claim* because I want to emphasize that this is not simply a property inherent in a photograph but a claim made for it (dependent, of course, on our understanding of its inherent properties). Perhaps its Ur-form can be found in Dion Boucicault's 1859 melodrama *The Octoroon*, in which Scudder, the play's Yankee "photographic operator," discovers that an act of murder has been recorded by a camera. He offers the photograph of the actual act of murder, showing the true

culprit, as evidence to a lynch mob about to lynch a Native American falsely accused of the murder, declaring, "'Tis true! the apparatus can't lie!" (Boucicault 1984, 163).

We might add immediately that the apparatus, in itself, can neither lie nor tell the truth. Bereft of language, a photograph relies on people to say things about it or for it.[4] It is no accident that Boucicault's melodrama involves a mock trial in which the photograph exonerates the falsely accused Indian chief Wahnotee and determines the true culprit. Given the early date of this play, characters question whether an official court of law would actually accept such evidence. Both historically and institutionally, in order to tell the truth, the photograph must be subjected to a series of discourses, become, in effect, the supporting evidence for a statement. Anyone who knows either the complex history by which photographs were granted evidentiary status in legal trial, or indeed the scrutiny and discussion to which they must be subjected before they are granted such status in contemporary trials, must realize that in order to speak the truth the photograph must be integrated into a statement, subjected to complex rules of discourse—legal, rhetorical, and even scientific (discussing the technical aspects of the photograph, its exposure, developing, and printing).

But I think we would also have to contradict Mr. Scudder and say that a photograph can only tell the truth if it is also capable of telling a lie. In other words, the truth claim is always a claim and lurking behind it is a suspicion of fakery, even if the default mode is belief. That is, the value placed on the visual accuracy of a photograph, founded on its combination of indexicality and iconicity, forms the basis of a truth claim that can be made in a variety of discourses whether legal ("Here we see the accused caught by a surveillance camera . . .") or less formal and interpersonal ("Yes, his penis really is that big . . ."). But insofar as this value of visual accuracy exists, there will always be a drive to counterfeit it. The truth implies the possibility of lying, and vice versa.

Faking photographs has a long history and was always possible, given the processes that intervene or shape the indexical process as it becomes a picture. Spirit photography, the attempt by Spiritualists to prove the survival of a soul after death by capturing its image in a photograph, a practice dear to my heart, provides only one early example (see Gunning 1995b). The variety of doctored photographs for political purposes is another (King 1997). But my point here is not simply to claim either that

the manipulability of photographs predates the digital (undeniable)
or that this practice was frequently employed in circumstances where
truth claims were attempted (undoubted). Rather my point is that the
practice of faking or counterfeiting can only exist when true coin of the
realm exists as well. Rather than denying photography's truth claim,
the practice of faking photographs depends upon and demonstrates it.

Thus the concern over, or the celebration of, the possibility of the
digital undermining the association of photography with a truth claim
involves an inherent contradiction. If the digital undermines the truth
claim of photography, we will have to ask in what contexts this occurs.
For example, while someone could digitally alter the size of his penis in
a photograph, a general incredulity about extraordinary photographs
has already set in, leading to skepticism about such images. But in cases
of legal or scientific evidence, protocols are set in place for determining
the process by which the photograph would be made and the likeli-
hood of its accuracy. Clearly journalism (and governmental use of the
media) constitute arenas in which the greatest concern abounds. But
equally clearly, institutions of journalism and government watchdog
organizations will endeavor to preserve the possibility (the inevitability
not being possible) of photographs supporting truth claims in certain
situations. By no means do I claim that conspiracies of deception can-
not exist, only that they will not differ essentially from other attempts at
political deception. George Bush did not provide photographs of Iraq's
"weapons of mass destruction" to justify his invasion (although Colin
Powell did attempt some rather vague photographic evidence in his ad-
dress to the United Nations). The rhetoric of deception rarely rests on
a single form of evidence (indeed it tends to multiply and obscure evi-
dentiary claims and substitutes devotion to broad motivations such as
homeland security and the preservation of freedom).

A recent journalism textbook dealing with journalistic photography
in the digital era proposes that organizations dedicated to reporting
news take a pledge of "Truth and Accuracy in Media Photography" and
that organizations so pledging could display "a badge or symbol certify-
ing their commitment" to the visual integrity of their images (i.e., that
they have not been altered digitally) (Wheeler 2002, 207–9). My point
is not to predict whether such a practice will be widely adopted but
rather to demonstrate that truth claims about photographs possess an
institutional value in specific circumstances (this textbook at one point

queries its journalism student readers: "Will we Photoshop ourselves out of a job?" [111]). Therefore means will most likely be taken to preserve this value, even in an era where it is easy and cheap to alter photographs and produce a believable image. The truth claim must always be supported by rules of discourse, whether rigorously defined (as in scientific or legal evidence) or inherent in general practice (as in the belief that news reporting generally tells the truth—it seems to me that doubts about journalists' commitments to the truth, such as revelations of the bias underlying the reporting on the FOX network, more strongly undermine belief in the truth claim of a photograph than the simple fact of technical manipulability).

Likewise the use of photographs as evidence, whether legal or scientific, has always entailed a considerable disciplining of the photographic image. Consistency and uniformity of photographic processes (such as the very specific manuals written for police photographers or the strictly determined routine of distance, camera angle, lighting, and type of lens and apparatus used in the creation of Bertillon's photographs of criminals for use in identification) rule institutional photographic practices (Bertillon 1896). A photograph's use as evidence or scientific data often has to contend with the excesses of its intertwined indexical and iconic aspects. For scientific use, photographs frequently recorded too much information, and, as Peter Galison has shown, scientists debated whether to remove this excessive information or to forthrightly acknowledge it (1998).

Etienne Jules Marey (whose chronophotography offers the most direct ancestor of the cinema) provides a fascinating example, as Joel Snyder and Marta Braun have shown (Snyder 1998 and Braun 1992). Marey's first investigations of the human and animal body in motion used instruments that provided only numerical readings or graphic inscriptions (the well-known "graphic method"). However, after encountering Eadweard Muybridge's serial photographs of the horse in motion, Marey realized the increased sensitivity of new photographic processes and emulsions provided even shorter exposure times, allowing the photograph a new degree of control over time, capturing instants of motion that the human eye could not see. The possibility of analyzing human and animal motion through multiple instantaneous images in rapid succession excited Marey. However, for certain purposes the excess of visual information interfered with analysis, and Marey arranged

the subject in front of the camera in order to create a more abstract image.

We might describe Marey as a digital manipulator of photographs *avant la lettre*. Subjects wearing dark costumes in which white stripes and metal studs marked joints and limbs converted Marey's photographs into graphlike images, which, after a further abstraction, became literal graphs. But one thing Marey did *not* eliminate from the image was its indexical relation to the subject, another indication of the way in which the indexical and digital need not be opposed and that the indexical may have little relation to photography's iconic properties. Throughout the late nineteenth and twentieth centuries, scientists introduced protocols for both the way photographs were made and the way they could be read, which tamed the photographic image and made it useable as scientific evidence.

Let us consider the other side of the equation: the celebration of the new digital utopia (as Rosen calls it) in which digital manipulation liberates photography from its stable and predictable identity and its seemingly mechanical reiteration of the facts (Rosen 2001, 348). As an art form, photography has never been limited to any such restriction to the factual or accurate. In contrast to the protocols that enabled the truth claim of the legal or scientific photograph, art photography may create its own protocols and practices, free to explore and transform its forms. The processes of superimposing multiple negatives, gum printing, or solarization—not to mention aesthetic selection of lighting, exposure, and composition—have always delivered photography from a simple adherence to accuracy and truth claims when it desired to explore its visual possibilities as an art form. The techniques of nineteenth-century photographers on all levels (including the costuming and posing of models as in the work of Julia Margaret Cameron or Lewis Carroll) were hardly examples of "faking" photographs but rather the means of creating photographs as modes of play and imagination. The aesthetic triumph of styles of direct photography during much of the twentieth century (scorning many of these techniques in favor of hard-edged focus and printing techniques) primarily involves processes of artistic choice and stylistic differentiation, no matter how frequently claims of the essential truthfulness of photography might be invoked by practitioners and critics. We must not confuse these carefully mastered aesthetic modes and purposes with simple reportage.

Digital manipulation can hardly be seen as transforming the nature of photography as an art form, although it offers both new exciting techniques and new processes of discovery in the exploration of those techniques. We must keep in mind that only a limited practice of photography ever made accuracy or truth claims an essential part of its practice and that many uses of photography intentionally flout such claims. Beyond the modernist practices of art photography, popular forms of what we could call "rhetorical" uses of photography, such as in advertising or political persuasion, do not depend exclusively, or often even primarily, on such truth claims.

Finally, we could observe that if indeed a digital revolution ever did trigger a complete overthrow of the truth claim of photography—if the association of photography in people's minds with truth claims and accuracy were entirely abolished through repeated encounters with photography images that could not be trusted—then the possibility of deception would also be abolished, and little motive for counterfeiting would remain. If the truth claim were utterly destroyed as a possibility, what would be the motivation for making photographs rather than drawings or paintings, other than Fox Talbot's embarrassing claim that photography could place visual representation in the hands of the artistically challenged?

Here I think we encounter a basic aporia in our understanding of photography, one that I believe can only be approached phenomenologically, rather than semiotically. It is only by a phenomenological investigation of our investment in the photographic image (digital or otherwise obtained) that I think we can truly grasp the drive behind digitalization and why photography seems unlikely to disappear and why, even without a formulated truth claim, it offers us something that other forms of visual representation cannot.

Let us consider modes of photography that seem designed to flout the truth or even the accuracy claim associated with photography. While I would not deny that forms of photography can exist in which this flouting triumphs to such a degree that any referential role seems to vanish, I think that in most instances such photographs actually strive to present a contradiction, an oxymoron, an impossible presence, invoking photographic reference even while contradicting it. Surrealist superimpositions in the work of Man Ray, photomontages by John Heartfield, or defamiliarizing camera angles by Rodchenko, to cite a few masters of

modernist photography, all work with (and against) the recognizability and reference of the photograph.

Our delight in a clever digital manipulation of a photographic image in an advertisement or magazine cover does not come from being fooled by the image but rather from the playful push-pull between its associations with accuracy (that is how a woman's face looks) and its obvious distortion (but no face looks like *that*). But just as a counterfeit image relies on our still believing in the reliability of images, a playful image that deconstructs itself before our eyes relies on our common investment in the photograph's ability to show objects in a way we recognize. If faking photographs dishonestly appropriates the truth claim devised for photography, we might say aesthetic play counterpoints the work of evidence, even if in the art of photography work and play intertwine.

Nor is this playful inversion of our ordinary recognition of photographs simply the product of the novelty and unfamiliarity of new technical manipulations. In other words, I do not believe that seeing a large number of photomontages, surrealist superimpositions, or bizarre digital manipulations will abolish this inversion of recognition for us (although making original and fresh images from these processes remains a challenge to artistic skill and originality). I think the delight in seeing a photographic image of a familiar world skillfully or imaginatively distorted in an unfamiliar manner will always provide pleasure.

I would maintain that the particular artistic and entertaining delight of digitally manipulated photographs depends on a continued investment in the photograph as potentially an accurate representation, causing a playful inversion of associations rather than simply canceling them out. Thus a sense of the photograph as reference remains inherent even while contradicted (or played with) in a manipulated photograph. Yes, the back of a woman does not have incisions like the soundboard of a violin. But while Man Ray's pun *The Violin of Ingres* could have been conveyed by a drawing or even a rebus, it is the photographic nature of this woman's back rubbed against the absurdity of seeing her as a fleshly violin and the wit of Man Ray's joke that produces its effect. This photograph makes no truth claim (there never was a woman like this), yet it does still depend on a perceptual accuracy (we recognize the contours and texture of the woman's flesh and back).

I am positing a phenomenological fascination with photography that involves a continuing sense of a relation between the photograph and a

preexisting reality. While this is precisely what "indexicality" supposedly involves, I am less and less sure this semiotic term provides the proper (or sufficient) term for the experience. It is often claimed that our belief in photographic images depends on our knowledge of how they are made, on being aware of the fact that light bounced from the object has a causal role in the creation of the image. Without denying this, since I believe that cultural knowledge shapes our perception of things, I wonder whether this putative knowledge really provides the principle source of our investment in the photographic image. If a friend shows me a quill pen and tells me it was the one Herman Melville used to write *Moby-Dick*, my fascination with the pen is dependent on this fact. If I find out my friend is joking and bought the pen at a souvenir store, my fascination vanishes. But when I am told a photograph has been digitalized I may cease to believe its truth claim, but I think I am still intrigued by it. The same irrational appeal partly explains the uncanny fascination that spirit photographs have for me.

I am not sure that the indexical explanation fully accounts for our fascination with the photographic image, its sense of perceptual richness and nearly infinite detail that strikes us as somehow more direct than other forms of representation. Confronted with a photograph, I do not so much make a judgment based on my knowledge of its means of production as I immediately inhabit its image and recognize it, even if the recognition involves the playful discovery that this world is impossible. I believe that in fact the groundwork for such a phenomenological description has already been laid, especially in the work of André Bazin and, in a complex manner, in the writings of Roland Barthes. While I do not feel these authors offer sufficient accounts, I should emphasize that my critique of the indexical does not involve a disregard of the "realist" positions held by these theorists. Indeed, I feel Bazin's discussion of photography in particular has been as much distorted by aligning his thought with the semiotics of the index as it has been illuminated. I will try, in the remainder of this essay, to indicate why I think this tradition of interpretation of photography is valuable and why it outruns the indexical account.

I think we should pause in our attempts to *explain* the effect of the photographic image and instead *describe* it more fully. There is no question of mistaking a photograph for the world; its stillness, borders, sense of texture, and so forth forbid that. Photography therefore does

not affect me like a hallucination. But outside of some form of analysis, I am not sure we ordinarily approach photographs semiotically, that is, taking them as signs. Certainly a photograph can function as a sign for something (what can't count as a sign in some context?), usually its subject, a souvenir of a place or a person, a way of identifying or referring to something. But I think this is a secondary process to its ability as a picture to present us with an image of the world. Pictures generally are more than signs, and frequently we would be hard pressed to claim they refer to anything other than themselves. But photographs do seem to point beyond themselves in a curious manner, and this is part of the reason the index does seem to explain part of its power. But whereas signs reduce their reference to a signification, I would claim the photograph opens up a passageway to its subject, not as a signification but as a world, multiple and complex.

Photographs, then, are more than just pictures. Or rather, they are pictures of a special sort, ones whose visual reference invites us to a different sort of observation, to ask different questions and think different thoughts. The photograph does make us imagine something else, something behind it, before it, somewhere in relation to it. Barthes indicates this, I believe, by his claim that the photograph and its referent "adhere" (Barthes 1981, 6). And yet even Barthes, the semiotician, differentiates this adherence of the photograph to its referent from the way other signs refer. Photography, Barthes first told us decades ago in an early essay, is an image without a code, thus outside ordinary semiotics ("The Photographic Message," 1977). He later told us, reaffirming his earlier position, that photography is not a copy of reality but rather its emanation (1981, 80). In his self-described realist position, Barthes shares Bazin's belief that a photograph puts us in the presence of something, that it possesses an ontology rather than a semiotics.

The fairly recent preoccupation with the index as a means of understanding photography derives not only from the rediscovery of Peirce that accompanied the shift to a semiotics of culture but more directly from Peter Wollen's brilliant application of Peirce's category to Bazin's discussion of the ontology of the photographic image, as well as a host of discussions that followed including those of Rosalind Krauss (Wollen 1969; Krauss 1985). But Wollen's translation of Bazin's ontology of photography into a semiotics involved a canny appropriation and transformation of Bazin, who never used the term *index*, although his terms

of comparison with photography—death masks, fingerprints, molds—certainly invoke some of Peirce's examples of indices (Bazin 1967). If Wollen's semiotic gloss on Bazin rendered his argument more rational and understandable, it may have also cut us off from a different understanding of the power of the photograph implied in some of Bazin's less understandable passages.

For Bazin, the photograph is not a sign of something but a presence of something, or perhaps we could say a means for putting us into the presence of something, since clearly Bazin realizes that a photograph differs from its subject. But is the indexical relation to a referent enough to truly explain what Bazin describes as photography's "irrational power to bear away our faith" (14)? An indexical relation falls entirely into the rational realm. Likewise Barthes describes the power of photography as "a magic, not an art" (1981, 88). When Barthes describes a photograph as an emanation of a past reality rather than a copy of something, he underscores the way a photograph relates to a single individual object and a unique moment in the existence of that object. Within the realm of signs, only an index possesses this sort of specificity, but one might question whether semiotics provides an account for those aspects of the photograph that seem most compelling to Bazin and Barthes. Rather than finding equivalents to photography within the science of signs, we might explore the way photography transforms—or even possibly avoids—the sign's essential function of substitution. Barthes and Bazin are agreed that the photograph offers neither a copy (a simple iconic sign) nor a substitute (the function of all signs, including indices). "Photography actually contributes something to the natural order of creation instead of providing a substitute for it," claims Bazin (15).

Besides photography's ability to put us in the presence of its reference, the quality Barthes describes as an emanation, we might want to describe aspects of it visually which the index alone does not imply. It is not enough, I think, to simply class photography as an icon without describing its unique depictive qualities. These unique qualities are often described in terms of photography's mode of production, especially the mechanical nature of its process, so that images do not derive from a skilled human hand but rather rely on principles of optics, mechanically controlled and chemically captured. While the importance of, as Bazin puts it (13), the absence of man remains an issue in need of

continued exploration, I would rather emphasize the sense of a nearly inexhaustible visual richness to the photograph, combined with a sense of the photograph's relative lack of selection. The photograph appears to share the complexity of its subject, to capture all its details, even those we might not ordinarily notice. The first commentators on photography marveled over this sense of an unprecedented visual array, possessing overwhelming detail. Marey's processes or Bertillion's procedures sought to remove precisely this excessive aspect of photography, so that photographs could function better as unambiguous signs and clear sources of indexical data. It is photography's resistance to significance, its excessive "noise," which characterizes its realism, as well as its sense of uniqueness and contingency, values especially prized in Barthes's account of photography and important, I would claim, to our fascination with photographs as a different sort of picture.

These qualities do not necessarily relate to indexicality, but they certainly make up a considerable part of the desire for total illusion that Bazin described in the "Myth of Total Cinema," the companion piece to his essay "The Ontology of the Photographical Image," and an essay in which indexicality plays a subsidiary role to the capturing of the visual richness and complexity of the world (1967). In this essay Bazin places cinema in the tradition not so much of indexical photography but of other nineteenth-century devices designed to overwhelm the senses with their perceptual richness, such as the panorama, the diorama, the stereoscope, and ultimately the phonograph. For Bazin the painted colors and entirely nonindexical animated drawings of Émile Reynaud's Pantomimes Lumineuse may be more essential to the history of cinema than the abstracted motion studies of Marey.

Here our discussion comes full circle, because if the digitally produced new media may differentiate themselves from cinema and photography, they would seem to relate strongly to the artificial realities of the panorama, diorama, and Reynaud's animations. If these devices lack the indexical claim of photography, they absolutely claim the ability to fashion a counterreality through perceptual stimulation. But rather than maintaining the absolute barrier of the indexical, we might want to place photography into this tradition, accenting its visual richness and excessive detail too often bypassed by recent commentaries (although Jonathan Crary's treatment of the stereoscope opens a similar line of investigation [Crary 1990]).

If the richness of a detailed visual array may be one aspect of photography that needs exploration (and the aspect most obviously imitated by digital processes), another aspect, which I will only touch on here, is photography's specific relation to temporality, its ability to refer to a relatively brief and very specific point in time. This aspect is especially central to Barthes's discussion and is implicit in many of Bazin's arguments. Theorists emphasizing photography's relation to index often stress this aspect, referring to the photograph as a trace of a previous time.[5] I agree that this role is extremely important in a phenomenology of the photograph but would point out that while a trace may be an index, an index is not always a trace. Many indexes (such as weather-vanes) are simultaneous to their effects, while others, such as relics, refer to past events but not to specific moments. In other words, the important relation that the photograph bears to a past moment involves more than an indexical relation, worthy of more in-depth discussion, which labeling it as an index does not fulfill.

Thus I think we are able to pose the questions about the relation between the new digital media and photography in ways which avoid the sacred cows associated with each side of this supposed divide. To refer to the digital as the "post-photographic" seems not only polemical rather than descriptive but most likely mystifying. The translation of photographic information into a number-based system certainly represents a revolutionary moment in photography, but one not unlike the replacement of the wet collodion process by the dry plate, or the conquering of exposure time with instantaneous photography, or the introduction of the hand camera. Like these earlier transformations in photographic history, the digital revolution will change how photographs are made, who makes them, and how they are used—but they will still be photographs.

The new ease of manipulation of the image that digital processes offer can at points seem to attenuate the indexically based truth claim of the photograph, but this threat of deceit has always been an aspect of photographic practice: the risk that defines the game, dependent on the social value of photography's truth claim. Since this claim is the product of social discourses as well as the indexical quality of the camera, it seems likely that means will be found to preserve it, at least in certain circumstances. The risk will remain a risk, not become a rout. Likewise,

since the fascination of a transformed photograph lies partly in its veri-similitude, it would seem likely that even on a popular or artistic level, the sense of photography as an accurate record of the way things look will also survive, or the fun found in distortion becomes thin.

But finally I would claim that we still have only the beginnings of an account of the fascination photography exerts, and although the use of the term *index* may have helped explain some aspects of this fascination, I am not at all sure it is either an adequate or accurate term. The semi-otic category of the index assimilates photography to the realm of the sign, and although a photograph, like most anything (everything?), can be used as a sign, I think this approach prematurely cuts off the claims made by theorists like Barthes and Bazin (and possibly Deleuze) that the photograph exceeds the functions of a sign and that this indeed is part of the fascination it offers.

The description of a photograph as putting us into the presence of something (and for Barthes especially the presenting of a past time) needs to be explored beyond the concept of the index. To explore this further the actual visual experience occasioned by the photograph needs more probing. Here our delight in visual illusions may play as impor-tant a role as indexicality. And if we are to deal with illusions, it seems to me that the play with photographic imagery that the digital revolu-tion allows may provide the perfect playground/laboratory for a greater understanding of a fascination that I maintain is likely to have a long and fertile future.

NOTES

I want to thank Arild Fetviet for supplying the original impulse to write this essay, and to signal the inspiration long conversations with my colleague Joel Snyder pro-vided, without implicating him in the several places where we would disagree.

1 Huhtamo 1994, to cite one among many.

2 Scott Curtis's excellent essay on medical hermeneutics, "Still/Moving," shows the relative lack of importance in the switch to digital instruments in medicine versus analogue (Curtis 2004).

3 Is indexicality simple? I should signal here that I am not involved in this essay in a deep discussion of the concept in Peirce's philosophy, in which it functions not as a simple concept but as an aspect of a larger semiotic and philosophical system. But most discussions of the indexicality of the photographic image do not invoke the large aspects of this system. In this essay, I use the term *index* to refer to the

more restrictive concept of a sign created by some existential connection with its referent.

4 One might point out that some philosophic systems, such as the thought of Martin Heidegger, would not endorse the idea that truth is simply a quality of propositions and that works of art and poetry may involve truth. Personally I am quite sympathetic to this approach, but I would point out that it does not support the sort of truth claim discussed here.

5 I am thinking here primarily of the extremely important discussions of the temporality of the trace in cinema offered in Laura Mulvey's *Death 24X a Second* (2006), which I entirely agree with, except for the identification of this with the index.

"THE FORGOTTEN IMAGE BETWEEN TWO SHOTS": PHOTOS, PHOTOGRAMS, AND THE ESSAYISTIC

Timothy Corrigan

I am an essayist . . . Film is a system that allows Godard to be a novelist, Gatti to make theatre and me to make essays. —Chris Marker, quoted in Nora Alter, *Chris Marker*

My aim here is to examine a key transition in the historical formation of the "essay film," a practice I consider the most important innovation in film practice since 1945. This transition period, roughly from 1940 to 1958, describes the emergence of the essay film out of the heritage of the photo-essay, which can in turn be seen adapting the imperatives and strategies of the literary essay to photography. This transition defines and distinguishes a cinematic tradition significantly different from the documentary practices with which it overlaps and is sometimes confused (such as cinema-verité or ethnographic film) and one that remains the driving force behind the most engaging and engaged films today (from Derek Jarman's 1993 *Blue* to Errol Morris's 2003 *Fog of War* and virtually all of Trinh T. Minh-ha's work).

My conceptual framework for this study grows out of a body of critical and theoretical work that has valorized and debated the centrality of the essayistic since the nineteenth century. Through the course of this work, the essay takes shape as a form of expressive thought and dialogue which places personal perceptions against the concrete pressures of the actions, objects, and communicative forms of public life: the essay becomes, by definition, expressive, provisional, reflective, and

critical, without the elevations of aesthetics or philosophical systems to remove it from the changing complexities of everyday life. As it has informed different material practices in the last one hundred years, it has become, I will argue, the central practice through which subjectivity and thought engage and measure themselves through two of the most dominant forms of twentieth- and twenty-first–century public life, photography and film.

Beyond the historical and theoretical groundwork, my argument here will focus on the early work of Chris Marker—specifically his 1959 photo-essay entitled *Coréenes* (*The Koreans*) and his 1958 essay film *Lettre de Sibéria* (*Letter from Siberia*). Marker is now seen as one of the most relentless and innovative essayists working in film and new media, with his 1982 *Sans soleil* (*Sunless*)—a film paralleled by another Marker photo-essay, *Le Dépays* (*Abroad*, 1982)—considered one of the landmarks of modern cinema. Yet it is at the early crossroads of the photo-essay and the essay film where one finds most visibly his complex engagement with the possibilities of creating space and time for thought between the images of a moving world.

FROM THE ESSAY TO THE ESSAY FILM

The precedents for the essay film extend back through four hundred years of the literary essay, moving at least from Montaigne to Samuel Johnson and William Hazlitt to James Baldwin and Christa Wolf, with each of these distinctive voices representing different phases within the vast historical and cultural evolution of the essay. Through these many incarnations, the essay has been consistently characterized as some version of "personal expression," aligning this practice primarily with its essentially romantic formulation as a "personal essay." Far more than what seems self-evident here, this connection between the essay and personal expression opens, for me, the more complicated, dynamic, and often subversive qualities of the essay. Essayistic practices have been most innovative and suggestive, in short, in how they have troubled and complicated that very notion of *expressivity* and its relation to *experience*, that other cornerstone of the essay. If both verbal and visual expression can commonly suggest the articulation or projection of an interior self into an exterior world, essayistic expressivity describes, more exactly I think, a subjection of an instrumental or expressive self to a public

domain as a form of experience that continually tests the limits and capacities of that self within a public domain. Experience becomes the linchpin in this activity with all the density and dynamics suggested by Miriam Hansen's reformulation of Oscar Negt and Alexander Kluge: for her "experience is that which mediates individual perception with social meaning, conscious with unconscious processes, loss of self with self-reflexivity; experience as the capacity to see connections and relations . . . ; experience as the matrix of conflicting temporalities, of memory and hope, including the historical loss of these dimensions" (1991, 12–13). Within this framework, we find in the best of essays the difficult, often highly complex—and sometimes seemingly impossible—figure of the self or subjectivity *thinking* in and through a public domain, in all its historical, social, and cultural particulars.

These points have been variously, differently, and certainly more fully engaged and articulated by the many twentieth-century champions of the literary essay, such Georg Lukács and his notion of the essay as "judgment without verdict" (Lukács 1978, 18) or Robert Musil in his 1930 essayistic novel *The Man without Qualities* where the "essay is the unique and unalterable form assumed by a man's inner life in a decisive thought" (Musil 1995, 273).[1] Completed at my historical focal point of 1958, T. W. Adorno's "The Essay as Form" is, for my purposes here, conceivably the most rigorous and theoretically sustained argument about the essay as "the reciprocal interaction of concepts in the process of intellectual experience" through which "the thinker does not actually think but rather makes himself into an arena for intellectual experience, without unraveling it" (Adorno 1991, 13). Indeed, these descriptions and definitions can, I believe, apply equally to nonliterary forms of the essay, such as the photo-essay and the essay film, although both significantly begin to recreate the public domain so central to the essayistic as increasingly defined by the imagistic and, more specifically, the technological image.

An important sidebar to my argument is a broad debate within film studies as to the modernist heritage of the cinema as a whole: one side claiming that a modernist practice enters film culture after World War II, the other insisting that film is inherently a modernist form. At the center of these debates, I believe, is the representational confrontation between the technological image and language as expression. If film form has always reflected modernist concerns with spatial frag-

mentation and temporal motions, its early association with mass culture tended to undermine its radical potential for subjective expression and interpretation and to reshape them as realist transparencies. In this context, the precursors of the essay film appear only on the margins of classical film culture as lecture films like Eadweard Muybridge's demonstration of how animal locomotion fits a scientific logic or travelogues such as Lyman Howe's early movie presentations and tours.

The defining years for the essay film become, however, the turbulent period of 1940–45 when, amid the devastations of World War II, film culture on many fronts struggled with the new versions of experiential realism and how they might be the grounds for more complex reflections and spectatorial activity—distinctly different from classical contemporary modes of identification or cognition.[2] As Paul Arthur has noted, it was only "after the Holocaust—our era's litmus test for the role of individual testimony in collective trauma—that essay films acquire a distinct aesthetic outline and moral purpose" (Arthur 2005, 61). In 1940 the experimental filmmaker Hans Richter writes a commentary in which he coins an innovative genre called "The Film Essay," a new practice which he claims evolved out of the documentary tradition but which, instead of presenting what he calls "beautiful vistas," would aim "to find a representation for intellectual content," "to find images for mental concepts," "striving to make visible the invisible world of concepts, thoughts, and ideas," so that viewers would become "involved intellectually and emotionally" (Richter 1992, 195–96). Very much related, André Malraux delivers at about the same time his *Esquisse d'une psychologie du cinéma* arguing for "the possibility of expression in the cinema" (Malraux 1946, 14). And in 1948, in his essay "The Birth of the New Avant-Garde: The Caméra-Stylo," Alexandre Astruc announces the foundational terms for the essay film and the French New Wave:

> To come to the point: the cinema is quite simply becoming a means of expression, just as all the other arts have been before it. . . . After having been successively a fairground attraction, an amusement analogous to boulevard theatre, or the means of preserving the images of an era, it is gradually becoming a language. By language, I mean a form in which and by which an artist can express his thoughts, however abstract they may be, or translate his obsessions exactly as he does in the contemporary essay or novel. This is why I would like to call this new age of cinema

the age of the camera-stylo (camera pen). This metaphor has a very precise sense. By it I mean that the cinema will gradually break free from the tyranny of what is visual, from the image for its own sake, from the immediate and concrete demands of the narrative, to become a means of writing just as flexible and subtle as written language. . . . It can tackle any subject, any genre. The most philosophical meditations on human production, psychology, ideas, and passions lie within its province. I will even go so far as to say that contemporary ideas and philosophies of life are such that only the cinema can do justice to them. Maurice Nadeau wrote in an article in the newspaper *Combat*: "If Descartes lived today, he would write novels." With all due respect to Nadeau, a Descartes of today would already have shut himself up in his bedroom with a 16mm camera and some film, and would be writing his philosophy on film: for his Discours de la Méthode [sic] would today be of such a kind that only the cinema could express it satisfactorily. (Astruc 1999, 159)

These claims would immediately become technologically viable with the arrival of portable lightweight camera technology, introduced as the Arriflex system in Germany in 1936 and as the Éclair 35mm Cameflex in France in 1947. More than coincidentally, these different "camera-stylos" would also feature reflex viewing systems linking the pragmatics of filmmaking with the conceptual reflexivity of the emerging essay film and its "idea of the cinema expressing ideas" (159).

That these original intellectual foundations are so largely French (and German) should help explain the prominent place of the French New Wave (and later New German Cinema) in establishing the essay film from 1948 through the 1960s. Clearly significant is the bond between the critical essayists writing for *Cahiers du cinéma* in the postwar years that generated this movement, but, more specifically, two early documents stand out as signaling a cinematic sea change: (1) André Bazin's essay on a film portrait of Stalin, suggesting how the essayistic might free cinema from film's dominant narrative logic and situate itself in the more exploratory logic of the edit or cut, and (2) Alain Resnais's 1948 film *Van Gogh*, a short essayistic portrait much less about painting than about the grounds for cinematic expression.[3] In 1953, Resnais, Chris Marker, Agnès Varda, and Astruc become part of the "Group of Thirty," urging the development of the short film as the grounds for developing essayistic film practices, and by the mid-1950s the term *essai cinématho-*

graphique (cinematographic essay) is in frequent use in France.[4] By the 1960s, Jean-Luc Godard, perhaps the most renowned and self-professed film essayist, transports the logic of essayism to longer films such as *Two or Three Things I Know about Her* and *La Chinoise*. Explicitly drawing on the tradition of Montaigne and implicitly dramatizing with each film that central problem of thinking through our daily and public experience of signs, sounds, and images, Godard characterizes his work during this period as that of an experiential improviser and a thinking critic. In December 1962, referring to his beginnings as a writer for *Cahiers du cinéma*, Godard would claim, "Today, I still think of myself as a critic, and in a sense I am, more than ever before. Instead of writing criticism, I make a film, but the critical dimension is subsumed. I think of myself an essayist, producing essays in novel form and novels in the essay form: only, instead of writing, I film them. Were the cinema to disappear, I would simply accept the inevitable and turn to television; were television to disappear, I would revert to pencil and paper" (Milne 1972, 171). One glaring irony within this symbiotic relationship between the French New Wave and essayism is, as we will see, that the latter works expressly to trouble and often undermine the coherency of what is commonly thought the hallmark of that new wave: auteurism.

As the essay film comes more clearly into historical view, one of its most distinguishing features—especially visible from Godard's films of the sixties to Alexander Kluge's films of the eighties and nineties—is the foregrounding of its literary heritage in the material performance of language as part of an encounter with the dominance of a public culture of visual technology. While inheriting from the literary essay a critical encounter between subjectivity and a public history, the essay film (and its relative the photo-essay) adds a key third dimension to the evolution of the essay: the foregrounding of language across and through the moving image as part of the production of thought and thinking through film. This is where and why Gilles Deleuze becomes, I believe, one of the few to suggest incisively a theoretical basis for postwar cinema that does service and justice to the practice of the essay film. Running counter to models of both classical film narrative and avant-garde cinema, the essay film swerves from the naturalization processes of both documentary realism and narrative fiction, in redefining models of both expressivity and receptivity in the cinema. Or, in Deleuze's brashly suggestive words: "'Give me a brain' would be the other figure of modern cinema. This

is an intellectual cinema, as distinct from a physical cinema" (Deleuze
1989, 204).

"AND": CHRIS MARKER, PHOTOS, AND PHOTOGRAMS

If the essay film inherits many of the epistemological and structural distinctions of the literary essay, the key transitional practice linking these two practices is the photo-essay. The photo-essay has taken many shapes at least since Jacob Riis's 1890 *How the Other Half Lives*, translating essayistic concerns with expression, experience, and thought into a variety of formal configurations of photographic images.[5] Rhetorically, photo-essays assume a spectrum of positions, from the social and political pleadings of Riis's landmark work through the sociological portraits of August Sander and the meditative celebration of local life in the essays of W. Eugene Smith. This variety shares, of course, a structural foundation built on linkage of separate photographs whose implied relationship appears in the implicit gaps or "unsutured" interstices between those images. Often this relationship can be considered analogous to the shifting and aleatory voice or perspective of the literary essay as it attempts, provisionally, to articulate or interpolate itself within the public spaces and experiences being represented. Not surprisingly, therefore, the photo-essay has frequently relied on these vestiges of the literary, a verbal text, to dramatize and concretize that shifting perspective and its unstable relationship with the photographic images it counterpoints.

The 1930s are perhaps the heyday of both the photo-essay and its formulation as a dialogue between verbal text and photographic image, culminating in James Agee and Walker Evans's 1939 collaboration *Let Us Now Praise Famous Men*.[6] The photo-essay remains a rich and creative practice today, but this transitional period, from the 1930s through World War II, becomes, significantly, the prefatory years for the essay film. As Chris Marker demonstrates in his work just after the war, the photo-essay provides a transitional paradigm that allows film to discover its capacity to explore the conceptual and intellectual spaces between images and for Marker to define himself, as Richard Roud puts it, as "1 to 1:33 Montaigne" (1962–63, 27).

Best known for his 1962 film *La Jetée* (*The Jetty*), his futuristic "photo-roman" of still images, and the 1982 *Sans soleil* (*Sunless*), his extraordinary

essay film about a cameraman traveling the globe between "the two extreme poles of survival," Marker has created a multimedia body of work that ranges through novels, literary criticism, museum installations, and the CD-ROM *Immemory* (1998). As different as his subjects and media practices are, however, his concerns have remained remarkably consistent: memory, loss, history, human community, and how our fragile subjectivity can acknowledge, represent, surrender, and survive these experiences. Across the continual undoing and redoing of expression in different forms and places, Marker's work becomes a concomitantly rigorous, witty, and poignant effort to document the human experience as a struggle to understand itself in an increasingly smaller, fragmented, and accelerated global space. If the literary appears as a consistent mode within his early experiments with expression (including a 1949 novel, *The Forthright Spirit*), in 1952 Marker recognizes a new cultural dominant in the public domain. Concluding a book-length literary essay on Jean Giraudoux, he acknowledges that now it is the technological image and specifically the cinema that will recapture the "miracle of a world in which everything is at once absolutely familiar and completely strange" (Marker 1952, 43). At this personal crossroads of the literary and the cinematic, for Marker the photo-essay becomes a critical articulation. Just after the completion of his second short film, the 1953 *Les Statues meurent aussi* (codirected with Alain Resnais), he edits a series of photo-essays for Éditions du Seuil, produced from 1954 to 1958, an experience that lays the groundwork for his own photo-essays. In her excellent book *Chris Marker: Memories of the Future*, Catherine Lupton describes this first venture into the photo-essay in a way that suggests the larger concerns that would permeate all of Marker's work:

> A potent sense of the prospective disorientation of world travel informs Marker's announcement of the Petite Planete series, which appeared in the Éditions du Seuil house magazine 27 *Rue Jacob*. He pinpoints a growing sense that the post-war world has come within reach as never before, but that as a subjective experience this prospect of increased access seems confusing and elusive: "we see the world escape us at the same time as we become aware of our links with it." To combat this disorientation, Seuil is launching a series of books that, to adapt one of Marker's metaphors, are intended to be user manuals for life on a small planet. He proposes that each volume is "not a guidebook, not a history, not a

propaganda brochure, not a traveller's impressions," but is intended to be like a conversation with an intelligent and cultivated person who is well-informed about the country in question. (Lupton 2005, 44)

Marker would bring his own distinctive voice to that conversation with his 1959 photo-essay *The Koreans*, an essay fittingly published as the only volume in Editon de Seuil's "Court métrage" ("Short Film") series.[7]

The Koreans is a meditative travel essay about extremes and oppositions but mostly about lists and inventories—and the spaces made visible by all these organizations. Shadowing the images and text are the cold war politics dividing North and South Korea,[8] yet oppositions such as this are less central than the categorical abundance found in the experience and fabric of everyday Korean life, the multiplicity of things that, to borrow a phrase from Marker's film *Sunless*, quicken the heart. "I will not deal with Big Issues" (Marker 1959, 135), the commentator concludes in an address to his cat. Rather it's the daily routines, legends and myths, conversations, relics of history, a "list of the spirits and stars that govern human life"(85), and fragments of a developing industrial future that are photographed and observed from numerous angles at passing moments. Even the seven-part organization of *The Koreans* is a set of numerical categories—"The Six Days," "The Two Orphans," "The Seven Wonders," "The Five Senses," "The Three Sisters," "The Nine Muses," and "The Four Corners"—that weave together lists and inventories of particular historical, imaginative, relational, emotional, and sensual experiences. "The Seven Wonders" mentions explicitly only the "wonder of ginseng" and, as a free association, "the seventh wonder . . . the work of builders" who took "fifty years to complete a ginseng plant" (51–53). The other wonders appear in the markets and street scenes that come in and out of view as a series of ten photos:

A great deal of Korea strolls by on Koreans' heads. . . . Baskets, earthenware jars, bundles of wood, basins, all escape the earth's gravity to become satellites of these calm planets, obeying exacting orbits. For the Korean street has its cycles, its waves, its rails. In this double décor, where hastened ruins and buildings still balancing themselves in a second of incompletion, the soldier who buys a civilian's sun hat, the worker leaving the construction site, the bureaucrat with his briefcase, the woman in traditional dress and the woman in modern dress, the porter carrying a brand new allegory to the museum of the Revolution with a woman

in black following step by step to decipher it—all have their route and precise place, like constellations. (44)

In Adorno's words, here the "elements crystallize as a configuration through their motion" becoming a constellation or "force field, just as every intellectual structure is necessarily a force field under the essay's gaze" (Adorno 1991, 13).

These lists, inventories, and oppositions are primarily fading scaffolding that constantly draws attention to the conjunctive intervals that hold them together: the "and" that momentarily connects without a teleological logic. They create continual movement, a recollection and anticipation as a serial activity whose accumulations are endlessly generative and open-ended. If the fundamental structure of all photo-essays tends to approach that of a spatial categorizing of images, for Marker this inventory of images always approximates a photogrammatic series of film frames. In *The Koreans*, he notes, "A market place is the Republic of things . . . It all went by as quickly as a forgotten image between two shots" (39), a barely visible conjunctive place where the "and" opens potentially as the space of intelligence. As Deleuze notes about the cinema (and Godard's films specifically), through this conjunctive "and," categories are "redistributed, reshaped and reinvented" and so become "problems which introduce reflection on the image itself" (Deleuze 1989, 185–86). "The whole undergoes a mutation . . . in order to become the constitutive 'and' of things, the constitutive between-two of images" (180). No episode in *The Koreans* dramatizes the poignancy and power of this conjunctive place better than an encounter at the theater where the experience of a celebrated play based on the well-known legend of Sim Chon suggests both a mythic categorization and the emotional and intellectual energy within anticipatory conjunctives: Marker encounters a female friend crying during an interval over the plight of the heroine, despite her having seen the play two hundred times, and when he tries to assure her that all will be well in the end, she replies in bewilderment, "How could I be so sure of the future?"

Several key sections of *The Koreans* are especially dramatic illustrations of that wavering line between the photo-essay and essay film, places in the book where the photos become virtual photograms that draw attention to the space between the images as an interpretive "void" for the photographer/commentator. In this instance especially, the

writer's voice as "expressive subject" documents the experiential expressions around him as faces "literally embodied [as] a smile that melts away, a face that comes undone" (25). At one point, a series of nine photos depicts a woman looking out of the frame telling "her life story." Or "more exactly," the text fills in, "she told us that there was nothing to be told, really nothing" (21–24). Immediately following, one of the most dramatic conjunctions in the book presents just two shots of two expressions. First there is a woman's smiling face answering questions about her personal life (her boyfriend, her prospects for marriage), but, when asked about her parents, the second photo captures the ruptured transition between the two images as she explains that her parents were killed during the Korean War: "At that moment," the commentator remarks,

> I was sunk in my [Rolleiflex] camera. It was on the Rollei's ground glass that I saw the metamorphosis, the smile vanishing into pain like water drunk by sand . . . and now the young woman's face was covered in tears, but she did not lower her head, and the hands that had hidden her laughter lay immobile on the table. The instant was hers. . . . The extraordinary hymn of hate and will power that followed would need more than a story and an image to do it justice. (25–26)

Here the camera lens itself becomes both a physical and metaphoric interface upon which the commentator engages a radical shift in the expressions of the self and its relation to a world and a history. The "vanishing" that marks the space between his experience of her experience is precisely where he relinquishes himself, his images, and his stories— that is, his thoughts—to the unrecoverable reality that "was hers."

In a later sequence the centrality of this subjective space in its encounter with the world reappears as a typically askew or inverted exchange. In this case two photographs of construction cranes operating over an urban site show first a relatively empty lot and then the shapes of emerging buildings: "All night long, the aurora borealis of welding torches, spotlights on cranes, reflections of the moon and the headlights on the great glassy facades of new buildings," the commentator observes about the two photos. Yet comparative images such as these and the interval they document, he quickly notes, are not about that scene and the temporal passage it records but about the experiential space from which they are seen, from which subjectivity and thought have ventured

forth to test themselves: "I don't care much for propaganda photos in the style: 'Yesterday . . . Today.' But I still took these pictures of what I saw out my window, at fifteen days distance. In order not to mistake the room" (53–55).

The Koreans follows a temporal and spatial journey through these conjunctive spaces between numerous faces, things, activities, and images, searching those "forgotten image[s] between two shots." As he notes early in the text, "There are many ways of traveling" (16), and one way to view the photographic and photogrammatic travels might be as a mimetic attempt to represent the dynamic continuity of these active and changing people and this place. The journey of *The Koreans*, however, is better characterized according to the ambitious model offered by Henri Michaux's surrealist travel memoir *Plume*, in which, according to Chris Marker, the traveler embraces the transitions in time and place as disorderly "rhythms, waves, shocks, all the buffers of memory, its meteors and dragnets" (Marker 1959, 15). The opening photo on this trip is thus appropriately a women descending from a plane, described as the "first Korean girl descended from heaven with the 'gift of transitions'" (10).

The textual commentary that documents these personal experiences of a vibrant and changing world becomes then a string of insertions or interpolations into these rhythms, waves, and shocks. In *The Koreans*, unlike the consistent voice of some traditional photo-essays, this one is multivocal, mobile, scattered, and both historically and geographically layered. Weaving together poetry, photos, ancient maps, quotations from historical reports, literature, reproductions of paintings, Korean tales and legends, and comic book images, the commentary sometimes precedes the photos; sometimes it follows or is interspersed in the spaces between a series. It recounts parables, historical events, personal reflections, observations, and reminiscences of other places, melding myths with daily observations, anecdotes about ginseng, profoundly serious commentaries on the atrocities of war, and self-debunking and whimsical humor about the commentator's own efforts. Sometimes it describes the photos; sometimes it gives voice to the images. Each becomes a way of speaking/seeing as a different representational encounter with a world that resists denotation. As Marker would later insist in his photo essay *Le Dépays* (*Abroad*): "The text doesn't comment on the images any more than the images illustrate the text. They are two sequences that clearly cross and signal to each other, but which it would be pointlessly

exhausting to collate" (Lupton 2005, 62). Like the images it responds to, the intense, inquisitive, and reflective subjectivity of this traveling voice and text dissolves into the fissures between the different representational materials they struggle to occupy, as moments of reflection and thinking, in the space between the photographic images.

These doubled fissures—within the textual commentary and between that "forgotten image between two shots"—become in one sense a version of what W. J. T. Mitchell calls a "site of resistance," produced in the photo-essay through its leanings toward nonfictional subjects, its subjective anchoring in a personal point of view, and its "generic incompleteness" (Mitchell 1994, 287): "The text of the photo-essay typically discloses a certain reserve or modesty in its claims to 'speak for' or interpret images; like the photograph, it admits its inability to appropriate everything that was there to be taken and tries to let the photographs speak for themselves or 'look back' at the viewer" (289). Signaled throughout *The Koreans* with faces and eyes looking directly at the camera, this spatial resistance is dramatized most poetically in one exchange featuring five sequential photos of six children playing and staring back at the camera, watching the author "watching them. A mirror game that goes on and on where the loser is the one who looks down, who lets the other's gaze pass through, like a ball" (Marker 1959, 43). As he quickly acknowledges, "My third eye was a bit like cheating" (43). In this exchange and in the photo-essay in general, according to Vivian Sobchack, temporality itself becomes necessarily remade according to a spatial dynamics in which a "temporal hole" appears as a "gap" or "arena" opening up and staging the possibility of meaning:

> The lack of depth and dimension in the still photograph seems less a function of the phenomenal thickness of the subjects and objects that it displays than of the temporal hole it opens within the world in which we gaze at it. Indeed, the most "dynamic" photojournalism derives its uncanny power from this temporal hole, the transcendence of both existence and finitude within existence and finitude. . . . The photograph, then, offers us only the *possibility* of meaning. It provides a significant gap that can be filled with every meaning, any meaning, and is itself meaningless in that it does not act *within* itself to choose its meaning, to diacritically mark it off. Like transcendental consciousness, the photograph as a transcendental structure posits the abstraction of a *moment*

but has not *momentum*—and only provides the grounds or arena for its possibility. (60)

For Marker, however, the resistances and holes created in his photo-essays, where language and subjectivity lose themselves in images of the world, might be best understood with the cinematic framework used by Deleuze. Here, thinking and "intelligence" occur when comprehension and understanding encounter the world on its own terms—in what Deleuze labels "a void" or an "interstice" in the time and spaces of representations: "What counts is . . . the *interstice* between images, between two images: a spacing which means that each image is plucked from the void and falls back into it" (Deleuze 1989, 179). This is neither spectatorial "identification," a position of a familiar emplacement in the world, nor a version of Brechtian "alienation," a position of unfamiliar exclusion from that world represented. Rather this is a suspended position of intellectual opportunity and potential, a position within a spatial gap where the interval offers the "insight of blindness," where thought becomes the exteriorization of expression.

If Marker's photo-essays open a space, a changing geography in which thinking may pitch its tent, the essay film must aim to retrieve the possibility of that active intelligence within the continuous landscape of film.[9] Bridging these different forms of the essayistic, the photogram describes a conceptual borderline between the photography and film, a kind of "stop action," since it pinpoints the transformation of film's moving image into the suspension of "real movement and time" as a series of overlapping photographic images. No doubt, *The Jetty* represents this reflexive merging of the photographic series and film form most famously (also constructed only of still images except for a few seconds when those series of photograms become a continuous movement), but, enlisting the narrative framework of a science fiction tale rather than an essayistic framework, *The Jetty* creates a significantly different viewing position from the essay film, one based in identification, memory, and desire, rather than observation, reflection, and belief.[10]

Despite the canonical prominence of *The Jetty*, the majority of Marker's films are best understood within the framework of the essayistic.[11] Partly because of its historical proximity to *The Koreans* and its place at this historically formative stage of the essay film, and partly because it eschews the narrative logic of the more renowned *Jetty*, I'll con-

centrate here on the 1958 *Letter from Siberia*,[12] which represents an early paradigm for the essay film for Marker and for the practice in general. Writing about *Letter from Siberia* in 1958, André Bazin has the first and most prescient word: *Letter from Siberia* "resembles absolutely nothing that we have ever seen before in films with a documentary bias." It "is an essay on the reality of Siberia past and present in the form of a filmed report. Or, perhaps, to borrow Jean Vigo's formulation of *À propos de Nice* ('a documentary point of view'), I would say an essay documented by film. The important word is 'essay,' understood in the same sense that it has in literature—an essay at once historical and political, written by a poet as well" (Bazin 1985, 44).[13]

Even more explicitly than *The Koreans*, *Letter from Siberia* presents itself as an epistolary travelogue, whose voice-over begins with lines appropriated from that exemplary traveler in *The Koreans*, Henri Michaux: "I am writing to you from a far country. . . . I am writing you from the end of the world." Here too cold war, East/West, oppositions linger in the background, and here too a traveler commentator, now a disembodied voice rather than a printed text, negotiates and reflects on serial inventories and oppositional categories: lists of Siberian plant and animal life alternate with descriptions of daily activities, and the film concludes with the polarized journeys of underground scientists burrowing to the center of the earth while their colleague-cosmonauts launch themselves into outer space. Digressions into an archeological past jump quickly forward to the industrial future: from Yakut tribal rituals and drawings of the wooly mammoths that once populated Siberia to the construction of new highways and telephone lines. The representational heterogeneity of *Letter from Siberia* also parallels that of Marker's photo-essay as *Letter from Siberia* mixes black-and-white and color film, still photographs, archival footage, and animation to underline, here too, how the bond between experience and representation is the fault line between the world and our knowledge of it.

Unlike the photo-essay's efforts to inhabit the spaces between these images, however, this essay film opens a second dimension to its travels, that particularly cinematic dimension of the temporality of the moving image. Together with the rhetorical and spatial gaps found in the photo-essay, the film thus additionally depicts and examines the continual dynamics of movement captured on film, from the vertical ascents of flying airplanes to horizontally racing reindeer, through a visual syntax

of continual tracks and pans capturing those temporal rhythms with a similar array of directional movements. Early in the film, for instance, dramatically different materials create dramatically different forms of temporality as a fabricated image of the past, a realistic transparency of the present, and a visual rhetoric of a desired future: animated drawings of mammoths precede a transition to documentary shots of the Lena River bustling with its industry and commerce, and, shortly after, the film offers a "spot commercial" spoofing the market value of reindeer as pets, transportation, clothing, and food. Bazin goes so far as to identify these constructions as a "new notion of montage" that he calls "horizontal" or "lateral" where, unlike the traditional "sense of duration through the relation of shot to shot," "a given image doesn't refer to the one that preceded it" (Bazin 2003, 44). Comparable to the spatial openings mapped in *The Koreans*, in these instances *Letter from Siberia* pries open the temporal "presence" of the moving images as an interstice (both spatial and temporal) containing multiple time zones ranging from past memories to future fantasies. As the commentator remarks in his conclusion, this Siberia is the image of a temporal vertigo: "between the Middle Ages and the twenty-first century, between the earth and the moon, between humiliation and happiness. After that it's straight ahead."

Two sequences stand out in this effort to open the cinematic image as planes with different temporal zones. The most famous is a single shot of a Yakutsk town bus passing an expensive car shown four times with four different types of commentary. The first is silent, the next a Soviet panegyric, the third an anti-Communist denunciation, and the last the voice-over's description of the commentator's own impressions. Each commentary not only creates a very different interpretation of the street scene but also directs the perspective toward different details and activities in the shot: for one, the Zim luxury car dominates the scene; in another, the voice-over points out a man's injured eye. For the commentator this series of judgments without verdicts most immediately questions the impossible notion of objectivity regarding a landscape "with huge gaps and the will to fill them." Indeed, a major problem with "objectivity" is that it "may not distort Siberian realities but it does isolate them long enough to be appraised." Instead, the four different commentaries here offer four interpretive planes or zones which describe the street scene and direct our attention in a way that maps the tempo-

ral fullness of a short interval where "What counts is the variety and the driving momentum."

The second, considerably longer, sequence follows these four shots to suggest that even this layering of a cinematic present is inadequate. "A walk through the streets of Yakutsk isn't going to make you understand Siberia," the commentator admits. "What you might need is an imaginary newsreel shot all over Siberia" in which "the commentary would be made up of those Siberian expressions that are already pictures in themselves." Locating and measuring its own voice in "those Siberian expressions" it aims to document, here the commentator literally evokes images of those expressions by opening a second frame within the center of the image of the street scene, which then expands to fill the entire frame and become a collage of winter images. As the collage proceeds, this "imaginary newsreel" assumes a future-conditional voice developing through a series of conjunctive "ands": "And then I'd show you" the snow, the Yakut, the spring festivals, and so on.

As these sequences suggest, the voice-over in *Letter from Siberia* becomes a time traveler and guide through a world that will always elude him and us temporally as well as spatially. Whereas the text-image relationship in *The Koreans* identifies a fissure or gap, the audio commentary offers a more temporally mobile relationship with the fragmented chronologies of the film image. The changing voices, incorporated quotations, and music and sound recordings—from the lyrical to the bemused to the pedagogical—describe a series of shifting subject positions surrounding and intervening in the visuals. This address of the voice-over can even be dramatically insistent in attempting to direct the viewer according to a specific chronology: at one point, the commentator anticipates the contrast between the past and present in the image of a large truck passing a horse-drawn cart and quickly reminds the viewer that this is "the shot you've been waiting for." The unusual mobility of this voice exploring time between images creates, in Bazin's words, a "montage . . . forged from ear to eye" (Bazin 2003, 44). Through it, *Letter from Siberia* insists, according to Bazin, "that the primary material is intelligence, that its immediate means of expression is language, and that the image only intervenes in the third position, in reference to this verbal intelligence" (44).

It seems to me a curious paradox that Deleuze says nothing about Marker's films in his monumental *Cinema 1* and *Cinema 2*, for few

writers have theorized the cinema in terms so sympathetic to Marker's essayistic films and their aim to elicit a "cinematic thinking." Although Deleuze's perspective on "thought and cinema" casts a much wider net than the essayistic, it accommodates Marker's work and essayistic cinema in general in a manner that few theoretical models can—which is the justification for my selective appropriation of Deleuze. For Deleuze, thought is "the essence of cinema" (Deleuze 1989, 168), and it can be discovered in various orders throughout film history, beginning with the "movement images" of Sergei Eisenstein, Abel Gance, and Alfred Hitchcock.[14] Of a different order, however, is "the modern cinema," the cinema of the "time-image" (169) and, for me, the essayistic. In these films, of which there are no better examples than Marker's, thought in the cinema "is brought face to face with its own impossibility" (168) where "the suspension of the world" "gives the visible to thought, not as an object, but as an act that is constantly arising and being revealed in thought" (169). Just as the essayistic subjects personal expression to the public domain of experience, "thought finds itself taken over by the exteriority of a 'belief,' outside any interiority of a mode of knowledge" (175). For Deleuze and Marker, encountering the interstices and time zones between film images is thus the pathway to "belief" in a world always eliciting and refusing thought.[15]

Although the genealogical relationship between the photo-essay (and literary essay) and the essay film is not, I believe, a difficult argument to make, few writers, photographers, or filmmakers demonstrate their intricate and compelling connections better than Chris Marker, a writer and photo-essayist who can deservedly be characterized as one of the earliest, most consistent, and most articulate practitioners of the essay film. Essay films have arguably become one of the most innovative and popular forms of filmmaking in the last fifteen years, producing a celebrated variety of examples from filmmakers around the globe. However extremely they may vary in style, structure, and subject matter, the best of these, I believe, work in the tradition of Marker, a tradition that draws on, merges, and recreates the literary essay and the photo-essay within the particular spatial and temporal dynamics of film. Without assuming that one practice anticipates or prepares for the other in Marker's career, it seems certain that, in his early essayistic encounters with words and photographic images, Marker discovers an essential modern territory between images where the fading spaces and black time lines ask the

film viewer to become a thinker. After all, as Marker notes in *The Kore-ans*, the twentieth century "may have been nothing but an immense, interminable fade" (23).

NOTES

1 Musil's lengthy reflection continues with the critical reminder: "Nothing is more foreign to [essayism] than the irresponsible and half-baked quality of thought known as subjectivism" (73). Of the growing scholarship on essayism, two early studies provide an important literary grounding: Graham Good's *The Observing Self* (1988) is a solid introduction to some of these positions, while Reda Bensa-maia's *The Barthes Effect* (1987) takes a more specific look at the theoretical formu-lations and practices of the essay in Roland Barthes.

2 For the essay in general and the essay film in particular, the dynamics of reception always have been a distinguishing feature, beginning in the 1920s with the ciné-clubs, the formation of an audience for whom film was less about entertainment than a forum for reflecting and debating social issues and experience, and evolving through Gilbert Cohen-Seat's "filmology" movement in the 1940s.

3 Always the contrarian, Godard denounces the short films yet for reasons that, I'd argue, make the relation of the short film and the essayistic so important: "a short film does not have the time to *think*" (Milne 1972, 110). Later he notes: "If the short film hadn't existed, Alan Resnais surely would have invented it. . . . from the blind, trembling pans of *Van Gogh* to the majestic traveling shots of *Styrène* what in effect do we see? A survey of the possibilities of cinematic technique, but such a demanding one, that it finishes by surpassing itself, in such a way that the modern young French cinema could not have existed without it" (115).

4 François Porcile makes this appropriate comparison in writing about the short film: "Next to the novel and other extensive works, there is the poem, the short story or the essay, which often plays the role of the hothouse; it has the function of revitalizing a field with fresh blood" (Porcile 1965, 19)

5 The photo-essay figures prominently in the early twentieth century, but J. Hillis Miller has identified some of the precedents for this practice in his *Illustration* (1992), where he examines precursive examples such as the photographic frontis-pieces that accompany Henry James's *The Golden Bowl* (1904).

6 There are numerous reasons for the spread and success of the photo-essay during this period. Responding to a mass-market visual culture, the first publication of Henry Luce's *Life* magazine on November 23, 1936, was the most famous product of a decade of expansion of photojournalism in Europe and America. Stretched tensely between two wars and strained by an economic depression, this trend was in part a response to general desire for increasing documentation of the events in the world that the cultural politics of the 1930s often refocused on social issues and crises. In his 1937 "The Camera as Essayist," Luce writes: "When people think of the camera in journalism they think of it as a reporter—the best of reporters: the

most accurate of reporters: the most convincing of reporters. Actually, as *Life* has learned in its first few months, the camera is not merely a reporter. It can also be a commentator. It can comment as it reports. It can interpret as it presents. It can picture the world as a seventeenth-century essayist or a twentieth-century columnist. A photographer has his style as an essayist has his" (Luce 1937, 60).

7 Besides Lupton's recent book, also of note is the two-part series on Marker in *Film Comment* in 2003.

8 Despite these political reminders, the book focuses largely on North Korea.

9 Telling of the critical relation between the photo-essay and the essay film, two of Marker's own photo-essays are in fact companion pieces to specific films: "China's Light: A Film in the Guise of a Greeting Card," a series of photos and commentaries published in *Esprit* to accompany his film *Sunday in Peking* (1956), and the 1982 companion piece to *Sunless*, the photo-essay *Abroad*. Lupton notes that in these cases the "film and the photo-text publication are not designed to explain or absorb each other, but as an open-ended relay that invites fresh perspectives on their shared subject matter" (62). Marker's *If I Had Four Dromedaries* (1966) is another version of his exploration of this intermediary zone: a film made up entirely of still images whose premise is "a photographer and two of his friends look through and comment on a series of images taken just about everywhere in the world between 1956 and 1966."

10 In *Between Film and Screen* Garrett Stewart describes *The Jetty* as a "text of decelerated process" where "Marker's plot is a perfect allegory of this devitalization" (Stewart 1999, 103).

11 See Ross Gibson, "What Do I Know?" (1988).

12 That Marker seems to regard his work preceding *Le Jolie mai* (1962) and *The Jetty* as juvenilia suits my argument in that that work clearly represents a testing and exploration of a new practice.

13 Since Bazin's observations, scholarly work on the essay film has, especially in the last ten years, grown considerably. See, for instance, Michael Renov's "*Lost, Lost, Lost*" (1992), Nora Alter's "Documentary as Simulacrum" (1997), and, for broader discussion about the new strategies of contemporary documentary, Bill Nichols's *Blurred Boundaries* (1994).

14 Deleuze's three relations to thought at the level of the movement image: (1) forces thinking and thinks under shock (critical thought); (2) with a "second movement" or "spiral" between "intellectual cinema" and "sensory thought" or "emotional intelligence" (hypnotic thought) (157–59); and (3) "identity of concept and image" or "the externalization of man" (action thought) (162–63). It is worth considering Garrett Stewart's strong counter-argument to Deleuze's bipartite, particularly as he insists on a much broader photogrammatic tension in film practice that encompasses the "movement-image" as well as the "time-image." He writes: "Everything Deleuze resists attributing to the movement-image as an already textured or textualized imprint of the scopic field seems displaced onto the time-image, where betweenness, stratigraphic layering, interstitial and lacunary process . . . where the whole opalescent faceting of indeterminacy takes place" (89).

15 There is, of course, an admirable utopianism joining the writer and the filmmaker on this never acknowledged (to my mind) common ground. It begins with an aesthetic that aims to overcome the human limits that allow a cinematic illusion of movement based on projecting twenty-four images a second and continues to a wry and relentless hope in what Marker calls in *The Koreans* "a politics of understanding."

STRUCTURAL FILM: NOISE

Juan A. Suárez

n the summer of 1969, P. Adams Sitney, one of the leading critics of experimental film in the United States, announced in the pages of *Film Culture* the sudden appearance of "a cinema of structure" (Sitney 1970b, 326).[1] He was referring to such titles as Peter Kubelka's *Arnulf Rainer* (1960) and *Unsere Afrikareise* (1965), Tony Conrad's *The Flicker* (1966), Paul Sharits's *Ray Gun Virus* (1966) and *N:O:T:H:I:N:G* (1968), Joyce Wieland's *1933* (1967) and *Sailboat* (1968), George Landow's *Film in Which There Appear Sprocket Holes, Edge Lettering, Dirt Particles, Etc.* (1966) and *Bardo Follies* (1966), and, perhaps the most influential of them all, Michael Snow's *Wavelength* (1967). In subsequent revisions of this essay, he added to this corpus the films of Ernie Gehr, Ken Jacobs (*Tom, Tom, the Piper's Son* [1969]), Hollis Frampton, and, as an important precursor, Andy Warhol. As Sitney concentrated on the filmmakers of his immediate environment, he did not mention artists working in similar modes in other parts of the world, but he had the insight to conceptualize an approach that turned out to be widespread and enduring. In the mid-1960s to early 1970s alone, it was also practiced by Wolff Vostell and Briget and Wilhelm Hein in Germany, Kurt Kren in Austria, Peter Gidal and Malcolm LeGrice in the United Kingdom, Riszard Wasko and Josef Robakowski in Poland, and Ito Takashi and Matsumoto Toshio in Japan. There has been as well a second generation of structural filmmakers (James Benning, Bette Gordon, Chantal Akerman, Peter Wollen, and Laura Mulvey, among many others) who

inflected the formal concerns of the first generation in the direction of narrative, politics, or ethnography. And in addition, many structural gestures remain lodged in the gene pool of video art, independent narrative film, and other visual cultures. For reasons of length and access, however, my main focus here will be the first-generation structuralists in the hope that my conclusions may be extrapolated to other filmmakers working in this vein.

Under the structural label, Sitney placed quite a diverse group, connected by common concerns, style of production, and screening venues rather than by manifestos or collective actions. Structural filmmakers belonged roughly to the same generation. Most were American, although Kubelka was Austrian and Wieland and Snow Canadian. During the late 1960s New York became the main launching pad for their work, which they showed in the city's main outlets for avant-garde cinema, the Filmmakers' Cinematheque and Millennium, but their paths also intersected at Knokke-Le-Zoute, Oberhausen, and other European experimental film festivals. Many came from fine arts schools and, by the time they started making films, had already exhibited their painting and sculpture—the case of Wieland, Snow, and Sharits; others were trained musicians—Snow had been playing jazz for some time and Tony Conrad was a violinist in La Monte Young's Theater of Eternal Music and a former member of the Primitives, the band that recorded Lou Reed's first foray into pop music, "The Ostrich" (Sarig 1998, 19). Most were self-taught filmmakers. The majority broke into film with structural pieces but some had been involved in underground productions: Conrad had created the soundtracks for Ron Rice's *Chumlum* and Jack Smith's *Flaming Creatures* and *Normal Love*, where he had brief appearances; Jacobs already had a substantial trajectory in underground film; and Sharits's first film, *Wintercourse* (1962), was an underground short influenced by Stan Brakhage, his teacher at the University of Denver's School of Art. Their ideologies were equally diverse. At the risk of simplifying, one could say that Gehr, Conrad, Jacobs (in his structural phase), and Kubelka were essentially formalists, Snow and Frampton were conceptualists, Sharits regarded his works as occasions for "meditational-visionary experience" (1978a, 91), and Wieland was the most political of them all and would soon evolve from structural concerns to feminism.

Despite differences in background and ideology, all these filmmakers

shared an interest in the literal workings of the apparatus. They rejected subjectivism, expressiveness, narrative, and direct social reference and focused instead on the medium's formal and material properties: framing, editing, exposure and screening times, the effect of light on the emulsion, and even the cone-shaped beam emanating from the projector. Taken as a whole, the movement could be seen as a catalog of filmic repertoires: hence flicker films were about retinal response to rapidly changing frames, Snow's *Back and Forth* and *La Région centrale* about mobile framing, Peter Gidal's and Barry Gerson's films about focus and depth of field, J. J. Murphy's *Print Generation* and Ken Jacobs's *Tom, Tom, the Piper's Son* about reprinting, Ernie Gehr's *History* and Sharits's *Axiomatic Granularity* about the grain of the image, and so on down the line (James 1989, 236–37; LeGrice 1977, 105–23). Besides, structural film also inquired into the spectator's perceptual activity. While flicker and single-frame films engaged the psycho-physics of vision, titles such as Frampton's *nostalgia* and *Zorns Lemma* or George Landow's *Remedial Reading Comprehension* were calculated to trigger in viewers the cognitive processes needed to grasp these films' overall design.

In all cases, structural film was essentially about film. As several commentators noted, its most immediate parallel in the art world was minimalism, itself an art of process, nonreferential, self-reflexive, and concerned with the way its (non)objects inhabited space and time; but structural film was also an example of one of modernism's dominant tendencies: the turning of the means of mimesis into the main subject matter of art. Its pictorial antecedents ranged from Cézanne and Mondrian to Ad Reinhardt and Frank Stella, and, in film, from Marcel Duchamp, Fernand Léger, Hans Richter, and Dziga Vertov, to Robert Breer's animations and single-frame films, Andy Warhol, and Fluxus.[2]

All this is well known, but I bring it up at the outset to highlight that the main frame for understanding structural film has always been vision and its vicissitudes. How could it be otherwise? After all, what was mostly at stake in this trend was the investigation of cinematic specificity: "film-as-film" (Gidal 1978b, 2), or, in Peter Wollen's terms, "the full range of properties of the photo-chemical process" (1982, 194). "From now on, we will call our art simply: film," wrote Frampton (James 1989, 237). And what *film* meant for structural filmmakers is best glossed by Paul Sharits's words: "the higher drama of: celluloid, two-dimensional strips; individual rectangular frames; the nature of sprockets and emul-

sion; projector operations; the three-dimensional light beam; environ-
mental illumination; the two-dimensional reflective screen surface; the
retinal screen; optic nerve and individual psycho-physical subjectivities
of consciousness" (1978a, 90). Such emphasis on light and optical per-
ception has obscured the fact that structural film made ample use of
sound, a use that, with a few notable exceptions, has remained largely
unheeded by historians and only mentioned in passing by filmmakers.
For all his desire to dwell on the mechanics and psycho-physiology of
vision, Sharits stated that his method of composition was essentially
musical and his early works include sound loops that often function as
aural correlates of his percussive visual loops. And Frampton's art may
have been "simply film," but it was seldom silent. Melissa Ragona (2004)
has recently shown that films such as *Surface Tension* (1968), *Zorns
Lemma* (1970), *Critical Mass* (1971), and some sections of *Magellan* used
sound as a fundamental ingredient in the design of open combinatorial
and permutational aggregates inspired by set theory. They play with
phase changes, rhythmic contrast, voice synthesis, echo, delay, and non-
synchronicity. The closing section of *Zorns Lemma* features composite
sound made up of six different female voices (each reads only one word
at a time) reading a text by Robert Grossetexte. And *nostalgia* (which
opens with the repeated question "Can you hear me all right?") shows
a number of photographs burning on a hot plate while an off-screen
voice whimsically describes not the image currently disintegrating but
the one that will burn in the following shot.

Frampton and Sharits are not isolated examples. Sound was an im-
portant tool in structural film's program of dismantling the unity of
cinematic representation, and its use certainly predates Frampton's
Surface Tension. Kubelka, Snow, and Tony Conrad were influenced by
music and employed sound in inventive ways. Andy Warhol's early films
(for Sitney, the main catalysts of this trend) are greatly indebted to John
Cage's experiments with duration and indeterminacy. And Michael
Snow's *New York Ear and Eye Control* (1964) is both an extension of
Snow's site-specific work ("the walking woman project," which consisted
of inserting a cut-out of a female form in a variety of environments), and
an homage to "free jazz." (Free jazz luminaries Ornette Coleman, Albert
Ayler, and Cecil Taylor used to rehearse at Snow's studio and briefly
appear in the film [Macdonald 1992, 58].) If one of the main functions
of sound in traditional filmic mimesis is to "naturalize" the image and

anchor it in the real, in structural film sound does exactly the opposite. It openly contradicts the visual track, abruptly appears and disappears, or changes tone, quality, or intensity without a clearly visualized motivation. *New York Ear and Eye Control* is built on the contrast between the inert, two-dimensional cut-outs and the three-dimensional motion around it (passers-by, wind-blown foliage, traffic), as well as on a further dissonance between the sedate presence of the walking woman and the frenzy of the music. Snow's subsequent *Wavelength* alternates between ambient sound and an intermittent sine wave that comes on and goes off at seemingly arbitrary moments and rises in pitch and volume as the film progresses. And *La Région centrale* has an electronic soundtrack (the sonic signal that directs the camera's movement from a distance) with no apparent relation to the film's natural setting. In conventional cinema sound is generally subordinate to the image, but in *New York Ear and Eye Control*, *Wavelength*, *La Région*, and *Zorns Lemma* it has an independent life, seldom converging with the visual track. And while it questions the specious naturalness of the visuals, it also denaturalizes itself and draws attention to its own artificiality: radically atonal (as in free jazz), synthesized, electronically processed in a variety of ways, it evokes unnatural aural universes, hard to locate and formalize, universes that originate in free jazz's modal scales, magnetic tape mixes, electric fields, and primitive computer circuits. Structural film is certainly about film but it also demands to be heard, and this is what I want to do here: lend it an ear. Its soundscapes draw on contemporary avant-garde music and sound art. From the start, structural film was informed by an intense dialogue with these areas of artistic research. One can trace this dialogue in the trajectory of structural filmmakers, many of whom alternated between sound and visual experimentation; in the soundtrack of the films; and in the way structural films transposed into the visual field contemporary experiments with sustained tones, aural loops, noise, synthesized sound, and manipulations of found sound carried out by contemporary avant-garde musicians. In fact, the "fixed camera," flicker, loops, and "rephotography off of a screen" that, according to Sitney, characterized the cinema of structure had their aural correlatives in duration, machine noise, audio loops, and re-recording (1970b, 327; 1979, 370).

In part, what I am trying to do is follow Catherine Russell's suggestion: "Rather than being circumscribed by its own history, structural

film needs to be positioned within a larger history of representation and visual culture"—and, I would add, auditory culture (1999, 161). So far, we only have inklings about this interface. Ragona's analysis of sound in Frampton's films is an important step, but her reading is quite self-contained: it completely abides by Frampton's own description of his work and says little about the connection between Frampton and contemporary music/audio experimentation or about the cultural politics implicit in Frampton's use of sound. Before Ragona, when sound was mentioned in relation to structural film, it was to bring up a connection with serialism (as practiced by Schoenberg and Webern). Sitney (1970b, 347) and Annette Michelson (1985, 160) related Frampton's permutational strategies to the tone row and retrograde inversion, while David James mediated the analogy between twelve-tone music and structural film at large through Adorno's reading of Schoenberg—the twelve-tone's negation of the fictitious order of culture as parallel to structural film's refusal of narrative and representation (1989, 267–68). Schoenberg and Webern are plausible parallels, but far from the only ones. By mid-century, their conventionally instrumental music was well enthroned in academia and constituted a staple of musical education (McClary 1998, 14–16). It was therefore a front of respectability opposed by subsequent avant-garde musicians. John Cage, La Monte Young, Terry Riley, Steve Reich, and Richard Maxfield, among many others, were raised in serialism (Cage studied with Schoenberg and Reich with Luciano Berio) but broke away from it to pursue their interest in silence and chance (in the case of Cage), tonality, jazz (which in the late 1950s and early 1960s was developing from chord progressions to modal structures), non-Western musics, improvisation, and, above all, noise, electronically produced and relayed.[3] The sounds they produced, and the way they produced them, stand as unexplored but important frames of reference for structural film.

There should be nothing striking about the existence of "operational analogues" (Sharits 1978b, 70) between avant-garde film and music in the 1960s. The audio experiments I review in this essay developed slightly ahead of structural film, but the connections between the two go beyond the fact that both were in the air more or less simultaneously. While they were ridiculed or ignored by the classical music establishment, music and sound experiments found their earliest audience among marginal artists and filmmakers.[4] Fluxus, hospitable to

both structural film and avant-garde music, was a case in point; its activities brought together musicians like Young, Maxfield, and Dick Higgins, and filmmakers like George Landow, Wolff Vostell, and Paul Sharits, among others. And Warhol's Factory proved equally congenial to unconventional ears: Warhol's sponsorship of the avant-pop band the Velvet Underground is well known. Less known is his interest in John Cage's ideas and activities and his one-time collaboration with La Monte Young, who designed a sound installation to accompany loops of Warhol's films shown in the mezzanine lobby of the Philharmonic Hall at Lincoln Center during the Second Annual New York Film Festival, in 1964. (When the Lincoln Center authorities asked Young to turn the volume down, he withdrew his work and left Warhol's loops to fend for themselves [Strickland 2000, 156–57; Joseph 2002, 84–87].) But music and film met as well in institutional venues such as the Filmmakers' Cinematheque, the Museum of Modern Art, and the Whitney Museum of American Art. Sound complicates the received picture of structural film as simply a cinematic avatar of visual minimalism and forces us to consider other histories, other paths of connection and sense. It also tells us much about the movement's cultural politics—more specifically, about its intermittent alliance with difference, an alliance that ultimately accounts for its subterranean persistence in a strand of independent film and, in another media context, in the visual styles developed alongside contemporary dance music.

The admittedly whimsical interest in sound in a book devoted to the relation between photography and film is premised on one of the generative ideas in this volume: the notion that it is necessary to discuss cultural artifacts from a perspective that is formal as well as historical and political. While remaining close to the shape and movement of the texts under study, one must also take into account much more than form and medium-specificity. In the case of structural film, in addition to the specificity of the cinema—"the higher drama" of light and the eye—it is crucial to take sound into account: a crucial area of reference for this seemingly most film-oriented of film movements. But even if one tried to remain exclusively confined to the materiality of the image, the programmatic focus of the movement, it would be difficult to keep out the racket. One would end up having to consider noise not only by listening to the soundtrack of structural films but also by taking liter-

ally these films' reduction of the cinematic image to its basic material components.

The most essential of them is, of course, the cinema's photographic base—"the full range" of "the photo-chemical process," as Wollen put it. In structural film, photochemical reproduction rarely yields readable pictures. While photography and film have traditionally been regarded as means to replicate the world and to index experience, structural film acted as an un-indexing medium. It questioned and interrupted the transparency of photographic representation at every turn or, differently put, it showed that the photographic image was full of *noise*. Flicker and single-frame works, for example, showed that film's continuous visual flow rested on the repression of the individual photogram, which these films restore to its discreteness. The thick-grained textures obtained by reshooting off a screen or blowing up the image, and the granulations caused by running unexposed film through a dimly lit optical printer (as in Gehr's *History*), drew attention to the effect of time exposures and film stocks while simultaneously suggesting that photographic representation is, after all, a matter of dots dancing on an empty field. (This recalls other radical reductions: Mallarmé had defined literature as letters on the page; the pointillists reduced painting to specks and daubs on the canvas, and Mondrian and Malevitch, to flat colored surfaces; and, as we will see, the contemporary musician La Monte Young reduced music to sound, and sound to its acoustic components.) The single photogram and the grain of the image are, from the perspective of information theory, pure noise: interferences that leak into the communication channels and impede transmission. But they also suggest the possibility of communication. Before a message comes on, there is the interminable murmur of the world and the hiss of static; at once no sound and (potentially) all-sounds, murmur and static indicate that the channels are open, ready to receive the signal. In Michel Serres's words: "Background noise is the necessary condition for the transmission of any message: a basic multiplicity of sound which fills the channels and spaces of communication" (1972, 191).

Noise—in its informational, cybernetic sense—takes on other forms as well: the dust, scratches, and lesions that the passage of time leaves on the strip. In Sharits's *S:TREAM:S: S:ECTION: S:ECTION:S :SEC-TIONED* (1968–71), the vertical scratches that multiply in the course of the film end up practically obliterating the superimposed images of

a running stream (a charged metaphor for time, the continuum of experience, and the flow of the cinematic image); in this way a normally negligible accident becomes the film's central subject. And in George Landow's *Film in Which There Appear*, the deterioration of the emulsion adds a rich layer of lines and dots to the double-printed image of a blinking woman (a looped color correction fragment). In both cases, there is an element of indeterminacy and open-endedness: the more these films are projected, the more dust and scratches they will collect, and the noisier they will become. (They seem to anticipate Christian Marclay's *Record without a Cover* [1985], a sleeveless album where the work was as much Marclay's collage of turntable manipulations as the crackling and popping caused by the gradual deterioration of the unprotected vinyl.) In Peter Gidal's *Condition of Illusion* (1975), noise does not appear in the visible trace of time but in the way the image keeps going out of focus and the camera veering off assorted objects in a room before they can be apprehended.

Yet even when things are legible, they are not necessarily clear. Structural cinema delivers an opaque world full of unaccountable reverberations. Wolff Vostell and Udo Jansen's *Sun in Your Head* (1963), a "décollage" of found images shot off a television screen, uses flicker effects, zooming, and distortion to create interference and noise in eminently consumable media imagery. (The film is not completely opaque, however: one may read an indictment of militarism in the progression from talking heads to an air bombardment, to a sustained flicker of black-and-white frames that evokes a nuclear blast at the end.) But more than media images, depopulated spaces are the main sources of visual noise in structural film. In Gehr's *Serene Velocity* (1970) an institutional hallway seems to palpitate as shifts in the focal distance of the zoom lens produce a pulse that becomes more extreme as the film advances. Snow's *La Région centrale*, filmed with a stationary camera that could pan, tilt, and swirl in any direction, registers a landscape that is at once the same and always in flux. While we are always confined to the same tract of land, the constant changes in the positions of sky and earth and in the speed of the camera movements make a circumscribed space virtually infinite and unknowable. In a slightly different vein, both *Wavelength* and *Back and Forth* are slices of the enigmatic life of two different rooms: a loft and a classroom, respectively. *Wavelength* juxtaposes trivial incident (three people carrying a set of shelves, two women listening to

music) with a break-in and an unexplained death that take place mostly off-screen. In turn, the constant pans in *Back and Forth*, punctuated by a metronomic tock every time the camera reaches the end of its trajectory, sweep across a space occasionally filled with activity: classes in progress, people reading, a cocktail party, the cleaning staff at work, and, toward the end, an ominous policeman staring into the room through a window. (Is there an investigation? Is this the scene of a crime?) What all these examples show is a world plagued with meaninglessness, a noisy quotidian that does not easily yield sense.

These examples show that structural film exploited one of the main traits of the photographic image and of the analog media at large—their potential for noise. Despite the traditional association of the camera and sound-recording mechanisms with modern epistemophilia, that is, the desire to explore and archive the minutest configurations of matter and experience, the analog media had a strong propensity to scramble the traces of reality. There was always the danger of the machine malfunctioning: going out of focus, over- or underexposing the film, superimposing different takes, or simply failing to record, delivering an empty frame. But in addition, because of its total receptivity, machine registration captured sense and non-sense, information and noise, and because of this, often relayed an unfamiliar world dotted with enigmas and indeterminacy. Already the pioneers of photography noted that the camera had an uncanny affinity for off-center particulars that derailed the photographers' intentions and questioned the world's legibility. In Fox Talbot's words: "Sometimes inscriptions and dates are found upon buildings, or printed placards most irrelevant are discovered upon their walls: sometimes a distant sundial is seen, and upon it—unconsciously recorded—the hour of the day at which the view was taken" (Ray 1995, 29). Writing in the 1850s, two decades after Talbot, the American writer and photography buff Oliver Wendell Holmes was similarly fixated with "incidental truths" on stone inscriptions. He noted that stereoscopic views of ancient monuments provided "not only every letter of the old inscriptions, but ... the grain of the stone itself. On the pediment of the Pantheon may be read, not only the words traced by Agrippa, but a rough inscription above it, scratched or hacked into the stone by some wanton hand during an insurrectionary tumult" (Holmes 1980, 78). Such accidents are precisely the subject of Ken Jacobs's *Tom, Tom, the Piper's Son*, a painstaking rearticulation of the homonymous 1905

Edison film, or of Ernie Gehr's *Eureka* (1979), which rephotographs the urban panorama *Trip down Market Street before the Fire* (1905), retarding its original pace and highlighting the visual textures of the aged film and the weaving trajectories of vehicles and pedestrians in front of the lens. *Eureka* takes its name from one of the unconsciously recorded details that intrigued Talbot and Holmes (the words "Eureka, California" visible on the side of a horse-drawn wagon and allusive to accidental finds) and ends with an enlargement of another, the date 1896 inscribed on the façade of a building at the end of the street.[5]

The ambiguity of photography is registered almost subliminally—photographically?—in one of the classic studies on the cultural effects of the technologies of mechanical reproduction: Walter Benjamin's famous "Artwork" essay (1936 version). While in the body of the essay Benjamin interprets photography and film as instruments for the "surgical" exploration of reality and the conscious penetration of space, a seldom-cited footnote points out that film was "the first art form capable of demonstrating how matter plays tricks on man" (Benjamin 1968, 247). Precisely because it captures in close detail the complex physiognomies of matter, camera vision shows that reality always contains an excess that cannot be entirely reduced to sense. Matter constantly escapes attempts to fully understand it and reduce it to pattern. The photochemical image plunges the viewer into the disorder of a material horizon alien to human intention and design. It is then the essentially allegorical medium, in Benjamin's sense of the term: it articulates reality as an aggregate of bits and pieces that are not unified by an underlying organic connection and therefore do not add up to a whole. Benjamin's thinking about photography was directly influenced by his friend Siegfried Kracauer. In his 1927 essay "Photography," Kracauer had already pointed out that photochemical reproduction captures "the inert world . . . in its independence from human beings" and "nature alienated from meaning," and he associated this form of representation with allegory (1995, 61, 57–60). Photography, he continued, catches "the residuum that history has discharged," "a jumble that consists partly of garbage," a "ghostly" "unredeemed" material horizon that "dissolves into its elements" like a "corpse"—the ultimate embodiment of the nonsymbolizable residue, or absolute noise (55, 62).

Commercial photography and cinema sought to eliminate this kind of noise. In fact, technical expertise in the analog media consisted in

noise-abatement. Centering, focus, lighting, composition, and (in film) continuity editing had as their main purpose the elimination of the constant buzz perceptible on the edges of the image or of the aural field—the rustle of the apparatus or of an irrepressible real constantly on the verge of nonsense. However, this excess can never be entirely eliminated. It may be caught, on and off, in the commercial media, in accidents and throw-away moments when obstreperous materiality leaks in in the form of gratuitous gestures, excessive textures, a peculiarly "grainy" voice. But what counts as leakage in commercial culture has occupied a central position in experimental culture from the beginning of the twentieth century. From futurism, dadaism, and surrealism to 1960s electronic music and structural film, one of the goals of the avant-garde was to interrupt the normative representations of reality by turning up the noise, and the hardware in this pursuit was the information media, duly (mis)used: initially gramophones and film and photo cameras, and later on, magnetic tape, synthesizers, video, and computers. Kracauer closed his essay on photography by recalling the political potential of noise—those senseless warps of matter captured by the photograph. In their unassailable inertness, they proved that available systems of intelligibility had limited coverage and that there was nothing inevitable about the current state of things. "The valid organization of things remains unknown" (63), he stated; therefore, the present is by definition provisional and the future still in process. With their capacity for mechanical error, interference, and nondiscriminating capture, film and photography—not to mention phonography—were powerful vehicles for this potentially revolutionary knowledge, and this is what structural cinema sought to transmit. In the words of Peter Gidal, structural film posited "[t]he unnaturalness, ungivenness, of any possible meaning," and used "virtually unloaded" or "empty signifiers" that did not admit "ready associative analogues," hierarchies of meaning, or "heavy associative symbolic chains" (Gidal 1978b, 7–8). In sum, "[a] materialist film makes the viewer a non-knower"—a consumer of noise (Gidal 1989, 56).

In the early to mid-1960s, about the time when the cinema of structure emerged, it was in experimental music rather than in film or photography where noise circulated widely as either machine interference (the noise of the apparatus) or environmental reverberation (the noise of the world). Environmental noise was the central ingredient of Pierre Schaeffer's *musique concrete* (which he had been refining and conceptu-

alizing since the late 1940s with the aid of his assistant, Pierre Henry), and in combination with electronic sounds or instrumental music, it was amply featured in works by Karlheinz Stockhausen and Maurice Kagel in Germany, Luciano Berio in Italy, Cornelius Cardew in the United Kingdown, Pierre Boulez and Iannis Xenakis in France, and, especially, John Cage in the United States. Cage, in turn, decisively influenced younger composers such as La Monte Young, Terry Riley, Steve Reich, Dick Higgins, and Richard Maxfield in the United States.[6]

While he is best known for his silences, John Cage systematically explored both machine and environmental noise. His *Imaginary Landscapes* (1939–52) were rich compendiums of the former, combining variable-speed turntables, gramophone cartridges (rubbed on to create explosion-like rumbles), radios (twelve of them playing on different frequencies for *Imaginary Landscape, No. 4*), and electric buzzers together with prepared pianos, siren-like glissandi, and percussion instruments; and *4'33"* (1952) consisted of four minutes and thirty-three seconds of silence (in three parts) during which environmental sound became the piece itself. Shortly afterward, Cage began to use contact microphones to amplify commonly unnoticed resonances, whether produced by musicians by simply holding or touching their instruments, or generated by quotidian tasks (eating, drinking, preparing a meal). Perhaps inspired by Cage, in 1959 Young and Riley, at the time graduate students in the music program at UC Berkeley, availed themselves of the recently inaugurated San Francisco Tape Music Center to record a tape of loud friction (metal scraped against various hard surfaces) to be played back at top volume. The following year, Young expanded the concept of this noise tape in *Two Sounds*: two tapes to be played simultaneously, one of cans rubbing against glass, the other of a gong played with drumsticks and dragged on a concrete floor. (These pieces proved inspirational for dancers: the former had been commissioned by Anna Halprin for one of her choreographies, while *Two Sounds* was used by Halprin's student Simone Forti and, later on, by Merce Cunningham in *Winterbranch* [1964] [Rainer 1995, 138–40; Strickland 2000, 136].)

Other composers at the time bypassed the noise of the world to dwell on that of the machine. Young's experiments with "noisy" timbre and amplification had a precedent in the work of one of Cage's students at New York's New School for Social Research: future Fluxus member Dick Higgins. Higgins's *Loud Symphony* (1958) consisted of thirty minutes of

feedback created by passing a live microphone in front of a loudspeaker according to predetermined graphic patterns. Outside of pop music, where feedback figured prominently in the music of Jimi Hendrix, the Velvet Underground, or Sonic Youth, the best-known realization of this concept is Steve Reich's *Pendulum Piece* (1968), in which feedback is randomly produced by four microphones left to swing freely above as many loudspeakers; as their motion dwindles, feedback increases, and the piece ends when all four mikes are motionlessly suspended above the speakers emitting a steady buzz. For his part, Richard Maxfield, a New York–based pioneer of electronic music of enormous yet subterranean influence, relinquished the gesturality and aleatorics of Reich and Higgins and constructed his noises entirely in the studio, achieving astonishingly controlled, textured effects with very simple means. *Night Music*, a three-channel tape composition made with an oscillator and a tape recorder, was titled for the resemblance of the electronic sounds he had achieved to (as he put it) "the chirping of birds and insects at night" in New York City parks.[7] *Pastoral Symphony* (1960) is less directly denotative in its evocation of a crisply abstract yet exhilarating outdoors. And *Bacchanale* blended in spoken voice, jazz (a peculiar combo of sax, prepared violins, and "underwater clarinet"), and folk recordings, with an undertow of synthesized tonalities perceptible under the jazz sounds and the voice of the poet Edward Field reciting one of his own texts.

These audio experiments used as their raw material what in traditional music had long been regarded waste (unmodulated and resident noise), just as structural filmmakers highlighted grain, frame division, or the marks of deterioration in the image; and they also used accidents and contingencies (captured through contact mikes or environmental recordings) in the same way that structural film dwelt on off-center details and seemingly unmotivated events. Whether in music or film, using waste was a way to vindicate the unstructured textures and shapeless materiality of the world, to emphasize matter over signification. But just as important as materiality was the conceptual grounding of the works; after all, both films and audio works were process pieces, where the rigorous application of a set of rules mattered as much as the final results: noise-saturated (sound or visual) environments designed to envelop audiences.

In 1960s experimental music, noise did not always come from the environment or electronic circuits. It was also the byproduct of tone-

decomposition and the re-recording of found sound. Tone decomposition was the particular interest of the composer La Monte Young. Since his undergraduate years at UCLA, Young's driving concern had been the exploration of long-sustained tones. His early work *Trio for Strings* (1958), often regarded the opening act of minimalist music in the United States, was a spare score of restricted tonality and dynamism, built on the alternation of long tones, often held for three or four minutes, and equally lengthy silences. In the early 1960s, after graduating from UC Berkeley with a master's degree in music and moving to New York to study with Richard Maxfield, Young progressively abandoned conventional instrumentation and started to produce long tones through oscillators and sine-wave generators with his ensemble, the Theater of Eternal Music. In its most stable lineup, the Theater consisted of Young himself on sax, keyboards, and voice; the visual artist Marian Zazeela, who intoned and designed light shows for the performances; Tony Conrad on violin; and John Cale on viola; at different stages in the band's history, Angus McLise, Terry Riley, and Billy Linich also took part in the proceedings. Young's band sounded like an ensemble interminably tuning up their instruments. They played predetermined harmonic frequencies above an electronically generated bass drone. Each musician entered and exited as he or she wished, always playing tones harmonically related to the drone and thus creating subtly varying chords. At first, Young used these long tones as backgrounds for extremely fast improvisations on sopranino sax that owed much to his experience in jazz bands in the mid- and late 1950s. But eventually he dropped the improvisations to join the rest in the emission of long notes, and thus to concentrate exclusively on the harmonic structure of the endlessly sustained tones and chords. As he often put it, the goal of his idiosyncratic music was "to get inside the sound," and length and extreme amplification were essential to this (Young 1995, 78–80). In combination, length and volume revealed the paradoxical eventfulness of seemingly static sound. They showed that any tone comprised simultaneous and constantly changing bass tones, upper harmonics, and a steady beat that remained hidden in ordinary conditions of audibility. As Terry Riley put it, "What becomes apparent on listening to an amplified, well-tuned drone that La Monte sculpts is a molecular world of sounds whose workings are ordinarily covered up by fancy rhythmic and melodic footwork" (Riley 1996, 22–23). Young showed that a sound

is actually many sounds, since, under close scrutiny, it dissolves into a multiplicity of interacting components.

Michael Snow may have been inadvertently echoing Young when he stated that the purpose of his famous *Wavelength* was to stay "inside" the zoom—a movement that "normally happens fast" and is hardly heeded—for "a long period" (Macdonald 1992, 63). While he alluded to Bach's Goldberg Variations and to Duke Ellington as distant inspirations for his piece, he never mentioned the Theater of Eternal Music. In any case, it is clear that, despite Snow's early pronouncement that the film is "all about seeing," *Wavelength* is also about hearing (Snow 1967, 1). Its soundtrack is a complex collage that references a number of sound media: the telephone, the radio—playing the Beatles' "Strawberry Fields Forever," one of their most experimental songs, to be taken apart years later by the musician Alvin Lucier in *Nothing Is Real*—naturalistic sound-on-film, and electronic sound. This last is a synthesized sine-wave that rises from a barely audible 50 cycles per second at the beginning of the film to 12,000 by the end in a barely interrupted glissando. Both sound- and visual tracks combine abstraction and realism.[8] The abstract movement of the zoom rhymes with the sine-wave's programmed rise; the wave comes in when the image changes from positive to negative for the first time, and it rises in pitch (that is, its length diminishes) as the visual field narrows. Both zoom and sine-wave obey the logic of the apparatus, machine vision, and sound. At the same time, the inklings of narrative that the film contains are transmitted through realistic depictions of human incident—the moving in at the start, the unexplained entry of an intruder who collapses on the floor, and the alarmed call of the woman who discovers him—but also through (roughly) synchronized ambient noise (voices, steps, the shuffle of furniture being moved, the din of hammering and breaking glass that precedes the entrance of the trespasser into the frame, and the sound of sirens at the end). These narrative hints have a counterpart in the familiarity of the pop song, with its recognizable structure and sonority. *Wavelength* combines the noises of the world and the apparatus and seems to partake both of Cage's openness to environmental contingency and of Higgins's, Reich's, and Maxfield's fascination with machine-made noise. In addition, the length of the zoom—a sort of sustained visual tone—and the sine-wave recall La Monte Young's experiments with duration and electronics.

In both Young's music and Snow's film, lengthy exposure leads to dis-

solution and decomposition. The advance of the zoom is quite irregular; even though Michael Snow described it as "continuous," it is more accurate to consider it (in Annette Michelson's terms) "a stammer" (1978, 40). It proceeds by jump cuts marked by changes in lighting, aperture, and camera set-up. In addition, the slow advance of the zoom is punctuated by fields of color (white, pink, and orange) flashing on the screen, changes from photographic positive to negative, flicker (caused by overexposed frames), and overlapping double printing. Altogether, jump cuts, mismatches, and overlaps suggest that the film is on the edge of self-dissolution; while remaining largely the same, it is also in constant mutation, like Young's endlessly self-exfoliating tones.

At the very end, visual exfoliation is arrested and the film concludes in a close-up of a photograph of waves on the wall. The final image zeroes in on what was at first an illegible spot on the wall and recalls the essential two-dimensionality of filmic representation, but it also evokes further dispersions and decompositions. As various critics have noted (Michelson 1978, 41; Wees 1992, 159–60), it reopens the visual field again into virtual infinity, giving the film (in Noël Carroll's term) the geometry of an hourglass (Carroll 1998, 105). In addition, the picture of the waves freezes a constant undulating energy that adopts ephemeral configurations. The waves themselves, whose length and amplitude vary but whose shape is always translatable through a sine function, bring to mind the graphic representation of the sine curve but also its variation throughout the film. At a more denotative level, the photograph represents just water. Perhaps because of its fluidity and peculiar sonority, water is a choice material in the postwar musical avant-garde, starting with John Cage's *Water Music* and *0'00"* and continuing with George Brecht's *Drip Music*, Yoko Ono's *Water Event*, Chieko Shiomi's *Water Music*, and Philip Corner's amplified drops for Lucinda Child's dance *Pastime* (Kahn 1999, 276–88). Water was also invoked metaphorically in relation to minimalist music. The critic John Perrault once described one of Young's ear-splitting environments as "a room full of brine" (Strickland 2000, 160) and others pointed out that there was something oceanic in the relentless motility and intricate layering of Reich's and Terry Riley's works. Water occasionally enters structural film as well: in Snow's *New York Ear and Eye Control* (the walking woman under water), in Snow and Joyce Wieland's *Drip Film*, Wieland's *Sailboat*, Ken Jacobs's *Soft Rain*, and Sharits's *S:TREAM:S:*

S:ECTION: S:ECTION:S :SECTIONE:D and *N:O:T:H:I:N:G* (where there are occasional gurgles in the soundtrack). (And without leaving the terrain of the ephemeral, waves also point to memory and nostalgia: Snow has stated that the photograph is an enlarged fragment of a picture of a cottage built by his grandfather where he used to spend the summer as a child.)[9]

If *Wavelength* can be read as a counterpart of La Monte Young's sustained, decomposing tones, so can flicker films, only in them the rapid permutation of a small number of elements replaced (more or less) continuous camera movement. In Tony Conrad's *The Flicker* the elements are black-and-white frames, and in Paul Sharits's early films (*Ray Gun Virus, Piece Mandala/End War, T,O,U,C,H,I,N,G* and *N:O:T:H:I:N:G*) there are also color screens and flashing representational images.[10] Both filmmakers drew on harmony and acoustics to explain the rationale of their work. For Conrad the point was to generate the visual equivalent of harmonic effects, applying, as he put it, "harmonic structure to light, and that is to modulate its intensity with time, leaving color [and image] momentarily out of the picture" (Conrad 1966a, 1). Taking the frequency of 24 flashes per second (identical with the speed of sound film) as a tonic, or key note, he produced flicker effects that went down to 4 flashes per second and gradually back up to 24. The greatest part of the film remained in the range between 6 and 18 flashes per second, a band covering one and a half octaves, where harmonic effects were possible and where, as a result of these effects, "more or less strange things" might occur: a "whirling and shattered array of intangible and diffused color patterns, probably a retinal after-image type of effect," mild hallucination, and hypnotic fixation. Conrad described the film as "a hallucinatory trip through unplumbed grottoes of pure sensory disruption" and acknowledged psychedelia and the stroboscopic light in rock shows and dance clubs among his sources of inspiration (1966a, 2–3), but his main influence was the music he produced with the Theater of Eternal Music. *The Flicker*'s soundtrack provided an analog of light harmonics; it consisted of "homemade electronic music composed indissolubly of tones . . . bordering closely on the lower range of audibility and of very rapid rhythms, rhythms whose speed is comparable in frequency to the tones" (1966a, 1). The conflation of pitch and rhythm (which has precedents in the work of Edgar Varése and Henry Cowell) was intended to convey "aural vastness and spaciousness" and to generate unpredictable

overtones. It does generate a dry continuous rattle that seems to shift slightly in volume and timbre during the projection of the film; according to the filmmaker himself, it evokes motor sounds ("a tractor or a locomotive" [Mussman 1966, 5]) yet to contemporary ears it may sound like the continuous bass fuzz tones in the compositions of bruitists such as Merzbow or Karkowski.

Conrad's ideas were echoed years later by Paul Sharits. As he looked back on his work in the late 1970s, Sharits characterized his films as experiments with visual harmonics; they were different attempts to answer the following question: "Can there exist a visual analogy of that quality found in a complex aural tone, the mixture of a fundamental tone with its overtones?" (Sharits 1978b, 71–72). He arrived at a conclusion similar to Conrad's: "A series of single frames of different colors, which creates 'flicker,' can, depending upon the order and frequency of the tones, suggest such a quality." In his films, these visual overtones are perceptible in the manner in which color fields and single- and double-frame images bleed into and resonate against each other, creating subliminal gradations in color and alterations in the shape of the frame. And his soundtracks offer aural counterparts of his images: the rapping of sprockets and splices seems to vary in volume and pitch after a time, while endlessly repeated, irregularly spliced word loops change shape and meaning. In *T,O,U,C,H,I,N,G*, for example, the word *destroy* gradually mutates into "his straw," "his draw," "his story," or "his turn-on," and (as far as I can understand) *sterilize*, turns into "'s futile," "he's sterile," or "he's fertile." A word then turns out to be many, since looping and splicing change its sonority, and it also turns out to be nothing—sheer rhythm and noise. Richard Maxfield and Steve Reich had already demonstrated this in a number of tape works in which obsessive repetition, splicing, and phase shifting deprive human speech of its recognizable attributes. Yet, noise and all, their tapes have a musicality that is absent from Sharits's abrasive aesthetic. In the end, Sharits's approach is also a far cry from Conrad's, with whom he shares considerable formal similarities, however. Conrad used the flicker as a form of initiation into a different style of viewing and hearing, and he directly linked his film to his music: both sought to increase tolerance for scales and harmonies different from the traditional Western ones (1966b). Sharits talked about his works in mystical terms, but in his case, flickering, looping, and noise are purely percussive, and rather than to illumination, they

lead to implosion and collapse. Each word, color field, or image flashes briefly before being annihilated by the driven pace of the films, which move toward breakdown. This is literally represented in the medium shot of Sharits with a gun to his head in *Piece Mandala*, the draining bulb and falling chair in *N:O:T:H:I:N:G*, or the face scratching and tongue cutting in *T,O,U,C,H,I,N,G*.

A similar kind of decomposition takes place in Ken Jacobs's *Tom, Tom, the Piper's Son*, which subjects an Edison one-reeler—a tumultuous chase film involving the theft of a pig at a crowded marketplace and the pursuit of the culprits through the village—to a thorough restructuring. Using a translucent screen and an analytical projector, Jacobs reframes and enlarges segments of the original and slows down, stops, and reverses its movement, creating complex light and motion studies. Like a DJ picking out break-beats and sound effects from found recordings, Jacobs selects and replays especially resonant fragments. The film is silent, even though the original performances of the piece were accompanied by projector sound, just like the distilled version of these that Jacobs eventually printed. But its overall conception seems directly drawn from Terry Riley's decompositions of found musical pieces and from Richard Maxfield's, Steve Reich's, and Alvin Lucier's defamiliarizations of voice.

The works of these musicians are quite kindred to La Monte Young's; they also disassemble seemingly compact sounds into their minimal components, yet instead of synthetic sonorities they use found acoustic objects that they re-record on magnetic tape, and the decomposition takes place by means of loops, time lag, echo, and phase and frequency shifts. In any case, tape works also show the extraordinary intricacy of even the most trivial of sound sequences, an intricacy that had to be laboriously teased out by complex replay and editing devices. (Digital sampling has made these processes infinitely easier.) Richard Maxfield's *Amazing Grace* (1960) speeds up and slows down the voice of a revivalist minister and mixes it with looped electronic effects; the composition occasionally slips into a bluesy rhythm with the oddly reverberant voice marking the beat. Maxfield may have prompted West Coast musicians to try similar experiments. Thanks to the insistence of La Monte Young, his music became known around 1959–60 to Bay Area experimentalists such as Riley, Morton Subotnik, Ramon Sender, and Pauline Oliveros. Maxfield's influence is most noticeable in Riley's tape works with loops

and echo. The first of these, dated 1961, was another Halprin commission: *The Three-Legged Stool* (also known as *The Five-Legged Stool*), later reworked into the live piece *Mescaline Mix*. Soon afterward, he made the music for Ken Dewey's *The Gift* (1963), a decomposition of Miles Davis's "So What?" expressly recorded by Chet Baker for the occasion. Riley took the performance apart by playing each instrument separately and subjecting it to a primitively designed time-lag process. In this way, the music lost its original outline and gained a thickened texture and labyrinthine structure. Similarly conceived were two works from 1964: *Shoe Shine*, a cut-up of Jimmy Smith's version of "Walk on the Wild Side," and *Bird of Paradise*, a reassemblage of Junior Walker's "Shotgun."

While Riley recut preexisting music, Steve Reich's tape works took as their main raw material everyday sound and voice—with a particular predilection for African American voices. In the early 1960s, when he was finishing his graduate degree in music at Mills Collage in Oakland, he became acquainted with Riley and eventually followed in his tracks. Reich's tape *Livelihood* (1967) chronicles his time as a cab driver in San Francisco through a montage of the hum of traffic, car noise, and bits of conversation with his passengers. More famous are *It's Gonna Rain* (1965) and *Come Out* (1966). They rework speech fragments by looping, overdubbing, and by throwing the overdubbed voices slightly out of phase, producing "beating" or fading echoes. As the pieces advance, continuous vocal articulation dissolves into spurts of frication, sense into noise, and the voice into sheer grain. (Grain was getting some play at the time: a few years after Reich's *Come Out*, Roland Barthes published his famous essay "The Grain of the Voice." In it he rejects the contemporary fetishism of technique, which produces flawless but insipid renditions, and pays homage to outdated performers, less academic but more flavorful, and amateur singers and players, whose limited technique makes the music more unpredictable, personal, and embodied. Reich and Barthes were certainly on to something. In a resistant brand of pop music at the time, it seemed that the grainier, the better, as the success of such vocalists as Eric Burdon, Mick Jagger, Janis Joplin, Bob Dylan, and Nico amply demonstrates. Their unorthodox style was an implicit stand for absolute particularity and a refusal to accommodate, and it was the flip side of the academicism rampant, according to Barthes, in classical music. And what about film? Grain stars triumphantly in structural

film, from Warhol to Paul Sharits and Ernie Gehr, as radical reduction or sheer interference. It makes Warhol's *Empire* and *Sleep* look like they have been filmed underwater. Whether in music or film, grain is the triumph of material over semantics.) A more extreme version of Reich's tape loops is Alvin Lucier's *I Am Sitting in a Room* (1969–70), for voice and two tape recorders. Lucier recites a short text describing his whereabouts ("a room, different from the one you are in now") and the process of the piece: "I am recording the sound of my own voice and I am going to play it back into the room again and again until the resonant frequencies of the room reinforce themselves and any semblance of my speech, with perhaps the exception of rhythm, is destroyed." Halfway through the forty-two repetitions, the syllabic attack is smoothed out, the high frequencies are dulled, the low ones boom, and the voice begins to take on the timbre of a gamelan ensemble; by the last repetitions, all that remains is a lugubriously modulated rumble full of whistling overtones and bell-like echoes. Rather than a study of the grain of the voice, it is a rehearsal in sonic annihilation.

Where Riley, Lucier, and Reich pushed sound beyond referentiality, Jacobs enhanced grain and shape, creating what looks at times like abstract animations. And where Riley took apart the different tracks of a piece and replayed them separately, Jacobs singled out individual characters within the frame: a lady on the edge of the action who tugs nervously at a neckerchief, two men in fisticuffs, a female funambulist who soars above a crowded marketplace, or a juggler who somersaults exuberantly. Anticipating EP remixes and turntable wizardry, 1960s avantgarde musicians replayed found or prerecorded sounds in order to expose hidden resonances and latent melodic and rhythmic possibilities; following a similar procedure, Jacobs opened up the seemingly compact plot of the original to unsuspected stories and connections—to the many films unfolding within a film. The lady who plays with the handkerchief around her neck seems caught in a private story of grief; the female funambulist is ethereal and angelic, yet also fleshy and incongruously paired with a horse painted on a façade behind her; and reframed in twos, characters stare at each other with defiance or sexual tension. As group scenes are slowed down and flickered, their chaotic swirling becomes phrased as a dance.

Of course, sound is not the exclusive correlate of these experiments. Jacobs's rearrangement of the Edison film may be related as well to the

surrealists' "irrational enlargement" of film; only, while their enlargements were verbal—they took the form of written replies to whimsical questionnaires—Jacobs's is visual, but it shares with them a taste for absurdity and dream atmospheres. Like the central event in Michelangelo Antonioni's *Blow-Up* (1966), *Tom, Tom* concerns the enlargement of a photograph to the point where it dissolves into grain, but in Antonioni's film, this is a plot event, not a principle of construction, and it lacks the rhythmic quality that enlargement and replay have in Jacobs's film. And David James (1989, 249) noted the resemblance between Jacob's *Tom, Tom* and Roland Barthes's *S/Z*, a slow-motion analysis of Balzac's short story "Sarrazine" that is full of freeze-frames, loops, and pattern-recognition and -dissolution. (*S/Z* was first published a year after Jacobs printed his film.) In all these examples, as in the aural reassemblages reviewed above, there is something forensic about the obsessive retracing of given texts. The surrealists' "irrational enlargements" tended to amplify the violent, perverse intimations latent in apparently innocent films, *Blow-Up*'s enlargements sought to uncover a murder, and Barthes's analysis ended up demonstrating the instability—and eventual collapse—of the symbolic codes that underpin literary mimesis. For their part, Maxfield's *Amazing Grace* and Reich's *It's Gonna Rain* retain some of the apocalyptic urgency of the street preachers that provided the original voices, and Reich's *Come Out* memorializes a statement by a victim of police brutality (an African American student framed for murder) and turns it against the abusers. In turn, Jacobs has described *Tom, Tom* as "a perilous journey" into disintegration and back (Macdonald 1998, 381). The film insistently dwells on the sinister subtexts of the original. One of its most memorable sequences converts the bald-headed juggler into a memento mori. In the thick-grained, high-contrast enlargement, his features disappear and the shadows around his eyes resemble the empty eye sockets of a skull. His skillful flips, demonstrations of precision and control, are transformed into icons of injury when, frozen in midair, he seems about to crumple to the ground. On three different occasions, the frame wanders off the center of the action to a random detail in the painted backdrop—square shadows that look like a row of tombstones.

Death, symbolic collapse, subterranean stories-beneath-stories, forensic investigation, initiation trips, the secret lives of rooms, and the

unformalizable undulations of water: it is an odd list to bring up in relation to a type of film ordinarily characterized by structure, control, and minimalist reduction. But minimalist reduction is never quite so minimal; for all its apparent schematism, it is always traversed with difference. This is certainly the case with structural film: reduction is only a moment in its aesthetic, which is also inhabited by an alterity that I have been calling noise, partly because it is a form of informational noise and partly because it is often literalized as an acoustic presence. Either way, the noise of structural film has much in common with the noise that circulated in contemporary audio experiments. In all cases, what was registered and played back was the noise of the world and of the apparatus—analog recording-transmission technologies. This noise reveals the ultimate opacity of experience, the limit where knowing and acting shade off into corporeality and tactility. Abuzz with noise, structural film is "materialist" in the most literal sense of the term: not only because it reduces filmic representation to its component materials, or because this reduction may be theorized as a form of political materialism, as Gidal amply showed. Structural film is materialist also because it foregrounds the radical otherness of materials, spaces, and things. Another way of putting it would be to say that structural film is a cinema of difference, not necessarily embodied in anthropomorphic categories (ethnicity, class, gender, sexuality) but in a domain that is at once pre- and posthuman: the uncontrollability of matter, the unpredictability of the machine, the enigmatic pulses of everyday life.[11] It is more than "a cinema of the mind" (Sitney 1979, 370) that subordinates "the retinal to the intellectual" (James 1989, 240), reduces contingency through systemic process (Michelson 1985, 160), and sublimates corporeality (Arthur 2005, 133–34). There is more than meets the eye (and the disembodied mind) in it—precisely that unaccounted vibration that meets the ear.

How does one put noise to work, though? What are its politics? The awareness of opacity easily becomes tautological—a passive contemplation of the ineffable strangeness of things. Or it may foster the recognition that, to paraphrase Bill Brown, all (micro)politics and practice might have to begin with some experience of the profound otherness of the everyday (1999, 11; 2001). Besides, as it undermines consensual representation, noise is the harbinger of new possibilities, new ways of doing and thinking. Attali wrote that noise "makes possible the creation

of a new order on a different level of organization, of a new code in another network" (1985, 34). In his view, every major social rupture has always been preceded by a mutation in musical codes, styles of audition, or networks of sound distribution—mutations that, until they are assimilated into new encodings, are lived as so many forms of noise. His examples are the adoption of the semitone in the Renaissance by a rising merchant class, the embrace of the twelve-tone scale by a free-thinking, mostly Jewish bourgeoisie in early-twentieth-century Vienna, and the emergence of "free jazz" in the early to mid-1960s. Other examples are possible: rock 'n' roll, rock, punk, and house all brought on new styles of embodiment, relation, and community. It is possible that all utopias start as sonic utopias—unprecedented landscapes for the ear.

Utopian longings and the awareness of an opaque quotidian have remained attached to structural gestures in both film and music. The films of Chantal Akerman, Gus Van Sant, Jim Jarmusch, Hou Hsiao-hsien, or Tsai Ming-liang—among many others—dwell on an enigmatic everyday that is scrutinized by means of long takes and defamiliarized sound.[12] To take a recent example, Gus Van Sant's *Elephant* (2003) revisits the architectures of structural film—institutional hallways, classrooms, private rooms—using many of its stylistic trademarks: long takes, abstraction, shallow fields that limit visibility, looped action, alternations between deep and flat space, self-reference, and noise. The film is awash in noise: it renders a day in the life of a high school visually as well as aurally. The crisp audio capture makes the aural field denser than the visual, more solid and multilayered. A sonic index of the "independent, subterranean life of matter" (Chion 1993, 147), noise denotes the mass and movement of bodies and things just outside the field of vision. It also forecasts disturbance: the sudden amplification of the ambient clatter at the cafeteria announces the imminent breakdown in one of the protagonists; and a casual conversation between two students in a hallway, shown three times from three different angles, acquires with each repetition a hollow, cavernous resonance that shifts it into the register of memory or dream. There are, in addition, surreptitious drips, bird calls, electric buzzes and drones.[13] Retroactively, these floating bits of noise make sense as an undecipherable threat that hangs in the air like the storm clouds at the opening of the film and explodes in the end when two fully armed students start a massacre.

Independent film is not the only realm of the culture where struc-

tural biases persist, however. I pursued some of these ideas by losing myself in the beat. These are recent memories of times when I probably should have been home writing this essay but somehow found myself elsewhere. On a mild spring evening in the city in southeastern Spain where I live and teach much of the year, at a performance space on the edge of the city, the show is just getting under way: two sets by visiting DJs, Flevans and Dr. Rubberfunk. They start out with a looped squeaky cartoon voice (sounds to my ears something like "now we're going to get up and dance") that gradually blends with a brass phrase from an obscure soul track mixed in with a rubbery, bouncing bass that starts the crowd swaying and nodding. Above their mixing table, the video goes on: a four-split screen showing solarized TV images from long-forgotten newscasts, computer-designed icons, bar codes, isolated words, fluid psychedelic designs like those from a West Coast light show forty years ago, spinning turntables, microphone heads, and even film sprockets. It all evokes low-grade technology and homemade equipment—the primitive-modern feel of early computer games, of *Neuromancer*, or of *Tron*. The images succeed each other rapidly, bits of atmosphere that hover on the edges of recognizability and vanish before they can be pinned down. At times the pictures flicker, but most often they are looped in synch with the beat of the music, a visual translation of the hypnotic repetitiveness of the sound that, by now, has everyone dancing with abandon. Flickers, loops, reshot and manipulated imagery, self-reflexive gestures, and an insistence on the materiality of both music and picture. There is no symbolism or anecdote, just immediate physical stimulus through sound as sound, through image as sound: cyclical, textured, percussive. Where have I seen all this before?

Some time later, at a more academic venue, La Casa Encendida, an art center on the edge of the Lavapies neighborhood in Madrid, the crowd files into the auditorium and settles along the perimeter of the room, including on the empty stage. The center is taken up with electronic equipment, mixers, controls, samplers, all covered with a black tent, while the loudspeakers are on the corners. The musician—a label he dislikes—Francisco López performs, as is his habit, from the center with the lights out and the audience around him. A well-known sound artist, López seeks to produce an experience of total sound immersion and rejects as distracting the theatrical elements in music and sound-art. It's a self-consciously anti-Cagean attitude: when Cage started to

perform his electronic music in public in the early 1950s, he worried that the audience would have nothing to look at, so he made sure the equipment and the musicians' manipulations were in full view at all times. Lopez, on the contrary, wants to disappear and let sound stand on its own, without any visual supports. His work is based on the manipulation of ambient recordings. Justly famous are *La selva* (*The Jungle*), which he reprises abundantly tonight and consists in manipulated live recordings of jungle life: insects, birds, the brush of animals against underbrush, and a vast, dripping vegetable mass; *Azoic Zone*, modified takes of the spectral life in the underwater abysses; and *Buildings [New York]*, a sonic report on the secret life of houses that contains gurgling radiators, squeaking elevators, slamming doors and windows, secretive footsteps. At times these sounds are phrased rhythmically, other times they are prolonged and amplified, subjected to minute mutations in pitch and timber. One does not just hear the sound but ends up dwelling inside it, just like one loses oneself in a landscape, only this is an unmappable one without coordinates or landmarks. It is at once distant and near: the familiar white noise that envelops our lives returned to us in strange configurations—worlds within the world.

"Do you think sounds should be able to hear people?"—La Monte Young

NOTES

1 "Structural Film" was originally published in *Film Culture* 47 (Summer 1969); Sitney revised it in 1970, 1974, and 1979. While Sitney's is the epochal intervention, other important elucidations of structural film are Arthur 1978, 1979; LeGrice 1977, 105–52; Heath 1981; James 1989; and Wollen 1982.

2 See LeGrice 1977, 17–62.

3 The only allusions to the contemporary music avant-garde are Gidal's passing mention of "Reich and Riley" as representatives of "Structural music" (together with J. S. Bach) (Gidal 1978b, 8) and his comparison of the soundtrack of *La Région centrale* to Steve Reich's *Drumming* (variations on a basic pattern) and to Terry Riley's *Poppy Nogood* (nonmelodic layering and overlapping) (Gidal 1978c, 54).

4 Lee (2001) makes a similar point.

5 Rather than indeterminacy, Scott Macdonald reads sense in this detail (2001, 200–203).

6 On this group of musicians, often called minimalists, I have found useful Nyman (1999), Mertens (1983), and Strickland (2000, 119–253). On electronic music in general, see Holmes (2002) and on minimalism, jazz, and electronica with an am-

bient bias, see David Toop's extraordinary books (1995, 2004)—and listen to his music.

7 Sleeve notes to *New Sounds in Electronic Music: Richard Maxfield, Steve Reich, Pauline Oliveros*. 33 ½ rpm (Odyssey 1967).

8 Snow himself made this distinction (1978).

9 Snow reminisces about this in the documentary *On Snow's Wavelength: Zoom out* (dir. Teri When-Damish; First Run/Icarus Films, 2001).

10 The immediate antecedent for the U.S. flicker film is Kubelka's *Arnulf Rainer* (1960). As it was made before Kubelka became known to American filmmakers, direct influence seems unlikely, but the similarities between it and Conrad's *The Flicker* are considerable. *Arnulf Rainer* alternates black-and-white frames according to numeral ratios and has a soundtrack consisting of white noise and silence. I would have liked to discuss it more at length but was not able to screen it again while I was preparing this essay.

11 This makes minimalism sound like a descendent of surrealism; Michael Fried noted the connection in his influential (and questionable) assessment of what he called "literalist" art (1998, 171).

12 Paul Arthur has pointed out the persistence of structural strategies in the feature-length, narrative avant-garde of the 1970s and early 1980s (Jarmusch, Bette Gordon, Sheila McLaughlin, and Lizzie Borden) (Arthur 2005, 80–83).

13 I am referring to the fragments of Hildegard Westerkamp's *Beneath the Forest Floor* and Frances White's *Walk through the Resonant Landscape #2* used in the soundtrack of the film.

nation
memory
history

AN ESSAY ON *CALENDAR*

Atom Egoyan

The idea of nation is something which fascinates me. If we are to presume that a nation is the result of a collective projection, then it is clear that the idea of national territory is more of a psychological concept than it is a definition set by physical borders.

Nationhood, as a philosophy, has really found its clearest expression since the middle of the nineteenth century. It is no coincidence that the development of the idea of nationhood has paralleled the development of photographic reproduction. The power of images to intensify the identification of nation is clear, and the advent of mechanical processes that could graphically locate and situate national landmarks has had an overwhelming effect on the intensity of nationalism.

As a child growing up in a small city on the west coast of Canada, my clearest identification with my background was through such images. Photographic evidence of my early years in Egypt has become so entrenched in my brain that when people ask me if I remember Cairo, I find it impossible to differentiate these mechanical memories from any "real" recollections of my experience in that city.

My relationship to Armenia was even more abstract. Since my parents were also born in Egypt, any connection to Armenia was certainly not passed on to me by personal recollection. In fact, I can trace the origins of my first strong feelings of being Armenian to the moments when I saw pictures of Armenian art. I felt, or projected, a feeling of pride onto

Still from *Calendar* (1993).
Courtesy of Atom Egoyan

those achievements, wanting to identify my own creative instincts with these monuments. It became comforting to me to believe that I came from a people that could make such impressive testaments to their own imagination.

But who were these people? Who was this race that had endured such martyrdom? What did this nation have to do with present-day Armenia? What did it have to do with me?

When I met Arsinee in 1984, my relationship to my nationality took on another level. She was born in Beirut, but, unlike me, who had been raised in a completely foreign environment, she was brought up within the largest Armenian community in the diaspora. She had a clear idea of what it meant to be Armenian, based on a tangible and continuing experience with community values and traditions.

Her relationship to the actual territory of Armenia, however, was less clear. Her diasporan community had certainly taught her to dream of

Still from *Calendar* (1993).
Courtesy of Atom Egoyan

Still from *Calendar* (1993). Courtesy of Atom Egoyan

Still from *Calendar* (1993). Courtesy of Atom Egoyan

this historic homeland, and while her experience of Armenia was less "voyeuristic" than mine, it nevertheless remained an abstraction.

In conceiving *Calendar*, I wanted to find a story that would deal with these three levels of Armenian consciousness: nationalist, diasporan, and assimilationist. Thus, the guide, like Ashot Adamian, is an Armenian who was born and raised in Armenia. The translator, like Arsinee Khanjian, is an Armenian raised in a large Armenian community outside Armenia. And the photographer, like Atom Egoyan, is an Armenian completely assimilated into another culture.

The metaphor of separation in the film, as it is expressed by camera placement, sound, language, and physical separation of characters, is intended to emphasize the precarious nature of national identity. While the photographer is in the process of creating images that will be used to reenforce national identification (for Armenians project a tremendous love onto their churches), he is also witnessing, through his camera lens, the disintegration of his own relationship with his lover, and to their shared experience of being in their ancestral homeland.

What I find so fascinating about telling stories which involve the actual participation of recording devices (photography, film, video, etc.) is that the viewer is allowed to witness the actual impulses and decisions

made by the principal characters as they engage in a process that the director himself is also extremely involved in. In this way, the audience is allowed access to an extremely complex space: between the lens and the soul of a character. As viewers are watching projected images of a film, they can also see images of how the characters they are watching would project those around them, and what they project of themselves in the process.

In this way, the idea of a boundary, both as a physical and psychological phenomenon, becomes intermeshed. As the photographer loses himself into a memory of what happened in Armenia (as we see what is happening in his apartment), the distinction between mechanical memory (videotape) and remembered experience is blurred. In fact, the photographer is creating the border of an assimilated nation—or at least an assimilated state of mind—as his memory of Armenia is incorporated into his experience of being in his "host" environment, as he himself, ironically, is acting "host" to a variety of different women. To make matters even more complicated, the languages of the "guests" the photographer has invited represent countries that have "hosted" Armenian communities.

Taken outside of its source, national identity can become contrived and absurd. Yet what is the "source" of something so complex and profound? Is it limited to a physical dimension? Can it be defined by other means? These are questions that I'm still asking, and I'm excited that *Calendar* has helped me begin to answer them.

PHOTOGRAPHY'S ABSENT TIMES

Jean Ma

> But History is a memory fabricated according to
> positive formulas, a pure intellectual discourse which
> abolishes mythic time; and the Photograph
> is a certain but fugitive testimony.
> —Roland Barthes, *Camera Lucida*

Near the end of *A City of Sadness*, the acclaimed film by Hou Hsiao-hsien that placed Taiwan on the map of international art cinema in 1989, is a sequence too expressively understated to be properly termed a climax, yet containing a freeze frame that stands out as a pivotal moment in a story marked by rupture, separation, and loss. The freeze frame punctuates an act of image making in which the film's main character, a professional photographer named Wen-ching Lin, takes a family portrait with his wife Hiromi and their young child. The three are presented in a shot framed as if through the camera's viewfinder as they settle into a pose, and at the instant of exposure, the film "freezes" into a still image.

The scene enfolds a citation of photography with a reference to the materiality of the filmstrip, as the freeze frame recalls us to the individual photogram whose stillness is rendered invisible through the mechanism of projection. In its sudden arrest of movement, the device functions as a figure of death in multiple ways. To begin with, it conveys the demise of the main character, for Wen-ching's act of portraiture stems from his awareness that he is about to die, targeted for execution by the Chinese Nationalist regime. The photographic portrait marks Wen-ching's very last appearance in the film and anticipates his absence from the remainder of the story; its jarring disruption of temporal flow

intimates a death otherwise withheld from the viewer's gaze. In this regard, *A City of Sadness* participates in a tendency throughout the history of cinema that turns to the stilled image both as a harbinger of death and as a mechanism of narrative closure.[1]

The freeze frame's affinity with the sense of ending resides in the contrast between its deathly stasis and the lifelike motion that surrounds it, a contrast that has been noted by numerous theorists of the image. In *Camera Lucida*, for instance, Roland Barthes posits an essential distinction between the cinema's continuous, present-tense flow and the disjointed temporality of the photograph, which transports an immobilized fragment of the past into the indeterminate future of the beholder. The effect of the still image is spectral, infusing the visual evidence of a living subject with the paradoxical intimation that this subject is nonetheless already dead—entrapped in a moment ineluctably past, beyond, and "without future." Whoever the subject and regardless of whether the subject is alive at the moment of viewing, says Barthes, the meaning of every photograph devolves into the certainty of this future death. While the photograph is thus steeped in death and melancholy, by contrast the cinema presents an animated subject unencumbered by such mortal fixations. Cinema is, according to Barthes, "protensive, hence in no way melancholic. . . . It is, then, simply 'normal,' like life" (Barthes 1981, 78, 89).

Even as such comparisons usefully elucidate the differences between photography and cinema in both aesthetic and phenomenological terms, however, they nonetheless elide their commonality as technologies of temporal dislocation. Just as photography severs a momentary fragment of the past from the continuum of time in order to preserve it within a frozen image, so cinema displaces and reassembles durational segments of the past in its stream of images. Its depiction of life as flow in the present tense of viewing is always shadowed by the other time of inscription. As Mary Ann Doane observes, photography and cinema share an important similarity in that both "produce the sense of a present moment laden with historicity at the same time that they encourage a belief in our access to pure presence, instantaneity" (Doane 2002, 104). Thus, the difference between the two ought to be characterized not in terms of the aura of death versus the illusion of life but rather as a more subtle variation between what Garrett Stewart terms the "cadaverous" versus the "ghostly" (Stewart 1999, 37). If photography

offers its viewer a visual presence that is haunted by the absence of a future death, so too cinema's lifelike plenitude is haunted by a more literal absence—that of the image itself, constantly and intermittently disappearing from the screen as the film winds through the projector.

The persistent perception of both photography and cinema as haunted media can be further discerned in the striking degree to which figures of death and immortality have been invoked throughout the history of these media as a way of distinguishing their unique representational capacities. Early press accounts published shortly after the first Lumière screening at the Grand Café in Paris marvel that "it will be possible to see one's loved ones active long after they have passed away," that "when these cameras are made available to the public, when everyone can photograph their dear ones, no longer in a motionless form but in their movements, their activity, their familiar gestures, with words on their lips, death will have ceased to be absolute."[2] Here, the evocation of victory over time signals cinema's unparalleled power to mediate presence and absence, and to negotiate past and present. From one perspective, this power issues from the verisimilitude of the mechanized image—its degree of iconic resemblance to the reality it depicts, and its creation of, in the words of Alessia Ricciardi, "human referents whose mortality has been technologically suspended or annulled through the visual production of the perpetual simulacra of life" (Ricciardi 2003, 13). Even as the image serves to preserve and to certify a past reality, however, it simultaneously introduces an element of indeterminacy to reality by staging an uncanny encounter between distinct moments in time. As indices of an estranged past, photography and cinema account for a sense of ongoing crisis in our experience of time, mortality, and memory; they play a central role in the radical restructuring of lived temporality in the modern era.

The freeze frame that opens this discussion is only one of several references to photography scattered throughout *A City of Sadness*, all centering upon the main character Wen-ching. Wen-ching, played by the famed Hong Kong actor Tony Leung, is a deaf-mute as a result of a childhood accident, a trait that lays a particular emphasis upon his status as a maker of images and, moreover, heightens the viewer's consciousness of the various perceptual layers within filmic discourse. Certain scenes very deliberately identify the viewer's gaze with his through the mediating apparatus of the camera, while others highlight the

viewer's lack of aural identification with Wen-ching by calling attention to the conversations and sounds that he cannot hear, to the disconnection between the perspectives of character and audience. And throughout the film, Wen-ching communicates with others through written notes whose contents are conveyed by the dated device of the intertitle. As transcribed communiqués, these intertitles introduce into *A City of Sadness* another discursive layer, one located somewhere between a subjective reality framed by an individual point of view and a more objective reality hovering beyond the fictive diegetic universe.[3]

The film thus privileges Wen-ching with an exceptionally high degree of enunciative agency, such that his subjectivity comes to the fore as one of the principle motivating forces of the narrative and effectively mediates the viewer's knowledge of history, but the outcome of this strategy is fragmenting rather than suturing. In stark contrast to the absence of his voice, this character gives rise to a proliferation of technologies of recording, documentation, and transmission which both reconstruct a moment in history through a multiplicity of perspectives and reveal its reconstruction as ridden by lacunae, and limitations. In particular, Wen-ching's relationship to photography constitutes a rich meditation on image technology's framing of time, presence and absence, memory and amnesia. Together they establish photography's significance as, on the one hand, a mechanism of recording that produces a relic of personal memory and, on the other hand, a signifier of death and absence— that is, within the film's narrative logic, the subject of the photograph is always one who is no longer among the beholders of the photograph. Whether through the insertion of the photograph as a mise-en-scène object, or the restaging of the activity of picture making, or the freezing of the mobile image into an inanimate still, photography conveys an elusive time imbedded in the memories of characters and inflected by the theme of loss. In *A City of Sadness*, an intriguing tension obtains between the evidentiary drive to make this lost time available for the present and the image's unsettling resistance to the revivifying effects of remembrance.

Moreover, *A City of Sadness* develops this tension as a trope of mourning, raising the question of how to recognize and represent death with respect to the actual casualties of history. The film occupies a unique position as the first work to revisit a particularly violent and ideologically fraught moment in Taiwan's history. Set in the aftermath of World

War II, when Taiwan reverted to Chinese jurisdiction after fifty years under Japanese colonial rule, its story deals with the tensions between Taiwan's longtime inhabitants and the newly transplanted and extremely corrupt Chinese Nationalist regime. Ignited by a minor police-civilian altercation known as the February 28 Incident, these tensions exploded into an open conflict that threatened to escalate into a large-scale civil uprising.[4] In response, the Nationalists declared a state of emergency and initiated a brutal repression of the insurgency, a clandestine purge of Taiwanese leftists and intellectuals that continued through the next two decades. Wen-ching's character hails from this milieu; drawn into the native resistance through his association with a group of progressive intellectuals, his unaccounted for disappearance at the end of the story reflects the fate of numerous others during this period. Not until the late 1980s, with the revocation of a period of martial law that lasted nearly forty years, did these events receive any public acknowledgment. Thus, photography's notation of death is central to A City of Sadness's confrontation with the real casualties of history, its endeavor to represent an occluded past from the perspective of the victims of state violence and political terror. Frequently invoked as a signpost of the post–martial law democratic era, the film has figured prominently in the rewriting of history within Taiwan's counterpublic spaces.[5]

MEMORY AND MEDIUM

A City of Sadness establishes photography's link to absence and memory in an early scene where Wen-ching composes a portrait of a Japanese schoolteacher with several of his students. A shot of Wen-ching behind the camera and gesturing instructions at his clients precedes a reverse shot of his subjects gazing into the lens, frontally framed so as to duplicate the borders of the camera's viewfinder in the edges of the filmic image. The portrait shot therefore acquires an ambiguous status, signifying at once the photographer's perspective as he takes the picture and the objective, mechanical perspective of the camera. The scene numbers among many in the early part of the film depicting the consequences of the repatriation of Japanese nationals resident in Taiwan to their country of origin following the handover. Here, the portrait functions as a token of farewell for the group, taken on the eve of the instructor's departure. For these characters, photography serves to cap-

Still from *A City of Sadness*
(Hou Hsiao-hsien, 1989)

ture an image from a vanishing present and to preserve a visual record of relationships soon to be severed. In the face of imminent separation, it stages a confrontation between the persistence of the memory of individuals and the eroding tides of history as it dictates the movement of populations.

The absence anticipated by the photographic image here indexes a momentous historical shift, when the dawning of a "new era" demanded a peeling away of the old, a severing of bonds, and ultimately a renunciation of colonial culture. In the film's subsequent scenes, however, the actions of the new regime effectively deflate the progressive implications of change, and the absence indexed by the photograph becomes tinged by the brute finality of death. History leaves its mark upon the members of Wen-ching's family in a lethal fashion: of his three brothers, the oldest, named Wen-heung, dies a victim of cold-blooded homicide; another remains missing in action after many years on the battle front as one of many Taiwanese conscripted by the Japanese army to fight its war in the Philippines; and Wen-ching himself eventually falls prey to the Nationalist government for his involvement with the resistance. Death and photography are explicitly interwoven in the scene of Wen-heung's funeral after his murder by gangsters from Shanghai with whom the family has become entangled. The incident testifies to the lawless and chaotic climate of the transitional period, when local and mainland triads rushed in to fill the power vacuum created by the Japanese evacuation, unchecked by a Chinese regime preoccupied with the civil war and in some cases actively allied with the triads.

Still from *A City of Sadness*
(Hou Hsiao-hsien, 1989)

Wen-heung's funeral scene consists of two fixed tableau shots of the family standing in a row before the ceremonial pyre, with Wen-ching among them solemnly holding before him a picture of his dead brother. He displays the picture outward to the viewer, so that the composition of the shot presents the photograph as a stand-in for the missing member of the Lin family. It offers an image preserved from the grip of death and incorporated into a ritual of mourning. In this scene, the still photograph contains a presence that has been lost to the diegetic flow of the moving cinematic image, suggesting a link between photography and the memories of those who have gathered to honor Wen-heung's death. Thus the intersection of the two media is articulated through an opposition of presence and irremediable absence, a division between a past life and a present tense.

The impulse to memorialize fulfilled by photographic technology for these characters illustrates commonplace understandings of the photograph as a form of prosthetic memory, a souvenir. And as the ultimate stake in the conquest of time, death most clearly demarcates the medium's ability to store the past for future access and to render lifelike apparitions of the dearly departed. Thus the meaning of photography is constituted through the work of mourning and memory. Such notions find expression in Andre Bazin's well-known formulation of the "mummy complex," where he endows photography with an unparalleled capacity to preserve an image of life, and thus to rescue that likeness "from the flow of time, to stow it away neatly, so to speak, in the

hold of life." Hence the medium's power to halt the mortifying effects of time—in Bazin's analysis, the fidelity of photography's memory-image evokes a past time so powerfully as to defy the passage of time itself (Bazin 1967, 9). The ritual of the funeral points to the archaic origin of images in the cult of death, endowing the absent dead with a presence among the living and rendering unto their memory a visible form. As Bazin suggests in his reference to embalming, the photograph fulfills an age-old representational drive to deny death, to have the "last word in the argument with death by means of the form that endures" (10).[6]

A City of Sadness imbues the question of memory with a historiographic significance, given the film's critical concern with the imaging of death as a historical event, its addressing of a series of deaths foreclosed from public discourses of remembrance but preserved in a private sphere of experience. Indeed, one of the most heated points of debate in post–martial law Taiwan has been the number of casualties inflicted by the Nationalist regime, demonstrating the central role of death in the rewriting of national history in which the film participates.[7] According to Hou Hsiao-hsien, the initial inspiration for the film came from Taiwanese vernacular music, "namely love songs expressing the loneliness of a woman as she waits for a lover departed for the war" (Hou 1990, 8). The idea of a musical lament for lost love resonates with the film's attempt to imbue loss with a representational form and to locate historical knowledge in a private realm of affect and expression. *A City of Sadness*, the director points out, also draws heavily upon fiction of the era, informal records such as diaries and memoirs, as well as hundreds of interviews with survivors of the transitional period. In this regard, the production process mirrors the work of contemporary historians of Taiwan, who have relied to a large extent upon the collection of personal testimony and oral histories in the absence of official forms of documentation. The film develops this heterogeneity of sources as a collage of media of transmission—gossip, radio, diary, songs, postal letters and notes, and photography—that compels the viewer to reflect upon the various modes through which history is channeled.

Many commentators have interpreted the main character's inability to speak as a failure of witnessing and testimony. For example, Pinghui Liao maintains that the photographer "neither hears nor speaks, in order not to get into trouble," much as "the filmmaker can maintain an

ambivalence that allows him to at once say nothing or anything"—despite the fact that Wen-ching does take an unambiguous political position leading ultimately to his demise (Liao 1993, 293–94). Tonglin Lu echoes this analogy in her discussion of the film, arguing that because of the photographer's inability to express himself in spoken words, his "perspective is at best ambiguous, if not self-contradictory, [and] historical representation in the film is logically evasive" (Lu 2002, 105). In addition to committing the methodological fallacy of equating character behavior with narrative position, such readings overlook Wen-ching's agency as a photographer and the related question of how the past is articulated through the intersection of medium and memory. Photography's status as a technology of memory here must be understood with respect to the emergence of memory as an alternative form of history within this national context, capable of confronting history with its excluded remainders. Drawing out these connections, some have couched an analysis of the film's revisionist intervention within a definition of photography as a straightforward representation of memory. The still image, they argue, constitutes "a sign granting access to the past," and "an alternative mode of representation for history and memory" (Abe-Nornes and Yeh 1998).

Examined more closely, however, *A City of Sadness* demands a more nuanced articulation of the relationship of medium and memory, one that does not merely posit the image as a recuperation of the past for the present. Already imbedded in Bazin's discussion of photographic ontology is a paradox: cinema develops the embalmed time of the photograph as "change mummified," yet the very compulsion to represent time to which it caters stems from an apparent interest in overcoming temporality itself.[8] The aspiration to capture life in all its movement, it seems, emanates from a drive to put a stop to the march of time. This contradiction, which remains tacit within Bazin's analysis of the image, finds a clearer articulation in the writings of Barthes and Siegfried Kracauer, which gesture at a more complex dialectic between movement and stasis on the one hand, and medium and memory on the other. As a device that breaks down the polarity of cinematic flow and photographic immobility, the freeze frame offers a useful starting point from which to consider the issues they raise.

Stills from *A City of Sadness*
(Hou Hsiao-hsien, 1989)

MORBID MÉCANIQUE

The freeze frame that comes near the end of *A City of Sadness*, described above, both punctuates the act of picture taking and communicates the imminent demise of the film's main character. In one sense, the scene represents another act of memorialization, analogous to the funereal portrait of Wen-ching's brother in its rescuing of an image of a life on the verge of eradication, and a documentation of personal bonds that also registers a moral indictment of state violence. At the same time, however, the temporal displacements that transpire in this sequence also point to other figurations of death at the juncture of photography and cinema. With the click of exposure the shot freezes, its movement giving way to stasis like life to death, an allegory of the death of the photograph's subject. In the stark contrast between movement and ar-

rest introduced by the device of the freeze frame, the position of mortality shifts—instead of a death kept at bay outside the parameters of the picture, we find here the intimation of a death uncannily residing within the photograph itself, a death precipitated by its disruption of duration. Within the film's narrative logic, the photographic portrait does not deliver Wen-ching's image from the grip of death; rather, it serves as a death warrant.

The scene calls to mind a different set of conceptions concerning the preservative functions of photography and points to the medium's ambivalent position in relation to death. Barthes, for instance, has noted the duplicity of the photograph as "an image which produces Death while trying to preserve life" (Barthes 1981, 92). Like Bazin, he identifies an instinctive denial of death as the motor force in the creation of images of life. However, his response is to mourn rather than to celebrate the photograph, for this perceptual repression of the reality of death comes at the expense of the experiential boundaries of time. To inhabit the age of photography, Barthes writes, is "to be no longer able to conceive *duration*, affectively or symbolically" (93). Past, present, and future collapse into a "vertigo of time defeated"; the discrete tenses of "this will be" and "this has been" lose their differentiation within "an anterior future of which death is the stake" (96–97). In a society that has banished the knowledge of death, death finds a last refuge in the medium itself, undisturbed by assignations of meaning or symbolic value.[9] Rather than making the dead appear as if alive, then, the photograph delivers its subject to this certain death.[10]

In a similar vein, Siegfried Kracauer identifies a "sign of the *fear of death*" in mass media culture's proliferation of images aimed to "banish the recollection of death." Technology placates the fear of mortality by offering up a seemingly timeless, deathless image. However, the vexed temporality of the photograph renders this attempt to forget death futile: "In the illustrated magazines the world has become a photographable present, and the photographed present has been entirely eternalized. Seemingly ripped from the clutch of death, in reality it has succumbed to it all the more" (Kracauer 1995, 59). This representational profusion both denatures death and displaces mortality as a limit that endows lived time with meaning. As death's visibility withdraws into the horizon of an endless and eternalized present, it consequently makes itself

palpable as a ubiquitous temporal paralysis. If photography thus brings about an impasse wherein the attempt to preserve life can only produce more death, Kracauer eventually extends these views to cinema as well. As Miriam Hansen has noted, in his later writings film comes to stand for "the episteme of a postmodern, postmetaphysical, postanthropomorphic universe of death" (Hansen 1997, xvi).[11]

To deny time is to deny memory as well—as Kracauer specifies, what is banished is not merely the thought of death but its "recollection." Instead of positing photographic technology as a prosthesis capable of perfecting human memory in its indiscriminating accuracy, then, his analysis gestures at a more complicated interplay between the two. Photography is situated in direct opposition to what he calls the "memory-image," which is imbedded in affect, experience, and "the uncontrolled life of the drives," and its onslaught of images in mass media culture inflicts an assault on "the dams of memory" (51, 58). This formulation resonates with the antagonistic relationship of photography and memory posed by Barthes, who similarly insists that "not only is the Photograph never, in essence, a memory . . . but it actually blocks memory, quickly becomes a counter-memory" (91).

If the status of the image as a "sign granting access onto the past" is thus called into question, so must the notion of memory discourse accordingly be reconsidered. That is, the intersection of photography and cinema in *A City of Sadness* casts a critical light upon the recent emergence of memory as a dominant paradigm of historiography, even as it participates in this global discourse of memory. On the one hand, the film draws from the popular archive of memory as a corrective to the organized forgetting of official narratives of the past, exposing history as but a single, incomplete version of the truth by confronting it with its excluded remainders. Its revisionist stakes rely to a certain extent upon photography as an instrument of history writing, capable of filling in the disjunctures between popular and institutional memory. On the other hand, even as *A City of Sadness* works toward the recuperation of a disavowed past through the channels of memory, it simultaneously calls attention to memory's own discursivity, its mediation and embodiment by particular technologies like film and photography. Given the danger of establishing yet another regime of authenticity as an alternative to the verities of official history—an authenticity naturalized by the truth

of experience and subjectivity—the film demonstrates an awareness of the limitations of a revisionism that interrogates the truth claims of history merely to replace them with the self-evidence of memory.

For Kracauer, the value of photography lies precisely in its difference from memory—a difference that dissolves the "transparency of history" by juxtaposing the remembered and the forgotten, by confronting consciousness with "the reflection of a reality that has slipped away from it" (61–62).[12] The photograph's inscription of death as a resistance to memory offers important insights into *A City of Sadness* as a work that attempts to give death its proper due. The film centers upon a violent past that consists not of positive signs but rather of missing bodies, the casualties of the Nationalist campaign of political persecution. Insofar as the film's historical intervention is premised upon a belated reckoning with deaths foreclosed from a national narrative of history, its work of revision is at the same time a work of mourning. Here, mourning serves as an allegory for the salvaging of a narrative from a trail of dead whose traces persist in the memories of those they leave behind. If psychoanalysis defines mourning as an individual process of reconciling life with death by ascribing to loss a significance rooted in private remembrance, then *A City of Sadness* explores the possibilities of collective mourning, of ascribing a broader social meaning to individual losses. The question that emerges from the task of shifting the event of death from private memory to public record, and of framing an individual experience of loss as a common history, is centered upon intersecting itineraries of mourning. Grief, as a response to death, becomes a point of entry into history, a means of affectively inhabiting a memory that doesn't belong to the self and of sensing one's belonging to a violent history.

The temporal impasse that Kracauer identifies with photography—a denial of death that simultaneously brings about the death of time itself—strongly evokes a deviation from mourning as a normative response to mortal loss. According to Freud, the process of mourning hinges upon an acceptance of loss that "impels the ego to give up the object by declaring the object to be dead and offering the ego the inducement of continuing to live."[13] By contrast, the melancholic responds to the death of the object by refusing such consolation. Rather than renounce the love object, the ego preserves it by incorporating it. Thus it "banishes the recollection of death," to recall Kracauer's words, and

finds itself unable to move forward in the present. In *Theory of Film*, Kracauer makes explicit what is only suggested in his discussion of photography by drawing a connection between the languorous attitude of the melancholic, "likely to lose himself in the incidental configurations of his environment, absorbing them with a disinterested intensity no longer determined by his previous preferences," and the unselective receptivity of the emulsion plate and the alienating gaze of the camera lens (Kracauer 1997, 17).[14] Kracauer illustrates this melancholy vision by citing a passage from *The Guermantes Way*, in which Proust describes an unexpected encounter with his grandmother: "I who had never seen her save in my own soul, always in the same place in the past, through the transparent sheets of contiguous, overlapping memories, suddenly in our drawing room which formed part of a new world, that of time, saw, sitting on the sofa, beneath the lamp, red-faced, heavy and common, sick, lost in thought, following the lines of a book with eyes that seemed hardly sane, a dejected old woman whom I did not know." And at this moment, for the narrator, "the process that mechanically occurred in my eyes when I caught sight of my grandmother was indeed a photograph."[15]

Kracauer's understanding of melancholy transforms what Freud views as a dangerous loss of interest in the world into a more positive condition of "self-estrangement," a perceptual attitude unclouded by "memories that would captivate them and thus limit their vision" (15). By bringing into view that which lies beyond memory, photography predicates a different relationship of past and present, one characterized by discontinuity and alienation. As the notion of mechanical melancholy suggests, Kracauer views the confrontation with mortality as central to this estranging effect, and specifically allies the excess of photographic vision with the stubbornly intrusive quality of this intrinsic deathliness.[16] This fixation on death resonates especially strongly with *A City of Sadness* as a film that treats absence as a sign of history; given that this history consists of a series of denials of loss, the film responds to the negation of death as an event by recourse to a melancholic refusal to forget. For the violence of the Incident of February 28 encompasses a series of erasures that transcend the infliction of bodily injury, instanced by the ambiguous absence of the disappeared, when death cannot be attached to a body; the erasure of identity when death is relegated to anonymity; the distorted significance of the death justified by a

false charge. As examples of how the state renders the personal tragedy of unnatural death undecipherable in terms of social meaning—and thus all the more effective as a political weapon—these negations can be considered alongside the modes of producing death specific to the twentieth century which have introduced a sense of crisis to the intellection of death as a historical event and placed its very representability into doubt. *A City of Sadness* expresses this doubt as a suspicion of national narratives of the past that privilege particular losses as universally meaningful, while relegating others to the oblivion of amnesia.

MELANCHOLY HISTORY

The melancholic ambivalence between fixating on and moving beyond the past is figured in the tension between paralysis and movement imbedded in the freeze frame. While the term itself somewhat misleadingly invokes the image of a single photogram stalled in the projector, in actuality the freeze frame consists of a repeated series of an identical frame. This repetition severs movement from time, such that movement no longer serves to index the passage of time within the image. And yet, as Stewart maintains, "what rushes in to fill the vacuum of motor stimuli in the freeze frame is nothing less than . . . our time." The still image presents to the viewer a sort of sheer time—what he calls a "pure durative, bred of repetition, amputated from all change" (139, 143). Thus, if the freeze frame reveals stasis to be the basis of the cinematic illusion of motion, it also deconstructs the very idea of stasis as an absence of flow.

The transition from the freeze frame portrait of Wen-ching, Hiromi, and their child back into cinematic representation further elaborates this dialectic of stillness and duration. As the still shot lingers on the screen, Hiromi's voice-over relays the contents of a letter she has written to Wen-ching's family, enclosing the photograph, to inform them of his arrest. The voiceover continues as a sound bridge to the next shot, which depicts Wen-ching's niece Ah-shue as she reads Hiromi's letter:

> Ah-shue, Wen-ching has been arrested. We still don't know where he is. We thought of running away but there was nowhere to go. I'm writing so long afterwards because only now do I feel calmer. This photo was taken three days before Wen-ching's arrest. When they came, he was taking

Still from *A City of Sadness*
(Hou Hsiao-hsien, 1989)

someone's portrait. He insisted on finishing the job before they led him away.

This series of images elliptically joins together three moments in time—identified respectively with the acts of photographing, writing, and reading—through a counterpoint of sound and image. Hiromi's words mark a shift of perspective away from Wen-ching's point of view, identified with the viewfinder of the camera, to one centered upon her own act of writing. They also signal a shift from photography back to film, a shift that can be identified with the switch from the present tense of Wen-ching's act of photography to the past tense of Hiromi's narration. The shifting and collapsing of tenses across this scene complicates the freeze frame's relation to time and gives form to its invisible duration. Finally, the perspective of Ah-shue as the recipient of the letter is introduced in the last shot. Her appearance in turn relegates Hiromi's voice to the past tense by signaling a new present tense in which the act of reading, and of regarding the photograph, takes place.

In this sequence, cinema and photography converge to produce a melancholy vision of death, a vision characterized not only by a quality of inconsolable grief but also by a "vertigo" of time. Wen-ching's death as figured in the freeze frame is at once imminent and already transpired. Just as technology's excess to memory induces a paralysis of time, so melancholy tropes a present held captive to the past. Within the film's historical project, the freeze frame as a figure of unmourned loss presents a pointed critique of the symbolization of death within official

narratives of the nation, and of the nation's appropriation of loss as a mechanism for producing its subjects. This critical dimension can be discerned by comparison to a more well-known icon of loss, the Tomb of the Unknown Soldier, which opens Benedict Anderson's study of nationalism. As a monument to death that transforms an individual loss into an event intelligible on a national scale, the Tomb of the Unknown Soldier illustrates how the channeling of individual grief into a collective scene of mourning endows the dead with a presence among the living, with the power to organize and mediate relations in the present. The very anonymity of the subject of commemoration here, according to Anderson, renders possible "the insertion of private memory and grief" into a social narrative of loss (Anderson 1998, 56). The eventfulness of death effectively joins together private and public realms of experience into an integral identity.

Particularly striking in Anderson's discussion is the importance he attributes to the dead in the formation of national identities that derive legitimacy from their assumption of an unlived but inherited past, and from their affiliation with an unknown but imagined community. He emphasizes the strategies by which nationalism's imagined community embraces the dead as well as the living. The forging of "links between the dead and the yet unborn" into a chain of descent enables the claiming of a past unattached to actual memory or experience as a narrative of selfhood, and the habitation of what he calls the empty, homogeneous time of the nation. Out of rupture and discontinuity, the nation produces an experience of time as continuity that underpins the positioning of the modern subject within a collective past. Thus the Tomb's abstraction of the individual death into an empty and universalized placeholder for national identity brings about a "transformation of fatality into continuity, contingency into meaning" that joins together past and present in a socially meaningful way by filling in the void rendered by death with a value that transcends the individual (Anderson 1991, 11).[17] It is in this sense, Anderson notes, that narratives of the nation often presume to speak *for* the dead while appearing to commune *with* the dead.[18]

The ascription of a social narrative to death by the act of public mourning renders its absence present as an event, not unlike private acts of mourning that reckon with death by ascribing to it a significance rooted in subjective experience. The consolatory effects of narrative therefore issue from a codification that simultaneously functions

as an erasure of death, a conferral of meaning that abstracts from the singularity of loss. As Catherine Russell puts it, "If the threat of death is a threat of disappearance, loss, and absence, the disavowal of death is a confirmation of presence, mastery, and meaning" (Russell 1995, 7). Every act of memorialization, then, entails an element of forgetting, a negotiation of grief aimed ultimately at the substitution of the lost object by a new one. Concomitantly, Anderson singles out the necessity of "having forgotten" certain truths as a crucial component of the narrative production of national identity: "All profound changes in consciousness, by their very nature, bring with them characteristic amnesias. Out of such oblivions, in specific historical circumstances, spring narratives. . . . Out of this estrangement comes a conception of personhood, *identity*" (Anderson 1991, 204).[19]

By contrast, even as *A City of Sadness* attempts to recuperate death as a historical event, it simultaneously delivers it from the homogenizing purview of narratives of the nation. In the countermemory embodied by the photograph, death is not "remembered" simply to be reforgotten in a tale of mourning intended to lay to rest the ghosts of history. Rather, the film resists the redemption of individual death within a national story, instead signaling the possibility that death and loss can overrun the narrative container of history and disrupt, rather than ratify, the order of the present. Anderson's analysis furthermore serves as a reminder of how memory's challenge to history can amount to but a temporary detour that finally returns us to more conventional forms of historical fiction suturing personal destiny to a social totality and thereby constructing a shared past as a basis for group identity. However, the freeze frame in *A City of Sadness* establishes a different kind of boundary between the psychic and the social and concomitantly gestures at alternative conceptions of social identity and community. The intersection of cinema and photography contained within the device at once disarticulates the opposition between still and moving, past and present, established earlier in the film, and highlights the power of technological media to denature memory itself and to disorganize its relationship to history.[20]

Stewart has defined the freeze frame as a "desubjectified memory" because the image is coded in the past tense but not attributed to any single character, standing apart from the fictional world of the diegesis (18). The device as it is deployed here, however, works somewhat dif-

ferently. If Wen-ching's final image becomes a vanishing point through which the viewer experiences the loss of this character, this vanishing itself is reembodied through a multiplied set of memories. The photographic portrait thus creates a space of shared remembrance in which several character subjectivities collide and intersect with one another, without fusing together their particular perspectives within a single omniscient narrative perspective. Here, memory and history converge at a site of both continuity and breakage, overlapping with one another without coalescing into a singular reality. By thus driving a wedge between memory and history, the melancholy of photography contradicts the idea of history as collective origin, which presumes that individuals are simply completed by the historical narratives available to them as part of their social identity. In this sense, the freeze frame highlights an unreconciled tension between stasis and temporality, remembrance and disavowal, individual and collective memory, and ultimately between the plural coextensive subjectivities of those who share memories and the pluralized subject of memory posited by national history as a particular form of collective memory.

NOTES

1 For a discussion of examples ranging from *Butch Cassidy and the Sundance Kid* (George Roy Hill, 1969) to *Thelma and Louise* (Ridley Scott, 1991), see Stewart 1999, chap. 1 ("Photo-gravure"). Also see Bellour, "Concerning 'the Photographic,'" in this volume.

2 *Le Radical* and *La Poste*, December 30, 1895, cited in Burch 1990, 20–21. Doane discusses early cinema's fascination with death, exemplified in the execution film, in chapter 5 of *Cinematic Time* ("Dead Time, or the Concept of the Event").

3 Antoine de Baecque draws a connection between Hou Hsiao-hsien's use of the intertitle and the dream of a universal language invested in cinema of the silent era. "All that Wen-ching writes on paper," he argues, "becomes the intertitle of a silent film. It is in this sense that the character 'speaks cinema,' transforming the 'absence' of the word into the 'surplus' of self-referentiality." See de Baecque 1990, 26 (my translation).

4 The altercation involved an unarmed black market tobacco vendor and Nationalist police officers and resulted in the shooting of an innocent bystander in a crowd of onlookers protesting the officers' beating of the vendor. On the February 28 Incident and its significance in Taiwan's history, see Lai, Myers, and Wei 1991.

5 For discussions that relate *A City of Sadness* to local struggles to define history, see Li 1993 and Liao 1993.

6 Hans Belting's discussion of the role of the image in the cult of death usefully situ-
ates Bazin's argument within a broader history; as he points out, "of the conditions
that contributed to the introduction of physical images into human use, the cult
of the dead ranks as one of the oldest and most significant" (Belting 2005, 307).

7 The figure most commonly circulated is 10,000, versus an official count of 6,300
and estimates that run into the tens of thousands.

8 For a reading of Bazin that takes up this paradox, see Rosen 2001, chap. 1 ("Subject,
Ontology, and Historicity in Bazin").

9 Or as Barthes puts it, "Photography may correspond to the intrusion, in our mod-
ern society, of an asymbolic Death, outside of religion, outside of ritual, a kind of
abrupt dive into literal Death" (92).

10 These meditations are prompted by a photograph of Lewis Payne, about to be
executed for his attempted assassination of Secretary of State W. H. Seward, but
Barthes quickly extends their implications to all "historical" photographs, includ-
ing a picture of two anonymous little girls in a village. His analysis of the Payne
image presents an interesting contrast to his discussion of another photo in *Empire
of Signs*, taken on September 13, 1912, of the Japanese general Nogi and his wife
shortly before the couple's ritual suicide. Here, he marvels at the absence of Death
within the image, at the viewer's inability to intuit the act that is on the minds
of the couple by gazing at their carefully composed expressions (Barthes 1982a,
94).

11 The theory of the double set forth by Freud in his essay "The Uncanny" also relates
to the photograph as a double of reality. He writes, "For the 'double' was originally
an insurance against the destruction of the ego, an 'energetic denial of the power of
death,' as Rank says; and probably the 'immortal' soul was the first 'double' of the
body. . . . The same desire led the Ancient Egyptians to develop the art of making
images of the dead in lasting materials." As in photography, however, "the 'double'
reverses its aspect. From having been an assurance of immortality, it becomes the
uncanny harbinger of death." Freud 1953–74, vol. 17, "The Uncanny" (1919), 235.

12 For a full discussion of the temporality and historical stakes of photography elabo-
rated by Kracauer both in the "Photography" essay and in *Theory of Film*, see Han-
sen's introduction to the latter.

13 Freud 1953–74, vol. 14, "Mourning and Melancholia" (1917), 257.

14 Notably, it was this very fascination with the "role of melancholy in photographic
vision" that troubled Rudolph Arnheim in his review of Kracauer's book. Entitled
"Melancholy Unshaped," it criticizes Kracauer from the perspective that "a concern
with unshaped matter is a melancholy surrender rather than the recovery of man's
grip on reality. Perhaps, then, we are witnessing the last twitches of an exhausted
civilization, whose rarefied concepts no longer reach the world of the senses." Arn-
heim 1963, 297.

15 Cited in Kracauer 1997, 14. See also Hansen 1997, xxv for a discussion of this pas-
sage in *Theory of Film*. In a different fashion, melancholy frames Barthes's discus-
sion of photography, which is interwoven with a reflection on the recent death of
his mother; his unsuccessful quest for the *eidos* of photography centers upon an

absent image, a picture of his mother as a young child, the Winter Garden photo, withheld by Barthes as a testimony to his inconsolable grief.

16 As Hansen notes, the photograph not only signifies a general deathliness but also confronts the viewer with her own nonexistence, by triggering "a momentary encounter with mortality, an awareness of a history that does not include us" (xxvi).

17 Given that the Tomb of the Unknown Soldier represents a generic type of monument, its relevance to revisionary modes of remembrance can be considered alongside contemporary examples such as the Vietnam Veterans Memorial, the AIDS Memorial Quilt, the Holocaust Museum, the "Monumento a las victimas del terrorismo de Estado," and others where monumentality itself is brought into a transformative collision with popular culture, mass media, reproductive technologies, and experiential practices such as reenactment. See Sturken 1997; Huyssen 2003; and Landsberg 2004.

18 See his discussion of Michelet, *Imagined Communities*, 198. Anderson's comments on death can be compared to Jacques Derrida's discussion of death and culture in *Aporias*. Here he writes, "culture itself, culture in general, is essentially, before anything, even a priori, the culture of death. Consequently, then, it is a *history of death*. There is no culture without a cult of ancestors, a ritualization of mourning and sacrifice, institutional places and modes of burial" (Derrida 1993, 43). While Anderson describes the production of a bond of commonality through death, however, Derrida elaborates upon the role of death in the relation to the foreigner, the other. On the national symbolism of death and absence, also see Redfield 2003.

19 Notably, these phrases circumscribe the single reference that Anderson makes to photography in *Imagined Communities*; the remainder of the passage emphasizes the photograph's estranging excess to memory and understanding: "How strange it is to need another's help to learn that this naked baby in the yellowed photograph, sprawled happily on rug or cot, is you. The photograph, fine child of the age of mechanical reproduction, is only the most peremptory of a huge modern accumulation of documentary evidence which simultaneously records a certain apparent continuity and emphasizes its loss from memory. Out of this estrangement comes a conception of personhood, *identity* (yes, you and that naked baby are identical) which, because it can not be 'remembered,' must be narrated."

20 Landsberg argues that while in the past memory served to anchor history within an authentic realm of experience, it is now the case that individuals apprehend history itself as "prosthetic memory"—that is, as "a more personal, deeply felt memory of a past event through which he or she did not live" (2004, 2).

THE IDEA OF STILL

Rebecca Baron, interviewed by *Janet Sarbanes*

The filmmaker Rebecca Baron is known for her award-winning lyrical essay films, which use found footage and still photography to explore history, memory, and the space in between. Her first film to focus on still photography, *The Idea of North* (1995), reconstructs the history of the 1897 Andrée expedition, a failed Arctic exploration, through photographic images recovered thirty-three years later from under the ice—along with the bodies of the explorers and their diaries. Her film *okay bye-bye* (1998) reflects on the Vietnam War, U.S. involvement in Cambodia, and Baron's own experience of living in Southern California. A combination of historical research, media analysis, epistolary narrative, and personal meditation, it takes shape around Super-8 footage of an unidentified Cambodian man—footage Baron found on a Southern California sidewalk—as well as iconic and vernacular photographs from the Vietnam era. Both films use still photography as a springboard for what Baron calls "private research," an associative process that combines official and personal accounts of events, refusing a totalizing historical narrative and emphasizing the role of chance in human experience.

In some ways, Baron's film, *How Little We Know of Our Neighbours* (2004) constitutes a departure from her earlier work. Her focus in the new film shifts away from the receiving onto the taking of images, and her own research is no longer a driving narrative force. And yet, her

presentation of history remains elliptical and open-ended, carefully weaving a narrative of the Mass Observation Project—an eccentric social science enterprise founded in 1930s England that used surreptitious photography to record and scrutinize people's behavior in public—into a larger meditation on the multiple roles cameras have played and continue to play in public space. Refusing either to condemn surveillance or embrace it, Baron forces us to acknowledge both the power and the pleasure of looking.

J: We're here to discuss the "idea of still" in your work, which is to say, the way you use still photography to foreground questions of history, memory, knowledge, and narrative in your films. But still photography is also key to your filmmaking process—so maybe we should start there. How do you choose the central images, and how does the film take shape around them? At what point do you come to the still photos?

R: Often, the still images are ones I come across accidentally. Something about them first suggests further investigation and depending on what I find, may or may not set a film in motion. Frequently at issue is the dual role of the photograph as an aesthetic and informational or evidentiary object.

In the case of the film that is most focused on a particular set of still images, *The Idea of North*, I hadn't planned to make a film about those particular images at all. I stumbled upon them in a book on Scandinavian photography when I was doing research for a different project that *The Idea of North* then replaced. The photographs were so arresting that I abandoned what I had been doing in order to work with them. (The abandoned project was to be in part about Glenn Gould, and though it was never made, I titled *The Idea of North* after his audio documentary of the same name.)

I started to think about how this fragile and fragmentary evidence was all that was left to reconstruct an event with no surviving witnesses. The images' survival was extraordinary and the pictures provided a kind of mute testimony to the event. Then I started researching the story of this ill-fated polar balloon expedition and the film took on a kind of forensic aspect.

I came across the images a second time, reproduced in a book about the Andrée expedition. Here the photographs had been touched up, with details painted in that were not at all visible in the images I had

first seen. I started thinking about photographic evidence and what we consider to be an adequate representation of reality. The images had different registers of truth—the first set looked more degraded, which made it seem closer to the experience depicted; the second set contained more information.

In that film, I was also interested in what film could offer history in excess of language, so *The Idea of North* is also about what images and sounds provide that language is too impoverished to convey. Ironically, the diaries left behind by the Andrée expedition were even more degraded than the images. The printed page appears literally as fragments since the words had faded away. The missing and illegible parts for me held as much pathos as the photographs.

J: You use diaries and letters in those first two films and then diaries appear again in your latest film. Those are forms of text or writing that could be associated with the snapshot—they're also forms of narrative that contain uncertainty, because the diarist or the correspondent doesn't know how things will turn out. Is there for you a parallel with the snapshot and the diary?

R: I think there is a parallel between the snapshot and the diary because they belong to the private/vernacular world. I'm often drawn to snapshots that are damaged or "badly" taken because there is something unstable about them and that registers a kind of warmth or even excess. Maybe because it says to me that what's happening in front of the camera is so much more compelling than what falls within the frame. It's somewhat analogous to the private or casual writing that happens in a diary or letter.

J: There's that great scene in *okay bye-bye* where you go to the Cambodian community in Southern California and try to make some connection between that world and all of the images you've been looking at, and the history of what went on in Cambodia and Vietnam. You have an interaction in the restaurant with a waiter who is transfixed by your Astro Boy coin purse, which immediately transports him back to his childhood in Vietnam. The whole situation makes you very uncomfortable and you want to give the purse to him but you're ashamed to because it's grimy and used. The image there is working on so many levels—we don't have access to what he's remembering, we only have access to the image that's causing him to remember.

Stills from *The Idea of North* (1995).
Courtesy of Rebecca Baron.

R: That scene is also about vernacular history versus official history, vernacular imagery versus official imagery. Maybe the vernacular is the link to memory, because of that sense of intimacy. Sometimes those images support the official history but sometimes they contradict it.

okay bye-bye also includes sequences that challenge the way we look at the most familiar images. I ask the viewer to look anew at Nick Ut's image of children fleeing a napalm attack. The image is repeated; it is held for varying amounts of time; details not central to the image's composition are shown in close-up. In that image, we focus on Kim Phuc, the little girl in the center of the frame and forget that there are many other figures in the image. Just recently I saw Sam Green's film *The Weather Underground*, which includes moving images of the same event. The footage is in color and of course, the people are in motion. It just shatters the symbolic status of that image.

The artist Jon Haddock has returned repeatedly to that image. In one piece he shows the photograph with all of the people removed and while the image looks eerily familiar, it's very hard to identify. He did the same thing with John Filo's famous photograph of a woman kneeling over a student's body at Kent State. Again, the figures are removed. He also has recreated the napalm attack scene as a digital image that looks like it comes from a computer game. In this case, the angle of view has changed.

J: Getting back to the issue of looking at still photography in a time-based medium, that piece of Super 8 you pick up off the sidewalk in *okay bye-bye*—the shot of the man in a hut in Cambodia—at first you show it to us as stills, right?

R: The first time the footage is shown frame by frame through a loupe held up to the light. It is then presented as a series of full screen freeze frames. When I found the footage, I didn't have a Super-8 projector and I held on to it for a long time before I actually saw it in motion. I could only look at it through a magnifying glass as a series of tiny still images. That was sort of a revelation—it's a very balletic image, the way the camera moves with his motion—and it comes alive! It was really astounding because it's such a graceful shot and I didn't expect that at all. You can't tell from looking at those tiny Super-8 frames.

Still from *okay bye-bye* (1998).
Courtesy of Rebecca Baron.

J: It is really beautiful. So much of what you're doing in that film seems to be about forcing the viewer to dwell on the vernacular image—slowing it down, freezing it, speeding it up, changing the color.

R: The different treatment of that footage also had to do with how it is positioned in the film in relation to official images.

J: Let's talk a little about your relationship to documentary. In *okay bye-bye*, you give us a short exposition about the history of Cambodia and U.S. interests there. "For a while," you add, "I thought I would do a documentary about [that]," but then you say, "I'll never make that film." Why won't you ever make that film?

R: Since I was a kid, I've had trouble with determining "the main idea." I always go for details, digressions, tangents, the edges of the frame. When it comes to documentary, the moment I start to tell the tale, I can't bear what I'm leaving out. I think I have a particular relationship to documentary, having a background working as an editor for Pennebaker. Direct cinema is highly constructed to mask its construction—to give the viewer a sense of being there and of real time. In some ways my work responds to that experience. Of course, as an editor, I would see all of the footage and then have to pare it down to this fraction of the whole. I was always so interested in what was being left out. Given that experience, coupled with my interest in history, it's kind of funny that I make documentaries at all. And because of that, at some level my films are always about the form itself.

But, as I often ask my students, given the limitations of the form, what can you say? I'm coming to terms with that myself. What I find so

maddening is the kind of historical documentary shown on television.
Those documentaries are so neatly packaged that they give the impression of being comprehensive. I feel that it is my obligation is to remind viewers that they're only seeing a tiny part of the story. Again, it doesn't mean you can't learn anything from documentary, but the danger lies in creating a totalizing account. This is illustrated so eloquently in Claude Lanzmann's *Shoah*. The film is nine hours long and after that nine hours you're left thinking—right, and this could be another nine hours and another nine hours. The film is very specific in what it covers and makes no claim to cover everything. In that way, it approaches not only the magnitude and complexity of the Holocaust, but the magnitude and complexity of history.

And certainly, the history of the Vietnam War demands so much more than any single film could say. Partly why I work so slowly is my unwillingness to simplify the relationships between things, even as a lay researcher.

J: Yes, research is a central trope in your films, but you also make it a central problematic. So it's not just that you're questioning your own research—you're questioning the very notion of research by presenting a deliberately amateur inquiry. In *okay bye-bye*, you explicitly critique yourself. You say, "A random scrap of film sets off my research—I have no methodology." Is that failure of methodology key to your films?

R: (laughs) Yes! For me the process is associative. I think of it as a billiard game with the ideas banking off the sidewalls, leading to unexpected trajectories. It's an inefficient way to work but it allows for unexpected elements to find their way into the piece. I think it's largely responsible for my films being what they are.

J: I actually want to say I think you do have an agenda! It has to do with your fascination with the image, which is why still photography is so central to your films—it allows you to hold the image as an object in your hand to puzzle over. In a world where images have come to function almost entirely in the service of information, your work recovers their power to ask questions, rather than give answers.

R: Yes, I think if you're just reading images for information, you lose pleasure and criticality at the same time. For me, it's both about enjoying images and noticing their limitations or boundaries.

J: Okay, so on the one hand, your films ponder the historicity of still photos, the iconic role they take on in a culture. But photography also conveys proof, documentation, a direct relationship to the referent. How do your films deal with that aspect of still photography?

R: I often repeat a still image over the course of a film and, at the most basic level, this recontextualizes it simply by what shots surround it and what has happened in the film between its appearances. In *How Little We Know of Our Neighbours*, Edward Linley Sambourne's photograph of the family maid asleep in her bed appears as a somewhat mysterious image near the beginning of the film. When it appears again in the middle, its meaning is informed by the preceding discussion of surreptitious photography. In *okay bye-bye*, there are several recurrences of the photographs of prisoners from Tuol Sleng, the political prison run by the Khmer Rouge. The narrator encounters them as thumbnail images on the Web, in a fine art museum, and in a coffee table book. The image quality and contexts are very different each time and produce very different affects as well as meaning. There is an implicit question in this: given that each photograph is a record of the unique instant a person passed in front of the lens, when that image is experienced differently in different contexts, what does it say about the reliability of the photograph to stand in for the real?

In the digital realm, there need not be a referent in the world at all to create an image. Still, when we take in images on a daily basis we tend to trust what we see. I don't instantly question the image on the front page of the paper every morning. My questions about the fidelity of the image may be out of date—we know how easy it is to "falsify" a photograph, but I'm just not ready to accept that it doesn't matter.

J: You've made a transition in your filmmaking from working in 16mm to digital video—do you ascribe greater referentiality to film than to video?

R: That's interesting, I've never thought about it, but in a personal way, yes. I don't know if this is what you're getting at, but with film, since I have to be more economical about shooting, *my* relationship to the referent feels almost sacred. Film shoots are more memorable—not in a sentimental way, but I literally remember them better—where I was standing, the weather conditions, what else was happening around me, etc. But somehow in video, probably because I shoot so much more, I don't have that same relationship to the thing itself, to the event.

Surveillance imagery, which my new film deals with, is an extreme manifestation of this—the surveillance camera is on perpetually, and that changes the weight of the image. The very first shot in *How Little We Know of Our Neighbours* is produced by a camera obscura, and it's doing the same thing as a surveillance camera—it's an image viewed remotely with a live feed. So even though it's a pre-photographic apparatus, it very closely resembles contemporary surveillance's perpetual flow.

J: There's no gap between the image and the event there—which one could say is characteristic of our time. Things are filmed AND seen as they're happening—the media is embedded with the army. What happens when images are streaming like that?

R: They're constantly disappearing. I've been thinking about the Abu Ghraib scandal, and how there was a hierarchy of different forms of media. There were written accounts of what was going on in that prison long before the images were circulated. And as Hillary Clinton pointed out in the hearings, the written accounts were more disturbing than the images. But it was the imagery that defined the event as a scandal. And when the Department of Defense announced that there was video of what happened, it was as if the medium had determined the seriousness of the incidents rather than the content of the images. I'm struck also by the fact that a disproportionate number of female soldiers are now being charged with the abuse because they appear in the photographs and are obvious participants. But anyone behind the camera is better protected from prosecution. Those images would read very differently if a male soldier appeared giving the thumbs up or holding the leash that was placed around a detainee's neck.

Prisons in this country are full of surveillance cameras—what if there had been surveillance cameras in Abu Ghraib? Would that have changed anything?

J: That's interesting, because there was a huge debate when President Bush said his gift to the new, free Iraq would be an American-style maximum-security prison in place of Abu Ghraib. Some architects and prison designers did argue that if Abu Ghraib had been more of a panopticon—if there had been more surveillance—then these things wouldn't have happened.

R: Rumsfeld kept exclaiming, "Everyone's running around with digital

cameras!" a situation he used the word *unbelievable* over and over again to describe. But of course the images were the only thing that made the events believable because the written accounts were disregarded.

J: And in fact, the first disciplinary measure that the Army took was to take away digital cameras from all the enlisted men—that was the solution, to take away the technology. In *How Little We Know of Our Neighbours* you track the way that technology fell into the hands of regular people. It makes a difference *who* is watching. It's the same thing with the Rodney King video.

R: The question is what role ordinary people will play when surveillance technology is now so widely available to them. There was a proposal shortly after September 11 to hire private citizens as surveillance monitors. They were to be paid on an hourly basis to work from home and monitor areas over the Internet and report on any unusual activity. Remember Operations TIPS (Terrorism Information and Prevention System) proposed by the Department of Homeland Security? Workers such as postal carriers were to report on suspicious activities. The proposal was withdrawn after being denounced by the ACLU and other groups. Technology that could be used for surveillance is so widely available to ordinary citizens. The question is, how will we use it? The same was true with photography. From the beginning the question was asked, well, what is it for?

J: The Mass Observation Project whose history you trace in *How Little We Know of Our Neighbours* didn't start out as a surveillance project—there was a kind of wonder to the early images and information gathering. When did that information gathering devolve into a project of mastery, and why? Is that inherent in the medium—the problem of "shooting," in Susan Sontag's sense, the violent freezing or "stilling" of the subject? Do you find a kind of innocence in the earlier Mass Observation images? Because there is this narrative of Mass Observation's "fall" from an edenic collective undertaking to a government tool for spying on its citizens.

R: One of the things that interested me in Mass Observation to begin with was that narrative. It was a progressive populist movement that used surveillance—which is to say, surreptitious photography—because they believed that if you could show people a picture of themselves as they really were, then they could make decisions and changes in their lives. And then when World War II broke out, Mass Observation par-

ticipants were recruited by the Ministry of Information to act as civilian spies—although they didn't prove to be very effective! After the war, Mass Observation became a market research firm. But in doing more research, I found out that it really wasn't quite that direct (or poetic!) a fall. Because they were independent, they were constantly looking for funding, so they did occasional market research projects for hire even in the 1930s. And there wasn't as much of a progressive political agenda as I wanted to believe—it was pretty haphazard and there was a classist element to the whole thing.

I initially became interested in Mass Observation by reading an interview conducted twenty years ago with Mass Observation's photographer, Humphrey Spender. Spender believed photography was only worthwhile as an information-gathering medium; he did not believe in photography as an art form—he said any idiot could take a picture. He actually abandoned photography in favor of painting. Another reason he gave for abandoning photography is that he felt the only good photos he could take were surreptitious ones—they were the truest images. And yet he was a very shy person and he felt that he was invading people's privacy—plus he recognized his own class privilege, particularly in the Worktown photos. That fascinated me, that someone would become so skilled and such a beautiful photographer and then just abandon it completely, because he was appalled at the thing that he did best.

But by the time I went to interview him myself, his attitude had really changed. I quoted back to him what he'd said about the terrible invasion of privacy his work with Mass Observation had been and so forth, and he said well, your attitude changes over the course of a long life—he was ninety-two years old. He said when he was young he had hesitated and worried too much about those issues.

I'm personally very uncomfortable shooting people on the street and I've largely avoided that kind of photography. In *How Little We Know of Our Neighbours*, I wanted to push myself to shoot that way and I can see the fear and discomfort in that footage. In preparation for this film, I interviewed several photographers who did street photography to ask them how they felt about shooting strangers in the street. How do you deal with the fact that the best images are often the ones where people are the most vulnerable and in which they might be the least willing to expose themselves? But none of the photographers wanted to take anything like that; they wanted the people to know they were being

Still from *How Little We Know of Our Neighbours* (2004). Courtesy of Rebecca Baron

photographed. And that surprised me, because part of what's pleasurable about that genre of photography is knowing that it's surreptitious, as with Robert Frank's blind couple on a park bench or Walker Evans's subway series—I actually repeated what Evans did for this film with a tiny digital watch camera.

J: So do you think the desire for mastery is inherent in the medium?

R: I don't know. *How Little We Know of Our Neighbours* takes on these multiple desires we have for photography—in the case of surveillance it is about control and mastery, information and knowledge, and identification and authentication. But there's also an erotics to it—a pleasure in looking. I wanted all of those things to be included so that the piece wasn't just coming to the conclusion "surveillance is bad," but also that it's tremendously pleasurable to look and those two things coexist. It's not an attempt to rectify that fact, but just to acknowledge it.

J: Although what you do rectify is the way we look *through* the image in a surveillance society—the way we take it for granted. You never take the image for granted in that film or in any of your other films.

R: It's tricky though. There's been so much art produced using surveillance cameras and surveillance imagery that the meaning has been downgraded largely to style. Surveillance imagery in an art context has to do with the beauty of the image, and it's a kind of shorthand aesthetic that's not very productive anymore.

J: There's an interesting surrealist influence in Mass Observation, I noticed.

R: Mass Observation was actually founded by a surrealist poet, Charles Madge. Tom Harrisson, the other founder, was trained as an ornithologist. He was on an expedition to the New Hebrides and started using bird-watching techniques to watch people there and wrote a book about them called *Savage Civilization*. So he was a kind of self-styled anthropologist. Harrison came back to England and wanted to look at British society and rituals in the same manner. Humphrey Jennings, who was a brilliant painter, poet, and filmmaker, joined Harrisson and Madge and was part of Mass Ob for a short time at the beginning. He had been a central figure in the British surrealist movement and went on to work with John Grierson and the GPO Film Unit. In England at the time surrealism and documentary were not considered at all at odds with each other. The idea was that the photograph could see more than the naked eye and through the photograph you could read the collective unconscious. Like Vertov's Kino eye—the camera is better at seeing than the human eye.

So for the original Mass Observation team, the camera provided the opportunity to read the underlying desires of a culture. They regarded the image as both a source of information and a key to the invisible— views that seem incompatible to us now. There is a kind of innocent faith in photography that I find really appealing—I think there's an aspect of that in photography through the 1970s, something about the truth in an expression or the truth of a moment. I think that humanist perspective is still enormously attractive, as critical as we may be about the status of the real in photography. But it's hard to engage in that kind of photography today with the same kind of faith in the medium to tell the truth.

J: The "sur-" prefix in the word surrealism indicates a real that is realer than real—beyond the referent. When you reenact things in your films, as with the collecting of scientific specimens in *The Idea of North*—there's

a surreal quality to that. Part of what you're doing is showing us that we can never fully connect to the past, and yet reenacting the conditions of a photo when it was taken does create some kind of truth. In *okay by-bye*, you say, "There is something worse than forgetting the past and that's forgetting the relationship between the past and the present." Do you still have faith that there's a way to look at images that connects us to the past in the present, even if we can never truly know everything that happened?

R: That is actually a quote from Blanchot's *The Writing of the Disaster*. That book is so relevant to me, not just in terms of what he has to say about writing, but also in terms of photography: in the face of catastrophe, *not* writing is the ultimate concession. Which is to say, despite the limitations of representation in whatever form, not even making an attempt is to be defeated by the catastrophic event. So there is something I'm trying to recuperate for photography and I think it does have to do with, as you say, a way of looking. That we not receive this constant stream of images we read for content and instead take time to look. That is the most obvious reason to work with still photography in film because the filmmaker controls how long the audience looks at an image and where they look within an image. I can either give you a glimpse of an image or I can make you look for minutes at a time. You can look away, but you are made aware that you are looking away. When you're looking at images in a newspaper or on a billboard or in a gallery, you may feel that you have looked at an image but you haven't really seen it.

So there is some kind of recuperative gesture in that. It allows you and challenges you to look differently than you would in a casual way. And a lot has to do with the conditions of viewing. The most poignant thing about a photograph is that it only represents a fraction of a second and it doesn't include the before and after and it doesn't include what is outside the frame. The obvious difference between moving and still images is that the latter allows for time to look at a single moment and the former is a series of constantly disappearing images that allow you to see what happens over time and, depending on the shot, expand the frame.

On that score, there are filmmakers like Peter Hutton or James Benning—especially Peter Hutton—who are trying to make you slow down

and just look at an image, often with no sound. So the duration really is in the act of looking.

J: What I find compelling about your work beyond the play with duration is the play between everyday images and iconic images. They are images that have a prior existence—they belong to a whole language of images. I mean, landscape photography does as well, but these are really histori-cally coded images you're using and there is something about making us stop and look at them that isn't just an appreciation of the visual—it also forces us to think about time as it is inscribed in human events.

R: Yes. Often I find that if I look at an iconic image and don't just iden-tify it as something I know, but really study it, I realize I don't know the image as well as I'd thought. And simply taking the time to look at it in detail restores the picture's weight. It does what photography can do at its richest.

As a viewer I take the same kind of pleasure in Hutton's work as I do in the Mass Observationist approach to photography. I don't mean that I look to the images for information but that I can enjoy a more innocent mode of an unambiguous relationship to the image. His films aren't critical of photography; they embrace the "truth" feeling.

But I can't quite give myself over to that as a maker because I have this nagging feeling that it's something of a trap—a beautiful trap, and I want to be in there as much as the next person—that is to say, I'm cer-tainly not against that kind of beauty and I'm a big fan of Peter's work. But in my own work I try to resist the lure of timelessness. No image is really out of time. I'm more interested in getting specific.

CRASH AESTHETICS: *AMORES PERROS* AND THE DREAM OF CINEMATIC MOBILITY

Karen Beckman

Upon its release, Alejandro González Iñárritu's *Amores Perros* (2000) drew international attention to the state of Mexican cinema and Mexico itself. It was the first Mexican film to be nominated for an Academy Award for Best Foreign film in twenty-six years, won awards at Cannes, Flanders, Bogotá, Sao Paolo, Tokyo, Moscow, and many other international film festivals, and was repeatedly praised for capturing the "reality" of modern Mexican urban life. *Variety* named González Iñárritu as one of the top ten new directors to watch, and Lynn Hirschberg, in a *New York Times Magazine* article entitled "A New Mexican," described *Amores Perros* as "the most ambitious and dazzling movie to emerge from Latin America in three decades."[1] Yet in spite of the fact that *Amores Perros* was the most successful film at the Mexican box office in 2000, domestic responses were clearly ambivalent. On the film's release in Guadalajara, Patricia Torres San Martin found that while for most middle-class viewers, the film unleashed a surge of national pride, with one commenting, "We've had enough of gringo shit and now Mexican cinema is giving us great stuff," some working-class spectators found the film "disgusting," "sadistic," and "sad," claiming "they always put Mexico down" (Smith 2003, 27). Jorge Ayala Blanco, an established film critic and scholar, criticized the film's exploitation of "shock," calling it a "success prefabricated by the technomarketing, Fox-style strategy, a tridramatic soap opera." Blanco describes the handheld camerawork as "nauseating," the moral banal, the characters stereotypi-

cal, and the representation of Mexico City "grotesque."[2] Finally, the long-standing Mexican filmmaker Arturo Ripstein, asked to comment on *Amores Perros* at Cannes, stated simply, "I don't make films for idiots."[3]

This mixed critical reaction to *Amores Perros*—the celebration of its innovation, the critique of its exposure of a degraded Mexico to the international arena, and the condemnation of its commercial success—establishes a resonance between this contemporary film and Luis Buñuel's first Mexican film, *Los Olvidados* (1950).[4] Like *Amores Perros*, *Los Olvidados* depicts Mexico City as a place of violence, poverty, and crisis; it too won an award at Cannes (1951) and enjoyed major success at festivals while being widely condemned by Mexican critics for offending the "honor" of Mexico and for constructing "a viciously negative, false, and 'dirty' image of Mexico"(Acevedo-Muñoz 2003, 74).[5] But more importantly for the subject of this essay, Buñuel's work prefigures González Iñárritu's attempt both to represent the complexities and contradictions of Mexican national identity by explicitly invoking the complexities and contradictions of the medium of film and to make the knotty problems emerging from these mutually illuminating phenomena available to commercial audiences. Rita González and Jesse Lerner position Buñuel as a "perverse elder statesman for the subsequent generations of Mex-perimentalists," noting in particular his ability to create experimental spaces within, rather than in necessary opposition to, a commercial context: "Stressing the need for a more poetic cinema, Buñuel advocated a flexible filmmaking that could function within the strictures of the system, and yet subtly deconstruct the very terms of narrative. His choice to work within the industry may have been predominantly of economic necessity, but Buñuel did take offense at exclusionary or isolationist practices of the avant-garde that discounted the potential commercial audiences" (Gonzalez and Lerner 1998, 43). For González Iñárritu, as for Buñuel, aesthetic, industrial, and national crises are deeply intertwined, making it impossible to view *Amores Perros* within simplistic paradigms. Rather, as this film refuses fully to embrace or reject either U.S. commercial culture or Mexican nationalism, it challenges us to consider how the idea of the nation inflects González Iñárritu's exploration of the medium of film and its capacity to reflect the complexity of temporality, movement, history, and the contemporary traffic of images at the level of both form and content.

Set in Mexico City, *Amores Perros* skillfully interweaves the lives of

three separate groups of people and their dogs through the device of a brutal car crash that tangles the fates of these otherwise unrelated characters. The film is divided into three sections. In part one, "Octavio y Susana," the young and poor Octavio falls in love with his brother Ramiro's wife, Susana. He enters his brother's Rottweiler, Cofi, into dogfights to make money with which he plans to head north to Ciudad Juarez with Susana, but he ultimately ends up losing Susana, his dog, his brother, his hair, his money, and, almost, his life. When Susana runs off with her husband and the money, Octavio decides to make more money through dog fighting, in order to be able to head north with his friend Jorge, but as the friend is killed in the car crash, and as his brother Ramiro is shot dead, both Susana and Octavio end up back where they started. At Ramiro's funeral, Octavio invites Susana to join him on a bus ride to Ciudad Juarez, but she fails to show up, reinforcing the claustrophobia of this film, in which characters try to play out the familiar Mexican film narrative of heading north for the border, only to find themselves trapped in the space of Mexico City, their dreams of mobility thwarted. Part two, "Daniel y Valeria," tells the story of an advertising executive who leaves his wife and daughters to go and live with Valeria, a Spanish supermodel who is the poster girl for the perfume Enchant. He buys a dreamy apartment for the two of them that looks out onto a giant billboard on which is posted an image of Valeria's ubiquitous Enchant ad; but the dream becomes a nightmare when, in the wake of a car crash with Octavio from the first narrative, Valeria loses one of her legs. To make matters worse, her little white dog, "Richie," her "son," gets stuck under the floorboards of the apartment, where he is chewed by rats. In this second part of the film, then, the fantasy of mobility, deeply tied to the world of images, is again violently punctured. Daniel, in search of the dream woman, leaves his home life for a supermodel who is "all legs," only to find himself stuck with the crippling medical costs of Valeria's amputation, while Valeria loses all her mobility, both professional and physical.

The final section of the film, "El Chivo y Maru," depicts the transformation of El Chivo, the "Billy-goat," a school-teacher-turned-guerrilla fighter who was imprisoned twenty years ago before becoming, upon his release, a private hit man. El Chivo wanders the streets with a pack of dogs and rescues Octavio's dog, Cofi, from the scene of the crash. Once recovered, Cofi proceeds to massacre all of El Chivo's stray dogs,

provoking a change of heart in the old goat. El Chivo decides to re-establish contact with his estranged daughter, Maru, who believes her father to be dead, but he will do this only after he returns from a voyage of self-discovery on which he embarks in the film's final image. "El Chivo y Maru" constitutes the only section of the narrative in which mobility remains a possibility, but importantly, this option is open exclusively to the man who walks, the man who, in the course of the film, will actively dismantle automobiles, and who is persistently aligned with the medium of photography, not film. Paradoxically, the possibility of change, indeed of futurity itself, seems to exist in a fantasized space between stasis and motion, and it is in this between-space, characterized by a quality George Baker describes as "not-stasis," that the film, and perhaps by extension contemporary Mexican cinema, seeks to find a place for itself.[6]

Amores Perros problematizes the critical tendency automatically to align speed, movement, and capitalism with cinema through specific stylistic and formal gestures of resistance. First, as the film consciously evokes the images of the New York–based photographer Nan Goldin, its effort to create a New Mexican Cinema is complicated by the haunting visual presence of this U.S. photographic aesthetic that is itself already haunted by the specter of cinema. Second, the film's nonlinear narrative is structured around multiple (but changing) depictions of the same car crash. As we repeatedly return to this instant of collision, it becomes clear that if *Amores Perros* does create an image of Mexico's present, it is an endlessly traumatic present in which forward narrative movement can only be achieved paradoxically by moving backward to an already lived instant. Third, while commercially successful film might be associated with the velocity of images, in *Amores Perros* the possibility of forward motion, of movement aligned with "progress," is constantly troubled by competing movements within the shot. Just as at the diegetic level, speeding cars are brought to a halt by encounters with other cars moving in different directions, so at the formal level we repeatedly experience what we might call "competing vectors," movements within the frame that, pulling in other directions, seem to peel images open, disrupting their flow. Finally, these narrative and formal manifestations of interrupted or strained motion are reinforced by the intrusion of a phenomenal number of still photographs into the mise-en-scène of the film.

While we might assume that a commercially ambitious film like *Amores Perros* would try to repress the conflict inherent within the medium between the moving strip and the static photogram, a conflict that avant-garde filmmakers have productively exploited and exposed, *Amores Perros* highlights the confrontation of motion and stasis that defines film, and uses it to explore the difficulty of cinematically representing Mexico's urban present. In one of the most useful recent contributions to contemporary film theory, *Between Film and Screen*, Garrett Stewart shows that although film practice has traditionally tried to repress the incursion of the single unmoving image into the illusion of movement, film's "optical unconscious" repeatedly disturbs this illusion through the eruption of freeze frames and still photographs within various film narratives. Stewart asks, "When this automatically suppressed single integer of screen illusion is lifted to view . . . to what extent does it drag with it the historically forgotten or overcome?" and *Amores Perros* explores this question (Stewart 1999, 226).[7] Using various devices, including crashing cars, a circular narrative that begins in the middle, then moves backward and forward in time, an attention to gravity—a constant tension between the downward and horizontal movement of objects—and an obsessive interest in still photographs, the film highlights the medium's conflicted relation to movement and stasis, not to foreground aesthetic over cultural and historical questions but rather to reflect the complexities of nation, gender, class, and historical narrative through the encounter of cinema and photography.

Baker describes such encounters at the interstices of media as a kind of redemptive "sharing" that can potentially enable old and tired media to reinvent or reanimate themselves without simply becoming formless, without losing a sense of the limits that are being contested. In a discussion of James Coleman's films, *La Tache Aveugle* (1978–90) and *Untitled: Philippe VACHER* (1990), for example, Baker writes: "Photography now moves, and cinema freezes. . . . An interstice between media has not been 'crossed'; forms can only share themselves around that which they lack. Forms can only (truly) share themselves around an absolute limit, a limit that must be respected, and yet this limitation is a gift. For this limitation also means that forms have an outside through which they can—or perhaps even must—become other. It is in the interstice where film can become photographic, where not only 'shots' and 'frames' collide irrationally, but where image becomes extrin-

sic, extroverted, profligate" (Baker 2003b, 47–48). Baker's work on the redemptive possibilities of sharing offers a useful paradigm for understanding *Amores Perros*'s complex engagement with the limits of film. Yet the extension of Baker's work beyond the realm of artists working with or influenced by film to the sphere of commercial cinema requires a revision of the idea of the "merely cinematic" as it appears in this essay (Baker 2003b, 41).[8]

BALLAD OF AESTHETIC DEPENDENCY

Contrary to Fredric Jameson's suggestion that "whenever other media appear within film, their deeper function is to set off and demonstrate the latter's ontological primacy," photography emerges in relation to film within *Amores Perros* in the form of a mutual yearning, akin to the model of sharing Baker outlines (Jameson 1992, 84, n.19). *Amores Perros* metaphorically reflects the potentially destructive effect of this encounter through the narrative and visual trope of the crash, which instantaneously transforms moving vehicles into static frames for dying bodies. But the media of film and photography also "meet" each other more literally through González Iñárritu's incorporation of Nan Goldin's photography at the level of mise-en-scène, an encounter that in turn metaphorically parallels the complex human relationships depicted within the narrative. In an interview with Bernando Pérez Soler in *Sight and Sound*, González Iñárritu traces his decision to allow Goldin's work such a central role back to a somewhat mythological moment: "I like Nan Goldin's photographs very much, so for my first meeting with director of photography Rodrigo Prieto I took in a book by Goldin to exemplify what I wanted to achieve in terms of coloration, grain, visceral appeal. Curiously enough, he brought the same book with him, so from the very beginning, we had a similar vision" ("Pup Fiction" 30).[9] Whether or not this fateful moment actually occurred, Goldin's photographs ultimately play an important role in shaping *Amores Perros* as a film capable of taking itself to its own limit, to the border of the medium, as though endlessly in search of transformational encounters.

In order to attain the same level of color saturation in *Amores Perros* as Goldin achieves in her photographs, González Iñárritu and Prieto had to use a processing method that literally prevents the preservation of film. In an interview with Travis Crawford, Gonzalez Iñárritu ex-

plains: "We began to make experiments in the lab, and our conclusion was to use this Vision 800 color stock, with a silver-retention process in the negative. It was the second time in the world that anyone had used this. In the United States they say they don't want you to do that because it's very risky. But it gave us those electric earthtones, and it was terrific. I think it really helped the movie—it has something you cannot explain, but it makes it different. Maybe we lost our negative, but we'll have it on DVD."[10] Here, the film's mimicking of photography does more than unveil cinema's repressed proximity to the still image; in recreating the look of Goldin's images, *Amores Perros* willingly embraces its own chemical implosion, the limits of its existence as film, flipping the work into yet another proximate medium, reinforcing the film preservationist Paolo Cherchi Usai's recent claim that "cinema is the art of destroying moving images" while allowing that such destruction can mark the revitalization, as well as the end, of what we know as cinema (Usai 2001, 7).

Paul Julian Smith remarks upon González Iñárritu's debt to Goldin's photographs at the level of mise-en-scène, from "the saturated color, grainy texture and tight composition, the exploitation of mirrors and claustrophobically darkened exteriors" (Smith 2003, 76), yet at times the film's scenes of empty bedrooms, religious kitsch, photo bulletin boards, fluorescent green hospital interiors, and open caskets also seem so close to Goldin in terms of what we might call "narrative content" that they produce an uncanny effect, as though Goldin's photographs had been strangely transformed into tableaux vivants.[11] While Smith, highlighting the difference between Goldin and González Iñárritu, asserts that "*Amores Perros* shows no interest in Goldin's subcultures of drag queens and junkies" (77), the film may not be quite as disinterested in the content of Goldin's images, in subcultures and sexual politics, as Smith suggests. Indeed, I would argue that Goldin and González Iñárritu share more than a visual style, for both photographer and filmmaker also have in common a way of interweaving this visual style, a style that grows out of the encounter between photography and film, with depictions of borders between nations, genders, classes, and subcultures.

Although Baker sees photography's confrontation of cinema and cinema's "look toward photography" as "absolutely linked . . . but absolutely different, as if their intertwining was actually a chiasmus," in

Amores Perros, these interstitial yearnings are never so cleanly sepa-rated, as the Mexican film evokes cinematic photographs that in turn evoke photographic films. Though Prieto and González Iñárritu de-scribe Goldin as a "still" photographer, we need to remember that her photographs are familiar to us not only from their gallery and publi-cation contexts but have been exhibited as early manual slide shows, accompanied by ever-changing soundtracks; as sophisticated museum installations, in which the slides' relation to the soundtrack becomes fixed; and finally, within the context of Goldin's BBC film, *I'll Be Your Mirror*, which has been shown both on television and in a museum setting.[12] Furthermore, as J. Hoberman points out, her photographs have "a lot in common with what, in the late 1960s, used to be called the New American Cinema," and Goldin has acknowledged the influence of a wide range of film on her work, including the glamour of classical Hollywood, the eroticism of the European New Wave films, and the ex-perimentalism of Jack Smith and Andy Warhol, whose films repeatedly invoke a photographic stillness.[13] Her aesthetic grows out of an initial desire to "make Warholian films like *Chelsea Girls*," and she even goes so far as to say that she "never cared about photography too much" and that "film has been [her] number one medium all [her] life" (*I'll Be Your Mirror* 136–37).

Resisting the notion of an absolute limit, this intertwining of Goldin's cinematic photography and *Amores Perros*'s photographic cinema blurs the line dividing these overly proximate media as a result of what looks like a case of overidentification or hysterical mimesis. Though Baker asserts that the absolute limit between photography and cinema "must be respected" (47) in order for forms to truly share themselves, a sharing that depends upon the existence of a recognizable "outside," perhaps the lack of respect shown to these aesthetic boundaries by Goldin, González Iñárritu, and the encounter of their work in some ways stages at the formal level the psychic struggles depicted within the narrative, where desire at times refuses to recognize social borders, even when this refusal has destructive effects. While an ethical relation to the other may well depend upon the subject's capacity to recognize the limits be-tween self and that other, the complex and often unconscious opera-tions of identification and desire repeatedly trouble or confuse either that boundary or the subject's capacity to recognize it. If the shar-ing that emerges between media in the work of artists and filmmakers,

to which Baker attributes the medium's capacity to "become other" (48), can be thought of within the paradigms of identification (and the language of self and other used to discuss the relation between media suggests that this paradigm can, even should, be invoked), then it follows that this sharing has the capacity to disrupt or dissolve the "absolute" status of the limits that initially make sharing possible or desirable in the first place. For identification, as Diana Fuss suggests, is "a process that keeps identity at a distance, that prevents identity from ever approximating the status of an ontological given, even as it makes possible the formation of an *illusion* of identity as immediate, secure, and totalizable" (Fuss 1995, 2). To raise these questions is not to refute the need to pay attention to the question of "the medium" as it becomes increasingly visible in contemporary art and film, or to claim that because the borders separating media from each other are mobile and provisional, all distinctions are meaningless. Rather, these questions, emerging out of a consideration of a particular encounter between cinema and photography, challenge us to be more explicit about what motivates our attempts to explore or regulate the encounters between different media, to clarify the difference between analysis and prescription, and to be attuned to the complexities that arise when the discourse on the media becomes, as it inevitably does, a discourse on human relationships.

Through her work, Goldin has stretched the temporal and spatial implications of the photograph and has linked the shifting, mimetic nature of photography to the expanded, provisional, and at times destructive views of gender, family, desire, love, and community depicted in her images, establishing a continuum between form and content that at least in part illuminates our investment in regulating the distinctions between one medium and another. While it might be tempting to argue that the social grittiness and poignancy of Goldin's images have merely been incorporated by *Amores Perros* as glamorized urban chic (a critique that has also been leveled at Goldin's images), what interests me about González Iñárritu's visual referencing of Goldin's work is the way it invites the specter of her preoccupation with the temporal, spatial, and social possibilities of photography's exposure to film to haunt *Amores Perros*. By embracing this expansion of a single medium through its encounter with another, González Iñárritu underscores the difficulty of representing contemporary Mexican urban identity at a moment when

that identity is caught between a geographical specificity and the no-place of global capitalism. From Warhol to Goldin to González Iñár-ritu, though we are never outside the space of capitalism, we are always in a space where the tension between still and moving images refuses to resolve itself, as the two media, mimicking each other in a compulsive dance of desire, identification, and rejection, seem unable either fully to incorporate each other or to let each other go.

While Baker asserts that the "dual articulation" he finds in Coleman's work is not about "a collision of mediums as opposed 'essences'—the inherent stasis of photography, for example, proclaiming war upon the flux of cinema" (35), this space of encounter, the idea of collision never-theless emerges, as Baker describes the way shots and vectors confront each other in Coleman's work (48). Though this distinction between destructive and productive collisions would be hard to uphold in any absolute way, we might usefully remember that collisions and crashes function in multiple, sometimes even contradictory ways. With this in mind, I turn in this final part of this essay to look more closely at how *Amores Perros*'s narrative develops around a series of interrelated ani-mating collisions: the repeated car crash, the collision of vectors, and cinema's collision with various forms of the still image.

OCTAVIO Y SUSANA

Amores Perros opens with a breathtaking car chase that comes quickly to a dramatic and violent end. The sound of zooming cars first cues spectators to expect the onslaught of rapidly moving images that will soon follow. The black screen gives way to the black road, with move-ment across the space of that road signaled by the rapid passing of white divider lines across the horizontal screen. "This is a road movie," the opening shot seems to say, and yet *Amores Perros* departs dramatically from this genre, which is visually identifiable by its recurrent use of panoramic shots that align the freedom of the road with the horizontal space of the cinema screen, and by the repeated employment of travel-ing shots produced by mounting the camera on the edge of a moving vehicle (Laderman 2002, 14–15). Although the film's framing techniques frequently emphasize the concept of horizontality, *Amores Perros* ques-tions the possibility of moving freely across these cinematic planes through a juxtaposition of horizontality with competing vertical images

and vectors. Similarly, though González Iñárritu often employs a car-mounted camera, as he does in this opening scene, the fluid alignment of cine- and auto-mobility is disrupted by the choppy editing style, multiple points of view, and the sudden termination of the car's motion at the moment of violent collision, all techniques that resist spectatorial equation of the car's movement with cinematic freedom.

As the camera points down at the ground, the surface of the road evokes nothing so much as the early practice of sprocketing film strips in the center, hinting that a self-reflexive consideration of the medium's mobility, as well as the possibilities of that medium's transformation in time, will play a central role in the film. Within seconds, however, Rodrigo Prieto's handheld camera moves from this vertical, downward-pointing position to a horizontal position to depict the high-speed movement of Octavio's car through the space of Mexico City. This tension between horizontal and vertical camera positions is then further reinforced as the camera pulls our attention schizophrenically between the car's horizontal flight through Mexico City and the slow gravitational slide down of the dog Cofi, apparently dying on the back seat of the car.

This tension between high-speed, technological horizontality and the slow, animal, downward fall works, like the tension between cinema and photography, to establish two competing temporalities and vectors within the frame and to prefigure the accident, which, as Paul Virilio has argued, is embedded within the ideology of speed (Virilio 2003, 27). Like Walter Benjamin's historical materialist, the crash that ends this sequence seems to "blast open the continuum of history," making available, if only momentarily, the possibility of at least imagining a present in which time stands still long enough for thought to happen, in spite of the endlessly rolling film (Benjamin 1968, 262). After a disoriented camera briefly attempts to capture the impact and aftermath of the crash, allowing us a glimpse of the bloody Valeria pawing at her side window, we face the first of many black screens, as though the film had given up on itself within the opening four minutes. In the course of the film, three further variations of this crash seem to insist that the time of this narrative will be, in spite of film's quality of duration, a single, photographic instant. Yet if the encroachment of the photographic instant seems to impinge on the film's narrative progression, film in turn seems to expose, or traumatize, photography's singular relation to the present,

Still from *Amores Perros* (Alejandro
González Iñárritu, 2000)

correcting its ability to represent a moment from only a single perspective as it offers four different views of the same event.

Toward the end of the first section, Ramiro enters his brother Octavio's bedroom to inquire about the dog-fighting profits. But this exchange about capital is preceded by what seems like an inconsequential glance at a close-up shot of the television screen Octavio watches. What we see is actually one of the many car advertisements González Iñárritu produced for Mexican television, but this brief glance at the screen demonstrates not only the way film can appropriate and rework commercial images but also how commercials themselves might internally resist the capitalist culture in which they participate. This televisual fragment picks up on the film's formal leitmotif in which the horizontal movement of cars across the screen, aligned with cinematic mobility, is challenged by the presence of either a slower downward movement or by a vertical still image. In this instance, a row of stationary, forward facing cars pointing out toward the viewer is suddenly hit from above by a horizontally aligned car that drops out of the sky, as though forward motion had been completely overtaken by the downward pull of gravity that has hitherto been positioned in opposition to auto-mobility. Like the automobile stickers that adorn Octavio's bedroom wall, all cars in this film will eventually be immobilized. By refusing to allow either cars or time to move forward through the traumatic repetition of the crash, González Iñárritu disrupts spectatorial expectations that the camera must align itself with narrative progress and technological speed and instead insists that we attend to the proto-photographic instant when competing vectors intersect, opening the question of how, at what pace, and in what direction this new cinema might begin to move.

DANIEL Y VALERIA

Early in the story of Octavio and Susana, we see an unidentified middle-class family driving cautiously through the streets of Mexico City, which we will later learn is the family of Daniel from the film's second narrative. As the car slows for a stoplight, Daniel's upward gaze creates an eye-line match between the driver of the family vehicle and a giant billboard advertising the perfume Enchant, featuring Daniel's paramour Valeria, the Spanish supermodel. Here, the static low-angled camera position emphasizes the height and verticality of the image and creates a tension between the object of Daniel's upward gaze and the forward movement of the family's vehicle. This moment reminds us of Laura Mulvey's claim that "the presence of woman . . . tends to work against the development of a story line, to freeze the flow of action in moments of erotic contemplation" (Mulvey 1999 [1976], 841). Yet while Mulvey's critique of the "woman as icon" targets narrative films that exploit such moments of visual arrest for male spectatorial pleasure, in *Amores Perros* these static images draw critical attention to the way such images freeze and entrap both male and female subjects. If, as Jean Franco has noted, there is an interchangeability in Latin American cinema of the terms feminine, private, and immobile on the one hand, and masculine, public, and mobile on the other, then *Amores Perros* disrupts the tradition of Latin American cinema and provokes critical reflection on the way Mexican visual culture participates in this gendered ideology of stasis and motion through its excessive accumulation of static images of women, and its hijacking of male speed.[14]

After the next representation of the crash, which is followed by a second black screen, a friend takes Valeria to the surprise love-nest that Daniel has bought for the two of them, and in this new space of amorous bliss, the immobilizing effect of images on women is triply reinforced. While the apartment window looks out onto another giant billboard featuring Valeria's Enchant advertisement, within the apartment, two other images encroach upon her freedom. First, an enlarged contact sheet, a series of black-and-white photographic images of Valeria arranged in a gridlike structure, reiterates the film's interest in vertical and horizontal vectors, invokes again the specter of the filmstrip's individual static photograms, and creates the impression of an endlessly reproducible Valeria caught inside little boxes. On another wall, a painting of an

androgynous figure oppressively encased in a red sheath implicates the "purer" aesthetic object of the painting in the gender ideology so visible in the advertising image, while suggesting, through the androgyny of the figure, that the immobilizing effect of images might not only affect women. As the red sheath establishes a visual connection with the red circles on the photo-proofs and with the red background of the billboard poster, these three images seem to intersect with each other across the space of the screen, forming an invisible triangle that traps Valeria in their midst. As though to emphasize these images' gravitational force, their resistance to female mobility, when Valeria walks between them, she falls through the floorboards.

Given the fact that this love nest turns out to be a claustrophobic collection of frozen female images and floor traps, it's perhaps not surprising that Valeria insists, against Daniel's will, on nipping out in the car to get some champagne, taking her fluffy white dog Richie with her. Although Valeria's driving, and the filming of it, differs dramatically in pace from Octavio's driving in the opening scene of the film, here too we can note how the camera is torn between a traveling shot of the car's movement through Mexico City, represented largely from the point of view of the dog Richie, and a static, interior, and voyeuristic shot that lingers on the space between Valeria's crotch and lips. Immediately following the third version of the crash which ends this scene, represented this time by the black screen alone, we encounter an image of the hospitalized Valeria, who now, rigidly wrapped in neck brace and sheets, resembles nothing so much as the cocooned painted figure, now rotated ninety degrees and brought to a strange kind of still life.

When Valeria returns home from her first hospital visit, her leg has been heavily pinned, and she can move only by using a wheelchair. After Daniel leaves for work the next morning, the difficulty of unimpeded forward motion is again emphasized by establishing a tension between vectors, and between still and moving images. First, as Valeria turns her wheelchair to move left from the center of the frame, a wall mirror catches her reflection, uncannily doubling and dividing Valeria as she moves symmetrically toward the left- and right-hand sides of the frame simultaneously, folding the image out of itself as though exposing it for critical examination. This gesture of doubling is then reiterated as we cut to a shot of Valeria looking through the horizontal slats of the blinds that now cover the "billboard window," which further reinforces

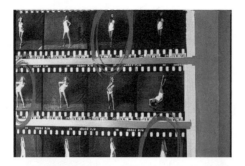

Stills from *Amores Perros*
(Alejandro González Iñárritu, 2000)

the former shot's division of this icon of femininity. After seeing a close-up of Valeria shot from outside the window, her face and the screen horizontally segmented by the blinds, we then cut to a shot filmed from Valeria's point of view of her representational double, the billboard image, which is similarly fragmented into thin horizontal strips. In the wake of these visual splits and fractures, Valeria pours over snapshots and magazine images of herself, as though trying to pull her identity together from these fragments of her life.

Valeria will soon be rushed back to hospital, and when she next returns home, it will be without her leg. After a brief night-shot of cars

Stills from *Amores Perros*
(Alejandro González Iñárritu, 2000)

moving along the highway, Valeria enters the apartment; her partial body seems rigid and petrified as the new electric wheelchair moves her through the room as though she is now fully at the mercy of technological motion. She immediately goes back to the window, this time wearing a black sweater that visually links her to the mourners at the two funerals that occur in the course of *Amores Perros*, and to the black screens that punctuate the film's multiple depictions of the crash. Looking again through the blinds onto the billboard, Valeria finds that her image has now been replaced by a black space on which is imprinted the word "DISPONIBLE" ("SPACE AVAILABLE") and a telephone number. Resonating with the film's repeated use of black screens, as well as with the final shot of Jean-Luc Godard's seminal car crash film, *Weekend* (1967), in which words on a black screen declare simply "Fin de cinema," this empty billboard mourns the death of spectacle and announces that there is no image for the present: it has yet to be found. As if to reinforce this gesture, the scene then ends with another fade to black.

González Iñárritu says of this scene: "I love Goya Toledo [the actress who plays Valeria] here. . . . She's stopped being a doll. Paradoxically, by losing her leg, she gains more inner life and spirituality. She stops being

a doll and becomes a woman." Yet in many ways, at this moment Valeria resembles nothing so much as dolls, specifically Hans Bellmer's corporeally fragmented *poupées*. Hal Foster reads Bellmer's *poupées* as an explicit "attack on fascist father and state alike," while recognizing that, in choosing to enact this political resistance on the site of the female body, they "produce misogynistic effects that may overwhelm any liberatory intentions" and "exacerbate sexist fantasies about the feminine . . . even as they exploit them critically" (Foster 1995, 115, 122). Foster may too easily separate his two readings of Bellmer's dolls: as sadistic toward women on the one hand, and as representations of the sadistic "armored aggressivity" of fascism on the other (115), prematurely suspending attention to the former in order to understand the liberatory possibilities of the latter. Yet the space Foster opens here, in which he engages the problematic coexistence of radical political and misogynist iconography, is useful for addressing this scene in *Amores Perros*. While *Amores Perros* clearly at some level participates in a form of misogyny that exhibits and mutilates the glamorous female body, in part justifying this mutilation by positioning Valeria as a Spanish allegorical figure whose presence destroys Mexican unity and integrity (here figured as Daniel's family), the fact that the film simultaneously works to expose the superficiality, aggression, and misogyny of a wide range of visual images seems to implicate the film in its own critique and creates a dialectical space around the question of gender that should not be reductively assessed. Though my critical comparison with surrealism may seem farfetched, we can, I think, localize this reference by remembering the self-acknowledged influence of Luis Buñuel on González Iñárritu, and by recalling the excesses of another female Spanish amputee. If the spectacle of Valeria's disfigured body in some ways participates in a Mexican tradition of aligning women with stasis and domestic confinement, it also cites Catherine Deneueve's aggressive exposure of her stump to the camera in *Tristana* (1970), which brings the narrative to a halt and forces audiences to reflect on patriarchal culture's ruthless immobilization of women, a disruption of the flow of images that is underscored in both *Amores Perros* and *Tristana* by the haunting presence in both films of mournful solid black images.

Although each of the three sections engages the tension between sta-sis and motion, photography and cinema, it is in the third section, "El Chivo y Maru," that the film works hardest to relate these formal ten-sions to the question of what a New Mexican Cinema might look like. As an ex-guerilla who abandoned his family to pursue revolutionary activities and who subsequently became a private hit man, El Chivo exists on the margins of human society, a fact underscored by his animal nickname: the goat. Though the commercial ambitions of *Amores Perros* clearly preclude any claims the film might lay to the category of "guerilla cinema," it is important to note how strongly González Iñárritu's vision for contemporary Mexican cinema aligns itself with the visual perspec-tive of this once-radical but now contaminated goat man and his dog, Cofi. Yet what are we to make of this turn to animal vision? In *Electric Animal: Toward a Rhetoric of Wildlife*, Akira Lippit identifies the ani-malistic nature of Eisenstein's vision of cinema in a way that might use-fully illuminate the final section of *Amores Perros*. Lippit writes: "One senses in Eisenstein's cinema a biomorphic hallucination. Films exist here as complex organisms—they have become animal, or animetaphor. . . . Eisenstein's animetaphor here functions as a technology. . . . Despite the concept of nature it references, the animetaphor is itself profoundly unnatural, prosthetic, pressing the limits of world against the void. . . . The animal projects from a place that is not a place, a world that is not a world. A supplemental world that is, like the unconscious, like memory, magnetic in the technological sense" (Lippit 2000, 195).

So what does El Chivo's animal vision bring to the film's struggle to construct, in the interstices between commercial, technologically repro-duced images, a new, authentic way of representing Mexican life? In the early part of this third section, El Chivo might seem to represent a kind of purity or naturalism in opposition to the cult of technologically enhanced vision and capitalist mobility that surrounds and undermines the other characters and brings them to a halt. Wandering the streets with a pack of stray dogs and a handcart like a modern-day flâneur, he cannot see clearly, for he willfully refuses to wear glasses, telling one character that if God wants him to see blurry, he'll see blurry. Yet in spite of this apparent rejection of visual technology, El Chivo's world re-volves around not only dogs but also photographs; if his dogs represent

a connection to life and movement, photographs repeatedly function as signs of death and loss. He encounters his assassination victims first in photographic form, for example, and later learns about those he has killed when he sees their images in newspaper death announcements. Over the course of this final section, however, this narrative becomes increasingly preoccupied with the question of how to animate the photographs that have been so aligned with death, that is, with the project of how to unite dogs and photographs; and cinema, I would suggest, is the place where the two eventually meet.

Increasingly unable to cope with the separation from his grown daughter Maru, who believes him to be dead, El Chivo lingers over an album of old baby photographs of her taken prior to his departure from the family for guerrilla life. He steals a graduation photograph of Maru with her mother and stepfather from Maru's apartment, studying it, as if wondering how to inscribe himself into the frozen memories of another, how to animate the image and thereby humanize himself. Early in this final section, El Chivo visits a photo-booth, and as the strip of images emerges from the machine, which, like the animal, looks on its subject from no place, we are reminded again of the still photograms which the moving filmstrip represses, and which threaten endlessly to disrupt the illusion, and ideology, of life as motion. El Chivo tears off an image of his grizzly head and sticks it over the face of Maru's stepfather, visually writing himself back into a story from which he was absent. The effect may be unconvincing, but this rough Eisensteinian collision of two images (staged within the frame instead of within the mind of the viewer) marks the moment when photography seems to start moving toward life. Although photographs never fully lose their gravity within the film, El Chivo's, and by extension the spectator's, relationship to photography fundamentally shifts after he witnesses the crash between Octavio and Valeria from the sidewalk (the film's fourth reiteration of this collision). He loads the left-for-dead dog Cofi onto his truck and nurses him back to life, but as soon as El Chivo leaves Cofi alone with his other beloved dogs, Cofi kills them all. Seeing the monstrousness of his own murders in those of the dog, El Chivo refrains from shooting Cofi and decides instead to shift his own relation to the image, and to the world.

Lying back on his bed, El Chivo stretches his neck backward to gaze up at the wall behind him. After a brief close-up of a framed photograph

Stills from *Amores Perros*
(Alejandro González Iñárritu, 2000)

of Maru, which hangs above his bed, followed by various shots of El Chivo stretched out below the image, the camera moves in for a close-up of El Chivo tentatively reaching for his glasses. Immediately before he puts the glasses on, we see a quick out-of-focus shot of the peeling wall, reminding us of El Chivo's decision to live in a "natural" state of impeded vision, a decision he now renounces. As the camera cuts back to El Chivo, he licks his lips in anticipation of the clarity of vision that these two lenses will bring him. Then, in one of the most poignant moments of the film, he puts on the glasses as the camera, now in focus, and reflecting El Chivo's point of view, slowly climbs up the peeling wall until it reaches the framed photograph of Maru. In a rare moment when the camera movement within a vertically oriented shot travels up and not down and is unimpeded by the pull of a competing horizontal vector, we receive the strange impression that this photograph is magically suspended, stopping time and defying gravity, creating a sense that this unbearably light cinema has finally been able to catch the present moment, and suggesting that perhaps only by adopting new perspectives on the images of what we have lost will the future of cinema reveal itself.

Still from *Amores Perros*
(Alejandro González Iñárritu, 2000)

In the final shots of the film, El Chivo cuts back his grizzly hair and beard, hacks through his thick toenails and fingernails, and dresses himself in the suit of a businessman who has earlier hired El Chivo to kill his half-brother. Instead of killing the half-brother, however, El Chivo ties both brothers up, takes their cars, and leaves them in a room with each other and a gun. Now physically humanized and enabled by his glasses, which are broken but mended with tape, he goes to a different photo-booth, this one located beneath another of Valeria's billboards. Here, he produces four new photographs, and then, in the front seat of one of the stolen cars, he removes the earlier, roughly torn photograph he had pasted over the stepfather's head and sticks on a new image with spit. At this moment the serial strip of slightly changing images combined with the act of carefully cutting the strip and pasting incongruent, nonsynchronous images on top of each other cannot help but again invoke the practice of film editing. But if this is cinema, it is cinema returned to its infancy, with the magical intervals between images that so entranced Eisenstein here being constructed and animated manually, one image at a time.

Before El Chivo drives off in his client's SUV, he glances briefly at Valeria's billboard image descending in the background, reinforcing the sense the film creates that commercial image culture is at the point of collapse, endlessly having to resist the force of gravity. As El Chivo starts driving the SUV, however, it seems momentarily that his pedestrian, animal cinema is picking up speed as he drives these images off in a bourgeois vehicle. But this is not how the film ends. Once El Chivo has returned his daughter's photo-collage to her, he takes the SUV to a scrap dealer where he sells it for parts, as he did earlier with the other

Still from *Amores Perros*
(Alejandro González Iñárritu, 2000)

half brother's car. As he stands with the dog Cofi in this car graveyard, the dealer asks what the dog is called, and, after a brief pause, El Chivo replies: "Negro." This name, which the subtitles translate as "Blackie," connects the dog to the film's repeated use of black, signifying lost limbs, lost loved ones, and the loss of the image itself; but "Negro" is also, as many of the promotional materials surrounding *Amores Perros* tell us, the well-known nickname of González Iñárritu himself. At this moment when the director casts himself as a dog, we catch a glimpse of his dream of a cinema that can show us our world from a techno-animal elsewhere, a place that forces us to encounter our own limits as by perceiving ourselves, impossibly, through the eyes of an other. Attempting to find a parallel for the human-animal encounter within the visual realm, he takes cinema to the edge of itself by staging its repeated encounters with stasis, photography, and the instant, creating a visual and temporal gap, a pause for thought and imagination. Leaving the detritus of car culture behind him, the bespectacled goat, carrying only a small bag that contains the image of his daughter, sets off on foot, accompanied by Negro, promising to return to Mexico City and his daughter only when he has discovered himself in the no-man's-land between human and animal, cinema and photography.

NOTES

1 Lynn Hirschberg, "A New Mexican," *New York Times Magazine*, March 21, 2001, 32–35; 34.
2 Jorge Ayala Blanco, *La fugacidad del cine mexicano* (Mexico City: Océano, 2001), quoted in Smith 2003, 25.
3 *El Universal*, May 19, 2000, quoted in Smith, 87.

4 Some critics did briefly compare the content of *Amores Perros* with Buñuel's work in their reviews. Edward Lawrensen mentions *The Exterminating Angel* in passing in "Pup Fiction," *Sight and Sound* 11, no. 5 (May 2001): 28; Claudia Schaeffer notes the fact that female characters lose a leg in both *Amores Perros* and *Tristana* (2003, 92–93); and Michael Wood, in "Dog Days," compares the film with both *Tristana* and *Los Olvidados*, the latter of which he describes as "another study of Mexico City as a place of danger and destitution" (*New York Review of Books*, September 20, 2001, 57–58).

5 For a full discussion of the domestic and international reception of *Los Olvidados*, see chap. 3, "*Los Olvidados* and the Crisis of Mexican Cinema," 57–79.

6 See George Baker's essay, "Photography's Expanded Field," included in this volume. Here, Baker echoes Krauss's use of the terms "not-landscape" and "not-architecture" in her seminal essay "Sculpture in the Expanded Field" (1979) (Krauss 1985, 283).

7 In the introduction to *Between Film and Screen*, Stewart problematically separates the mechanical eruptions from social questions, stating that the book "must necessarily remain unconcerned in any detail with all the things that may properly be noted about photographic ways of seeing apart from their instituted arrest. Set aside for the most part are social, economic, and psychosexual uses and abuses of the photochemically indexed world, except when certain screen narratives take them up. The book is preoccupied instead with the mechanical fixation of the photography and with the incursion of its discreteness into the projected film track" (37). We might read this early distinction of the mechanical and the social as symptomatic of Stewart's attempt to reorient film theory away from its late-twentieth-century focus on the psychology of spectatorship toward a more focused consideration of the medium itself, but happily, in the course of the book, Stewart's astute readings demonstrate the impossibility of severing these medium-specific discussions from sociohistorical questions and problems.

8 For a recent example of this reconsideration of narrative film within feminist film criticism, see Fischer 2004.

9 Interestingly, Rodrigo Prieto, González Iñárritu's cinematographer, articulates a stylistic debt to the work of Goldin, as well as to other photographers, in his second feature film, *21 Grams* (2003), which posed particular challenges for the cinematographer trying to turn the "look" of photographs into film. John Calhoun writes: "Prieto notes that he and Iñárritu used still photos by Laura Letinsky, Sebasteao Salgado, Nan Goldin and William Eggleston as reference points for their images. 'We emulated all of the defects that occur when you're shooting with available light,' he explains. 'The difference is that in still photography, you don't have issues of continuity. We had to do entire scenes in whatever time it took to shoot them, so obviously I had to light as well.'" "Heartbreak and Loss," *American Cinematographer* (December 2003): 48.

10 Travis Crawford, "Humane Society," *Filmmaker: The Magazine of Independent Film* (Winter 2000): http://www.filmmakermagazine.com/winter2001/features/index.php. In an interview with Jean Oppenheimer, Prieto describes the effects of the bleach-bypass process in the following way: "The contrast in general is en-

hanced with skip-bleach, but so is the contrast of the grain. . . . [The process] de-saturates certain hues and colors, such as skin tones, but the reds and blues [are] even enhance[d]." "A Dog's Life," *American Cinematographer* 82, no. 4 (April 2001): 20–29; 20, 23. Quoted in Smith 2003, 77.

11 In this "translation" of extant still images into new moving forms, González Iñár-ritu's work resonates in interesting ways with contemporary artists whose work seems to hover at the border of movement and stasis. For a recent example of this preoccupation in contemporary art, see Eve Sussman's *89 Seconds at Alca-zar* (2004), a tableau vivant of Diego Velázquez's *Las Meninas* (painted in 1656); Nancy Davenport's *Weekend Campus* (2004); or Adad Hannah's *Stills* (2002). An exhibition at the Baltimore Museum of Art in 2005, "Slide Show: The Projected Image," also reflects on this recent interest in the murky border between cinema and photography.

12 *I'll Be Your Mirror* (dir. Nan Goldin and Edmund Coulthard; London: Blast! Films for BBC-TV, 1995). Interestingly, Goldin states that had she had the final cut of this film, she would have excluded the slide show that appears at the end of the film. See "'My Number One Medium All My Life': Nan Goldin Talking with J. Hoberman," in Goldin, Armstrong, and Holzwarth 1996, 143.

13 See "'My Number One Medium All My Life'" for Goldin's discussion of her rela-tion to film culture.

14 See Franco 1988.

SURPLUS MEMORIES: FROM THE SLIDE SHOW TO THE DIGITAL BULLETIN BOARD IN JIM MENDIOLA'S *SPEEDER KILLS*

Rita Gonzalez

> Give me two photographs, a moviola and some music and I'll make you a film. — Santiago Alvarez, quoted in Derek Malcolm, "Santiago Alvarez: LBJ"

Writing in 1982, the filmmaker Jesus Treviño categorized early productions by Chicanos, noting among the range of documentary-based traditions "a basic form of Chicano docudrama . . . the recreation of historical events through the photo-animation of historical graphics, photos, and paintings, [brought] to life with narration, dialogue, music, and sound effects" (Treviño 1985, 112). What immediately comes to mind are the aesthetics of New Latin American Cinema and Third World Newsreel productions with their economic yet flashy uses of photography, didactic refrains, and dialectical montage. In Chicano cinema, the tactics culled early on from confrontations with the texts of Latin American film movements (actual viewings would not happen at festivals until the late seventies) played a significant role in the development of what has been called rasquache cinema, whose mode of innovation lies in making do with limited resources.

In this essay, I examine the contemporary filmmaker Jim Mendiola's revisiting of films culled cheaply with images and music "de todos partes" as a continuation yet also a radical reworking of rasquache cinema. Mendiola—and others in his generation—find an urgency and visible passion in the radical cultures of the 1960s and 1970s, and they also share the experience of coming into contact with these images and sounds in

familiar (familial) contexts. I characterize Mendiola's approach as one of historical appraisal and strategic assimilation similar in its roots to the imagined alliances of early Chicano filmmakers with New Latin American Cinema, but different in its contemporary and more free-form arrangements of popular cultural image landscapes.

The use of photography in recent Chicano film produces a textured mapping of the historical nature of found and familiar images within both experimental and narrative forms. The films *All Water Has a Perfect Memory* (Natalia Almada, 2001), *Dirty Laundry: A Telenovela* (Cristina Ibarra, 2001), *Coca cola en las venas* (Ana Machado, 2000), and the short videos of Juan Miguel Ramos all employ photography and home movies culled from public archives and family collections. The rush of images—the onslaught of repurposed images from public and private domains—poses a number of questions: To whom do these images belong? How do these conscripted images usually play out in the Latino melodrama or in political documentaries that set out to galvanize cultural affirmation and resistance? How are these images functioning in the so-called post-identity era? I choose Mendiola's work because it consolidates many preoccupations with still imagery and essays other histories of photography.

Mendiola is drawn to early Chicano cinema because it possesses a global imagining that is simultaneously anchored in the local, just as he considers his own work as coming from "the specificity of [his] experience" as a "Chicana/o from a particular place" while still engaging wildly with global pop cultures. During the formative history of Chicano cinema, Third Cinema filmmakers provided for Chicano filmmakers "an alternative geography or conceptual space within which to approach U.S. institutions," which has been interpreted in Chicano film manifestos (Noriega 2000, 160). Current invocations of this "alternative geography and conceptual space" take shape during a time when the socialist ideals that once ignited New Latin American Cinema are considered historical residue and reshaped into Che memorabilia. Mendiola raids the materials of radical cultures of the not too distant past and scatters them freely through multiple references and image arrays. He mixes the metaphors of high and low, but unlike the image scavengers of the past, he writes monologues and dialogues for his (semi)fictional characters that allow an inventory and analysis of what has been inherited, cast away, and conformed to meet the needs of a reference-hungry youth.

Rather than being guided by cultural essentialism, Mendiola's work scatters plural and polyphonic references to expose unexpected affiliations (Aztlán-a-Go-Go, Chicanos and heavy metal, La Raza Unida Party and Ziggy Stardust, etc.) and to foreground relationality.

Jim Mendiola has been making films and videos for the last decade. In that time, he has produced the short *Pretty Vacant* (1996), the feature-length films *Come and Take it Day* (2002) and *Speeder Kills* (2003), as well as a number of video/mixed-media installations in collaboration with the artist Ruben Ortiz-Torres. Mendiola has always played against the expectations of what it means to be a regional filmmaker. Rather than depicting a place unto itself or a local story, Mendiola writes narrative films—with documentary and experimental elements throughout—that center on the subcultural preoccupations of a distinct cultural milieu in San Antonio, Texas. But such a quasi-sociological-sounding statement does disservice to the dynamism, humor, and spirit of Mendiola's work. Perhaps because he is part of the first generation to grow up with MTV and New Latin American Cinema, Chicano studies and "post-identity" discourse, postmodernism and neo-folk, his work looks unlike that of any other Chicana/o filmmaker.

Mendiola has stated that he "was not part of a generation who was influenced by Latin American filmmakers" but that he circuitously discovered Latin American film manifestos of the 1960s through his interest in the early 1990s Dogme manifesto (or cinematic "vow of chastity"). Mendiola set out to transform the tone of the manifestos that inspired him into a depiction of the "politics of San Antonio." He fully acknowledges that the Mexican-American cultural milieu was decidedly different from the "third world oppression" that fueled the 1960s counter-cultural forms of cultural resistance, but the declarative ethos and impoverished aesthetics of manifestos and documentaries synched with his authorial credo: "the style is the budget" (Mendiola 2004).

Part of a generation of makers who represent "multiple and conflicting constituencies," Mendiola has created a digital cinema aesthetic that comes less out of the dialectical montage that structured early Chicano films and more from the hypertextual sites of bulletin boards, websites, and other forms of collage media (López and Noriega 1996, x). His multiplied-media aesthetic comes out of an urgent need to expand a culturally and regionally specific attitude and style. In considering Mendiola's most recent film, *Speeder Kills*, I hope to establish the means by

which a visual strategy akin to a digital bulletin board simultaneously
frames and mobilizes (via rapid arrays and montages of visual infor-
mation) the local and transnational subjects of the film. In referencing
the bulletin board, I call attention to photoanimation techniques of the
past that have aimed to produce coherent audiovisual slide shows of the
family (as) nation, a point I will take up later in the essay.

THE RAW MATERIALS OF CHICANO CINEMA

"Two photographs, a moviola and some music," the Cuban filmmaker
Santiago Alvarez's economically phrased axiom, was born out of scar-
city and conveyed the tactics of immediacy and resourcefulness de-
manded by the Cuban revolution. Congruently, Glauber Rocha's "aes-
thetics of hunger" and a multitude of manifestos scripted furiously by
Latin American filmmakers in the 1960s served as stylistic source ma-
terial and pedagogical tool kits for international diasporic cinema and
marginal media productions in the United States. The epistemologi-
cal and ontological concerns of so-called Third Cinema found critical
impetus among minorities living in the production corridors of com-
mercial films in the United States, and it was from a hungry mix of
photographic source materials and "some music" that a good number of
Chicano newsreels and narratives were born.

The lean look and sound of the first ten years of Chicano films—
in particular *I Am Joaquin* (Luis Valdez, 1969), *Yo Soy Chicano* (Jesus
Trevino, 1972), *Chicana* (Sylvia Morales, 1979), and *Requiem 29* (David
Garcia, 1971), among others—are a testament to collaborative proving
grounds (like El Teatro Campesino) and incipient circuits of profes-
sional development. The manifesto of the Chicano filmmaker and
visual artist Francisco X. Camplis, "Towards the Development of Raza
Cinema" (1975), quoted the Bolivian filmmaker Jorge Sanjinés: "[Latin
American cinema] is a cinema that makes history. It makes history not
only because it rebuilds it, deepens it, and expresses it, but because it
participates in the historical phenomenon, at the same time it influences
it" (1992, 291). Echoing Sanjinés, Camplis championed an active cine-
matic shaping of history—now, thirty years later, Latino filmmakers
are drawn to the raw materials and roughhewn craft that characterized
both the "aesthetics of hunger" of 1960s Latin American film and the
rasquache style of early Chicano film.

Luis Valdez's *I am Joaquin* developed out of the need to translate what started as a modestly cobbled mimeograph to an *acto*[1] with slides and live soundtrack into a mobile grassroots multimedia presentation. Valdez, his cohort in El Teatro Campesino, the photographer (as well as documentary filmmaker) George Ballis, and the poet Rodolfo "Corky" Gonzales all contributed to the cinematic assemblage of the poem, slides, and music. Ballis, a trained journalist, documented the formative years of Cesar Chavez and the United Farm Workers movement. Gonzalez's "Joaquin" is the Chicano everyman who speaks across time and space, tracing the triumphs and defeats of his people, and reflects on the contemporary economic and social dilemmas of contemporary Chicanos. Montages of Ballis's activist images are interspersed with still shots and pans over reproductions of Mexican murals. Rapid editing and layering of historical periods produce a cinematic scrapbook for the cause, la raza.

Rosa Linda Fregoso refers to these seminal Chicano films as "'actos of imaginative discovery' because they work to 're-invent,' 're-cover,' and 're-vision' a lost history for Chicanas and Chicanos" (1993, 1). As she notes, the mechanisms by which these operations of renewal took place were developed out of an already established tradition of teatro and educational presentations. While Fregoso notes that *I Am Joaquin* displays a "unique improvisational style of juxtaposing images" (7), it is important to situate these actos within a long history of documentary film techniques of compilation and photo-animation. Compilation techniques and dialectical montage dating back to Soviet silent cinema and leading up to Latin American cinema aesthetics certainly played a part in the transformation of audio/visual pedagogical techniques into cinematic form. The use of photography and images of murals functioned to consecrate the everyday and seemingly ordinary. Images of farm workers, children playing, and above all the nuclear Chicano family were monumentalized in Chicano murals and in these early films through both cinematic and painterly crosscutting.

Noting the development of means by which to create an affirmative Chicano image, Fregoso writes that the sound and image experiments of *Chicana, Yo Soy Chicano*, and *I Am Joaquin* "construct an 'underlying unity' for Chicanos and Chicanas mainly by imposing an 'imaginary coherence on the experiences of dispersal and fragmentation.'" Further, Fregoso cites Stuart Hall, who wrote about how "such texts restore an

imaginary fullness or plenitude, to set against the rubric of our past" (19). In both the cinematic and mural images, Chicanos could witness Aztec and Olmec faces dissolve into contemporary brown faces that looked very much like their own.

AMALIA AND THE WALL OF IMAGES

To consider the complexities of engineering these connections through cinematic juxtapositions of image and sound, I turn to Don Slater's essay "Domestic Photography and Digital Culture," in which he analyzes the uses of photography in family scrapbooks and bulletin boards and argues that the editing of family images in private inventories "seem[s] capable of shifting private experience from the plane of the mundane, ordinary, insignificant onto a plane of idealized moments and images around which socially significant identities can be formed by people" (1995, 133). I would like to use Slater's writing to launch a discussion on how young filmmakers like Mendiola are retrofitting the raw materials of rasquache cinema to appraise the visual and rhetorical lore of nationalism and to provide an image map of their own network of affiliations.

Mendiola's arrays of photographs and amateur film footage are discursively linked, in the filmmaker's words, to a utilitarian inventory and mobilization of radical techniques—not exclusively from 1960s–70s Latin American film movements and Chicano film but also from various visual cultures of punk and rock zines, and amateur and art photography. In this blending of agit-prop and pop, he follows in the footsteps of early Chicana/o makers who also had a keen eye and ear out for street-level manifestations of culture. What is different about Mendiola's nexus of affiliations is that he comes after the historical moment in which cultural nationalism set the standards for allegiance and authenticity; in other words, he is neither against juxtaposing seemingly contentious quotations nor, like his journalistic hero Greil Marcus, bringing revisionist genealogies to the fore (the "browning" of an underground history of all things pop).

In such films as Valdez's *I am Joaquin* and Morales's *Chicana*, appropriated photographs functioned largely as archetypes, although Morales's feminist revisionism proves more steeped in gender concerns for the personal and political. Mendiola's *Speeder Kills* and his previous indepen-

Still from *Speeder Kills*
(Jim Mendiola, 2003)

dent films, *Pretty Vacant* (1996) and *Come and Take It Day* (2002), find multiple ways to empanel the screen with photographic materials. In these films, the display of photographs conveys an aura of the personal and authentic while producing and mobilizing an image archive about a generation of Latinos who negotiate identity through a range of investments in cultural history and subcultural performance. The photographs and props in Mendiola's films are functional and translational; they are testaments to Latino cultural productions in San Antonio, Los Angeles, San Francisco, New York, and urban points beyond. The fictionalized personas in his films are collections of the filmmaker's own obsessions, materialized with a superabundance of photographic content: 35mm photographs, digital snapshots, photographic collages, Xeroxed flyers with appropriated images, fotoesculturas (photo-sculptures), t-shirts, buttons, zines, film stills, Polaroids, studio photography, slides, 8mm home movies, and stickers.

Both *Pretty Vacant* and *Speeder Kills* feature the conceit of female authorship and self-narration; the former is the alleged Super 8 zine shot by and about Molly Vasquez, a Chicana musician who fronts a band called Aztlán-A-Go-Go, while the latter follows Amalia Ortiz, a video artist on the lam from Rockefeller Foundation officials who are looking for the completed project that they funded two years prior. While living in San Francisco Amalia learns of her grandmother's death and returns to her birthplace, San Antonio. She becomes consumed with her grandmother's legacy—a commercial photography studio—and attempts to resurrect the once fashionable Mexican American (and Latin American) tradition of fotoescultura. Meanwhile, Amalia is located by the Rockefeller Foundation and given an ultimatum—to finish her commissioned project on "the exciting confluence of Latino youth culture

Super-8 movie still from Amalia's
film within the video, *Speeder Kills*
(Jim Mendiola, 2003)

with mainstream America" or risk legal consequences. Amalia finds her epiphany on a brick wall plastered with Xeroxed flyers and homemade stickers all announcing local rock shows. She will complete a conceptual video portrait of a local indie rock band, Speeder, fronted by Ramones-worshipping Chicanas. The film's finale mixes 1960s documentary jamming tactics (à la Haskell Wexler's *Medium Cool*, 1969) with a dose of 1980s nostalgia in the form of an extended quotation from John Hughes's *Ferris Bueller's Day Off* (1986).

Amalia's film within the video, *Here's My Life in 200 Seconds*, is a mock-up collage of an identity in flux—yes, her images are the images of middle-class Mexican American family life in a newly transformed ("browned") suburb. Amalia, the compilation character, is a hodgepodge of cultural references, subcultural stances and styles, a portrait made up of hundreds upon hundreds of poses and fragmented expressions. Amalia is also the voice—the narrator of this fake documentary—and presenter on all "things cultural and pop."

Mendiola embeds photographs within the frame to supply extratextual knowledge of cultural phenomena that exceed the parameters of his staged autobiographies. His treatment of space—as frames within frames or as stage for the rapid montage of documentation—echoes Pierre Nora's claim that "representation proceeds by strategic highlighting, selecting samples and multiplying examples" (1989, 17). Photography moves from the realm of the allegorical to an active site where "retrospective, selective, and coded" images produce levels of association for the viewer. I characterize this as a shift from the organized and hierarchical frame of family (as) nation, herein affiliated with the slide show (and thus the Chicano cine-actos), to the dispersed and mutable space of the bulletin board (Langford 2001, 65).

Throughout *Speeder Kills*, arrays of photographs surround and confront Amalia. In reality, these snapshots of San Antonio youth involved in the music and art scenes come from the private collections of Mendiola and the artist Juan Miguel Ramos. Photos double as signifiers of material history *and* as extratextual details that establish the fictional characters. Thus Mendiola is able to negotiate his double task of rendering a portrait that is both particular and general. The early films of Chicano producers used rephotographed images of visual art reproductions and photojournalistic images to galvanize the interconnected movements of political resistance and cultural affirmation. The representation of Mexican muralism in the historical revisions of Chicano cinema, by contrast, serve as legitimizing sources (to historicize Aztlán).

The use of photo-animation and rephotography allowed Chicana/o filmmakers to scale the epic on a nonexistent budget. Similarly, mural art rendered the barrio larger than life, and its citizens were scripted into what became a distinctly working-class representational form. The use of images in contemporary film and video asks us to destabilize the iconicity of the image, as in the critical appraisal of nationalism, and to approach the indexical relationship of the photograph to the photographed. In early Chicano films, photographs became shorthand for an ideology of affirmation and resistance, chiefly through the pacing of the slideshow and its reliance on the orchestration of images according to different musical moods/tones, or through the interplay of a text with the images in an illustrative or ironic mode.

As "props" that provide detailed geographies for a cast of characters, the photos in *Speeder Kills* move from the megaspace of a cohesively rendered ethnic subject to a micromap of events, personalities, attitudes, and cultural stances. According to the photography scholar Don Slater, the family album "represents a process of editing images into icons and narratives through which a familial identity is constituted and stabilized." By contrast, the bulletin board "evokes a haphazard, ephemeral and shifting collage which is produced by and within the activities of the present. The photograph takes its place within a flow of other images—photographic and non-photographic, public and private" (139). The liminality of his narrative form and its accompanying layers of photographic display (documentary portraits woven into his fiction) allow Mendiola to move seamlessly from a documentary resonance to

fiction. Photographic technologies are remade as "narrative textualities" (Corrigan 1997, 314).

Mendiola is particularly interested in the framing of Mexican Americans in the history of photography. The sequences that feature archival photography in *Speeder Kills* all stem from a research project commissioned by the Guadalupe Center for the Arts in San Antonio. His Secret Archives project was originally to result in a video essay on the thousands of photographs in the Institute of Texas Cultures. The surplus of photographs represented for Mendiola the missing photographs of Mexican American cultural memory and stood in contrast to the more dominant "FSA ... social issue type of photos that usually depict Mexican Americans at the time ... you know those Roy Stryker documents of poor unsmiling Mexican Americans living in abject poverty ... because of the exposure to my own family archives (my mom was an avid picture taker from her junior high years on), I knew that even though we came from very humble and rural and poor beginnings the pictures I saw reflected happiness, pride, birthday parties, hanging out with friends, etc, etc, a kind of life never reflected by the socially conscious do gooder photogs" (Mendiola 2005).

I am interested in the historiographic function of Mendiola's intermedia as it relates to the role of media artist of color in the archive. This performative relationship with institutional and ad hoc archives is perhaps best represented in the scripting of Amalia's grandmother Irma Ortiz. Although loosely based on Mendiola's mother, the successful Mexican American businesswoman and image maker fictionalized in a montage of photographs is perhaps the filmmaker's most utopian historical flourish. Mendiola transforms the anonymous (yet seemingly familiar) documents culled from his research at the Institute of Texas Cultures into memories. Again in that choreography of the general and the particular, Mendiola commemorates a public sphere—a range of cultural, economic, and aesthetic traditions owned by the Mexican American middle class—and places a female protagonist with agency and a camera as its trusted documentarian. As Mendiola states, "Those pictures were chosen very specifically to suggest a life in the '50s that included all-American things like birthday parties and baseball. A lot of my ideas are about hybridity and participating in an American discourse, but it's not new—there were always Mexican-Americans participating in what's perceived now as white cultural expression" (Garibay 2003,

Still from *Speeder Kills*
(Jim Mendiola, 2003)

45). In his reimaging, Mendiola suggests the gendered maintenance of cultural memory in both "domestic and geopolitical spaces" (Saldivar 1997, 87).

Somewhere between the acts of compiling and constructing, documenting and fabricating, Mendiola has created a mutable site on which images accumulate and trigger connections. The compilation narrative and its resulting bulletin board aesthetic give Mendiola license to strategically sample performance footage, documentary techniques, and generic conceits. As Slater suggests, "rather than a narrative or shrine, the pin board (bulletin board) evokes a haphazard, ephemeral and shifting collage which is produced by and within the activities of the present . . . the photograph takes its place within a flow of other images—photographic and non-photographic, public and private" (139).

Amalia's role is to make sense of these images, "the haphazard, ephemeral and shifting collage" that surrounds her. As a distracted documenter of "all things pop," Amalia starts (and abandons) a number of short projects (all films within the film). In one sequence, Amalia gets over one of her many creative blocks and begins work on an experimental documentary about the band Speeder. Photographs are videotaped, processed, and repurposed. In contrast to critiques wherein digital video's totalizing "coverage" creates an ahistorical space, the densely populated frame functions here as a dynamic site to model the intersections of popular culture and cultural memory. The montage illustrates the processing of cultural memory in Amalia's attempt to make sense of the historical images that surround her. She positions a film still of the Mexican diva Maria Felix alongside the girls in Speeder to animate the transhistorical resemblance of mestiza glamour and self-transformation.

In this scene, Amalia inhabits what the art historian Jennifer A. González has called autotopographical space. Autotopographical spaces, as González describes, are "private-yet-material memory landscapes" (González 1995a, 133). González refers to home altars and shrines, but I see productive similarities in the image-saturated world created for a number of Mendiola's filmic protagonists. The level of detail is well plotted; *Speeder Kills*'s script describes in detail the contents of Amalia's old-fashioned suitcase: "disparate images of Ana Mendieta, Niñon Sevilla, Mia Zapata, Love and Rockets' #24, Lydia Mendoza, the cover of Aztlán-a-Go-Go's "Romantic Young Girls" CD, and Bob Dylan."

The characters—and their narrative concerns—evolve against the backdrop of a densely populated object world. Mendiola set the precedent in his short film *Pretty Vacant*, a "self-portrait" of a young Chicana artist named "La Molly" Vasquez. As in *Speeder Kills*, *Pretty Vacant* does not simply mimic a twenty-something's experimental film diary but must add a generic twist—a profound and profane quest for "relics" left in a San Antonio country and western bar by the Sex Pistols on their only tour through the United States. Molly's pursuits pile up and are loosely glued together in a zine where she pays tribute to both the Mexican poet Sor Juana Ines de la Cruz and Johnny Rotten, all in the baroque space of one page. Mendiola's own baroque agenda is really what is figured here through so many alter personas thick with layers of subcultural quotations.

In both *Pretty Vacant* and *Speeder Kills* a "retinal, televisual memory" is located—even if temporarily—in the feminist spaces of Molly's room and zine and Amalia's source materials and aborted projects (Nora 1989, 17). The objects are both filmic props and the material proofs of personalities that inhabit the filmmaker's life. Mendiola uses the force of extratextual minutiae in a back-and-forth dialogue between what is constructed for the film's narrative and what is assembled from his own archive and research tapes.

Mendiola is not alone in this preoccupation with digital film's intertextual relationship with photography. The insatiable need to represent—the impulse to use the imagery and narratives unconsidered by mainstream commercial film—has been a longstanding one in the media content of makers of color. The family photograph or the images of cultural heritage (historical photographs culled from regional archives) have often served the weighty purposes of authenticating, tes-

tifying, and magnifying the contributions of marginalized peoples—in both documentary and narrative formats.

In his essay on post-photography, Geoffrey Batchen writes that the artist's use of photography has taken on "a memorial role, not of the subjects it depicts but of its own operation as a system of representation" (2002, 111). In Mendiola's film, the main character learns that it is not merely the photographic objects or practices (e.g., fotoescultura) that sustain history but the drive to represent one's surroundings—in other words, the drive is not to suspend these practices in amber or to freeze the moment in photography or sculpture but rather to keep on innovating ways of making individual and collective (obviously interlaced) faces and stories known. In Mendiola's films photographs are signs of transactions and sites of exchange rather than unifying and consolidating tools. They trace the move from the Chicano family album to the bulletin board, from the family album of Slater's configuration where the frame "represents a process of editing images into icons and narratives through which a familial identity is constituted and stabilized" to a space of multiplicity (138).

Noriega has noted that the history of racial and ethnic categories has not kept up with social practices, and the same can be extended to the representational strategies of mainstream Latino narrative films (Noriega 2004). Mendiola strives to be present with still and video cameras to document the social practices that are already far beyond our categorical strictures. The photographs and film relics in *Speeder Kills* come from a surplus of memories that link historical and personal images of Mexican Americans. This vast emporium of images surrounds the characters and constitutes the audience's ability to fabricate its stance, attitude, and convictions. As the credits run on *Speeder Kills*, we come face to face with hundreds of images of twenty-something (plus) Tejanas and Tejanos striking poses—at turns fierce, comical, sexy, and bored.

In reference to the impoverished and agitative aesthetics of the Chicano performance group Asco and their film stills for nonexisting films, the No Movies, Noriega suggests that these conceptual documents "served as a pointed reminder that Chicano cinema had perhaps foregrounded the politics of access and revolution at the expense of the make-do aesthetics and local orientation of the Chicano movement" (2000, 200). Mendiola's far-reaching inventory of all things "pop" and

Photo wall end credits from
Speeder Kills (Jim Mendiola, 2003)

radical conveys a retrospective discursive framing of Chicano film that places experimentation and community building at center stage. Mendiola's "style as budget" credo and his multiple image sources reflect and renovate the project of an ethnically specific (or affiliate) media. In his films, Mendiola places snapshots and family/familiar footage in the spaces between narrative film and documentary, between the particular and the general, and between invocations of authentic subjectivities and subcultural aesthetics, or as Jennifer González has put it, on "the frontier between . . . the 'authentic ethnic' and the 'self-critical avant garde'" (González 1995b, 22).

NOTE

1 An *acto* is a short theatrical form much like a vignette that Chicano playwrights and theatrical groups began to use to address social and political issues in a humorous and parodic manner.

working
between media

PHOTOGRAPHY'S EXPANDED FIELD

George Baker

begin not with a negative, nor with a print, but with a screen. On the screen can be seen a landscape, a campus it seems, identified by cheerful signage and imposing brutalist buildings. This is a screen in motion, as the view begins to rotate, parading before us the series of changing buildings but also the denizens of this place: various youth, students both bohemian and conformist, potential professors, security and police. Along with the bodies, the camera scans automobiles not so much in motion as sentenced to their destruction, car wreck after car wreck, an obvious homage both to one of the great moments in the history of photography, Andy Warhol's use of catastrophe photographs in his series "Death in America," and to one of the great moments in the history of cinema, Jean-Luc Godard's infamous eight-minute tracking shot of wrecked automobiles in the film *Weekend*. And yet if the cars here do not move, neither do the people; both wrecked object and frozen subject simply pass by in an endless scroll, punctuated repetitively by one accident after another, a revolution that reaches its end only to loop and repeat itself again. Indeed, the strangely static moving-image work in question, Nancy Davenport's *Weekend Campus*, 2004, was made by a photographer; it consists entirely of a scanned series of photographic still images and was positioned as the introductory piece in a recent exhibition otherwise given over to digital photographic prints.[1]

Everywhere one looks today in the world of contemporary art, the photographic object seems to be an object in crisis, or at least in severe

transformation. Surely it has been a long time now since reformulating the history and theory of photography has seemed a vital intellectual necessity, an art historical project born rather of the new importance of the photograph in the art practice of the 1970s and 1980s. As theorized then, postmodernism could almost be described as a "photographic" event, as a series of artistic practices were reorganized around the parameters of photography taken as what Rosalind Krauss has recently called a "theoretical object": the submission of artistic objects to photography's logic of the copy, its recalcitrance to normative conceptions of authorship and style, its embeddedness within mass cultural formations, its stubborn referentiality and consequent puncturing of aesthetic autonomy (Krauss 2003a). With hindsight, however, we might now say that the extraordinary efflorescence of both photographic theory and practice at the moment of the initiation of postmodernism was something like the last gasp of the medium, the crepuscular glow before nightfall. For the photographic object theorized then has fully succumbed in the last ten years to its digital recoding, and the world of contemporary art seems rather to have moved on, quite literally, to a turn that we would now have to call cinematic rather than photographic.

We exist in a quite different moment from that described by Rosalind Krauss twenty-five years ago in her essay "Sculpture in the Expanded Field": the elastic and "infinitely malleable" medium categories decried by the critic then seem not to be our plight (Krauss 1985, 277). Critical consensus would have it that the problem today is not that just about anything image-based can now be considered photographic but rather that photography itself has been foreclosed, cashiered, abandoned—outmoded technologically and displaced aesthetically. The artist stars of the present photographic firmament are precisely those figures, like Jeff Wall, who reconcile photography with an older medium like history painting, in a strange reversal of photography's former revenge on traditional artistic media; or those who, like Andreas Gursky, have most fully embraced the new scale and technology of photography's digital recoding (this is hardly an opposition of possibilities: Wall has also embraced the digital, and Gursky is also a pictorialist). And even the most traditional of a younger generation of contemporary photographers cannot now resist the impulse to deal the concerns of other mediums into their practice, less utilizing photography to recode other practices than allowing the photographic to be recoded in turn, as when Philip-

Lorca di Corcia lights his street photography with the stage lights of theater or cinema, or Thomas Demand now accompanies his constructed photographic simulacra with equally simulated projections placing his constructions into motion, or Rineke Dijkstra feels compelled to place video recordings of her portrait subjects alongside their photographic inscriptions. Even among those artists then who continue in some form the practice of photography, today the medium seems a lamentable expedient, an insufficient bridge to other, more compelling forms.

And yet I am pulled back from the finality of this judgment, from this closure of the photographic, by the strange vacillation in the Davenport work with which I began. How to describe its hesitation between motion and stasis, its stubborn petrifaction in the face of progression, its concatenation into movement of that which stands still—its dual dedication seemingly to both cinema and photography? It is this hiccup of indecision, whether fusion or disruption, that I want to explore here. For it seems that while the medium of photography has been thoroughly transformed today, and while the object forms of traditional photography are no longer in evidence in much advanced artistic practice, something like a photographic effect still remains—*survives*, perhaps, in a new, altered form. And if we could resist the object-bound forms of critical judgment and description, the announcement of a medium's sheer technological demise, we might be able to imagine critically how the photographic object has been "reconstructed" in contemporary practice—an act of critical imagination made necessary by the forms of contemporary art, and one that will not answer to either technological exegesis or traditional formalist criteria.

To "reconstruct" one's object: this is a structuralist vocation, as long ago described by Roland Barthes, and it was precisely the critical gesture made twenty-five years ago in Krauss's demonstration "Sculpture in the Expanded Field."[2] At a moment today when the photographic turn in theories of postmodernism no longer seems so dominant, this other explanatory device from that era—the notion of postmodernism as opening onto a culturally and aesthetically "expanded field" of practice—only gains in usefulness.[3] And yet it is striking to me that the explanatory schema of postmodernism's expanded field was never, to my knowledge, put into place to explore the transformation of photographic practice undergone twenty-five years ago, during the early years of aesthetic postmodernism, this event otherwise sensed by critic after critic

as a photographic one. Surely, writers like Abigail Solomon-Godeau absorbed Krauss's critical lesson and described postmodern photography as opening onto an "expanded" rather than reduced field of practice; and yet the precise mapping of this expansion was never essayed, nor concretely imagined.[4] If today the object of photography seems to be ever so definitively slipping away, we need to enter into and explore what it might mean to declare photography to have an expanded field of operation; we need to trace what this field has meant for the last two decades of photographic practice, in order to situate ourselves with any accuracy in relationship to the putative dispersal—whether melancholic or joyful—that the medium today is supposedly undergoing.

Perhaps photography's notorious epistemological slipperiness—think of the famous difficulty faced by Roland Barthes throughout the entirety of his book *Camera Lucida* to define in any general way the object of his analysis—inherently resists the structural order and analysis of Krauss's expanded field. Perhaps, indeed, photography's expanded field, unlike sculpture's, might even have to be imagined as a group of expanded *fields*, a multiple set of oppositions and conjugations, rather than any singular operation. And yet it is striking how consistently photography has been approached by its critics through the rhetoric of oppositional thinking, whether we look to the photograph as torn between ontology and social usage, or between art and technology, or between what Barthes called denotation or connotation, or what he also later called punctum and studium, between "discourse and document" (to use an invention of Benjamin Buchloh's), between "Labor and Capital" (to use one of Allan Sekula's), between index and icon, sequence and series, archive and typology. One could go on.

This tearing of photography between oppositional extremes is precisely what we need to begin to map an expanded field for its practice, and indeed any one of the above oppositions might serve as this field's basis. However, in the very first art historical essay I ever published, I introduced my own opposition into the mix, an exceedingly general as well as counterintuitive one, but an opposition intended nevertheless to encompass many of the terms just mentioned between which photographic history and practice has been suspended since its invention. In an essay otherwise devoted to an analysis of the photography of August Sander, I asked when would it become necessary to conceive of the photograph as torn between narrative, or what I also called "nar-

rativity," and stasis (Baker 1996). The question was counterintuitive, for the frozen fullness of the photographic image, its devotion to petrifaction or stasis, has seemed for so many to characterize the medium as a whole. And yet, by the moment of the early twentieth century, it had become impossible not to think of all the ways in which the social usage of photography—its submission to linguistic captioning, its archival compilations, its referential grip on real conditions of history and everyday life, its aesthetic organization into sequence and series—thrust the photographic signifier into motion, engaging it with the communicative functions of narrative diegesis, the unfolding of an unavoidable discursivity.

"Photography between narrativity and stasis," I called this condition, isolating its emplacement within the aesthetics of Neue Sachlichkeit at the moment of high modernism, an aesthetic, in Sander's case, torn between the narrative dimensions of his archival compilation of portraits, and its typological repetitiveness, its inability to avoid freezing its own diegesis through the systematic and serial deployment of identical poses, formats, and types. While Sander's engagement with a kind of narratological, even literary "noise" in his photography might be dismissed as one sign of Neue Sachlichkeit's antimodernism, his project complicates such a judgment by rupturing every claim it makes to narrative cohesion, and by simultaneously rupturing its supposedly photographic dedication to immobility or stasis. In the twentieth century, this had been an unnoticed but increasingly unavoidable condition for photography. While Roland Barthes had always wanted to separate a narrative art such as cinema from the different temporality of the photograph, he was always also unsure that a specific "genius" of photography in fact existed, and in his own most thrilling criticism he would be unable to keep the cinematic and photographic apart at all. For when he would look to find the genius of cinema in a series of films by Eisenstein, he would of course focus all his attention on the photographic film still, in which he would locate the paradoxical essence of the "filmic" (in the essay "The Third Meaning"); and in his book *Camera Lucida*, the genius of photography would ultimately turn out to be its creation, in what Barthes began to call the photographic "punctum," of a movement onward and away from the image that Barthes also called the image's "blind field," a property he had otherwise earlier reserved in his book for the medium of film.

It is this rending of photographic language between the movements of narrative and the stoppage of stasis that might become visible today as a structuring condition for modernist photography as a whole. Applicable both to artists of the avant-garde and the *retour à l'ordre* (return to order), this is a condition that we sense structuring the Soviet model of the photo-file (Rodchenko), as much as the FSA legacy of the photo novel (Walker Evans). It haunts every attempt by the modernist artist to create a medium of visual communication, and the various sequencing and captioning schemes that were devised for so doing. It simultaneously haunts every counterattempt by other modernist schools of photography to invent modes of silencing the photograph's referentiality, of inducing the photographic image to a more pure and purely visual stasis, a condition and a limit that no modernist photograph in the history of the medium, however, was ever able truly to achieve. In this way, the modernist usage of photography—what we could call its *rhetoric*—seems to result in a general condition of double negation like that which we find more specifically in the case of Sander. The modernist photograph seems suspended in the category of the neither/nor: it is either that object that attempts to produce narrative communication only to be disrupted by the medium's forces of stasis, or it entails the creation of a static image concatenated by the photograph's inherent war between its own denotative and connotative forces.

Another, less confusing way of generalizing this condition is to depict modernist photography as suspended between the conditions of being neither narrative nor fully static; the modernist photograph is that image which is paradoxically then both a function of *not-narrative* and *not-stasis* at the same time. My terms here begin to echo the logical conjugation explored by Krauss in her "Sculpture in the Expanded Field." As was the case with her structuring opposition for (modernist) sculpture of "not-landscape" and "not-architecture," the depiction of modernist photography as being suspended between not-narrative and not-stasis has a compelling interest. For, like the terms *landscape* and *architecture*, these two terms open onto what we could also call the "built" (or constructed) and the "non-built," with narrative signaling something like the cultural dimension of the photograph, and stasis its unthinking "nature" (Barthes's terms *connotation* and *denotation* are not far away). This opposition of nature and culture has long been one around which theories of the advent of postmodernism themselves turned, and in

photography history it would seem that it was the gradual relaxing of the rending suspension of photography between the conditions of not-narrative and not-stasis that would signal the emergence of postmodernism in photographic terms: the reevaluation in the 1970s of narrative functions, of documentary in all its forms, and of many types of discursive framings and supplements for photographic works.

In "Sculpture in the Expanded Field," Krauss utilized the mathematician's Klein group or the structuralist's Piaget group to open up the logical opposition she had constructed. I will paraphrase her terms and her usage of this structure here. For if modernist photography was somehow caught between two negations, between the conditions of being neither truly narrative nor static in its meaning effects—if the modernist photograph had become a sum of exclusions—then this opposition of negative terms easily generates a similar opposition but expressed positively. That is, to adopt Krauss's language, "the [*not-narrative*] is, according to the logic of a certain kind of expansion, just another way of expressing the term [*stasis*], and the [*not-stasis*] is, simply, [*narrative*]." The expansion to which Krauss referred, the Klein group, would then transform a set of binaries "into a quaternary field which both mirrors the original opposition and at the same time opens it up" (283). For modernist photography, that expanded field would look like this:

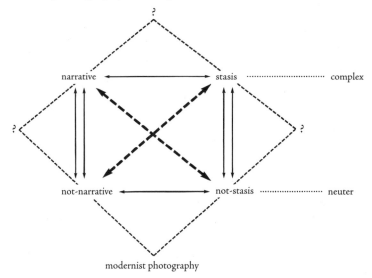

modernist photography

Now, I have been drawing Klein groups and semiotic squares ever since I first met Rosalind Krauss, sitting in her office conjugating the

semiotic neutralization of things like the terms *gender* and *sexuality*, some twelve years ago. When I first drew this particular graph, however, about two years ago, I was at first unclear as to what new forms might correspond to the expanded field of which modernist photography, with its medium-specific truths, was now not the master term, but only one displaced part. The graph became immediately compelling, however, when I began to think of the major uses to which the photograph had been put in the most important artistic practices to emerge since the mid- to late 1970s, after the closure of modernism and the legitimization of avant-garde uses of photography by movements such as conceptual art.

I was struck, first, by how the so-called Pictures generation of artists (Douglas Crimp's term) most often foregrounded the use of the photograph as a self-conscious fragment of a larger field, the most compelling example of this being of course the untitled "film stills" of Cindy Sherman. Such works were photographic images that, crucially, would not call themselves photographs, and that would hold open the static image to a cultural field of codes and other forces of what I am calling *not-stasis*. At the very same moment, however, postconceptual uses of projected images would see an artist like James Coleman producing, in the 1970s, works based directly on narrative cinema, works that would, as in *La Tache Aveugle*, 1978–90, freeze the cinematic forms of movement into still images to be projected over long delays; or that would eventually freeze films more generally into the durational projection of continuous still images; or, in Coleman's most characteristic working mode, would seize upon slide projections with poetic voice-overs continually disrupted in their narrative diegesis by the frozen photographic forces of what I have been calling *not-narrative*.[5] Two expansions of my quaternary field had thus been spoken for, the schemas of *narrative* and *not-narrative* as well as *stasis* and *not-stasis*, and the uncanny connection—but also the opposition—that had always puzzled me between the projects of Sherman and Coleman logically explained. More puzzling, perhaps, was what the structuralist would call the "complex" axis of my graph, the inverted expression of the suspension of modernist photography as a sum of exclusions, neither narrative nor stasis in its neuter state. What would it mean to invert this exclusion, to locate a project not as the photographic suspension between the not-narrative and the not-stasis but as some new combination of both terms, involving

both narrative and stasis at the same time? But of course Sherman and
Coleman in the late 1970s have a rather compelling and logical counter-
part in the claiming of new uses for "photography," even if the medium-
specific term now evidently needs to be reconsidered; if Sherman claims
the "film still" and Coleman the "projected image," Jeff Wall's appro-
priation then of the advertising format of the light-box for his image
tableaus arrives as yet another major form invented at precisely that
same moment which now seems to complete our expanded field.

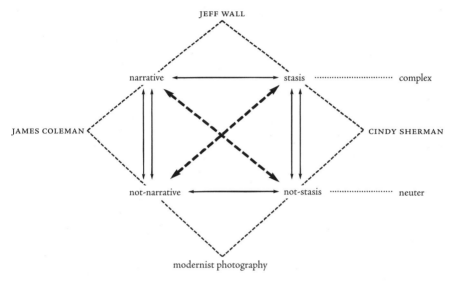

Critics have often wondered about the operation of the condition of
pastiche in Wall's images; they have wondered too about his reclama-
tion of history painting, disparaging his aesthetic as the false resuscita-
tion of the "talking picture."[6] These questions too we can now answer, as
Wall's aesthetic gambit was to occupy the complex axis of photography's
expanded field, positioning his own practice as the logical and diametric
inversion of modernist practice, as opposed to the oblique continuation
of at least partial forms of modernist disruption in the opposed projects
of Coleman and Sherman (the not-narrative in the one, the not-stasis
in the other). Two artists here, then, move obliquely away from and yet
thus manage to continue the critical hopes of modernism; the other
simply inverts its terms, allowing the ideological exclusions of modern-
ism to shine forth without disruption.

It is clear to me now that in the art of the last ten years, rather than
speaking tendentiously, as critics are wont to do, about the "influence"

of Cindy Sherman on a younger generation of photographers, or Coleman's or Wall's "impact" on contemporary art, we should be instead tracing the life and potential transformation of a former medium's expanded field. We are dealing less with "authors" than with a structural field of new formal and cultural possibilities, all of them ratified logically by the expansion of the medium of photography.

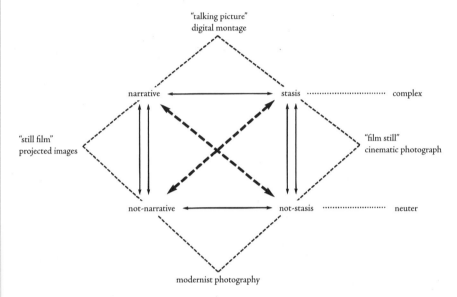

For the positions occupied by the great triumvirate of postmodernist "photographers" in the late 1970s have themselves spawned the more general birth of new forms we have witnessed in recent years. By the moment of the early to mid-1990s, a whole generation of artists using photography began to mine the possibilities of *stasis* and *not-stasis*, embracing the impulse to what could be called "counter-presence" that such an action upon the photograph provides, pushing the still image always into a field of both multiple social layers and incomplete image fragments. And so it will be apparent now that the intense investment in what might be called the "film still" or what I will call the "cinematic photograph" in contemporary art lies not in the closure of photography *tout court*, but in an expansion of its terms into a more fully cultural arena.[7] Thus we witness the mad multiplication of connotational codes within a single still image (the project in the 1990s, most conspicuously, of Sharon Lockhart's photographs); or the opening of the still image onto manipulations from other cultural domains (such as the Danish

artist Joachim Koester's use of the blue filters popularized by the di-
rector Truffaut in the former's series *Day for Night*, or the sci-fi menace
of the Norwegian artist Knut Åsdam's nighttime documents of urban
housing projects). The latter work by Åsdam has been presented as
both an open-ended series of photographic prints but also, significantly,
reconfigured into slide projections where the sequencing and narrative
possibilities discovered would lead to the artist's subsequent dedication
to producing semi-narrative films.

Thus, singular artists will now occupy opposing and quite different
positions within this expanded field; Lockhart for one, is known for
her production of not only cinematic photographs but also a series of
nearly static films, like *Teatro Amazonas*, that we can call instead of
the film still the "still film."[8] Both the still film and many forms of the
projected image began to give expression, at the same moment in the
mid-1990s, to the possibilities opened up by the specific combination
of *narrative* and *not-narrative*. For during the last decade, the projected
slide sequence has attracted a whole new group of adherents, an ex-
ample again being an artist usually associated with another aspect of my
field, namely, Joachim Koester's use of found slides abandoned at the
developers to create fleeting narratives. New forms will be invented in
each position within the field. Tacita Dean's frozen films might occupy
this position of *narrative* and *not-narrative* along with Lockhart's, just
as Dean will devote as much of her practice to still photography as the
photographer Lockhart does to film. And Douglas Gordon's "slowed"
films—reducing in their most extreme versions the narrative cinematic
product to the foundation of the still frame through extending films
to play-times of twenty-four hours or even a time-span of years—will
occupy the position of the "still film" just as much as Lockhart's *Teatro
Amazonas*. For even though one project may depend upon *video* and the
other on *film*, both are actually linked conceptually to a field mapped
out by the expansion of *photography*, to which, however, neither of them
will of course correspond.

The "talking picture" or complex axis of our field—the fusion of *nar-
rative* and *stasis*—has encompassed the most wild variety of solutions in
recent years, from the painterly manipulations of digital montage (from
Wall to Davenport and others), to the large-scale Hollywood tableaus
of the school of Gregory Crewdson (i.e., Anna Gaskell, Justine Kur-
land, et al.), to the invention of what I would call the "narrative caption"

in the photographic projects of artists as diverse as Andrea Robbins and Max Becher to the Irish artist Gerard Byrne, whose images are often accompanied by the most incontinent of supplements.[9] In addition to digital recoding and linguistic supplements, new forms will be invented here as well, even if pastiche will most often be their domain: one thinks of the *Five Revolutionary Seconds* or *Soliloquy* series of Sam Taylor-Wood, panoramic still photographs made by a special camera which rotates over time and through space, often restaging historical paintings, and which are most often accompanied, upon exhibition, by wall-mounted speakers spouting literal soundtracks. Here is a picture where the condition of "talking" has been taken, seemingly, as far as it can go, and where the complex field, the fusion of both/and, perhaps cries out for a renewed dedication to disruption once more (the negation of the "not").

Thus, to borrow Krauss's phrasing one last time, "[*Photography*] is no longer the privileged middle term between two things that it isn't. [*Photography*] is rather only one term on the periphery of a field in which there are other, differently structured possibilities" (Krauss 1985, 284). That this is a cultural as opposed to merely aesthetic field is something that certain recent attempts to recuperate object-bound notions of medium-specificity seem in potential danger of forgetting. This is one reason why I have felt it necessary to recuperate the model of the expanded field, and to map its photographic dimension in this essay. I am not so much worried about the return of ideas of the medium in recent essays by Krauss or Hal Foster—in Krauss's work, this concern never really disappeared—for the idea of the medium that these critics are trying to explore seems fully in line with the expansions mapped in their own earlier work (in fact, seen in retrospect, "Sculpture in the Expanded Field" amounts to a profound meditation on what a medium in the era of postmodernism might be). But their breaking of a postmodernist and interdisciplinary taboo has let loose a series of much more conservative appeals to medium-specificity, a return to traditional artistic objects and practices and discourses, that we must resist.

The problem is not to "return" to a medium that has been decentered if not expanded. The problem, as Foster remarked upon Krauss's essay now quite a long time ago, is to resist the latent urge to "recentering" implicit in the expanded field model of the postmodern in the first place.

In the "Expanded Field," Foster wrote, "the work is freed of the term 'sculpture'... but only to be bound by other terms, 'landscape,' 'architecture,' etc. Though no longer defined in one code, practice remains within a *field*. Decentered, it is recentered: the field is (precisely) 'expanded' rather than 'deconstructed.' The model for this field is a structuralist one, as is the activity of the Krauss essay ... 'The Expanded Field' thus posits a logic of cultural oppositions questioned by poststructuralism—and also, it would seem, by postmodernism" (Foster 1984, 195). This problem is ours now too. If the photographic object seems in crisis today, it might now mean that we are entering a period not when the medium has come to an end, nor where the expanded field has simply collapsed under its own dispersal, but rather that the terms involved only now become more complex. For as I hinted earlier, other expanded fields for photography may be possible to envision than even the one mapped quickly here, an example of which I would point to in the spatial (as opposed to temporal) expansion of the photograph we perhaps face in practices stemming from Louise Lawler to younger artists like Rachel Harrison, Tom Burr, and Gabriel Orozco (think, for example, of the latter's *Extension of a Reflection* or his work *Yielding Stone*). Given these potential expansions, we need now to resist both the "lure of the object" and the traditional medium in contemporary art. We should not retreat from the expanded field of contemporary photographic practice; rather we should map its possibilities, but also deconstruct its potential closure and further open its multiple logics. At any rate, when I first sketched my graph for the artist with whom I began, Nancy Davenport, she quickly grabbed my pen and paper and began to swirl lines in every direction, circling around my oppositions and squares, with a look that seemed to say, "Well, what about these possibilities?" My graph was a mess. But the photographer's lines, while revolving around the field, had no center, and they extended in every direction.

NOTES

1 Nancy Davenport, "Campus," Nicole Klagsbrun Gallery, New York, March 5 to April 3, 2004.

2 "The goal of all structuralist activity, whether reflexive or poetic, is to reconstruct an 'object' in such a way as to manifest thereby the rules of functioning (the 'functions') of this object. Structure is therefore actually a *simulacrum* of the object,

but a directed, *interested* simulacrum, since the imitated object makes something appear which remained invisible, or, if one prefers, unintelligible in the natural object." Barthes 1972, 214–15.

3 Krauss's schema has been revisited recently by Anthony Vidler in an essay on contemporary architecture (see Vidler 2004, 142–47); and it has been returned to only to be critiqued by Anne Wagner in a recent essay on 1970s sculpture (see Wagner 2004).

4 "Photography after art photography appears as an expanded rather than a diminished field," Solomon-Godeau wrote in "Photography after Art Photography," in Wallis 1984, 85.

5 While Coleman would only be widely recognized for his "projected images" (the artist's term) in the 1990s, his first uses of the slide projection with voice-over date to the early to mid-1970s, e.g., *Slide Piece*, 1972, and *Clara and Dario*, 1975.

6 See Krauss 2003b, 177–78, and 183: "The role of pastiche within postmodernism has long been an issue of particular theoretical concern. . . . Ever since my first experience with Wall's *Picture for Women* (1979), a restaging of Manet's *Bar at the Folies-Bergère*, I have been interested in accounting *structurally* for this condition in his work." The expanded field explored in the present essay would seem to provide this structural explanation.

7 It is true that Wall invokes the "cinematic" quite often in discussing his images. And while all the axes of photography's expanded field open potentially onto cinema through the folding of narrative concerns into the photographic construct, Wall's cinematic images and their progeny need to be rigorously distinguished from that category of work that I am here calling "cinematic photographs." While such images hardly engage with the actual cinematographic motion of the "still film" or "projected image," they also refuse the singularity and unified nature of the tableaus of photographers like Wall or Gregory Crewdson. Their engagement with cinema leads to an embrace of the fragment, of absence, discontinuity, and the particular phenomenology of what can be called "counter-presence." That said, it must also be admitted that Wall's aesthetic production is hardly monolithic, and like almost all of the artists under consideration here, many of his works—especially those conceived in series, like his *Young Workers* photographs (1978–83)—would belong to other axes of photography's expanded field than the primary one asserted here.

8 This is a term coined, I believe, by Douglas Crimp to account for similar work in the 1970s (his example is a film by Robert Longo); see Crimp 1984, 183. The reversibility of film still and still film is already fully recognized by Crimp in this essay from 1979 (written, then, in the same year as Krauss's publication of "Sculpture in the Expanded Field").

9 On Byrne's work, still unfortunately underknown in the American context, I point the reader to Baker 2003c.

WEEKEND CAMPUS

Nancy Davenport

The scene begins with a Parisian couple driving in their sports car, on route for a weekend in the countryside. They encounter a congestion of cars blocking the roadway. They are planning to kill the woman's parents for an inheritance and are impatient to be on their way. In one long continuous take, the camera tracks the slow progress of the couple's car as they bully their way through the honking line of stalled automobiles, frustrated drivers, and bored witnesses. As the camera moves steadily along this extremely shallow plane of roadway, we pass both the bizarre and the banal (bourgeois vacationers, a sailboat, farmers, singing schoolchildren, old men playing chess, a Shell Oil tanker, circus animals, etc.). By the time we reach the terrible accident which has caused the delay, it seems like we have passed by an extraordinary catalog of 1967 French society.

I imagine that most people rewind this famous sequence when they watch Jean-Luc Godard's *Weekend*. But in my case, it is not a simple instance of rewind fever, wanting to watch the great scene over and over. I literally do not want this scene to end. I have always fantasized that when we reach the final accident, it would not be the end, but the beginning of another traffic jam, then another accident, then another traffic jam—continuing on and on. The duration of Godard's shot certainly suggests an endlessness, a progression to more of the same. Scattered throughout *Weekend* are a number of fatal car crashes, but this scene has no verbose allegorical characters, no dialogue at all. The camera

Stills from *Weekend Campus*. Courtesy of Nancy Davenport

movement sets it apart from the rest of the film. In cinematic language, the tracking shot exaggerates an illusion of temporal continuity, a horizontal momentum of history and time. Here, this momentum confronts a plugged roadway of wreckage and waiting traffic, an image of interminable delay. It is a scene of excessive continuity which is also relentless in its congestion, its depiction of society at a standstill.

My DVD entitled *Weekend Campus* is clearly an homage to this famous scene, my fantasy of an endless *Weekend* traffic jam. On one level, it sustains and renders emphatic certain opposing forces evident in Godard's film: progress versus stasis, the individual versus the collective. On another level, the work also attests to the enormous (at times it seems endless) amount of time I have spent teaching at various colleges and art schools. I feel a deep ambivalence about many aspects of the university—as a symbolic social space, as a community—especially now that institutions of higher learning are increasingly being measured against the standard of businesses. Two notions in particular have persisted in my imagination. The university as an idealized site of knowledge, learning, and discourse is an idea which still persists despite the amount of time that I spend teaching. The other (perhaps equally nostalgic) notion is the campus as a site associated with upheaval, political energy, and dissent. There are obviously great possibilities inherent in the university, as well as serious questions to be asked about what might have been lost.

I intended *Weekend Campus* to express my ambivalence regarding the university and, hopefully, to raise questions about the conditions and aims of these spaces. The piece is set along the entrance of a university, the institutional buildings visible beyond a generic campus landscape. In the foreground, there is a seemingly endless line of waiting cars, punctuated by the wreckage of a series of car accidents. As the piece proceeds with its horizontal movement, we pass an accumulation of accidents and witnesses—portraits of the student body, faculty, and police. Intermittently, there are groups of students gathered at the edge of the road. Some are staring blankly out at the viewer; all are frozen in photographic stasis. In fact, the whole scene is a still image, a very long photographic frieze, a digital montage constructed from hundreds of stills I had taken at junkyards and at universities across the country. The montage was then looped and animated so that it moves across the screen like a tracking shot.

In addition to the rubbernecking motion of the image plane, the other element of the piece that counters photographic stasis is the recurring flash of police lights. The image comes awake momentarily with the changing light, which generates a transitory cinematic effect. It is a moving view of a stationary scene with no elements of photographic stop-action. Unlike the characters in Godard's traffic jam, who are all busily engaged with self-involved tasks or futile arguments, indifferent to the carnage around them, everyone in *Weekend Campus* is depicted in the stillness of witnessing and waiting. For me, these witnesses are not blank or apathetic subjects but rather shocked subjects—shocked by out-of-control forces into an appearance of passivity. They are also shocked into an unwilling collective. The social map of Godard's *Weekend* is impossible now, just as any catalog of the social is incomplete, inadequate. At this moment of postfeminism, post–identity politics, postcommunity—what could make subjects cohere as a collective? The witnessing of catastrophe is hopefully not the only way the irreducible "student body" might be rendered visible.[1]

In terms of temporality, the aftermath of an accident can have a tendency to naturalize the static, creating a dead calm which seems to stop the flow of time. Yet this traumatized immobility is not naturalized in *Weekend Campus*; the kinetic effects remain fundamentally at odds with the prevailing stillness. It was not intended to deceive as film, nor to sit quietly as photography. When animated, the image mimics a filmic flow, but the opposing forces of fixity and mobility are significant aspects of *all* digitized stills. The way we confront photography now is so often on screen and in motion. From online stills to QuickTime VR, from Photoshop to the immediate display of the digital camera screen—we hold down a key, drag the image around, zoom in, zoom out, navigating the image in an almost cinematic way. However fundamental this mobility might be to our experience of digital photography, it is invisible in the printed still. One exception might be the digital montage, or more specifically, its temporality. While the merging of separate photographic moments can create the illusion of a seamless photorealistic space, the temporality of the digital composite remains ambiguous and peripatetic: it does not evoke a cinematic "present" any more than it conjures a photographic "past" (which photographic past?). It is a temporality which is always congested and distorted.

In my own practice, I have embraced its temporality (or lack of tem-

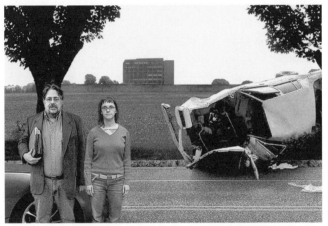

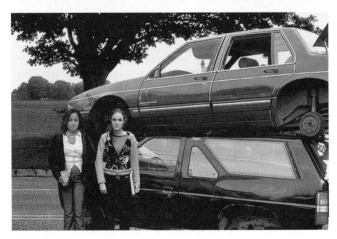

Stills from *Weekend Campus*. Courtesy of Nancy Davenport

porality) as apocalyptic. Both the digital montage and specific catastrophic encounters can be subject to similar paradoxical tensions, to related temporal entanglements. Often discussions of the apocalyptic have the absurd quality of "being late for one's own funeral"—and is this not one reductive way that photography is thought of in relation to the digital? But apocalyptic temporality cannot be reduced to a linear flow; it cannot be reduced to beginnings or endings. There is something deeply cyclical about it—the repeated delay which makes it possible, the constant updating of deadlines, each generation doing its apocalyptic rhetoric differently. It is always an ending and a beginning—structured like a loop.

Godard's *Weekend* is often described as apocalyptic, where the end of our materialist civilization gives birth to an equally savage culture of hippie cannibals—a Manson-family future. My never-ending *Weekend Campus* does not get as far as Godard; the loop repeats compulsively, sending us back again and again to a traffic jam. If my piece does have a point of semiclosure, it comes as we pass a campus pep rally disaster. We pass a large sign on the bandstand which proclaims "Taking care of Today—Tomorrow!," and then there is a sunset and then it begins again.

NOTE

1 In his discussion of Warhol's Disaster images from the 1960s, Hal Foster argues that disaster is necessary to evoke the mass subject—in the guise of witness. "Warhol did more than evoke the mass subject through its kitsch, commodities and celebrities. He represented it in its very unrepresentability, that is, in its anonymity, its disaster and death" (Foster 1996, 51).

ALEPH BEAT: WALLACE BERMAN BETWEEN PHOTOGRAPHY AND FILM

Louis Kaplan

INTERSECTIONS BETWEEN

n his essay "Wallace Berman and Collage Verité" for the catalog of the artist's 1968 exhibition at the Jewish Museum in New York, James Monte offers a tripartite portrait of Berman at the intersection of three media. "Berman is one part painter, one part still photographer and one part film-maker, with the latter pushing hard on the first two for dominance" (Monte 1968, n.p.). A seminal force among the West Coast beat poets and artists of the 1950s and the hippies of the 1960s, Wallace Berman's intermedia art ranged from experimental poetry and mail art (including the self-publishing and dissemination of nine issues of *Semina* magazine) to filmmaking and acting (appearing briefly in the cultish *Easy Rider* with his friend Dennis Hopper), from pioneering sculptural and assemblage art in the late 1950s to a visionary photo-collage practice in the 1960s. Berman remains a legendary figure at the crossroads of art and the esoteric with specific interests in Jewish mysticism (Kabbalah) and French surrealism in the heady years of the California counterculture.[1] Indeed, Jack Hirschman used the term *Kabbala Surrealism*, or ĸs in shorthand, to signify a cluster of artists and activities in the sixties and early seventies drawn to the intersection of these two practices, and he counted Wallace Berman as "one of ĸs's leading fotographic exponents" (Hirschman 1972, 8).

In inventing the neologism of "collage verité," Monte pinpoints how Berman's work brings photo-collage (with the works known as Verifaxes that were made using a proto-Xerox machine as an artistic instru-

ment) and cinema verité into communication with each other. Indeed, one could say that photography and cinema are exposed to each other in the exposures of film that each of them is. Already we find in Monte's description of Berman and his work one of the crucial questions raised by the slippery status of "still moving" and the between of photography and film—how does one medium's incorporation of or intersection with the other challenge our understanding of the specificity of each medium?[2] In taking up the Verifax photo-collages of Wallace Berman as "static films" and the film of Wallace Berman known as *Aleph* as "stills moving," my essay looks at a particularly relevant case study for affirming this intersection as an open border in an incessant resistance to medium-specificity and the policing of the border between photography and film.

In the only essay to deal extensively with *Aleph*, Tosh Berman, the artist's son, who appears in his father's film diary, also stresses the transplantation of media that brings the film into communication with the artist's lived environment and with still photography in particular. The latter effect is especially apparent by the inclusion in the film of a number of Berman's signature Verifax photo-collages that feature a hand holding a transistor radio with a different inset image. Tosh Berman recalls, "After recently seeing the film I was struck by how it resembles his studio. All the fixed images in *Aleph* had been placed on the walls for years. In one sense, the studio was consistently in a mess—but now I realized his working space as a projection of the film. All those images were 'floating' around there for an extended period of time. Art 'objects' and photographs, which at first seemed to have no connection with each other, were actually chained in a poetic/assemblage milieu" (T. Berman 1992, 73–74). Both the concept of projection—of the film as the projection of an assemblage in lived studio space and over an extended time period—and the use of the word *floating* (in quotation marks) signal the resistance to medium-specificity and the affirmation of the between. This account also stresses the diarist and scrapbook quality of the montage in its transplantation of studio life onto celluloid.

Interestingly enough, while James Monte claims that Wallace Berman the filmmaker sought dominance over the painter and the photographer, he bases this analysis on the Verifax photo-collages alone and he makes no mention of Berman's film (which he probably never saw). Indeed, it would take another thirty-seven years for this filmic document

Wallace Berman, *Aleph*, film still with Verifax image, 1956–66.
Courtesy of Shirley Berman and the Estate of Wallace Berman/LUX

to be screened at this same institution when Andrew Ingall, the cura-
tor of the new Goodkind Media Center at the Jewish Museum, would
exhibit a limited edition DVD of Berman's *Aleph* on a continuous loop
from January to March 2005.[3] The exhibition of this film allows for a
consideration of not only how filmic techniques enter into Berman's
photo-collages (à la Monte) but also how his animated photographs
enter into filmic space and time.

BRAKHAGE'S BLESSING

Where does one begin when it comes to Wallace Berman's one and only
film? Once referred to as *Semina* by the artist in 1959, this precious cellu-
loid relic was given the name of *Aleph* by Tosh Berman after his father's
death, thereby foregrounding the film's relation to this primal letter of
Hebrew linguistic and mystical significance that functioned as a kind
of signet for Berman throughout his artistic life. This is the film that
received the seal of visionary approval from experimental filmmaking
legend Stan Brakhage when he wrote, "The film took a decade to make

Wallace Berman, *Aleph*, film still with Rub-on Letters, 1956–66.
Courtesy of Shirley Berman and the Estate of Wallace Berman/LUX

and is the only true envisionment of the sixties I know."[4] Brakhage's
blessing calls attention to the temporal disjunction between the eight
minutes of the film's duration and the (minimum of) ten years of its
filmic creation. (While some references to the film cite the time frame
of its making from 1956 to 1966, other references date the film from 1958
to 1976 and therefore completed only with Berman's untimely death in
an automobile accident on his fiftieth birthday.) But perhaps only such
a temporal rupture and telescoping of time is able to induce an altered
state like "envisionment." Clearly, Brakhage's word choice links Berman
to the French avant-garde artistic legacy of the *voyant* (the seer or the
one who envisions) that can be traced from Rimbaud to surrealism be-
fore taking up deranging residence in the California countercultures of
beats in the fifties and hippies in the sixties. Tosh Berman relates how
Brakhage also played a crucial part in the material and archival pres-
ervation of the film through an act of translation and transfer: "*Aleph*
was mostly shot on standard 8mm (with some images photographed
on 16mm) and after his death, filmmaker Stan Brakhage preserved the
damaged (rotting, owing to layers of paint and dirt) 8mm print and

transferred the work to 16mm print" (T. Berman 1992, 75). Tosh also alludes to the mixed-media technique and expressionist gesture advocated by Brakhage and adopted by Berman of hand-painting directly onto the film negative as well as the use of rub-on letters (subject to mirror reversal) on the film itself. The tints of red, blue, and yellow that are found in parts of *Aleph* further illuminate Monte's point regarding the painterly aspect of Berman's artistry as speckled onto this filmic canvas.

GASEOUS STATES OF PERCEPTION

In *Cinema 1: The Movement Image*, Gilles Deleuze reviews a distinguishing feature of American experimental film in the sixties: "Now if there is any constant factor in this cinema, it is the construction by various means of gaseous states of perception" (1986, 84). How does this Deleuzean insight pertain to Berman's experimental film and how might it induce a gaseous state of perception? Or, to play sixties slang off of Deleuze's construct, how is *Aleph* "a gas"? Deleuze locates the roots of this gaseous cinema in the rapid-fire montage of the Soviet constructivist Dziga Vertov and in films like *Man with the Movie Camera* (1929) whose frenetic cutting makes the image and its continuity go up in smoke. For Deleuze, the key to the American avant-garde cinema involved the deployment of such techniques as "flickering montage" and "hyper-rapid montage" (1986, 84–85). With its barrage of discontinuous images and with its unsteady camera animating still photographs and photo-collages, Berman's *Aleph* appears to be associated with this gaseous brand of avant-garde filmmaking. It is a type of filmmaking where the visceral impact of the film on the viewer and the rhythm of its hyper-rapid cutting (which puts the viewer into an altered or even trancelike state) appear to take precedence over the apprehension of the film's meaning or the viewer's ability to follow a standard narrative plot line. In this way, *Aleph* is positioned as a link between an older European avant-garde tradition (the *cinema voyant* of French surrealism and its visionary lyricism) and the postwar American avant-garde with its more structuralist emphasis. The tension between these two approaches to experimental filmmaking can be viewed as resulting from the fact that the film took over a decade to make thereby spanning from beat

culture in the fifties to the rise of structuralist film in the sixties (which is linked in part to Deleuze's gaseous cinema).[5]

For Deleuze, the gaseous image of the American avant-gardists in the sixties can only be understood through the rhetoric of drugs and the ways in which the experimental cinema of gaseous states induces hallucinatory effects. Deleuze turns to the shamanistic and peyote-laced allegories of Carlos Castaneda for a key to understanding the cinematic program of the gaseous image and its proclivity toward temporal disjunctions:[6] "To follow Castaneda's programme of initiation: drugs are supposed to *stop the world*, to release the perception of 'doing,' that is, to substitute pure auditory and optical perceptions for motor-sensory perceptions; *to make one see the molecular intervals* . . . This is the programme of the third state of the image, the gaseous image, beyond the solid and the liquid: to reach 'another' perception, which is also the genetic element of all perception" (Deleuze 1986, 85). While Wallace Berman and his circle may not have had access to Deleuze's biogenetic language, it is clear that their aesthetic program was attuned to transforming vision in order to "reach 'another' perception" (an altered way of seeing) and that the logic of collage ("collogic") and montage,[7] the use of drugs, and the study of the esoteric wisdom of Kabbalah were all vehicles (and intensities) to get at what Deleuze refers to as "pure auditory and optical perceptions."

Deleuze also compares the motivating sociopolitical factors behind this challenging mode of cinematic perception in its first versus second utopian instantiations. For Dziga Vertov and his constructivist comrades, one returns to the revolutionary moment of Soviet communism in the 1920s prior to Stalin's repression of the avant-garde. For Berman and the freaked-out sixties, it is the hippie commune and drug culture that sparks this outpouring of perceptive experimentation. Deleuze asks rhetorically: "Might the answer be: drugs as the American community? If drugs have this effect, however, it is only because of the perceptive experimentation which they induce, which may be brought about by quite different means" (1986, 85). In Berman's case, those "quite different means" are to be found in the Verifax photo-collages and the *Aleph* film montage.

Affirming the bohemian way of life of the beats and the hippies, a number of images and sequences in Berman's film refer or allude to drugs and their usage. Indeed, *Aleph* is framed at both the beginning and the end by the shots of an unidentified man using a tourniquet while shooting up heroin into his arm. This is why its structure can be viewed as a recycling film loop rather than as a linear narrative. The opening scene becomes a metaphor for the "trip" on which the film takes the viewer and for the flashes and visions that ensue. The film also alludes to heroin in the first segment when the cover to William Burroughs' first book, *Junkie*, flashes on the screen along with an image of the author wearing a blindfold.[8] The insertion of the figure of Burroughs and his first beat literary venture about heroin into Berman's film is appropriate when we recall their shared interest in collage (whether via words and/or images) and in drugs as a vehicle for altered states of consciousness and for dissociation.[9] But *Aleph* does not show an exclusive preference for "hard drugs," for it includes other recreational drugs as well. For instance, the third section (*Gimel*) opens with a shot of marijuana plants growing in the backyard of Berman's friend Artie Richer. This filmic image also has corollaries in the photographic medium. For example, the photograph of the marijuana plants juxtaposed with the facsimile Greek statue head offers a direct parallel to the image on film. The affirmative display of these drug-laden images as they move between film and photography (and even lithography[10]) also points to the idea that these substances inducing altered states of consciousness are vehicles for accessing the intersections between media and the warped space-time of the "still moving" image. Finally, this section of the film ends with a shot of a peyote button—the psychedelic drug that played such an important role for Berman and his circle and their pursuit of what Marcus Boon has called the "imaginal realms."[11]

Another popular cultural allusion to drugs and hallucinatory experience comes in the appearance of Alice in Wonderland in the final section of the film. Here, we see Alice "getting higher" with her elongated neck in the illustration by John Tenniel at the start of Chapter 2, "The Pool of Tears." This image coincides with the moment in the narrative when Alice can only exclaim "curiouser and curiouser" in response

Wallace Berman, *Artie Richer's Garden*, photograph, 1959. Courtesy of the Wallace Berman Papers, 1907–79, in the Archives of American Art, Smithsonian Institution

to the extreme transformations in size that she has been undergoing. After Alice has "fed her head" with a magic piece of cake, Carroll writes that she feels as if she is "opening out like the largest telescope that ever was" (Carroll n.d., 19). The extended Alice in *Aleph* becomes a trope for psychotropic drug use and the distortions of time induced by both drugs and montage in its cinematic and photographic varieties.

BERMAN'S STONES

In playing out the chains of associations of meaning and significance for *Aleph* in terms of the gaseous image and its sympathy for drugs (if not the devil), it is interesting to note that one of the longest sequences in the film features a grainy clip of Mick Jagger and the Rolling Stones in performance in Santa Monica that was shot by Berman from a movie screen.[12] The moving images of the Stones on stage are juxtaposed with the ecstatic reaction shots of the audience to their "live" performance. While the performance took place in 1964, there is the Deleuzean temp-

tation to insert the Stones' 1968 classic "Jumping Jack Flash" with its refrain, "But it's all right now, in fact, it's a gas/But it's all right/I'm Jumpin' Jack Flash, it's a gas! Gas! Gas!"

But there are many stronger connections to be forged in Berman's work whereby the Stones roll between the media of photography and film. The Stones as a group also make an appearance in a sepia-toned Verifax painting from 1964 where the cuts and rips of the paper tatter and shatter the seamless and coherent image of the star image of the publicity still (presumably the original source of this appropriated image).

If one looks closely at this image, one notices that there is another female figure in this collage—what appears to be a scantily clad erotic dancer in a cage with her head thrown back and her arms outstretched as if gyrating to the music of these rock and roll icons and soaking up their radiating energies. The image suggests captivation (being held under someone's sway) and being transported in the complicated power dynamics staged between the rock icon, the groupie, and the music. This same juxtaposition of the Stones and the dancer was also reused but torn into two parts and on a much smaller scale in another mixed-media collage from 1964 where they share the stage with James Brown and a double portrait of Mohammed Ali. The work takes its name from Brown's hit single of that year, "Papa's Got a Brand New Bag," a pop tune that brought black funk and soul music to mainstream white American consumers. This juxtaposition of the Stones and Brown in this photo-collage is doubled in the film *Aleph*. In addition to the Stones performance, the eighth section of Berman's film contains a short clip of James Brown on stage and this footage is also taped from television. The film and the photo-collage communicate with each other around these pop music icons and their alterations. Tapping into the beat, Berman uses musical reference to enable medium intersections so that the meeting of film and photo-collage and the excessive relationship of the "still moving" often take place in a musical context. It is also interesting to note that this particular song by James Brown was on Berman's mind during the making and screening of his film. Tosh Berman relates that it served as one of many improvised soundtracks when Berman played it over the silent film. "At times, my father would play recorded music with the film. Sometimes it would be Brown's Papa's Got a Brand New Bag, Edgar Varese or Moroccan Folk music" (T. Berman 1992, 76).

Wallace Berman, *Rolling Stones*, Verifax painting, 1964. Courtesy of the Wallace Berman Papers, 1907–79, in the Archives of American Art, Smithsonian Institution

This tan-and-brown-toned image is much closer to Rauschenberg in its montage style than the typical Verifax collage although it does feature James Brown on the speaker of a handheld radio with a kabbalistic symbol over his forehead in the upper-right-hand corner of the image. Unlike the later Verifaxes, *Papa's* also features two television sets with inset images (one of nude women and the other of what appears to be a Buddhist monk). While Berman used this televisual format for some works, it would be discontinued when the serial pattern of the handheld radios became established as his signature style. This image is interspersed with Hebrew and English letters that feature some bilingual punning. Above Ali's head, the Hebrew letters *beyt* and *gimel* spell out the word *bag* when read in English and then followed by a second word in Hebrew with the letters *gimel, dalet, dalet* spelling out the name of "G-dd" in English. Thus "Papa's Got a Brand New Bag" translates into "Bag G-dd." In this way, the appropriated Stones' photograph (divided into two parts and recolorized) becomes a part of a larger matrix of pop cultural and esoteric references, some of which remain indecipherable.

Tuning into the pop musical sensibilities of his day, Berman also would insert the same portrait of Mick Jagger alone into the speaker of

Wallace Berman, untitled
Verifax collage, 1968. Courtesy of
Shirley Berman and the Estate of
Wallace Berman

the transistor radio of an untitled Verifax collage in 1968 wherein the
pop cultural icon becomes a static frame image. Coincidentally, this is
the same photomontage from which he took a few of the stills that are
animated in his film (including images of the pop cultural icons Flash
Gordon and Charlie McCarthy with Edgar Bergen). These star images
are offset with what appears to be an ancient fossil that repeats itself
to occupy the bottom half of the image so as to put vernacular culture
into geological perspective. This frame-by-frame repetition of the fos-
sil allows for a visual translation by Berman of the moniker "Rolling
Stones"—creating a visual pun out of the British rock stars and thereby
embodying the sense of the "still moving" in yet another non–medium-
specific way.[13] Playing between and mixing media, the speaker blares
out a vision of the rock star at the synesthetic crossroads of the sonic
and the visual arts. While this is the typical structure of the Verifaxes
where the vision comes through the radio, it acquires extra resonance
when the inset visual image is associated with a rock and roll musician
like Mick Jagger.

Wallace Berman, untitled Verifax negative, 1969. Originally published as half-title illustration in Jack Hirschman, *Black Alephs* (Trigram Press, London, 1969). Courtesy of Shirley Berman and the Estate of Wallace Berman

RADIO KABBALAH

What is it about the structure of the Verifaxes that challenges the strict separation of the senses and how do Jewish mysticism and kabbalistic ideas bear upon this intersection? Clearly, the Verifax series is a mind-bending take on sound and vision. To quote Dennis Hopper, one encounters here "the hand that holds the radio that sees."[14] While Hopper deranges the senses by calling attention to the radio speaker (associated with the mouth and the ear) that sees, one can also interpret the basic structure of the Verifaxes in the words of Gideon Ofrat as "philosophy in timpani, so as to hear with the eyes."[15] Berman's visionary gesture in the Verifax collages can be associated with Jewish mysticism and the idea that "the way to the absolute Other is by way of the ear" (Ofrat 2001, 161). The transgressing Berman does not abide by a stringent interpretation of the Second Commandment and the prohibition against graven images. Instead, he brings his work to the limits of the visible (and the opening of the void) in the Verifax collages by framing these visual transmissions through a sonic medium. In this paradoxical manner, Berman takes up the call of a Jewish spirituality believing that the sacred comes through the ear and that it is inscribed in the *Sh'ma Yisroel* ("Hear, O Israel") as the most important mantra of Judaism through the repeated figure of the handheld transistor radio and through the palm reading of its ethereal visions.

In the Verifax collages and in their transposition as "stills moving" in *Aleph*, Berman uses a modern portable invention, the transistor radio, as a means to convey an important meaning of the Kabbalah as a mode of transmission. While the more conservative approach to Kabbalah translates it as and in terms of "tradition," a broader interpretation apprehends it in terms of reception and receptiveness. Therefore, one could say that the handheld transistor radios (as receivers) frame their mundane and cosmic symbols in a uniquely kabbalistic manner. In other words, Berman literalizes the etymological meanings of Kabbalah as "transmission" and "reception"—of being open and attuned to the ethereal transmissions of the Divine, of being ready, willing, and able to receive them. Each of these receivers is an opening or a portal onto an imagined world. Here, Berman's Verifaxes touch directly upon the tradition of gnosticism which begins with Novalis and the Romantic poets and continues on to the beats, where "man seeks the flash of gnosis, or knowledge, in a form of a transmission from another cosmos or transcendental dimension in which the truth resides" (Boon 2002, 30). Utilizing the light waves of the Verifax machine, Berman's Radio Kabbalah transmits its signals over the airwaves and across the unlocalizable ether. Christopher Knight describes what is at stake in Berman's *Radio/Aether* series (1966/1974) as follows: "Sounds are transformed into pictures by the depiction of a transistor radio pulling invisible images from the aether and broadcasting them to viewers" (Knight 1992, 46).

A IS FOR ALEPH

While Tosh Berman says that he named the film *Aleph* for "practical purposes,"[16] the attachment of his father to (and identification with) the first letter/number of the Hebrew alphabet is well documented. For instance, there is the famous image of the aleph emblazoned on his motorcycle helmet in the "easy rider" photographic portrait of Berman taken by Dennis Hopper. Similarly, there is the marvelous self-portrait photomontage of Berman dating from the end of his life where he is looking down at an aleph alighting on his hand like some exotic and fragile butterfly. One also notes a tiny insect-form attached below the letter as if to ground it and not let it fly off into the ether. In addition, there are numerous photomontages where Berman would place the aleph in juxtaposition with such diverse subjects related to sex, drugs,

Wallace Berman, *Self-Portrait with Aleph*, postcard, 1976. Courtesy of the Wallace Berman Papers, 1907–79, in the Archives of American Art, Smithsonian Institution

and rock and roll as Charlie Parker on saxophone, Tosh holding a toy gun, marijuana plants, or a portrait of a naked Patricia Jordan in a mask. Both Stephen Fredman and David Meltzer have written about the aleph as a mystical letter of sanctification that gives an air of holiness to whatever it touches in Berman's works.[17] However, it is important to stress that the aleph also provides an air of mystery because of its kabbalistic associations with the unknowable and the idea of "pure becoming." Writing in *The Cipher of Genesis* (another important kabbalistic guide for Berman, according to David Meltzer), Carlo Suarès refers to the aleph as "unfathomable, timeless mystery evading all mental grasp" and asserts that "the non-thinkable has for its symbol the Aleph.... It is ever recurring, but never the same" (Suarès 1970, 55, 66). From a Deleuzean perspective, the aleph also may be said to partake of the gaseous state of perception because of the various airy characteristics that are associated with it. If one turns to the kabbalist classic the *Sepher Yetzirah* (Book of Creation), one reads the following story about the primal role of the aleph in this air-tight narrative of creation: "He caused Aleph to reign in the air, and crown it, and combined one with the other, and with these he sealed the Air in the world."[18] The equation of the aleph with the element of air carries over to the Christian Kabbalists of the Renaissance. For example, according to the alchemist (and inventor of

an early portable camera obscura) Athanasius Kircher, "the letter Aleph is symbolic of air & may be thought of as a breath-spirit."[19]

While Berman's film is punctuated by Hebrew letters/numbers that set off its various segments, one notes that there is no designation of aleph in the chapter headings and that they start (after some opening footage) with the second letter/number, beyt. In other words, the first letter of the Hebrew alphabet and the one to which Berman was devoted is absent from the film's numbering system from 2 to 11. This absence is very telling and it links up with the silent and hidden aspects of the aleph. As Charles Ponce writes in a book on Kabbalah that was also a part of Berman's library: "The letter aleph is an aspirate, a letter pronounced with a silent breathing, so the element air is assigned to this letter."[20]

In *Black Alephs*, Jack Hirschman offers a cryptic line of poetry directed to his friend that brings him into further relationship with this primal letter of kabbalistic mystery: "Wallace still firing aleph yawns."[21] There is a way of phrasing this line of poetry (if Wallace is yawning) whereby Berman is placed in apposition to a "still firing aleph." The concept of "still firing" (like "still moving") is another way of opening the lines of communication between a static and moving medium, between photography and film. Aleph, as and at the opening—the yawning of the abyss and the spacing of emptiness—allows for Wallace still firing.

VERIFAX AS STATIC FILM

In negotiating between film and photography, photomontage acts as a switching center and a way station. In arguing for the revolutionary power of photomontage, the dadaist Raoul Hausmann notes how it bears the marks of film, but as film stilled or arrested: "But just as revolutionary as the content of photomontage was its form—photography and printed texts combined and transformed into a kind of static film."[22] The understanding of photomontage as static film lends itself to a discussion of the Verifax collages to some extent on account of the serial quality of these images. In order to read a Verifax collage, whether divided into four or sixteen or fifty-six units, one has to move from frame to frame, from still to still. The handheld transistor radios function as the basic units that are repeated but also differ in that they transmit new images and the Hebrew letters that accompany them.

In his catalog essay, James Monte interprets the Verifax collages in terms of static film and he goes even further by employing the figure of the cinematic jump cut to make sense of this collaged body of work. "The film-like nature emphasizes in stasis the experience of the cinematic jump cut. At the same moment one becomes aware of the film as source material, the viewer sees the cinema verité nature of each image. The frame units can be read left to right, top to bottom with as much ease as one scans a sentence. Quick scanning causes the viewer to involuntarily react to the experience as he would while viewing a vanguard film" (Monte 1968, n.p.). But Monte's application of this cinematic term to Berman's Verifaxes is technically imprecise, for the jump cut in film is a cut between two images of the same subject with a difference in camera angle of less than thirty degrees rather than a cut between two completely different subjects (which is a crucial characteristic of the Verifax collages).[23] This means that the link between avant-garde film and Verifax photography would hinge rather on the concept of montage as radical juxtaposition, whether this is achieved by means of film editing or the pictorial juxtapositions of photomontage. In other words, it is the sudden and disorientating series of montage juxtapositions and shifts that produces the jarring and dislocating effects in Berman's Verifaxes (as well as in the film *Aleph*). This point further underscores that the slippage within the meaning of montage as it traverses between photography and film provides another means by which to challenge medium-specificity. Interestingly enough, Monte also anticipates both the style and viewing experience of *Aleph* that relies on the discontinuous flow of images and the disruption of narrative continuity without having seen Berman's vanguard film and its cinema verité aspects (similar to Warhol's early films). In scanning the Verifax frames, one moves from pop cultural references to the banal objects of the everyday life to images of the sacred across the world's religions to soft core pornography, all in the flash of a few frames. And given that Berman refused to title a majority of the Verifaxes, the viewer is further unhinged in relation to reference and to how to construct meaning out of the discontinuous flow of images.

With its coinage of the term *collage verité* to describe Berman's work, Monte's analysis keys into the common etymological root in Latin of the word *truth* that adheres to both cinema verité and the Verifax photocollages (as "true facsimiles"). But Monte's use of the term is ambivalent

in that the relationship established between "collage" and "verité" can be read in either a harmonious or a dissonant manner. On the one hand, Monte insists that Berman's collages can be viewed as in a relationship with the documentary genre since they rely on images that are drawn from the real. As he states, "one sees the cinema verité nature of each of the images." However, Berman's collages also can be understood as a betrayal of cinema verité's claim to present the truth of the world. From this perspective, Berman's "collage verité" is a mode of light writing that makes poetry out of primarily documentary images. William Burroughs's appellation for Wallace Berman, "the poet-maker,"[24] is corroborated not only through *Semina* but also because the Verifax collages construct open-ended visual poems, putting together disparate images that can be read in a number of directions. In this last respect (and also discussed by Monte), the Verifax collages appear to be rather uncinematic in their defiance of being read in only one direction and therefore opposed to the basic principle of the analog cinema of Berman's day even in its most vanguard varieties.

ABULAFIA AS MONTEUR

The Kabbalah provides Berman with a theory and practice of montage—a theory of juxtapositions and transformations that unsettles the brain and that seeks to take it out of its habitual modes of perception and reception. According to David Meltzer, Berman applies a modern artistic variant of a kabbalistic method that was instituted by the medieval Spanish Jewish mystic Abraham Abulafia called *dillug* and *kefitsah*—a method of "jumping" and "skipping" that is measured out to the beat of photomontage or in the quick cutting of his one and only film.[25] In this way, the viewer of the Verifax collages or *Aleph* leaps from frame to discontinuous frame. Gershon Sholem refers to *dillug* and *kefitsah* as "the climax of the entire *Cho'chmat Ha'Zeiruf* (the wisdom of addition or combination of letters/numbers) that yields to the achievement of the unknown or the hidden."[26] But it is important to point out that the aniconic-minded Abulafia saw jumping and skipping as tied to the letters of the Hebrew alphabet. In other words, these permutations and exchanges move through language and numbers (since every letter also corresponds to a number in Hebrew). However, Abulafia's concept

of jumping and skipping did not pertain to images—either still or mov-
ing. Yet this is at the heart of Berman's disorienting practice.

In his monumental treatise *Major Trends in Jewish Mysticism*, Sho-
lem discusses Abulafia's method of jumping and skipping as the highest
means of mystical meditation and as something designed to jump-start
divine consciousness. Sholem writes about this mystic's game of leap-
frog in a way that negotiates between free play and being bounded by
rules. To quote Sholem:

> The modern reader of these writings will be most astonished to find a
> detailed description of a method which Abulafia and his followers call
> *dillug* and *kefitsah*, "jumping" or "skipping" viz, from one conception to the
> other. In fact, this is nothing else than a very remarkable method of using
> associations as a way of meditation. It is not wholly the "free play of asso-
> ciation" as known to psychoanalysis; rather it is the way of passing from
> one association to another determined by certain rules which are, how-
> ever, sufficiently lax . . . The "jumping" brings to light hidden processes of
> the mind, "it liberates us from the prison of the natural sphere and leads
> us to the boundaries of the divine sphere." (Sholem 1946, 135–36)[27]

Abulafia's method of association serves as a Jewish mystical precedent
for Berman's own "remarkable method of using associations as a way of
meditation" in his beat experiments that quite literally bring things to
light via the jumping and skipping inherent to photo-collage and film.

SURREALIST JUXTAPOSITIONS

Given Berman's important place within Hirschman's conception of
Kabbala surrealism, it should come as no surprise to learn that the tra-
dition of Dada and surrealism also provides Berman with a theory of
collage and montage across the media of film and photography. One
is reminded of Max Ernst's famous credo for surrealist collage as the
"fortuitous encounter of two distant realities on an unfamiliar plane,
or in short, the cultivation of the effects of a systematic displacement"
(Ernst 1970 [1937], 126). However, most Verifax collages do not share
the proclivity of Ernst's collages to disrupt the integrity of the image
and to combine image fragments in one picture plane. Instead, Berman's
collage strategy is to appropriate discrete photographic segments that

3rd Los Angeles Film-Makers Festival Oct.12 & 13, Cinema Theatre 1122 N. Western

Wallace Berman, untitled (Third Los Angeles Film-Makers Festival), offset poster, 1964.
Courtesy of Shirley Berman and the Estate of Wallace Berman

are isolated and separated from each other (in their self-contained radio
hand units) and that have been subject to very little internal manipula-
tion other than simple cut and paste. The disjuncture and the displace-
ment occur in the attempt to relate or link the units or, to employ the
filmic term, the "still frames" in each collage. One again touches here
upon the filmic quality of the Verifax collages. As an anonymous re-
viewer in *Artforum* writes: "The word 'collage' has reference more to the
manner in which the works are produced, and perhaps to the idea of a
series of associated but only poetically related images, than to the kind
of art usually described by that word."[28] Interestingly enough, Berman
produced a Verifax poster for the third annual Los Angeles Filmmakers
Festival at the Cinema Theater in 1964. In this advertisement for the
film festival, each of the sixteen images can be seen as the frames of a
short film (perhaps at sixteen frames per second) so that the serial for-
mat lends itself perfectly to the film poster. This poster also features an
image of one of Berman's renegade surrealist heroes, Antonin Artaud,
who was a film actor and a performance theorist in his own right.

However, both *Aleph* and the Verifaxes do follow the surrealist pro-
gram in terms of its convulsive aesthetic and its cultivation of "frictional"

effects. Here the metaphor of the electrical charge guides surrealist rhe-
toric. The success of surrealist collage must be judged on the basis of
the sparks it sets off in its viewing—the flash of poetry that leaps forth
in the approach of incongruent realities. André Breton's praise of Max
Ernst at his first exhibition locates what Werner Spies calls the "poetics
of the leaping spark" and the catalyzing power of the artist to inspire
these effects: "It is a wonderful ability to reach, without leaving the field
of our experience, two widely separated worlds, bring them together,
and strike a spark between them."[29] Ernst also believes in the spark
emitted or ignited from this encounter and how it is linked to the ele-
ment of surprise. As he commented to Franz Roh in the late 1920s: "And
the more unexpected the elements brought together, the more surpris-
ing to me was the spark of poetry that jumped the gap."[30] In their juxta-
position of incongruous images from many different registers of the real
that meet on the plane of collaged surreality, the Verifaxes follow this
aesthetic program as they seek to set off the spark of poetry to jump
the gap. This spark often happens in the juxtaposition of images that
are normally classified in the categories of the sacred and the profane.
Aleph runs according to this program of juxtaposition when an image
of a robed Catholic cardinal is abruptly followed by a bare-breasted
nude. Similarly, the public image of President John F. Kennedy is juxta-
posed with a private "snapshot" image of Berman's son Tosh smelling
a flower. In the 1964 Los Angeles film poster, the images read as stills
that depict a promiscuous mixing of film genres from horror to film
noir to porno to surrealist experimental film (in the image of the young
Artaud). Whether shuttling between the single frame (still) and the
(moving image) series in the Verifaxes or whether moving between the
Verifaxes and their deployment in the film *Aleph*, Berman engages in
a visual poetics that relies on the jumping of the gap for its convulsive
impact.

SEMINA

Of all of the words in the dictionary, Wallace Berman chose *Semina*
as the name for his self-published and handcrafted magazine that ap-
peared in nine issues over the course of a decade (1955–64) that overlaps
with the making of his film. *Semina* presents the challenge to medium-
specificity in both its name and its contents. Combining poetry, pho-

Wallace Berman, *Semina* 5, book cover, 1959.
Courtesy of Shirley Berman and the
Estate of Wallace Berman

tography, drawings, collage, and artist ephemera, *Semina* was always
deemed to be a mixed media zine. Refusing to submit to the structures
of commodity exchange, *Semina* strove for surplus in that it could only
be received as a gift. Berman mailed it out to his friends and it is be-
lieved that the circulation for any given issue hovered around three hun-
dred copies.[31] In this way, *Semina* became a matter of "dis-semina-tion"
as it circulated among an artistic circle of hipster colleagues and allowed
for the exchange and cross-pollination of ideas and works. Christopher
Knight has suggested that this mail art magazine also had a subver-
sive or underground relationship to the Hollywood film magazine, a
relationship already in place in the first issue, which featured a "pub-
licity photograph" on the cover of the occultist Cameron, who starred
as the Whore of Babylon in Kenneth Anger's 1954 film *Inauguration of
the Pleasure Dome*: "It was the severe and forbidding face of Cameron
that graced the portfolio's cover, making it a kind of wry, underground
cousin of a mainstream movie-magazine" (Knight 1992, 41). As a foot-
note to filmic history, it is also ironic that a few years after the cessa-
tion of *Semina* Berman would be asked to play the part of one who
sows seeds on the commune in the hippie road movie *Easy Rider* (1968)
starring his friend Dennis Hopper. Given no speaking part and on the
verge of anonymity (his name does not appear in the credits), Berman

is shown working on the farm in the commune scene and enacting this agricultural form of dissemination.

However, one should not overlook the sexual connotations of the word *Semina* as gendered male and its etymological connections to both *semen* and *seminal*. This privileging of the generative seed of the heterosexual male conditions the erotics of Berman's photomontages (as in the Verifax nude in the first figure) and his filmmaking. On the one hand, the nudie magazine and the archive of pornographic images were often deployed in Berman's collage work. David Meltzer sees this proclivity as a means of reclaiming the body from the profane realm and "restoring it to a primary glory" at an especially repressive moment in American sexual mores. Meltzer writes: "Berman was interested in the visual and erotic content of the sado-masochistic images of the period. . . . In the millennial spirit, turning the world upside-down, it was redemptive to affirm the illicit, to iconize the fallen and lionize the lowly" (Meltzer 1992, 57). While Berman's goal may have been such a beat alchemical transformation, this does not change the fact that his view of sexuality was primarily heteronormative and phallic centered. This same tendency also shows up in the film where Berman's camera (in its up and down panning) foregrounds the nude female body as the male object of desire.

CROSSING WALLY AND ANDY

When Andy Warhol arrived in California in the fall of 1963 to visit his exhibition of Elvis silk-screen paintings at the Ferus Gallery in Los Angeles, the very space where Wallace Berman had been evicted by the police on obscenity charges six years earlier, he packed along his recently acquired 16mm Bolex movie camera.[32] Taylor Mead, Gerard Malanga, and Wynn Chamberlain accompanied Warhol on this cross-country trip that eventually led them to Tarzana, California, and the making of Warhol's first feature-length narrative film—*Tarzan and Jane Regained . . . Sort Of* (1964), starring Taylor Mead as Tarzan and Naomi Levine as Jane and with smaller parts allocated to Claes and Pat Oldenburg, Dennis Hopper, Wallace Berman (referred to as Wally in the credits), and his nine-year-old son Tosh. It is quite likely that Berman was first introduced to Warhol at the party Hopper threw in Dandy Andy's honor in early October 1963. Starting from a topographi-

Wallace Berman, *Wallace and Tosh Berman*, photomontage, 1960. Courtesy of the Wallace Berman Papers, 1907–79, in the Archives of American Art, Smithsonian Institution

cal and typographical pun playing between Tarzan and Tarzana (the place associated with Edgar Rice Burroughs and his literary film hero), Warhol's film offers an ironic and campy take on California as both a jungle and a paradise regained with scenes shot on the beach in Santa Monica, in the Beverly Hills Hotel, and in Wallace Berman's living room and backyard in Beverly Glen. As Tosh Berman recalls, "It was at this location that Andy Warhol shot his first full-length film 'Tarzan and Jane . . . Regained' [*sic*]. I have full memory of Taylor Mead and my father's fight scene in the film. I also remember the woman who played 'Jane.' I remember playing Tarzan's son 'Boy.' What I don't remember is Andy Warhol."[33] In his stroll down memory lane, Tosh Berman perpetuates the legend of Andy Warhol as the cinematic in-operator who turns on the switch and who disappears—as the absent voyeur, or, to reiterate Stephen Koch's phrase, the "phantom of the media."[34] Thus, Berman's first direct encounter with Warhol took place in the world of underground film and in the shadow of Hollywood, where he played "a native" for his special guest and lent his California artist-hipster image to one of Warhol's early countercinematic projects. Meanwhile, there is also a fast scan in the eighth section of *Aleph* of what looks to be one of Warhol's Elvis paintings that could have been shot by Berman at the

Ferus Gallery during this same eventful October—unless it is rather an
animated still of the work posing as a moving image.

Perhaps the most common art historical comparison for Berman's
Verifax photo-collages is the one that has been made with Andy War-
hol's silk-screen paintings. Given that Berman did not begin using the
Verifax copier machine in the service of artmaking until 1964, Warhol's
images certainly predate his by about two years. The Verifaxes and the
silk-screens share the formal aspect of serial repetition that foregrounds
the artwork and the commodity fetish in the age of mechanical repro-
duction and a "readymade" approach to image making that indexes a
strong indebtedness to Marcel Duchamp (pop art's Dada) in viewing
the art object as the effect of an image's appropriation and framing. The
Duchampian impact also can be traced to California and the exhibi-
tion curated by Walter Hopps in the fall of 1963 at the Pasadena Art
Museum that inspired both Warhol and Berman. While Duchamp's
readymades often involved the appropriation of objects (reframed as
sculptures), Berman's Verifaxes and Warhol's silk-screens relied on the
appropriation of images drawn from the mass media and consumer
culture. Specifically, both Warhol and Berman draw upon pop cultural
icons for their sources. Interestingly enough, many of these icons (like
Mick Jagger, Elvis Presley, or James Brown) are associated with pop
music, and so sound comes to play an important part in the "still mov-
ing" space of these visual media (whether silk screen or Verifax). Colin
Gardner also has noted a similarity between the two artists in the re-
fusal to privilege any part of their series. "Like Warhol, Berman's serial
strategy was non-hierarchical, treating each image as an autonomous
unit in a syntagmatic narrative chain" (Gardner 1992, 86). However,
there are also key differences between the two practices. While Warhol
favored the repetition of the same image (the Campbell's soup cans or
the Marilyn icon) ad nauseam, Berman's Verifaxes allow for both repe-
tition and difference. While the structure of the handheld transistor
radio remains the same, there is significant variance in the image trans-
mitted by the speaker. Similarly, there is also much more range in the
type of imagery that finds its way into the Verifaxes as opposed to the
silk screens. While Warhol, like Weegee, concentrated his cool voyeuris-
tic gaze on the stars and the disasters (the famous and the infamous) of
the sixties and the tabloid press as his source materials, Berman is only

partly indebted to the visual register of late fifties and sixties popular culture and he allows space for (and gives airplay to) more banal and esoteric images in the Verifaxes and in his film.

STILL EXCESS

The process of still animation is something that Tosh Berman makes much of in his analysis of the film and its "movements": "The film performs 'movements' from photographs and second generation film/t.v. images. If the stationary portraits are not moving, then the camera is, which has its own flicker movement . . . Other images are consistently in motion. Though in most cases—not all—the source of the image is a still photograph. The camera swoops in and out, which resembles movement, or comparable—a primitive version of animation" (1992, 74–75). In some instances, Berman performs these movements using still images of arrested or stopped motion. The animation of the still images of the parachutists and the motorcyclists are two examples of this strategy. In this way, the effect of simulation—where it appears that the images are moving instead of the camera—is achieved even more convincingly. Tosh also focuses on one recognizable still photograph that is transferred onto film. This is the portrait of Buster Crabbe as Flash Gordon, which appears next to some heavy black streaks that are painted onto the film. Even though Tosh refers to the Flash image as "stationary," it too has been subjected to the animating process of the still moving: "At times there are stationary images (such as the hand holding a transistor radio with an image of Buster Crabbe as 'Flash Gordon' inside the instrument—an Alex Raymond cartoon strip that was a major influence on my father's artwork)" (T. Berman 1992, 75). More than the cartoon strip, Wallace Berman's image alludes to the outer-space adventure film serial of the 1930s. These fantasies, pitting Flash Gordon against the Emperor Ming the Merciless and other sci-fi villains, fed the young Wallace Berman. The interest in the superhero's "flash" and the serial nature of the episodes suggest affinities with Berman's own artistic visions.[35]

The film *Aleph* is indebted to photography and to its stillness. Indeed, it takes its life from these stills that become animated and that are put into motion through the camera's movements. But there is another dangerous supplement in the "still" (in the sense of "moreover," or in the

French word *encore*) played out in the excessive economy that is staged between film and photography. In the same way that the viewer looks at a Verifax photo-collage as an image that still bears the traces of filmic montage, the viewer of *Aleph* watches a film that still bears the traces of the photographs that have been captured and animated in it. Jean-Luc Nancy has pointed out that the excessive economy of the still—what he calls the "double *still* of thinking"—also links it to the logic of concealment (Nancy 2003, 43). Even as it stops and arrests, quiets and silences (like the letter aleph itself), the doubled still gives something more for thinking ("still" in the sense of *encore*). In this latter sense, the still is on the side of becoming and moving rather than in strict opposition with it. Nancy writes: "The point of such an excess—the crossing over from the 'still' in the sense of 'in the same way' to a 'still' in the sense of a 'moreover,' to the still other and the still further—is the point of concealment, the extremity at which we can think along the lines of concealment, thinking having already passed into the other" (43). The logic of concealment performed by the excessive movement (and stasis) of the still aligns it with the mysteries of the Kabbalah as an esoteric and secret doctrine. The concealment of the still and its passing into the other also parallels one of the central paradoxes of the Kabbalah, which claims to transmit a truth that must be by definition secret or concealed.[36]

FLOWING IN ALL DIRECTIONS

In one of the most moving tributes ever composed on the work of Wallace Berman, Merrill Greene underscores why and how any analysis rooted in medium-specificity can never come to terms with his artistic practice. Compounding the realms of the air and the sea, Greene posits Berman's work not in terms of a rational grasping of a totality but rather as an opening up to a ceaseless flow of becoming that registers itself in and between still and moving images. She writes: "Wallace Berman lives substantially in an aether-ocean of images fed from all sources and flowing in all directions at once" (Greene 1975, 50).

As above, so below—as below, so above.

1 For an illuminating review of how Berman's work fits into the larger artistic and culture milieu, see Solnit 1990. Solnit also composed an essay on the California scene ("Heretical Constellations: Notes on California, 1946–1961") for Phillips 1995, 69–87.

2 I draw here from the language used in Karen Beckman's call for papers for the panel "Cinema and Photography: Time, Space, Theory" at the International Association of Word and Image Studies in Philadelphia in September 2005. I am grateful to Karen for including my work on Berman in this context.

3 For Andy Ingall's text on this special exhibition ("*Aleph*: A Film by Wallace Berman"), see http://www.thejewishmuseum.org/site/pages/onlinex.php?id=114 (accessed May 26, 2005).

4 Brakhage's blurb for *Aleph* is found on the Canyon Cinema website in San Francisco. Go to http://www.canyoncinema.com/B/Berman.html (accessed May 26, 2005).

5 I thank Jean Ma for helping me to refine this film historical and typological point. For a fuller investigation of these avant-gardes in American avant-garde cinema, see Sitney 1979 and his discussion in "The Lyrical Film" (chapter 5) versus "Structural Film" (chapter 11). Sitney also discusses seeing a "preview" of "Wallace Berman's 24-part Kaballistic film" in "A Tour with Brakhage: Underground Movies Are Alive along the Pacific," in *Village Voice*, December 5, 1968, 53.

6 The most famous of the Castaneda books is *Teachings of Don Juan: A Yaqui Way of Knowledge* (1968). Deleuze's reference to Castaneda in the context of experimental film is particularly apt for Berman, who was also fascinated with the mysteries of Mexico and the visionary potentialities of peyote. The cover of the third issue of *Semina* features two peyote buttons and its contents are devoted to Michael McClure's "Peyote Poem." Meanwhile, the fifth issue of *Semina* is dedicated, in the words of Stephen Fredman, to an "Artaudian view of Mexico." Fredman discusses these connections in "Surrealism Meets Kabbalah: Wallace Berman and the Semina Poets" in Duncan and McKenna 2005, 41–44. I also thank Kristine McKenna for her assistance in facilitating the images that are courtesy of Shirley Berman and the Estate of Wallace Berman.

7 David Meltzer discusses how the montage technique of de- and recontextualization enabled the mundane and the banal to acquire an air of mystery (marked as the "strange" or the "weird") and a reordering of perception for both Wallace Berman and his wife Shirley: "The Bermans attached themselves to the mysterious quality intrinsic in many things. Any object could be transformed into something of great interest; it was a matter of placing it in the right context. Wallace would say something was 'strange' or 'weird,' in that re-ordered perception, and by looking at it with greater intensity or assumption it would take on a new meaning." See Meltzer 1978, 100.

8 *Junkie: Confessions of an Unredeemed Drug Addict* was originally published under the pseudonym William Lee in 1953 by Ace Books in New York. Commenting

on Burroughs's *Junkie* and Allen Ginsberg's *Howl*, Marcus Boon has noted how "the Beats appropriated the addict or junkie into their outsider mythology. . . . In a word with the Beats, the rebellious gnostic narcotic user, craving the night again, becomes a *saint*" (Boon, 2002, 75). Given Berman's interest in Jewish mysticism in its gnostic variety (i.e., Kabbalah), one might substitute the word *tzaddik* (Hebrew, illuminated and righteous one) for saint. For another excellent take on Berman's gnosticism and his enigmatic relationship to Kabbalah, see Erik Davis's online essay "The Alchemy of Trash: The West Coast Art of Spiritual Collage" http://www.techgnosis.com/index_alchemy.html (accessed May 28, 2005). Mixing "mensch" and "guru," Davis offers Berman as a "Jew-bu" holy man, as a hybrid Jewish-Buddhist spiritual mentor. Davis writes: "If West Coast spiritual bricoleurs had a guru, that person would have to be Wallace Berman, a quiet but powerfully influential mensch whose work and life seemed to achieve the Beat blend of sacred and quotidian."

9 For a discussion of Burroughs's scrapbooks in terms of montage practice, see "A Silent Language of Juxtaposition" in Sobieszek 1996, 38–44.

10 In 1963, Berman also produced a pro-marijuana poster that features a tangle of plants set against the caption "Loveweed."

11 See Boon 2002, 218–75. Boon includes here a discussion of Artaud's *The Peyote Dance* based on his trip to Mexico in 1936. This trip was an important precedent for the beats (and Berman in particular) in linking drug use to gnostic wisdom. Artaud traveled to the Tarahumara "to experience in his own body what he believed the Tarahumara knew. This kind of endeavor would become popular with the advent of the Beats in the late 1950's" (243).

12 The Stones played the Santa Monica Civic Auditorium for the *T.A.M.I. Show* in 1964 when Berman met them and befriended Brian Jones. According to Tosh Berman, he shot "film of the concert when he saw it a few months later on a movie screen." See Duncan and McKenna 2005, 349.

13 I thank Karen Beckman for catching this word and image play that moves between visual and verbal media.

14 Dennis Hopper is quoted in Gardner 1992, 86.

15 Gideon Ofrat, "Epilogue: Philosophy and Judaism," in Ofrat 2001, 162. In "Wallace and His Film" (1992), Tosh Berman also transmutes sound into vision noting how "there is no need to hear, when the eyes are enjoying the sounds" (76), and how his father "reads the music in (on) the air—frozen by a hand, holding the sound image in a transistor radio" (74).

16 This comes from the slightly revised online version of the essay published in October 2002 on the website of the British film cooperative LUX. It can be found at: http://www.lux.org.uk/featured/berman.htm (accessed September 8, 2007). I also thank Ben Cook at LUX for his assistance with obtaining the film stills used in this essay.

17 Meltzer writes of "the Aleph, integrating and integral, sacralizing the everyday phantasmagoria, turning all into Aleph and Aleph into all" (see Meltzer 1992, 59). Meanwhile, Stephen Fredman writes in "Surrealism Meets Kabbalah: Wallace

Berman and the Semina Poets" that "the *aleph* took on a transformative, sacraliz-ing function, as though it were capable of conferring a blessing upon a degraded, commodified reality." See Duncan and McKenna 2005, 44.

18 See chapter 3, verse 5 of the *Sepher Yetzirah* (Book of Creation) translated by W. W. Wescott. This version can be found online at http://www.sacred-texts.com/jud/yetzirah.htm (accessed September 9, 2007).

19 Athanasius Kircher from *Oedipus Aegyptiacus* (1652–54) quoted in Ponce 1973, 40.

20 Ibid.

21 The poem is called "Jerusalem 33." See Hirschman 1969, 153. The book features three half-title illustrations by Berman of Verifax negatives.

22 Raoul Hausmann, "Photomontage," in Phillips 1989, 179. The original essay was published as "Fotomontage" in the journal *a bis z* (Cologne), May 1931, 61–62.

23 I thank Jean Ma for her insistence on maintaining the technical definition of the cinematic jump-cut in resistance to Monte's less rigorous nomenclature.

24 Burroughs's term *poet-maker* comes up in the interview between Michael McClure and Eduardo Lipschutz-Villa in San Francisco on October 30, 1992. See T. Berman 1992, 64.

25 Meltzer alludes to Abulafia's method in Meltzer 1978, 97.

26 This citation comes from a previously untranslated text by Gershon Sholem en-titled "Chapters from the Book of *Sulam Ha'Aliya* of Rabbi Yehuda Albotini," origi-nally published in *Kirjath Sefer* 22 (1945): 161–71. The essay elaborates further on Abulafia's method of jumping and skipping with concrete examples of the permu-tations of letters. I am very grateful to Romi Mikulinsky, who did an incredible job of translating Sholem's challenging and at times cryptic text.

27 For another important scholarly account, see Idel 1989.

28 Anonymous, "Wallace Berman's Verifax Collages," *Artforum* 4.5 (January 1966): 39.

29 Andre Breton quoted from his catalog essay "Max Ernst" in Spies 1991, 228.

30 Max Ernst quoted in Spies 1991, 228.

31 The germinating influence of Berman's magazine is the subject of the traveling ex-hibition "Semina Culture: Wallace Berman and His Circle" co-curated by Kristine McKenna and Michael Duncan at the Santa Monica Museum of Art in the fall of 2005. It should be noted that Berman referred to the film in 1959 by the name of his magazine. The fourth issue of *Semina* contains a card with nine film stills over the caption "Excerpts from a film now in progress entitled 'Semina' by W. Berman." This is reproduced in Duncan and McKenna 2005, 57.

32 I refer here to Berman's arrest by the Los Angeles police department in June 1957 on charges of obscenity for the inclusion in the Ferus Gallery exhibition of a draw-ing by Cameron depicting anal sex between a woman and a demon. The arrest led Berman to leave this city of "degenerate angels" for San Francisco for four years.

33 Tosh Berman, "Wallace and I," in Cary Loren, ed., *Blastitude* #13 (August 2002): 7. See http://www.blastitude.com/13/ETERNITY/wallace_berman.htm (accessed May 26, 2005).

34　Koch 1985, 29. I also take up the theme of "inoperativity" in Warhol's photography in my introduction to Kaplan 2005, xxv–xxxii.

35　The occult film monteur and magician Kenneth Anger was also a fan of Flash Gordon. In his notes to the Magick Lantern Cycle of 1966, Anger places Flash Gordon first on his list of heroes, which includes Lautréamont, William Beckford, Méliès, Alfred C. Kinsey, and Aleister Crowley. This list is found in the chapter on Anger's work ("The Magus") in Sitney 1979, 123. Indeed, there exists a colorized Verifax of the Flash Gordon image in the handheld transistor radio where Berman acknowledged his adulation. It is entitled *Portrait of Kenneth Anger*. The image is dated 1968–69 and has an aleph inscribed in its lower-left-hand corner. See Berman 1978, 18.

36　For a deft discussion of such kabbalistic paradoxes, see Biale 1987, 99–123.

MENTAL IMAGES: THE DRAMATIZATION OF PSYCHOLOGICAL DISTURBANCE

Zoe Beloff

PHOTOGRAPHING THE INTANGIBLE

What can the photographic image of a human figure reveal to us about his or her mental state, unconscious wishes, thoughts, desires, or dreams? This reproduction of life has always promised to deliver more than the eye can see. The photograph and the film play upon our desire to interpret, to create stories, to endow images with meaning.

In my work as a filmmaker and media artist, I'm fascinated by the idea of photographing the intangible, something that is not there. In works about spirit mediums and insane women from a hundred years ago, I have been exploring cinema's conception not only in technology but also in the psychic apparatus.

Here I will discuss four case histories of emotional disturbance documented in the *Iconographie Photographique de la Salpêtrière* and three 16mm films made in the early 1930s: *A Case of Multiple Personality* by Dr. Cornelius C. Wholey and *Child Analyses Parts I and II* by Dr. L. Pierce Clark. These works share both intellectual goals and formal structures. All purport to be objective clinical studies. Each work exhibits a complex relationship between photographed image and accompanying text or intertitles. Each exemplifies a quest to make the body speak.

I will begin by situating these works within the tradition of the photographic representation of the insane that preceded them. I will then consider each work in the context of how it was originally presented to the psychiatric profession.

These studies span the transition from still photography through motion studies to cinema. At the same time they show how doctors were radically rethinking the etiology of mental disorders from being primarily neurological diseases of the brain to having psychological underpinnings with their roots in the individual unconscious. Nonetheless, what ties them together is the belief that mental disturbance could manifest itself through physical enactment that could be captured photographically.

In each case the photographic medium was considered hard evidence in the sense that Albert Londe stated in the 1880s, "the photographic plate is the scientist's true retina" (Didi-Huberman 2003, 32). Yet when we look at the pictures something very different develops before our eyes. Under cover of the concept that the camera could not lie (as we say under cover of darkness), the scientist embraced fiction and the doctor staged illness as drama.

THE EMPIRICAL GAZE AND THE ALPHABET OF THE PASSIONS

While today the whole idea of documenting the unconscious on film might seem fanciful, in the nineteenth century it was considered a truism that one could recognize mental illness visually. Doctors believed that photography greatly aided diagnosis. The first person to systematically photograph the insane was Hugh W. Diamond, the superintendent of the Surrey County Lunatic Asylum in the mid-1850s.

When Diamond's photographs were published they were accompanied by captions such as "Religious Melancholy." This guiding text, whether in the form of captions or later on film intertitles, always accompanied clinical images of mental disturbance. Despite their author's often-repeated assurance that the images were self-evident, no one felt quite confident enough to let them speak for themselves.

How did Diamond justify his diagnosis? In searching for an explanation, we discover that the photographic representation of mental disorder shares common roots with guidelines for dramatic performance. Both derive their authority from the writings of the philosopher René Descartes.

The painter Charles Le Brun depicted the Cartesian passions in clinical detail—horror, fright, sadness, astonishment, ravishment, awe—in

the book *Méthode pour apprendre à dessiner les passions*, published post-humously in 1698. These images codified the idea that the passions impressed themselves on the human form as ideal templates. This concept influenced not only studies of the insane but also concepts of acting. The eighteenth-century theater scholar Aaron Hill based his simple four-step guide for actors on Cartesian physiology. First comes the idea. Second, the idea appears on the face because it is nearest the seat of the imagination. Third, impelled by the actor's will, a "commissioned detachment of the animal spirits" inflates the appropriate muscles. Finally, the whole body automatically performs the expression, action, and vocal intonation appropriate to a particular passion without any further work on the part of the performer. Very simply, Hill claimed that the body mechanically obeys an emotion.[1]

Almost two hundred years later these ideas were enacted in the performances staged by the neurologist Jean Martin Charcot at the hospital of the Salpêtrière during his lectures. He was a great believer in visual codification. In the chaos of hysterical symptoms, he was looking for a series of passions that could be repeated over and over the same way each time. His notion of repetition conflates scientific concepts with theatrical performance. His idea derives from the belief that scientific experiments must be repeatable and that an illness must first be defined and classified so that its unique symptoms can be studied. However, in practice he was asking his patients to produce a theatrical performance that conformed to his expectations, "splendor without surprises" (Didi-Huberman 2003, 217). It was a repetition that would find its most perfect form in the film loop, where every gesture is infinitely and perfectly repeatable. Shortly after his death, the very first films were often projected as loops. Ideally, he wanted his patients to act as living repetition machines, so much so that a frequent criticism from outside doctors was that patients at the Salpêtrière all copied each other.

Inspired by his friend Duchenne de Boulogne, who attempted to create an "Alphabet of the Passions" by touching a subject's facial muscles with electrodes, Charcot hypnotized his women patients, then used the Faradaic Stimulator to provoke expressions like "anger" or "astonishment." Here life was required to imitate art and again the passions served as a template. After all, how could his audience know what "anger" looked like unless it had already been codified by artists like Le Brun and this codification duplicated by countless actors? Charcot did

admit that his subjects improved with practice: "Like all reflex acts, they are perfected under the influence of repetition which is something that we vulgarly call habit."[2] Of course human subjects are always unreliable. So Charcot had his subjects photographed. These photographs were disseminated as more or less ideal models against which other patients could be compared, leading to still more reproduction.

FROM TABLEAU VIVANT TO DRAMATIC PERFORMANCE

Charcot's photographs look like tableaux vivants. Each image represents one particular passion and is complete in itself. Similarly, Diamond's images of the insane presented mental disorder, states such as "mania" or "melancholy," as static and unchanging. One image summed up everything one needed to know. However, to understand mental disturbance as psychological, based on unconscious processes that change and develop over time, a series of images is necessary. Dynamic psychiatry now required dynamic images, images that imply motion and time.

Hysteria was primarily an illness that manifested itself through performance, through motion, whether it was uncontrollable jerking and twitching of the body, crippling partial paralysis that caused distortions of movement, or delirium and all kinds of unruly acting out. Its symptoms were slippery, elusive, ever changing. A single photograph could not possibly hope to capture an attack of "la grande hystérie."

The first case to be represented with a sequence of photographs was that of Augustine, published in the second volume of *Iconographie Photographique de la Salpêtrière*.[3] The photographs included in the books were far from instantaneous snapshots. Each one required a long exposure time. Because of this, they represent not movement caught on the fly but defined poses: each presented a characteristic moment, in a way similar to how a storyboard or movie stills pare a scene down to just the high points. It was here that her illness pushed photographic technology to its limits and beyond, bringing into existence a strange new hybrid way of seeing, a bridge between past and future. It was a protocinema of sequential still images, each representing a key moment in her hysterical attack. Subsequently Albert Londe developed a special camera with twelve lenses and a timer to photograph just such images.[4]

There is another element in the description of Augustine's case that

makes it appear to us now like sound cinema *avant la lettre*—that of dialogue. Again, this had to do with structure rather than technology, as sound was not actually recorded any more than the camera could capture motion. Rather it was the juxtaposition in the book of the sequence of photographs in conjunction with a text that included transcripts of Augustine's dialogue with people whom only she could see and hear. Against the stark black backdrop of the studio, she rages, beseeches, and seduces. Listen:

> And then I have Monsieur C and after that, it would be good for me to tell Madame . . . to Papa . . . but Monsieur C said he would kill me . . . what he showed me, I didn't know what it meant . . . he spread my legs . . . I did not know that it was a beast that was going to bite me . . . I'm going to go out every night because he wants to sleep with me . . . He told me he was going to kill me . . . I'm telling you that it was him that wanted it . . . he wanted to hurt me, he told me that later it would do me good . . . And it's a sin . . . no I can't for tonight . . . I'm going to be forced to go to that house . . . him, no I don't love him, but you[.] (Bourneville and Régnard, 1877–80, 161)

Augustine was raped at age thirteen by Monsieur C., whom she subsequently discovered to be her mother's lover. Deliriously acting out the most traumatic events of her life, she lacked any fixed sense of time, as in dreamtime, moving very rapidly, forward then back again. She flung herself from pose to pose, from mockery to dread to desire in minutes, repeating her performances over and over. In so doing she turns the clinical tableau into a narrative that might be called "melodrama in embryo."

Freud did not arrive at the Salpêtrière until 1886 but he must have been familiar with her case. He came to understand that "hysterics suffer mainly from reminiscences" (Breuer and Freud 1982, 7). And it is just such reminiscences that melodrama turns upon. Stephen Heath has discussed how close narrative cinema is to the case history. He explains how film as it was developed commercially reproduced the novelistic form of the family romance. In dramatic films, according to Heath, the narrative almost always revolves around a problem in the past, something dark or hidden that must be worked through for the story to be resolved (Heath 1976, 41). By staging her own rape at the hands of her mother's lover, Augustine produced perhaps the first family romance of a cinema yet to be.

I use the phrase "melodrama in embryo" for a reason. While Augustine's presentation of her life contains high drama, there is not yet the resolution that we find in classical narrative. Over and over again, she reenacts her rape, her subsequent encounters with lovers, quarrels with her parents. There is no end. Resolution would suggest a cure, but there is none. By way of analogy one might think of the representation of her story as a kind of Mutoscope show with only a few key cards. Primitive cinematic apparatuses like the Mutoscope presented dramatic actions that ended only to begin again. The doctors simply recorded her story but did not attempt to intervene, question, or shape it. In contrast, Freud's later case histories entered the world of classical narrative when his patients' memories were restored to consciousness and the mysteries of their past were resolved. Only then did his story or case history come to a satisfying conclusion. In fact, his cure was predicated on the explication and resolution of the patient's narrative.

To what extent Augustine was consciously acting her hysteria for the doctors and to what extent she was in the grip of her unconscious compulsions we can never know. Indeed, this is what makes her so fascinating. Her case raises questions about the nature of performance in a way that a great star like Sarah Bernhardt does not.[5] What is clear is that the drama is highly eroticized. Paul Régnard almost never photographed her in the midst of fits where she was red in the face, foaming at the mouth, her body wracked by spasms. Rather we see a young woman, alone on a bed, her long hair flowing down her back, her nightgown falling from her shoulders.

Here is how her doctor described Augustine's delirious behavior. In this section he refers to her as "X."

> X makes the sound: psitt, psitt; and half seated, sees an imaginary love whom she calls. He arrives, X lies down on the left side, leaving a space for the imaginary lover in her bed. She shuts her eyes, her expression shows possession and desire; her arms are crossed, as though she is hugging the breast of her lover in her dreams. Sometimes we see light rocking movements, other times, she presses on the pillow. Then little complaints, smiles, movements of her pelvis; words of desire or encouragement. . . . After about a minute, we know that everything is going

Augustine. Courtesy of Archives and Special Collections,
Columbia University Health Sciences Library

quickly in a dream, everything disappears. X lifts herself up, sits down,
looks up, puts her hands together in a gesture of supplication, and she
says in a plaintive tone: "You don't want anymore? Again . . . !" (Bourne-
ville and Régnard 1877–80, 162–163)

I don't think that it is by chance that this performance recalls that of
an erotic film. Rather it is that this supposedly objective depiction
of psychological disturbance shares a certain common purpose with
pornographic cinema, though I don't mean that in the obvious sense of
overt sex. Instead, what links these two genres is that both aim to make
the body reveal its desires visually, graphically, repetitively to prove them
to the audience.

At the Salpêtrière this went beyond just photography. The labora-
tory contained state of the art technology to interrogate every aspect
of these women's bodily functions: blood pressure, pulse, temperature,
and vaginal secretions. It was no wonder that Pierre Janet referred to the
hysterics somewhat regretfully as "those experimental frogs of medi-
cal psychology" (Hale 1971, 144). The doctors' obsessive gathering of
empirical evidence spoke of their desire to know everything about the
women. No secretion, no smile, no words were too intimate to be kept

from them. Indeed, Didi-Huberman has suggested that Charcot did not believe in the unconscious because he could not bear the idea that there was something he could not see (Didi-Huberman 2003, 135).

We could call this documentation, in Michel Foucault's words, a "will to knowledge." In his *History of Sexuality: An Introduction* Foucault argues against the idea that sexuality was repressed in the nineteenth century; instead he shows how it was constantly searched out and transformed into discourse. This feverish incitement to investigate sexuality grew out of the Catholic confession. But not only priests but also doctors required their patients, especially those with nervous disorders, to "confess" their sexual desires.

These inquiries opened new sources of pleasure, "the pleasure that comes of exercising a power that questions, monitors, watches, spies, searches out, palpates, brings to light; and on the other hand, the pleasure that kindles at having to evade this power, flee from it, fool it, or travesty it . . . the psychiatrist with his hysteric and his perverts, all have played this game continually since the nineteenth century" (Foucault 1980, 45). To put it bluntly, this pursuit of the "truth of sexuality" was itself exciting to the researcher. I believe this pleasure is apparent in all the works discussed here and goes far to explain the extent to which the patient is always incited to act out. Of course on the far end of the spectrum of these pleasures lies pornography. Film pornography has to contend with the fact that you cannot see a woman's orgasm—you cannot "prove" it, you can only stage it. Augustine was already staging sexual pleasure for her Doctor Bourneville. She went further than his intertitles "Appeal" and "Amorous supplication." She cried out "Again!"

The symptoms of hysteria manifested themselves through performance, even if it was involuntary and involved real suffering. These performances cried out to be documented through moving images. Indeed, chronophotographic cameras were invented specifically to capture them. Through documenting them photographically, the doctors encouraged the patients to produce symptoms. It was a vicious circle. For a time, Augustine was the center of attention, the star of the asylum, but ultimately it was all too much. In 1879, tested, provoked, posed beyond endurance, she had had enough. Her experience in role playing served her well: she escaped from the Salpêtrière dressed as a man.

THE INFLUENCE OF MELODRAMA:
A CASE OF MULTIPLE PERSONALITY
(A FILM BY DR. CORNELIUS C. WHOLEY)

By 1923, narrative film had arrived and melodrama was a vastly popular genre. In the darkened space of the movie theater, viewers, unaware of the techniques of story editing, found themselves in a world of make-believe, identifying with the characters on the screen. But what happens if the lights never come up and identification with one fictional character segues into another and another? The film *A Case of Multiple Personality* attempts to document such a disorder. Most remarkable is the extent to which the doctor as well as the patient has fallen under the spell of cinema.

From the beginnings of the medium, cinema's effect was commented on by psychopathologists. Pierre Janet, who did pioneering work with cases of multiple personality, wrote, "Man, all too proud, figures that he is the master of his movements, his words, his ideas and himself. It is perhaps of ourselves that we have the least command." He went on to say that while people often told themselves stories as comfort against dull reality, sometimes these stories gained the upper hand (Ellenberger 1970, 310). Already in 1903 he noted that the first seven years of cinema contributed to agitation among neurasthenics (Gordon 2001, 194).

One could say that for the psychopathologist, a case of multiple personality was a kind of prize. It was a very unusual and fascinating condition. Dr. Cornelius C. Wholey's notes on *A Case of Multiple Personality* show in this instance that he looked back for inspiration to Morton Prince's case of "Miss Beauchamp" at the turn of the century.[6] Miss Beauchamp had caught the attention of not only university professors and medical journals but also ladies' magazines and Broadway producers (Hale 1971, 117). It may have been in part to show off his own remarkable patient that Wholey decided to take on the role of doctor/filmmaker.

In his film, Wholey does not mention the influence of cinema on his patient Mrs. X's personalities. However, in his accompanying essay he describes how this working-class teenager developed such a passion for the movies and for romantic fiction that she couldn't talk about anything else: "she was constantly romancing." When multiple personalities developed they were often based on the fictional characters she had

encountered. For instance, at one time she became "Lucille," a Chicago cabaret girl who could toe dance. Another time she emerged in a split-off state as a society girl, Pearl. As Pearl, she explained that after refusing to marry a wealthy man, he kidnapped her and forced her into white slavery. Susie was a New York woman who was married but had a secret lover (Wholey 1933, 658).

Wholey himself adopted the conventions of narrative cinema of the 1930s in his notes on the case. He begins the description of his film in the style of movie credits.

SCREEN PRESENTATION
"Characters" or Dissociated States, Appearing
in a Case of Multiple Personality.
SUSIE The most fully developed secondary personality.
JACK A male member of the multiple personality group.
MRS. X (Apparently) the primary, or original personality.
"THE BABY" . . Mrs. X in regression to the mental age of one year.
(Wholey 1933, 661)

At first glance film seemed to be perfect medium to convey the idea of one person playing numerous characters given that actors often take on multiple roles in fiction films. For instance, in his film *The Playhouse* Buster Keaton played every member of the band, the audience, the performers, and the stagehands. However, at the same time film is the slipperiest medium of all to act as verification of a case of multiple personality because everything can be staged. The medium invites acting. Wholey's film grapples with this ambiguity. First he had to get Mrs. X to "perform" her personalities for the camera, and then he had to prove that this performance was unconscious and involuntary. The film evidences his struggle with this ambiguous agenda.

Case of a Multiple Personality is twenty minutes long, black and white, and silent with intertitles. Most of the film was shot in 1923, with a coda added fifteen years later, according to the intertitles. It begins with scrolling titles telling us that the patient Mrs. X suffers from major hysteria. She is a "double personality." She has one dominant secondary personality called "Susie" and a number of more minor personalities, the psychic equivalent of bit players. We learn that hysterics sidestep adult difficulties by regressing to childhood states of consciousness. These secondary states represent unconscious attempts to escape pain-

ful situations. They are therefore directly opposite to the primary personality. The titles continue:

> We find in the double or alternate a childish, immature, devil-may-care actor. A mirthful oblivion is shown, toward the proprieties, duties and disciplines with which his original conscience struggled in vain. They co-exist, the one conscious, the other unconscious as they alternate in dominating the behavior of the individual.

Thus before we even see the woman, the stage is set. Wholey primes the viewer with description, interpretation, and moral value judgments on the character of the secondary personality "Susie," whom he describes as a frivolous exhibitionist. We learn that while Mrs. X is shy, Susie enjoys the attention of the camera and has "a childish, immature, devil-may-care" attitude. Throughout the film the titles speak of the doctor's anxiety to control, orchestrate, and fill up the void of meaning that images alone might reveal. Finally we see a chubby giggly young woman sitting on the grass. A man wearing a boater (C. C. Wholey) hits her knees with a reflex hammer. The following titles prepare us for the next personality:

> It was suggested that Jack, a male member of the multiple-personality group "come up" or appear. Susie is seen in the swoon or trancelike state by which she passes from one personality to another. She is completely anesthetic to pin jabs in these trance states. . . . Note the male posture and hand grasp; Jack's masculine protest against feminine encumbrances— removes earring and shoes, tugs at corset, pushes back hair. He is more anesthetic to the pin than the Susie personality—a strong jab with the pin is not felt.

The intertitles exaggerate the impression that Mrs. X is performing on cue. Immediately we see her falling into a trance with lightning rapidity worthy of a stage magician's assistant. Two men catch her. One of them, a fat man with a cigar, starts sprinkling water everywhere. Abruptly Mrs. X comes to and without missing a beat heartily shakes the fat man's hand. She doesn't seem at all surprised to see the three men crowding around her doing peculiar things, or to find herself a "man" in women's clothing. She patiently allows the doctor to stab her with a large pin.

What is going on? At the Salpêtrière, doctors jabbed pins in hypnotized or hysterical patients to ascertain whether their limbs were anes-

There is a brief transitional struggle, a swoon, and Jack finally appears. Note the male posture and hand grasp; Jack's masculine p r o t e s t against feminine encumbrances – removes earrings and shoes, tugs at corset, pushes back hair. He is more anesthetic to the pin than the S u s i e personality a strong i a h

Mrs. X as Jack. Stills from *Case of a Multiple Personality* (Cornelius C. Wholey, 1923)

thetic, that is, insensible to pain. In certain states hysterics would apparently feel nothing in parts of their bodies, while at other times the same area would be hypersensitive. Detailed charts were drawn up of the "zones of hysterical anesthesia." These measurements were considered scientific verification of a particular condition.

Since the performance of gender switching in the form of Mrs. X's "masculine" handshake might appear insufficient evidence of her inner transformation into a man, Dr. Wholey uses pin pricks to "prove" graphically to the audience that she is indeed transformed psychically. Only by reading Wholey's essay on the film do we learn that the fat man is Mrs. X's neighbor, a Mr. Fitch, who was attempting a cure that dated from a much earlier era. Believing that Mrs. X was possessed by the devil, Mr. Fitch was sprinkling holy water in one of his frequent attempts at exorcism.

A title announces: "The following pictures were taken in the patient's home at a later period. From a trance stage of twenty four hours duration caused by shock from the death of the parish priest, Mrs. X emerges as 'The Baby' at a mental age of about one year." We see a dimly lit interior with a large crucifix visible in the background. Mrs. X bounces

up and down, spits out food, pushes away a doll, and pokes her fingers in her husband's mouth. He eggs her on. The title "Interested in Daddy's unshaven face" accompanies an image of Mrs. X rubbing her husband's cheeks. Doctor Wholey refrains from comment.

What we are witnessing is a bizarre disjunction between Mrs. X's rich internal cinema, where she believed herself to be all kinds of colorful characters, and the doctor's film, in which this inner cinema is almost completely opaque to the audience. In contrast to the rich melodrama that is promised by Wholey's cast of characters, what he delivers is barely what we would call cinema at all. All we see is a collection of photographs that move, strung together one after the other. For example, while in her mind Mrs. X. lived the role of Susie, a sophisticated New York woman, all we see is a chubby girl sitting on the grass.

Wholey's film is deeply impoverished. Perhaps he was so wrapped up in the cinematic nature of Mrs. X's ailment that he thought it would somehow automatically impress itself onto the celluloid, not realizing that without sets, costumes, and continuity editing, to say the least, Mrs X. had no environment in which to dramatize her fantasies. Melodrama thrives on artifice. There is nothing natural about narrative film. It is entirely constructed for the viewer, something that is often lost on people who don't make films.

Augustine was photographed in a studio; the space was set up and contrived to foreground her performance for the camera. Despite the fact that her story could only be reproduced as stills, it is far more cinematic, far more suggestive of movement within the image than the 16mm film that simply reproduced at 18 frames per second someone who simply sat on a spot in the grass. Mrs. X didn't need to perform, for she had been swallowed up by cinema; she lived inside it and did not need to produce it for an audience.

HOME MOVIES

At the end, the film cuts to a title "Family seen fifteen years later." The husband, four little girls, a boy, and a more mature Mrs. X emerge from a ramshackle wooden house. Everyone smiles obligingly for the camera. The last shot is a close-up of three of the children proudly holding up four kittens for the camera.

Two things can be noted in this bizarre and abrupt ending. First is

that it resembles a home movie, most obviously by the fact that everyone smiles at the camera and the display of kittens. The second point is that this little home movie takes the place of narrative resolution. The viewer is left wondering what happened: was Mrs. X cured, and if so, how? I suggest that the whole film might be looked at as a kind of home movie, in which there is both a contrived display for the camera and also a kind of opacity due to the fact that only those who were actually present can read the images, since they remember what happened at the time and use this knowledge to fill in what is not visible.

In his essay Wholey provides a glimpse of the day-to-day circumstances of the case in the form of a long interview with Mrs. X., her husband, and her neighbors the Fitches, with whom Mrs. X stayed while she was unable to look after herself. It was they who convinced her that she was possessed by the devil. It becomes clear that they also seemed to enjoy provoking her to switch from one character to another for their own amusement. According to the interview, "Jack" was only one of four male multiples, each of which was of a different nationality, Polish, American, German, and Italian. Mrs. Fitch took pains to cook each of them meals of their choice. The Italian was served spaghetti and glasses of wine while "Jack" enjoyed ham and cabbage. When they had had enough of one personality, Mr. Fitch would chase it away with holy water.

Pierre Janet gave this advice to doctors: "to make yourself heard, you must dream with the patient and speak to him only words in accordance with his delirium" (Janet 1965, 35). In the spirit of Janet, Wholey entered into the collective fantasy prevailing in the house. For example, when Jack comes up, he asks, "Are you the boss?" Referring to Mrs. X's characters, he asks Mrs. Fitch, "Are the spirits friendly among themselves?" She replies, "When Lucille was turning good, them other spirits were punishing her terrible" (Wholey 1933, 673). Ultimately his diagnosis stated simply: "Multiple personality. Environment is one of family hysteria" (680).

The neighbors treated Mrs. X as a form of entertainment. They lived through her in a bizarre way. She added spice, not to mention frequent changes of cuisine, to their otherwise drab lives. Wholey's camera did not capture any of this. What went wrong? He shot with a 16mm motion picture camera designed specifically for the home market, first made available to the public in 1923. It was light, portable, and unobtrusive.

The apparatus promised immediate access to life as it was lived, but this promise proved illusionary, for it did not automatically reproduce life in a meaningful way. The camera has no imagination. Maybe Wholey failed to understand that cinema is much more than the apparatus of the moving picture camera because he too was immersed in the collective fantasy of the household, unaware of what was missing. Perhaps sensing the poverty of his images, he relied on intertitles to guide his audience quite literally to a proper reading of the images. At the same time, it is curious to see the visual diagnosis from the Salpêtrière, such as pricking the patient with pins, living on in Pittsburgh in the 1920s, all the more because Wholey was a self-professed Freudian.

By the second decade of the twentieth century the diagnosis of psychological disturbance had undergone radical changes from the time of Augustine. There was a movement away from a search for a strictly neurological etiology of mental disorders in favor of a psychological explanation. An understanding of Freud's new psychoanalytic approach was just beginning to penetrate the medical community. One of Freud's most important steps was to break with the visual. In the talking cure the ear takes the place of the eye. One might even go so far as to say that because the analyst no longer looked at the analysand, the talking cure was able to tame the baroque symptoms that made the Salpêtrière such a "pandemonium of infirmities." However, it was not a simple and clean break. The doctors who made the films I discuss still attempted to make their patients reveal or confess their inner life through physical performance.

Wholey was a practicing psychiatrist and professor at the University of Pittsburgh. It seems that it was his friend Trignant Burrow who introduced to him to psychoanalysis. In 1909 Burrow studied with Jung and in 1911 served on the council of the newly formed American Psychoanalytic Association.

In the years after 1910, Wholey was ready to defend psychoanalysis vigorously against old-school neurologists like F. X. Durcum, who attributed the causes of mental disturbance to heredity or physical degeneracy. Wholey backed up his arguments with case histories of his own where he showed how, following Freud, he was able to work with his patients to make their underlying psychological disturbances conscious to them. To grasp just how bizarre psychoanalysis must have appeared to the psychiatric profession, it is interesting to read Durcum's condem-

nation, in which he declares, "Psychoanalysis is an outcome of the general mystic tendency of the modern world. Occultism and symbolism in art, music, literature and the drama—cubism, futurism, modernism and the problem play—are all expressions of this tendency." The culprit he speculates was nothing less than modernity itself.[7]

Wherein did this association of mysticism with psychoanalysis lie? I think the connection lay in the fact that the forces of the unconscious could not be quantified rationally. They could not be visualized. To the psychiatrist with his scientific bent, the libidinal cathexis of which Freud spoke was as fanciful as Mesmer's magnetic fluid had been to scientists of an earlier generation. It was here that I think Wholey floundered. He tried so hard to show how Mrs. X expressed her personalities through physical gesture that he lost sight completely of any kind of psychoanalytic treatment or even interpretation of her condition. Despite his claims to being an ardent Freudian, Wholey never suggested how or even if he treated Mrs. X, only noting cryptically, "Family will have to be approached and help secured through priest and church . . . splendid understanding and cooperation on the part of patient's religious advisers was secured in the subsequent handling of the case" (Wholey 1914, 1036). Nor did he suggest any reasons for her dissociation other than it began in childhood.

CHILD ANALYSES—A FILM BY DR. L. PIERCE CLARK

Perhaps the most complex work in terms of the dramatic performance of fantasy on the part of both the doctor and patient is *Child Analyses Parts I and II*. It is a twenty-five minutes long, 16mm black-and-white silent with intertitles. The film was made in 1931 by Doctor L. Pierce Clark while he was the director of the Stamford Psychoanalytic Institute and Sanitarium. He wrote about the film and the case histories depicted in two essays, "On Child Analysis" (Clark 1932, 115–18) and "Child Analysis: A Motion Picture Dramatization" (Clark 1931, 111–17). Like Wholey, Clark appears to have made only one film.

Clark was born in 1870. After graduating from medical college he was appointed first assistant physician at the newly founded Craig Colony for Epileptics at Sonyea, New York, in 1896. In 1905, shortly after Clark's departure, a series of films of epileptics was produced at the Colony by Walter Greenough Chase and William Spratling. Each "epilepsy biog-

raphy" was brief but alarming. Warders brought in a naked man in the grip of a convulsive seizure and threw him down in front of the camera on a patch of grass. I imagine Pierce Clark, who treated epileptics, would have known these films. However, the reason for their production differed from the reason for his own *Child Analyses*. The "epilepsy biographies" were created to help doctors analyze the physical aspects of a seizure while Clark's film attempted to elucidate the secrets of his patients' minds.

Clark had a longstanding interest in explicating his ideas visually. I have found several examples of lectures he gave accompanied by lantern-slides. One of them, "An Experimental Study in Mental Therapeutics," delivered to the New York Psychiatric Society in 1919, showed "nervous invalids" being given a Montessori education. This presentation featured numerous photographic slides of the invalids in little Greek tunics cavorting in a pastoral setting that recalls the neoclassical paintings of Puvis de Chavanne (Clark, n.d.). The costumes and poses allow the viewer to imaginatively enter into a fantasy world where mental disturbance has been banished from an Arcadian idyll. But whose fantasy is this, the doctor's or the patient's? It is a question that will be very pertinent to the scenarios of Clark's films. Clearly he sees his patients in just as strongly aesthetic terms as Charcot, who used to declare that his hypnotized hysterics would make superb models for artists.

Throughout his career, he was to work with both epileptics and mentally retarded patients. However, his treatment of mental disorder shifted from the strictly medical to the psychoanalytic. Though he was not alone in making this transition, his approach was colorful and unorthodox. He embraced this new discipline with great zeal. In 1908 he gave the New York Neurological Society a report on "Freud's Method of Psychotherapy." By 1912 he was treating epileptics with psychoanalysis, with what he considered great success. He even developed a general theory that patients' convulsive disorders were unconsciously aimed to produce gratification (Burnham 1967, 168–70).

By the 1920s he was in touch with some of the most important psychoanalysts of the day. His friend, the Hungarian analyst Sándor Ferenczi, wrote to Freud that Clark had developed a new technique he called "forced fantasies" (Falzeder and Brabant 2000, 295). He prepared a never-published edition of Anna Freud's *Introduction to the Technique of Child Analysis* for the Nervous and Mental Disease Publishing House.

Clark's interest in the child analyses of Anna Freud and Melanie Klein was startling since their work was barely known outside Europe at this time.

However, he was more than simply a follower of this new discipline. He had ideas of his own. He pointed out that Freud could not treat certain types of patients because he believed they were not open to transference. These patients Clark labeled "narcissists." His category included schizophrenics, manic-depressives, psychotics, drug addicts, homosexuals, paranoids, and those suffering from melancholy, dypsomania, and epilepsy. In a sense one could say that for Clark, psychoanalysis was a new cure-all, the equivalent of a wonder drug.

Clark advocated his "phantasy method" in the treatment of these so-called narcissists.[8] This technique involved a mild self-hypnosis not unlike daydreaming. He insisted that his patients come up with fantasies related to their earliest childhood. He noted that these fantasies should not be confused with actual memories, but he believed that they were nonetheless psychologically true. Initially the analyst was to interpret as little as possible, allowing the narcissist to reach for the outer world.

In the treatment of children he followed the lead of Melanie Klein, who believed that small children were too young to understand the talking cure. Instead she advocated play therapy. The task of the therapist was to interpret the child's games from a psychoanalytic perspective and use this knowledge to make the child's unconscious wishes comprehensible to him or her.

What Clark did grasp was the importance of the novelistic within psychoanalysis. It was here that Freud had made his decisive break with the doctors of the Salpêtrière. Instead of showing or staging, Freud wanted to tell; his method of attempting to present his patient's mental state was all about narrative rather than the spectacle or tableau vivant. Perhaps for this reason, Clark turned to film over lantern slides to document his new psychoanalytic work. He wanted to create dramatic narrative through the medium of cinema. Intertitles at the beginning of *Child Analyses*, state:

> In presenting for the first time child analysis in dramatization by the motion camera, we hope to bring out the manner of behavior of certain neurotic children who symbolically act or reenact their conflicts in their play-activities. It is, perhaps, valuable as supplemental and accessory

data to psychoanalytic diagnosis derived from other sources. Whether one may hold that such symbolic dramatization is sufficient on which to base a therapeutic interpretation, or merely consider it a pre-analytic performance paving the way for a real analysis later, we cannot state at this time.

DRAMATIZATION

The word *dramatization* is used several times in the titles. The first, "dramatization by the motion camera" seems to imply a reenactment or "docudrama." But this is a contemporary reading. In this film we see the actual child patient with an analyst. To what extent both are performing for the director is something we can never know. The on-screen analyst is not Clark but rather a woman whose identity is never revealed. The implication is that the film shapes this encounter into a drama; the medium itself "dramatizes."

The second use of the word *dramatization* is in the phrase "symbolic dramatization." This refers to the child's performance in a clinical theater, in which he or she presents mental constructs symbolically for the camera. A few sentences later in the intertitles the word *dramatize* is used once more: "Case I. In child analysis as Anna Freud and Melanie Klein have so signally shown, the child dramatizes his problem." Here, the word connotes both acting out and creating melodrama.

The titles continue: "The film is self-explanatory. Detailed psychoanalytic interpretations are given elsewhere." However, gripped by a desire to express what he claimed to be the narrative of his patients' unconscious struggles, and finding the photographic images all too lacking, he resorts to lengthy intertitles to convey the weight of the story.

The titles introduce the analysand: "Winnie is an epileptic child of eight. Petit mal attacks begin at seven. Tantrum and rebellious moods are frequent. Her libidinal fixation-points are dramatized through oral sadism—cannibalistic acts towards the analyst (parent surrogate)." We learn that the film begins when Winnie has grown bored of playing at shooting the analyst. The little girl now enjoys punishing the analyst by directing her to have repeated sensations and spells. Finally we see Winnie and the analyst, a thin woman in a tweed suit. The camera is fixed, at the side of the bed. There are a few pans but no close-ups or reverse angles. Often the faces of the protagonists are obscured as they

wrestle around. The view is oddly flattened. Space is foreshortened and truncated. One finds oneself peering awkwardly, craning one's neck in a futile attempt to see more. Too close and too far, one finds oneself an unwilling voyeur in a bedroom drama. What we see is both flattened and affectless visually while at the same time highly melodramatic in the description provided by the titles.

As in Wholey's film, there is no "cinema"; all we see are moving photographs. The camera simply records evidence of what is in front of it from the point of view of someone trapped behind the bed. This awkward angle connotes something of a private detective capturing evidence of an illicit affair. Indeed, the subject matter, particularly the second film showing a young man and a female therapist wrestling on the bed, does nothing to dispel this. Rather than concern himself too much with what was in front of the camera, Clark lavished attention on the titles that spelled out his theories.

The titles refer to the "analyst-mother"—a direct reference to the work of Melanie Klein, who addressed childhood sexual anxiety through analyzing the symbolism of children's play. She was unafraid to confront children's transference feelings toward her as the therapist "mother." In so doing she showed how children exhibited intense love, hate, and jealousy toward their own mothers.[9] What we actually see in Pierce Clark's film is quite different. Here the analyst plays the role of the epileptic little girl, under the "direction" of the child playing the part of the mother, or so he claimed. As Winnie seems to lose interest, the therapist acts the part of the child with increasing alacrity.

The film opens rather alarmingly with the analyst in mid-simulated attack, twitching and shaking with her hand raised in a claw. Next she strokes the more or less catatonic Winnie, whose head is buried in the pillow. The titles tell us that the little girl shows strong ambivalence toward the analyst, alternating solicitude with disregard. It appears that to compensate for Winnie's lethargy, the analyst begs for attention, elaborating on her role as the child, "I'm awful sick."

A title announces the next part in the "play," in which Winnie attempts a cannibalistic ingestion of the analyst-mother and vice versa. Again Winnie is credited as the author of this game: "She eats the analyst, then makes her intact once more. The analyst is directed to eat Winnie and also to make her whole again."

One wonders what Winnie thinks of this odd woman who does not

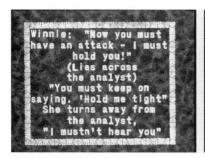

Winnie directs the analyst's attack. Stills from *Child Analyses Parts I and II*
(L. Pierce Clark, 1931)

act like a mother but instead seems to masochistically enjoy allowing herself to be beaten by the child. The title simply states: "Biting and scratching by both analyst and Winnie." This is where we leave them, flailing on the bed. Nothing is resolved, no dénouement, no awakening. As in *A Case of Multiple Personality*, there is no indication of what might be called therapy in the sense of the analyst attempting to make the child's desires conscious to her. However, while in the former film Wholey's intervention was confined to jabbing the subject with pins, here the analyst is herself involved in dramatic role playing.

Perhaps to cover for the emptiness of the images, an "interpretive summary" attempts to provide closure by reiterating what the intertitles have already told us. It ends bleakly:

> The destructive impulses alternate between [1] being directed by the super-ego (mother) against the ego (naughty child), and [2] being directed by the child herself against the disciplinary mother. One trend has the sadism regressive (she is eaten by the mother) while the other tendency is more progressive (she eats the mother). Meanwhile, the weak ego wavers and seeks protection, unable to stand alone.

This last sentence seems a fitting conclusion to a scenario that does seem quite lost, identities drifting, child-mother-child, analyst-mother-child flailing at each other on the bed as if it were a raft drifting out to sea.

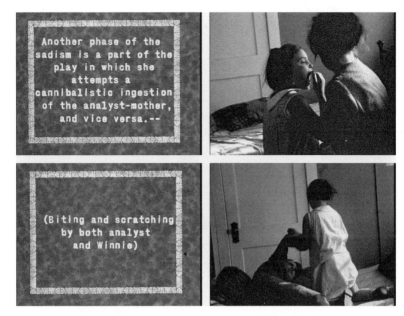

Cannibalistic biting. Stills from *Child Analyses Parts I and II* (L. Pierce Clark, 1931)

FORCED FANTASIES, OR DOCTOR
CLARK'S PROJECTIONS

Part II of *Child Analyses* is structured the same way, photographed in the same room with the same analyst. Again the film begins with titles: "Ned—an epileptic boy. Age 19. Maternal identification fixated at passive homoerotic level. He dramatizes the latter by the 'game' in which he alternately plays the part of a little girl and boy. Both roles are bound to the mother—identification." According to the narrative, the boy wishes to be told how his mother asked a witch to change him into a girl. Sometimes he missed being a boy, "but he thought it was just fine to be like mother, for he could help her with her work and sleep with her at night."

The fact that Ned is actually a young man of nineteen rather than a child definitely adds a certain tension to the bedroom scenario. However the Oedipal ramifications of sleeping with the "analyst mother" seem not to have occurred to Clark. "Ned whispers directions for analyst-mother to place a woman's wig on his head. He bids her lean over." These details—still unaccompanied by images—tease the viewer's imagination.

Ned whispers directions for analyst-mother to place a woman's wig on his head. He bids her lean over.

Ned and the Wig. Stills from *Child Analyses Parts I and II* (L. Pierce Clark, 1931)

When the photographic images do appear they are darker and more obscure than before. The female analyst is pinning what looks more like a small hairpiece rather than a full-blown wig on Ned's head with hairpins from her own head. She is the same woman we saw in Part I with Winnie. She appears to be giving Ned a small bun that mirrors her own hairstyle. The smallness of the hairpiece also gives it the connotation of pubic hair.

The clumsy performances, poor lighting, amateurish cinematography, and rigid camera focused on the bed are very close to the look of stag films from that era. Without the titles we might believe we are watching the clumsy seduction of an older woman by a young man. What we see connotes not the playacting of a child but rather some kind of rehearsed and private staging of an erotic scene. As Linda Williams points out in her book on pornographic cinema, "Amateurism of the stag film is a kind of guarantee of the real—a reassurance that this show is no act" (Williams 1989, 78). The same holds true here. We believe that these people are not faking it because they are so clumsily presented. At the same time, the role of the analyst works to force the patient to "confess" his desires, to act them out. It seems that Ferenczi was not far off the mark when he described Clark's method as "forced fantasies."

The scenario grows violent, Ned and the analyst struggle, they appear to have another tender moment, he asks her to punish him for taking off the wig, she slaps his face. A title indicates their dialogue: "NED: Now you must eat me." They struggle again. His arms are around her neck. Titles inform us that he rebels against this self-inflicted castration. After he appears to "kill the analyst" she lies motionless for a moment; titles inform us that he insists on repeating the scenario all over again.

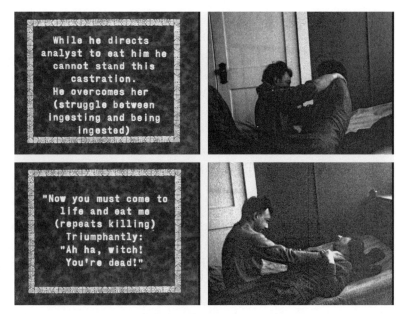

While he directs
analyst to eat him he
cannot stand this
castration.
He overcomes her
(struggle between
ingesting and being
ingested)

"Now you must come to
life and eat me
(repeats killing)
Triumphantly:
"Ah ha, witch!
You're dead!"

Ned kills the analyst-witch. Stills from *Child Analyses Parts I and II* (L. Pierce Clark, 1931)

Over and over they wrestle on the bed. Arms at her throat, he forces her down. As in the previous scene with Winnie, a sadomasochist drama is acted out, with the analyst each time in the role of the masochist, allowing herself to be "killed" over and over again by the young man. Note the repetition, the obsessive nature of the performance. Once again there is no narrative closure. There is no death, only artificial resurrection, the "one more time" of the peep-show loop. The analyst comes back to life only to attach the little wig once more to Ned's head. Nothing is real anymore. It is all just another take. As Augustine put it so succinctly in her delirium, "Again!"

From his writing it is clear that Clark was aware that his method diverged from the pioneers of child analysis, Anna Freud and Melanie Klein, whose names he invoked in the titles at the beginning of his film. Anna Freud firmly believed in the talking cure even for small children and disapproved of letting them act out. She insisted that the therapist provide discipline and guidance. Clark's approach was closer to that of Melanie Klein in that, like her, he observed and interpreted children's play. However, Klein did not indulge in dramatic role playing.

Clark's explanation for taking a different approach to treatment was

that the children in his care were developmentally retarded. He claimed that Winnie had a mental age of five years and eight months and Ned a mental age of nine and a half. They had "developed only the wraith of an Oedipus relationship" and thus transference was almost impossible. After seeing the film, to read that Winnie and Ned are developmentally retarded comes as a shock. It is something that is simply impossible to gauge visually.

One should keep in mind that the film was probably shown only in conjunction with Clark's presentation of the material.[10] Thus what he wrote about the case has a direct bearing on how his contemporaries viewed the material. He discusses how the patients' epilepsy may have been caused by emotional conflicts, in Ned's case, his conflict between wishing to be a man or a woman. He advocates that "mental arrest" should be presented in terms of Freud's libidinal theory. He explains that the procedure used in the film "consisted of a more abundant giving of love, a more active participation in the analysis, than would ordinarily be the case . . . at all times the child is encouraged in a free expression of his own impulses during the analytic hour—whether it be by play dramatization or by spoken words" (Clark 1932, 117). But are we really watching nothing more than a child's free expression?

THE DOCTOR'S DREAM

As I described earlier, Pierre Janet wrote that to communicate with patients, the doctor must enter into their dreams and speak to them in language that accords with their delirium. In *Child Analyses*, I suggest, we are also witness to the reverse situation, in which the patients find themselves entering into the dream of the doctor and acting in accordance with his passion. One might ask, who is the author of the sado-masochistic fantasy of eating and being eaten so remarkably similar in both the cases of Winnie and Ned and enacted with so much alacrity by the woman on the bed?

In all the dramatizations I have discussed there is always more than one fantasy at work, that of the patient and that of the doctor directing the performance. Perhaps the most telling shot is in *A Case of Multiple Personality*. The intertitle states, "She discovers the cameraman; imitates him as he turns the reel." We see Mrs. X in her baby phase being egged on by her husband to imitate the motions of the cameraman as he

She discovers the camera man; imitates him as he turns the reel.

Mrs. X discovers the cameraman. Stills from *Case of a Multiple Personality* (Cornelius C. Wholey, 1923)

cranks the camera. It is a startling image that foregrounds the presence of the cinematographic apparatus. Visually Mrs. X becomes a mirror image of the recording device. We see suddenly, with startling clarity, how the patient becomes ultimately no more than a reflection of the doctor's own cinematic fantasies.

These films *show* little but *tell* everything. On one level they could be described as failures, as cinematic dead ends, based as they are on the chimerical enterprise of reading on the surface of the body that which exists purely in the mind. But on another level they are interesting exactly because they tell: they are "confessions" of the doctors and the analysts as much as they are of the patients. They speak loudly and clearly of the new pleasures Foucault spoke of, the pleasures of discovering and exposing the truth of sexuality, the fascination in the attempt to provoke and uncover, and of course to capture on film.

NOTES

1 For a detailed discussion of Aaron Hill's system of acting in relation to the passions of Descartes and the influential writing on physiognomy of the insane by Johann Casper Lavater, see Roach 1993, 58–92.

2 He also pointed out that these women, thus transformed into what he described as expressive statues, would in his opinion make great models for artists. Charcot 1888–94, 443–45.

3 In the *Iconographie Photographique de la Salpêtrière*, the patient was referred to by a number of names: Augustine, Louise, X, L, and G. I will simply call her "Augustine."

4 Londe's camera could take pictures in succession slowly or rapidly depending on the nature of the hysterical attack. This differed from the physiological studies of

Marey where the camera took pictures at fixed intervals, because motion, not emotion, was important. For a detailed description of his photochronographic apparatus, see Londe 1893, 424.

5 Sarah Bernhardt actually visited the Salpêtrière in 1884 and spent time in the wards observing the hysterics in preparation for the mad scene in *Adrienne Lecouvreur*. Gordon 2001, 29.

6 Wholey 1933, 670. This paper was read at the eighty-eighth annual meeting of the American Psychiatric Association in Philadelphia, May 31–June 3, 1932. The film was screened as part of the presentation. I do not know whether Wholey intended the film to circulate or whether he always planned to show it as part of a lecture.

7 Durcum 1914, 751–56. For Wholey's rejoiner, see Wholey 1914, 1036.

8 For a full description of the phantasy method, see Clark 1926, 1- 22. I suspect that this "phantasy method" was what Ferenczi was referring to when he mentioned Pierce Clark's "forced fantasies."

9 As Janet Sayers describes it, very young children often develop internal representations of their parents as punishing and attacking. "Through children's experience of her as mother in therapy, Klein discovered that such internal figures are first formed as a result of the oral and anal frustrations of weaning and potty training— well before the phallic stage described by Freud as a source of patriarchal superego formation." Sayers 1991, 220.

10 These films were shown before the New York Neurological Society on February 3, 1931.

CONCERNING "THE PHOTOGRAPHIC"

Raymond Bellour
Translated by Chris Darke

TO MICHEL FRIZOT

"The photographic," as I imagine it, is not reducible to photography even while borrowing part of its soul and the fate of which we believed photography to be the guardian. The photographic exists somewhere in-between; it is a state of "in-between-ness": in movement, it is that which interrupts, that paralyzes; in immobility, it perhaps bespeaks its relative impossibility.

TWO HISTORIES

At the end of the hundred years of technology that was the nineteenth century, the history of the mechanical image culminated first with a division that has since seemed to constitute a point of truth. On the one hand, the photographic image, instantaneous from the outset, served to truly stop an abstract but living instant of time which might thus appear as even more immobile.[1] On the other hand, the cinematograph, for the first time, restored the movement of life. The contrast is still clearer if one reflects upon the effect that sometimes accompanied the first projections: a still image that began to move.[2] Moreover, this contrast is founded in the identity of the medium: the same "film" is, in one case, reduced to an image—or to a "photogram," as we would say fifty years later—and, in the other, multiplied by the number of images destined to create the most exact illusion.

This sudden and almost overly pure division seems to open in itself,

Still from *La Jetée* (Chris Marker, 1962)

via a beam of magical light, the reality or potentiality of two histories, or the two faces of a single history. The first, which extends back beyond cinema, is increasingly well known, as so many learned volumes attest—and it is noticeable that this is as a proportion of the fact that the second, announced by cinema, appears to grow confused the closer it comes to us.[3]

This first history, with its endless detours, is not driven, as we too often wish, by the irreversible tendency that would lead it to the creation of a pure lifelike movement that the cinema would end up by embodying. It is made up, above all, by rudimentary, varied, and frequently barely reconcilable attempts at movement, each linked to the singularity of the numberless vision machines and spectacular *dispositifs*, all maintaining a relationship each time more or less determined by a fixity that remained internal to them, even if they would, at times, have liked to have detached themselves from it. It is thus striking that, at the end of the eighteenth century, Robertson's "fantasmagoria," thanks to the simple principle of a carriage maneuvered behind a screen, offered spectators a greater illusion of movement than Daguerre and Bouton's diorama would twenty years later, despite its revolving *dispositif* and its diverse effects of animation achieved by fades and lights. One is also struck that the stereoscope, in the middle of the century and with staggering success, instilled a completely singular form of movement that

remained closed in on itself, a perceptual quasi-movement provoked by the formative visual accommodation of the relief and thus by an indiscernible mixing between a pure organic physicality and the hallucination that it opens in a frozen image into which the eye sinks as if to animate it. As for the camera obscura, the oldest of optical *dispositifs*, which inaugurates a genealogy with neither regularity nor goal, it is crucial to observe that an extreme movement is produced here, more complete than any other pre-cinematic vision machine. If we concentrate on the material effects on the one looking rather than on the theories of vision that it served to model, the camera obscura in fact captures a movement of reality that it restores more or less completely, either inverted or straightened by the use of an appropriate lens. Across its evolution, from the sixteenth to the eighteenth century especially, those looking find themselves, alone or with others, inside the black box as in a real room, or standing facing what often succeeded the camera obscura, a more or less manipulable box. From a certain point of view, the crucial aspect is that movement, as witness to a given reality, should reproduce itself with its associated qualities of surprise and continuity. "A continuity of movement from place to place," this piece of high praise recalls a pleasing analogy: "the waving of plants in the wind."[4] While in the case of the magic lantern, of which it has become customary to observe that it progressively replaced the darkened room as a spectacle, movement, as suggestive as it became, would remain limited to effects of superimposition and the interweaving of contrasting slides. One can imagine that the qualities of projection particular to a spectacular *dispositif* inherited from theater, as with the diorama, might prevail over the quality of illusion attached to movement before the two were to find themselves associated in the *dispositif*—as long anticipated as it was improbable— of Lumière's cinema.

PROUST'S LANTERN

One of the most celebrated of evocations seems to have deliberately mixed up these elements. When, immersed in *In Search of Lost Time* and his tender and tormented recollection of the rooms in which he slept, Proust came to describe his childhood bedroom in Combray, he summoned the image of the magic lantern with which, on certain nights, he attempted to assuage the pain of his loneliness. Of this knight

Golo who, leaving the forest, menacingly approaches the castle of Geneviève de Brabant, the narrator on several occasions underlines the jerky movement that seems to correspond to the manipulation of the slides, probably by his great aunt who reads him "the tall tale": "his horse's halting steps"; "approaching in starts"; "he withdrew with the same halting step." But the story just as quickly adds, "and nothing could stop his slow gallop" as if a continuous movement was thus substituted by the jerkiness dictated by the handling of the lantern, and that the naturally transitive art of literary narrative was thus married to the new state of the projection of images proper to the moment in which Proust was writing, the second decade of the twentieth century: the time of cinema, which superimposes itself over the immobile or jerky time of childhood's magic lantern.[5] In the same way, a contemporary reader cannot help being struck by the consecutive lines which give the last and deepest sketch of the episode:

> If the lantern were moved I could still distinguish Golo's horse advancing across the window-curtains, swelling out with their curves and diving into their folds. The body of Golo himself, being of the same supernatural substance as his steed's, overcame every material obstacle—everything that seemed to bar his way—by taking it as an ossature and absorbing it into himself: even the doorknob—on which, adapting themselves at once, his red cloak or his pale face, still as noble and as melancholy, floated invincibly—would never betray the least concern at this transvertebration.

One thinks today of these installations, these rooms of images with such variable contours, in which, here and there, everything is made or becomes a screen: a door, a window, the angle of a wall, the floor, this object and that, the handle of a door or something else, according to a singular and generalized effect of animation.

FREEZE FRAMES

The second history is that which begins with cinematic movement and has since been associated, at times, more or less with its interruption. It is a still neglected history but its general outline seems quite clear—here's hoping that it will one day be redefined.[6]

For a long time during the era of silent cinema, in the early days and

beyond, a particular kind of immobility had been suggested in order to emphasize, as if in passing, pregnant moments without similarly insisting on the physical reality of the image itself. In D. W. Griffith's *A Corner of Wheat* (1909)—when the people, outraged by the rise in price of wheat but threatened by the police, appear to stiffen in a brief movement; or at the beginning of *Intolerance* (1916)—the crowd appears as if "frozen" while the Pharisees are praying; equally, in Alexander Dovzhenko's *Arsenal* (1929), just before the uprising, to emphasize its imminence and gravity.[7] Conversely, in *Paris qui dort* (René Clair, 1923), as in *Man with a Movie Camera* (Dziga Vertov, 1929), it is the very film itself that appears to stop, as if by its own volition, whether in order to describe the illusion of a machine capable of suspending time or as much to recognize the machinelike aspect of cinema itself and to exalt its powers of montage and assemblage, whose materiality asks to be put to the test.[8] As it does, in the same year, albeit in a different way, in the astonishing sequence in *Menschen am Sonntag* (Robert Siodmark/ Edgar G. Ulmer), where the variable interruptions of a still camera's snapshots embed themselves for a matter of seconds in the film's unwinding. In this respect, the extraordinary freeze frame of a tram and its leaping driver in *The House on Trubnaya* (Boris Barnett, 1928), which appears just before those of Vertov, appears as even more enigmatic, deliberately suspended between magic and epistemology.

It is the intelligence of the machine in itself and, by extension, of its *dispositif* of projection that seems the most natural pretext for such an interruption of time. It remains fascinating that, unless proved otherwise, Fritz Lang should have remained the only filmmaker in sound cinema during its classical period to have reinvented the freeze frame. Fleeing Nazism via France (*Liliom*, 1934) and arriving in America (*Fury*, 1936), he did so from the point of view of projection conceived as proof both metaphysical and judicial, as judgment in the eyes of God as well as those of men. In two unique sequences, where the freeze frame chills its real and fictional spectators alike, cinema finds its own nature affirmed as being an ethical and social instant of a truth of the proof which, until then, had rather be seen as being the province of photography.

Is it not also surprising that between a number of films scattered across the war and postwar period in which the freeze frame turns out to be more or less surprising or motivated, it should be around photography that its violence focuses itself first in an insistent manner be-

fore becoming the emblem of a modern cinema threatened in its new faculties and intensity.[9] In *La macchina ammazzacativi* (1948), Roberto Rossellini pushes to its extreme the reflexive, mortifying, and nostalgic function that the photograph had immediately fulfilled in so many dramatic shots—from *Shadow of a Doubt* (Alfred Hitchcock, 1943) to *Letter from an Unknown Woman* (Max Ophuls, 1948), from *6 ½ × 11* (Jean Epstein, 1927) to *Blow-Up* (Michelangelo Antonioni, 1967). For, in this moral tale much prized by Rossellini, to rephotograph a photograph brings with it the instant death of certain characters, such is the premise and the crazy enigma that it sets forth: in the very positions that their old photographs showed them, the characters, one by one, are immediately paralyzed in the image of their everyday lives—as this same image of quotidian life was itself to become in so many ways in the cinema of the New Wave. For Serge Daney, the history of the freeze frame thus begins with the last shot of *Les Quatre Cents Coups* (1959) when Jean-Pierre Léaud approaches us as we face the sea and François Truffaut chose, as an ending, to interrupt his movement, thereby announcing a certain death of the cinema that he reinvents.[10]

Such is the interruption of movement, embodying a reversal of time, that Chris Marker's *La Jetée* (1962) determined once and for all (in its hundreds of photos and a provocative and revelatory instant of real movement), time that passes from one war to another, from the Second World War to the fictional Third World War and which also becomes a war of images. This war is played out between a frozen photograph and its reanimation by the time of projection (thanks to the commentary and music as well as the fades between images), between the fiction ascribed to the image and its value as a document—if it's true that the single image which serves here as source of obsessive fear, an image of childhood and a double death, folding the film's ending back onto its beginning, resurrects a famous shot taken by Robert Capa during the Spanish Civil War.[11] But just such a war brings together the image we see with the mental image that serves as its surrogate that, through the experiments to which the protagonist-spectator is subjected, becomes the very object of the film ("the inventors were now concentrating on men with very strong mental images. . . . This man was selected only because he was glued to an image of his past"). Such a choice has its corollary, which expresses what is without doubt the film's most important proposition as regards the creation of the image and its virtu-

ality: "He met a reasonable man who told him, in a relaxed way, that the human race was doomed. Space was off-limits, the only link with survival passed through Time." This time is, therefore, reversible. Everything actual is rendered virtual, it is the pure index of the "crystal image," the emblem of the "time-image"—to such a degree that one is surprised by the absence of Marker's film in the great book by Gilles Deleuze.[12]

And this emblematic value reaches outside as well as beyond cinema itself to take in the novel from which the film comes—*La Jetée*, this "ciné-roman," reanimates the psychic images of war and fighter planes from Marker's only novel, *Le Coeur net*. But, above all, this emblematic value privileges two gestures. The first of these we owe to Thierry Kuntzel. When, after several years of filmic analysis and hence of methodical freeze frames, Kuntzel turned toward conceptual art and then video-art (first tapes and, very quickly, installations), it was as a way of emerging from a singular experience of which he was, as Rilke liked to say of himself in his *Malta Notebooks*, the eternal "reconvalescent": this was an attempt at a reconstruction, lasting months, of *La Jetée* in the form of a second film, within which the shots of the images, shuffled like a deck of cards, were to acquire a redoubled autonomy made up from just as many mental harmonics. A wily gesture, which reinvests the virtualities of Time to the benefit of those of a second-degree Space, to be extracted from their original filmic unwinding. A utopian gesture, too, which would, in fact, have made more of an installation setting or a computer program than the videotape in which it sought to express itself.[13]

The second gesture is obviously that of Marker himself, having opened up—the first among filmmakers to do so—the time of the cinematic image to the space-time of the installation. From *Quand le siècle a pris formes* (1978) to *Silent Movie* (1995), his homage to silent cinema, up to his interactive CDROM *Immemory* (1997), Marker, this new Hamlet, has been exemplary among filmmakers in putting the time of cinema out of joint without letting it be assumed that he'd immediately burdened whoever was intent on setting it back in place. Time thus never ceases redoubling its potentialities to be endlessly multiplied through the Space across which it transforms and survives—including here the new and unavoidable mental discontinuity which affects the spectator transformed into a visitor, a stroller, a gazer, a reader, however we might wish to name this protean creature.

It is almost twenty years ago that the exhibition "Passages de l'Image" proposed to bring together images and sounds deriving from cinema, photography, video-art and what we then called "nouvelles images," digital and computer graphics, within the confines of a museum and according to the constraints of diverse *dispositifs*.[14] The exhibition implied mixing films, photographs, tapes, and installations, which were themselves populated by images of a greater or lesser degree of movement. Among the dozen of these installations, *Vortex* by the American Dennis Adams embodied a certain conceptual privilege. While the interior of the cube that made up the installation contained photographs, two of its opposing faces served as screens for a montage of extracts from films and tapes from a variety of genres and periods which, on one hand, showed mutations of analogical representation brought about by the new possibilities of video and, on the other, the degrees of immobilization owing to photography and to the modalities of the freeze frame and the various transmutations of the movement-image.[15] All of which served to make up *passages*, in the sense suggested by Henri Michaux but also implied by Walter Benjamin. An underlying idea, even with its degree of melancholy, desired that each of these mixed arts would be in part defined by one or several others, even while retaining its individual force.

It has taken this short time—two decades, and no few exhibitions— for these passages to have multiplied, at times to the point of imperceptibility, owing to a double increase in power: that of the computer (and all the machines it includes) and of the museum-gallery ensemble (thanks to all the mixings it favors).[16] Although absorbing ever more of these passages in its own way and diversely assimilating the digital revolution, cinema has, for its part, demonstrated a surprising resistance in reaffirming itself and has powerfully survived its much-foretold death. And this in spite of all that summons it out of its intangible *dispositif* (projection in a darkened room over a given time). With the result that, on one hand, cinema turns out to be increasingly innervated by what I call "the photographic." Without stopping one more time with the exemplary figure of Jean-Luc Godard, who, from *Ici et ailleurs* (1974) to *Histoire(s) du cinéma* (1989–98), stands as the principal arranger of denaturalized movement, it is enough to observe, for example, the calm

integration of slow motion and freeze frame in Wong Kar-Wai's recent 2046 (2004) or, some forty years after that work of pure "in-between" images *Persona* (1966), the engrossing, oceanic function of photographs in Ingmar Bergman's final film *Saraband* (2003), which was shot and projected in high-definition digital video. But also, the cinema remains alone among all the arts of the moving image to carry its spectator along a real continuity, as fragmented as it may be imagined to be, the subtlety of which must be endlessly calculated—because it is always on a unique capacity to embody and project the world, whatever world it be, that cinema depends. And, when faced with this unique *dispositif*, compared with cinema alone, just as much as there are other, nearly numberless, protean *dispositifs*, there are *states*.

Image-states, for as decisive as sound can be, it is really the image here that sustains deviation and variation. These states prove to be cut to the quick by *the photographic*, within the secondary space which models the time of their space in (its) restricted movement. With the result that the effect of the photographic extends in a staggered fashion, going beyond photography itself, according to the greater or lesser degree of movement with which it affects the image, but without extending as far as its own self-contained, singular identity which might add up to the fiction of cinema itself. And that such a process hangs on the movement embodied in the image at work, or on the visual and motor displacements induced by the *dispositif* through the perceptual treatment offered to the spectator.

We are dealing, therefore, with *an art of confusion, an aesthetic of confusion*. As we might imagine, the word is only intended positively, contrary to any idea of specificity or authenticity of media, which have meaning only inasmuch as they mingle. This aesthetic has, if not rules, which would be contrary to its invention, at least principles, a spirit that is led by and favors mixing.

First, as we have seen, it is above all the *dispositif* that guarantees the work, renders its meaning virtual, as in any *dispositif*; but here, because of a gap between its two faces, which are constituted by cinematic projection and the straightforward showing of photographs (or, equally, paintings). Next, it is evident that this invention, as if in proportion to its requirement to innovate, works through retroactive concentric circles across the history of the arts and techniques from which it draws its potential, stopping at certain of its former *dispositifs* or at certain

distinctive traits, to propose its renewed versions. Finally, the most mysterious but perhaps the most effective aspect hangs on the way in which certain works induce singular mental dispositions, in equal proportion to the intervals of space-time that they arrange between their images as between the unscripted movements of the bodies that experience them. We are beginning to realize that the cinema is a gigantic theater of memory, open and metamorphic, and one's apprenticeship in it begins all over again with each film rich enough to connect the life of the spectator to the unique network of associations it sanctions. In image-based installation work, this theater of memory proves to be a possible place between wandering and stillness, conditions that find themselves prescribed in each case as much by the work's specific regime of images as by the physical and thus mental experience which each installation invites. It is, above all, a matter of experimenting in varied spaces, within more or less random durations, with instants and intervals of time.

JOURNEYS

In order that a proposed itinerary (one of many possible) through different states of the image might lead in various directions, it makes sense to consider the greater or lesser extent to which photography or cinema attaches to each work but to consider, above all, their interweaving and to concentrate on its endless multiplication in certain singular *dispositifs*.

Michael Snow's *Solar Breath (Northern Caryatids)* (2002) appears the closest to cinema. If only in order to pay tribute to a lived experience by endowing it with its artistic dimension ("Life and Art": the words used by Snow to reassess the work) it was necessary that the wall of the enclosed room in which the film is projected become the screen which, when covered with a curtain and an insect shield, itself becomes an image of a real open window. The film hangs on the "mysterious performance of the wind" extending throughout a static shot of sixty-two minutes more or less animated by a movement which, when ruffling the folds of the curtain and lifting the insect shield, discloses fragments of a landscape. Here, the effect that I call "the photographic" resides first in the minor but intense sense of displacement of the work's *dispositif*—a modest-sized room through which spectators circulate in a necessarily random fashion—from that of cinema. But the photographic emerges

above all in the work's temporal quality: this static shot of long duration, like an endless Lumière *vue*, holds within itself as part of a movement which is, in truth, continuous and is sustained by micromovements of greater or lesser intensity, points of suspension that tremble at the very edge of immobility. The time for which the film has been exposed accommodates reality's ebbing, flowing, halting movement as if to allow psychic space its own rhythm, caught between frozen moments and animation. The gaze that confronts time and matter over such duration, with instants standing out sharp as pinpricks, finds itself inevitably sliding from perception to hallucination.[17]

An altogether different experience of the interval emerges from the double screen work by Pedro Costa (*Untitled*) (n.d.); the documentary currency of these long sequence shots, filmed during the making of *Vanda's Room* (2000), is augmented by a sense of the simple movement of life in which, again, one finds evidence of a Lumière-like tendency that surfaces in contemporary cinema. But the division of the screens implies an other distance, that of the gaze that oscillates between them, as well as in the film's endless projection—as if we can take from it what and when we want—and perhaps allow it to become embedded in memory in an other way.

Different yet again is the displacement to which the filmmakers Yervant Gianikian and Angela Ricci-Lucchi submit their work of poetical-political reconstruction in its orchestrated progression across three screens. From the point of view of instant and interval, the interesting thing about *La Marcia dell'uomo* (2004) is that it finds its pretext and primary example in footage by Marey, that is to say, as regards cinematographic *défilement*, in an effect of perceptual discontinuity anterior to it, in an offshoot of Marey's research into movement. This effect is, if not the same, then analogous to the treatment through which the filmmakers, since the beginning of their great undertaking of re-treating archive footage, have imbued their images with speeds both various and autonomous and through which the captive *défilement* of cinematic speed seems constantly to subdivide into forms of pauses in movement beyond or outside the impression of verisimilitude and the illusion of life. So the particular interest of this installation is to juxtapose two distinct levels of intervals: the interval of variable time which hollows out a furrow of anomaly between its images, in a fashion that invents a perceptual experience of time which becomes truly internal to that of

memory; and the intervals of open space which spread from one screen to the next as if from one archive to another.

In the works by David Claerbout and Dara Birnbaum one also finds the history of cinema continuing, folding back on itself in a movement that exceeds it. So, in Claerbout's work, one finds him following an obsession with one of the frissons for which cinema was immediately celebrated, for the simple fact that in several of his installations, as was often exclaimed in front of Lumière's films, "the leaves themselves move."[18] The seduction of *Untitled (single channel view)* (2000) is that this movement is liminal—but also that, in its double effect of a real window and a projected window screen, just as in the varied postures of these children who, in a classroom, are divided between being captured in the light and by a gaze directed toward their spectators, this image of a deep black and white oscillates between cinema of the 1920s and that of the 1940s, between a silent French or German cinema and a film by Jacques Tourneur.

Silent cinema surfaces in *Erwartung* (1995/2001), carried along by multiple intervals that make this installation an exemplary case of the uncertain state of the images. The story it tells unfolds over twelve minutes and thirty seconds through long transitions between fifteen transparencies. The projection effects here are, at first, multiplied: the central, suspended screen—made of plexiglass and decorated by a painted motif—onto which the images are projected allows for an effect of doubling in the way that the image passes through the screen to be cast onto the back wall transformed and made faint by its passage. The image is further doubled by being reflected on the ground and cast back to the wall from which it is projected. This image is also composite in nature. The painted motif is of a giant computer-generated reproduction of a painting by Schoenberg, one of the six he produced for the set of *Erwartung,* his 1924 one-act "monodrama" for single voice and orchestra and for which the libretto, composed in 1909 and published in 1916, was written by Marie Pappenheim, then a student in medicine in Vienna. The two other elements that make up the image are the white-clad body of a young woman and fragments of her monologue more or less mixed with intertitles (which tell of a woman's romantic wanderings through a forest at night—this might be a dream—in search of her lover whom she finds murdered). Such is the silent cinema aspect to these images, the actress conveying the story of which she is victim and protagonist

through intensely expressive gestures (two gestures sometimes merging across the image) and whose slow-fades endow them with a kind of quasi-movement (a little as in the photographic installations of James Coleman). The exteriority of the sound (a repetitive, electronic treatment of a twenty-second excerpt from Schoenberg's thirty-minute score) contributes further to the work's evocation of a former cinematic quest for the fusion of the arts.[19] The highly singular *dispositif* of Birnbaum's installation responds to that cinematic past in today's terms, as transformed into a kind of post-cinema which possesses a new type of immobility bought about by the migration from the auditorium (cinema or opera) to the museum's open room.

Across all the works the power of the still image serves to concentrate the frozen quality of those images that move and to participate in it through its own movement. It is, therefore, more or less from the matter of immobility that the exhibition starts in the images selected by Jeff Wall from his own oeuvre. At one extreme there is *Blind Window* (2000), with its aperture barred by a crosspiece, which could stand for photography itself in all its self-enclosed duration were it not for the presentational format of the light-box which Wall has employed right from the start and which endows all his images with their particular quality of vibration and density that has qualities of motility to it. At the other extreme, the photographic series *Partial Account* (1997), with its nine images plus a tenth (which is split in two as if poorly cut from the last frame of a reel of film), intensifies the effect specific to all series-work by the variation from one photogram to the next which extends to the spaces between them and connects the depiction of acts and gestures in a scenario-like tableau.[20] Between these extremes, the double image of *Man on the Street* (1995) reduces and concentrates the effect of variation; *Boys Cutting Through* (2003) captures an action in movement through an instant of lively emergence in such a way as to confuse (which is the very vocation of this art between photography and painting) the any moment whatever with the pregnant moment and the decisive moment.

In his *Series of Images* (1975), James Coleman brings an enigma forward from the very depths of time. For it is from somewhere before photography, closer to a particular kind of painting, that these seven photograms of a transcendent cinema deliver their lesson. These ancient images arrived at a turning point in Coleman's oeuvre, between his projections of illusions (*Two Seagulls and One Seagull Twice* and *Playback for a Dream*,

1974) and his first creation of scenario-transparencies (*Clara and Dario*, 1975) and film loops (*Box*, 1977). The two lines inscribed seven times onto the aluminum have a double property. Each lends to the illusion: we first make out a central form which might be a stylized body, or we see two faces. From here on in, this automatic perceptual reflex doesn't stop engendering an on-the-spot palpitation, like a frozen movement. What stands out, here, is the series effect, a second-degree variation that is only enhanced by the care taken with the lighting and that creates the physical *défilement* of quasi-conceptual expressions. The importance of this semi-*trompe l'oeil* animation of paintings, of which the idea had tormented Coleman for an entire year, is that it in fact provides a model for his future large-scale projections of scenario-transparencies which, from *Living and Presumed Dead* (1996) to *Photograph* (1998–99), are at the very heart of his oeuvre and, through being situated exactly between photography and cinema, are very pure examples of the photographic. And if we consider the beginning of *Charon* (1989), with its six images connecting and alternating around the single motif of a car crash, a traumatic event which coincides with the very ideal of the photographic process, then it is in *Series of Images* that one finds their source, in its series of superimposed visions and the slippages therein from space to time.[21]

The relationship between intervals of space and intervals of time is conjured up by Thierry Kuntzel through the juxtaposition and fusion of instants. In *Tu* (1994), the title itself uses the form of address which, gently or violently, denies the child a future ("tu es cela," "you are that"— this was the caption Barthes gave to the ideal and fictive image of "the mirror stage" [Barthes 1975, 25]) and which, in Kuntzel's piece, commits the spectator first to seeing "this," then "that." *This* consists of eight huge, vertically arranged photographs showing a bust of a child from eight different positions and with eight different facial expressions, ranging from a neutral countenance to a devilish smile. *That* is a ninth image, which closes the circle, a video reanimation in which the eight photographs are morphed together. A dialogue (one constituted by its own extravagance) is thus opened up between the intervals separating the photographs and their cancellation by the continuity of the moving image, which, however, they keep punctuating, as if the mind were scanning the video to fix the photographic intervals within it. For we cannot help but look from the photographs to the video and back again, trying to figure out whether, in the video's continuity, facial expressions

emerge that are not visible in the photographs. But we cannot name these expressions because they are nothing more than movement opening a gulf between and within the frozen images of the photographs and, between them, something nameless emerges that cannot be corroborated by either. Here, with cinema thus transformed, comes a novel condition of looking, one that constrains us to penetrate the mental process by which we break down the very temporality that constitutes the condition: the interval between photography and cinema is thereby captured in its purest essence.

Kuntzel has long worked through his previous film analyses to disconcert filmic time, to interrupt it, break it down and space it out, thus generating his own oeuvre. We find a not dissimilar approach being taken by Chantal Akerman, who, in turn, has broken down her most well-known film into an instant of suspension. *D'est: Au bord de la fiction* (1995) was an object lesson in thinking through the relations between a projected film, an exhibited film, and a détournement of television. Here, the spacing-out is slow, subtle, at the limit of perceptibility. Those who remember the film will know that the woman sitting at the dining-room table has just killed the man to whom she prostituted herself; others have the title of the work to assist their imaginations: *Woman Sitting after Killing* (2001). Each spectator will attempt, a little fruitlessly perhaps but with the requisite application, to grasp the minuscule variation between the seven instants of the same moment looped across seven monitors. This barely varying but fully alive instant of a shot takes on the character of a painterly tableau to which we lend the quality of movement by dint of its stillness.

A final group of installations, departing from the space of a single look or projection, serves to capture other powers, those of interactivity, relief, and the Internet, as well as other forms of circulation, other states of images, other intervals of space and time.

Shelly Silver's *What I'm Looking For* (2004) tells the story of an experiment. First, there are the photographs of future models that the artist received via the Internet in response to her invitation. The raw individualism of these photographs, each seen in the light of the others, makes up an array of so many exaggerated instants. Then there are the selected photographs of certain models taken by the artist herself. Two long series of photographs, linked but opposing, are thus arranged on two facing walls. And finally, given a space all to itself, there is the

film made from the photographs which reassesses the experiment and, through a combination of montage and commentary, attempts to express and reflect upon the relationship between its source-images, the photographs, and the resulting film. The gaze of cinema (or, rather, video) that Silver brings to bear on these photographs becomes the opportunity for one of the most extreme testing grounds of the interruption of the instant and the acceleration of montage which make up the two sides, powerful in their intrinsic duality, of something visible in the process of disappearing.

The specific wager of Jean-Louis Boissier is to transform into a manipulator of images what could be said to remain of the spectator in the installation-visitor, on whom the image, or rather the extent to which it appears, depends. And so perspective, employed here as the object of elaboration via the crucial motif of Renaissance painting—hence the work's title, *The Annunciation* (1992)—becomes "relational perspective," to be experimented with by a visitor according to a particular method: "When the installation is manipulated and observed in its setting it has three functional modes: that of interactive recording and assembling of images; that of the live manipulation of the vision machine; that of the direct and all encompassing apprehension of the scene itself."[22] Everything hangs on the relationship set up between the action of the person wishing to see and the nature of the scene as the production of an image. This emerges, on the one hand, from the "models" (Boissier adopts Robert Bresson's term to qualify the style of performance suitable for actors or actresses whose images are destined to be treated in the computer) and, on the other hand, from the discontinuous rhythm of the images which, as they unfold albeit jerkily, incarnate essential instants of gestures rather than so-called natural human movement. The work's logic, as it attaches to the interval itself, produces a sort of post-cinema image which also seems to be a return to an image predating the cinema of the Lumières, namely, Marey's chronophotography, with its own specific temporality and movement.

The interactive actions required by Masaki Fujihata's *Field-Work @ Alsace* (2002) are, in a sense, more simple (donning a pair of glasses, turning a command-wheel) but the results are stunning. It's therefore even more important to attempt to describe the phenomenon it produces, in terms of its *dispositif*, beyond the well-informed technical commentaries on the work supplied by the artist himself and others.[23] On

the black background of the screen a varying wavelength undulates in bright sine curves, but these moving lines carry images, or what appear to be images, which seem to be suspended from them even as the lines pass through them; the comparison that comes to mind is that of photographs hung on wires to dry. But these images move in every direction, toward and away from each other, collapsing on themselves, changing size and proportion. And these images speak: the beings we see in them talk among themselves as well as to the film's maker: such are the "shots," if one can so name them, because we also think of them as a mass of photograms, derived from a documentary reportage filmed in digital video (and using GPS, Global Positioning System) on the frontier between France and Germany, a source of fascination to this island-bound Japanese artist. An extreme tension emerges here between the aspect of realism, of witnessing, and the irreality of an artifice that aims, however, also to express the vivid character of all lived experience. The most extreme impression of this concerns the two-sided images that seem to have a life of their own and through which we weave our way either via our interactive commands or the work's own programming. Here, all limits of instants and intervals are constantly vacillating in the spectator's physically embodied experience of sight, as they do in the system under which they operate.

THE IMAGE: OUTSIDE AND WITHIN

What to retain from the lesson of such image-states in the light of what went before, of the history and the intricate involvement of *dispositifs* and the identity of the spectator of images?

It's necessary to start again from photography. From two visions, for example, that crisscross to form a knot that mixed-image works, such as those that we are looking to situate here, have as their implicit aim to undo and re-lace. In many contemporary arts, including cinema, Susan Sontag sees "logical extensions of the model established by photography." And she concludes her remarks with a formula that somewhat underpins the idea I am looking to elaborate from the photographic: "all art aspires to the condition of photography" (Sontag 1971, 149). But another of these visions might seem to contradict the first: "The photographed world stands in the same, essentially inaccurate relation to the real world as stills do to movies. Life is not about significant details,

illuminated in a flash, fixed forever. Photographs are" (98). Here, the cinema might be that life that photography is not, it might be "the real form—the process that moves in time."

And yet, it could be the still image that, par excellence, lodges itself therein, and that witnesses. In comparing the regrettably well-known image (in black and white) of the little Vietnamese girl burnt by napalm to the filmed reportage (in color) which corresponds to it, Gisèle Freund emphasizes: "The irony is that the more we consume moving images, the more the single still image rises above the rest, substituting itself for our reality."[24] Or, better still: "It remains the still image and not the moving image which stays engraved in the mind, becoming for ever a part of our collective memory."[25]

But how does the image remain there? Frozen, as it would seem to be in its state as an image on paper, or animated by a discontinuous, random, and fragmentary movement—which Barthes designated in photography through the "punctum" and extended, via his thoughts on the photogram affected by a "third meaning," toward a utopian cinema, hence mostly virtual, whose unreal reality he concentrates in the floating term of the "filmic."[26]

This movement that the eye experiences when faced with the still image that incites it and which Barthes, above, expands across and between images which animate themselves without submitting to their natural movement—such movement is equally characteristic of the inner eye as soon as it confronts any image-reality, whether still or moving, through its powers of imagination or memory. The characteristic of the mental image is not so much its essential poverty, as Sartre in *L'Imaginaire* (1940) believed he had identified (he repeatedly asserts that it appears at once as fully present to the mind, as complete in itself, but with no relation to a reality which it annihilates), but a wildly fluctuating, moving discontinuity; this discontinuity, in its very unreality, appears to situate the mental image between photography's somewhat too-complete fixity and cinema's often too-calm illusion of movement. It is through successively grabbing, fixedly and fleetingly, inferring a discontinuous movement (movement no sooner begun than it is interrupted) that mental reality captures and memorizes a movement, whether real or invented: the movement of life, or of a technology or an art appropriate to capturing within itself an illusion of truth; or the very movement of a dream, as soon as it is thought. For if in the intimate

experience of dreaming there is movement felt to be analogous or even superior to that of life, it is through the story told of it in words that it is truly restored, held within and experienced again in an obscure bodily memory. As soon as we fix on the images themselves, they yield to us in fits and starts, like a broken film.

To contemplate the Bosporus Strait provides an ideal way of experimenting with mental images as regards so-called real perception: boats continually passing in both directions, boats of different sizes gliding by at different speeds, passing or catching up with each other. If I shut my eyes and try to follow a vision turning in my memory, one boat passing another for example, a jerky succession of progressive flashes appears. There is a video work that comes close to this, through the very *défilement* of its projection: Thierry Kuntzel's *Venises* (1995), with its boats and barges gliding and stacking extremely slowly on the Grand Canal. What arises from this work (a little like facing the window in Snow's work) is a sort of hallucination in which what we see appears to suspend itself, as if interiorized in broken images, even as the incessant slow movement holds sway. Inversely, it is in *Tu* where the clear-cut interval between the photographs inserts itself in the continuity of a fictive, machinelike movement to try in vain to loosen its stranglehold and to maintain this pulse, as fascinating as it is unbearable, between too much immobility and too much movement.

It is the particular magnitude of these works of "in-between images" that each, according to its specific *dispositif*, clarifies a variation that is significant above all for being conjugated from the spectator's perceptual and mental life so that the differences and overlaps between the two are emphasized. From which derives the specific and particular power of *La Jetée*, to create movement from fixity and thus to carry fixity to its highest intensity, and this in proportion to the exploration that the work proposes of a new capacity for creating mental images, "some years before the outbreak of the Third World War," as a way of not saying "on each new today." Which is also the importance of a work such as *Charon*, which, across its fourteen episodes and according to its continual procedure of dramatically linking static views, provides an inventory of the theoretical and narrative paradoxes specific to the activity of photography, as much in its personal as its professional dimension, touching on the self-portrait, on madness and death, and on fantasies with multiple significance. Excessively present here, the photographic is

also, just once, overevident. In a color still image animated, like all the others, by the text and the cross-fades from which it comes, a television set, on the right, shows black-and-white images in the distance that appear to move. It's this same effect, programmed by computer-aided projection, which makes the cloth-screen hanging on the right side of the frame change color in the beginning of *Lapsus Exposure* (1992–94), imbuing in the still photograph an idea of painting in movement.

The twelve works presented here as examples sketch a journey lifted from the interior of a landscape which is already fairly ancient and everyday more immense. It extends from the large illuminated photographs of Peter Campus (*Woman's Head, Men's Head,* 1978) to Douglas Gordon's *24 Hour Psycho* (1993); from the infinitesimal movement that intermittently stirs in two photographs of women filmed and projected on a double video-screen by Jaki Irvine (*Losing Doris,* 1996) to the oceanic movement that, for years, has welled across the large, linked photographic scenes by Beat Streuli; from a wave reduced to a fixed, abstract point in *Leaning Curve (still point)* by Gary Hill (1993) to *La Vague gelée (The Frozen Wave)* by Alain Flesicher (1997) to the interactive immobilized wave of *The Waves* (Thierry Kuntzel, 1999); from the omnipresent intermediary movements dreamed up by Bill Viola to the exacerbated contrast between fixity and agitation captured in *City* by Liang Juhui (2003)—this quasi–Tower of Babel shown at the Venice Biennale, with its two circular rings printed with mini-silhouettes and its floor overrun by intense, frenetic movement, filling and emptying to the rhythm of its computer-generated crowd. Such an overview of the whole landscape can just as well extend to the gaze of Andy Warhol's *Empire* (1964) or *Sleep* (1963), to Hollis Frampton's *nostalgia* (1971) with its ravaged and consumed photographs, via Michael Snow's *A Casing Shelved* (1970).[27]

This inventory is without end. From the beginning of this text, two works discovered by chance one evening have remained in my mind.[28] First, two photographs in lightly tinted black and white by Christian Boltanski, *La Dernière Danse* (n.d.). They show a tight shot of a semi-entwined couple of which you see only the bust, without arms, so that the bodies seem to be suspended. It suffices for a gap, for a little extra space between the bodies, and for the young woman's gaze to be turned toward us in the second photograph, with its modified lighting and its distribution of tones, for time to have entered and passed through these

two images incorporated in a movement. The second work is *Nine Perfect Minutes at the Phoenix Hotel* by Pierre Huyghe (1994), the time of which could well extend beyond its "nine perfect minutes" so infinite does it seem: a young woman is seated in a bus, her body more or less illuminated by the light falling through a panoramic window which gives on to an indistinct landscape and, above all, the sky. The light changes imperceptibly; we think we see the young woman's body vibrate with the rhythm of her breathing—like a Lumière *vue* held indefinitely in which almost nothing happens.

A century will therefore have been enough for three possibilities to have spread and multiplied in every direction, and above all, to have combined; three possibilities that can be suggestively brought together in a single name: Lumière. Barely ten years separated the arrival of cinema and the creation of autochrome photography (invented in 1904, marketed in 1907). But from one to the other, at the exact moment that one century folds into the next, 1900, Lumière, who, when it comes to moving and still images and the *dispositifs* capable of serving them, without doubt invented almost everything, also created for the Exposition Universelle the Photorama. This was an installation projecting "panoramic images with a cylindrical image around which revolves twelve lenses . . . the screen, lightly ellipsoid, of 20 metres width and 6 metres in height."[29] Offering a catalog of several hundred titles, operated until 1903 in an auditorium purpose-built by the brothers Lumières, abandoned for reasons of cost—but, equally, perhaps for obscure reasons having to do more with intimate needs and mindsets—the Photorama proposed, between the *dispositifs* of manipulated photographs and projected cinema, what might be called a stroller's vision, at the same time as an intermediary situation, physical and psychic, between these too-pure fictions that were photography and cinema. And such is the obscure light that it casts on us today.

NOTES

With thanks to Martine Beguin, Jean-Paul Felley, Agnès Fiérobe-Katell. and Jaffrés-Anja Schneider of the Marian Goodman Gallery in Paris; Michel Frizot, Corinne Giandou, Hou Hanru, Jaki Irvine, André Parente, Yuri Tsivian, and Teri Wehn-Damisch.

This text was originally written for the catalog of the exhibition "States of the

Image: Instants and Intervals," curated by Raymond Bellour and Sérgio Mah for the Biennial LisboaPhoto 2005.

(TRANSLATOR'S NOTE: Throughout the text I have retained the terms *défilement* and *dispositif* in the original French, partly for reasons of elegance but mostly because the terms have specific connotations in French film theory that are lost when directly transposed into English. Literally rendered, *défilement* implies the temporal "unwinding" of a film but, when so translated, it loses the sense of "filing-by" that the term also carries, both as regards the figures on screen but also the ambulant spectators of contemporary moving-image installation works. The term *dispositif* has, in the past, been rendered as "apparatus" in reference to the influential work of theorists in the 1970s who conceptualized cinema as a psychosocial "apparatus" which worked to interpellate its spectators along particular institutional and ideological lines. It seems to me that to retain the original French term is to acknowledge that Bellour is extending the application of the term to a wider field of "image-machines"—from the cinema to the installation—but also to a wider range of perceptual and mental affects.—CD)

1 Michel Frizot, "Un instant, s'il vous plait . . . ," in *Le Temps d'un mouvement*, exhibition catalog, Paris: Centre nationale de la photographie, 1986, 9.

2 For example, see Mannoni 1994, 425.

3 Even though a lot still remains to be done, as was attested by Patricia Falguière's paper "Aristote, la cinématique et les machines" (in the series of conferences "Comme une histoire de l'art," "Revues parlées/Cinema du Musée," Centre Pompidou, Paris, February 24, 2005), prelude to a forthcoming book.

4 Jean Leurechon, *Récréation mathématique composée de plusieurs problèmes plaisants et facétieux* (Pont-à-Mousson, 1626), cited by Mannoni 1996, 134.

5 Proust, 1987, 9–10. In the "Drafts" included in the Pléiade edition, the movement's jerkiness is explicitly attributed to the handling of the slides and there is no equivalent to this "lente chevauchée/slow ride" (662–64). Elsewhere, an interesting variation shows Proust hesitating between the "cinématographe" (his first solution) and the "kinétoscope" (the solution he retained), to qualify "the whirling, confused evocations" that are bought to mind on waking by the "successive positions" attached to what the machine shows (following the classical example of the galloping horse) (7 and 1090). [Translator's note: the extended passage from the first volume of *In Search of Lost Time* is from the translation by C. K. Scott Moncrieff and Terence Kilmartin, revised by D. J. Enright (Proust 2002, 9)].

6 Daney, "Une histoire de l'arrêt sur image serait instructive," in Daney, Biette, and Crimail 1993, 38; see also 36–37.

7 Dovzhenko gives a commentary on this moment, which is cited in Schnitzer and Schnitzer 1966, 56–57. Thanks to Yuri Tsivian, who bought these three examples to my attention.

8 Annette Michelson has compared the two films in Michelson 1973.

9 *Les Visiteurs du soir* (Marcel Carné, 1942), *It's a Wonderful Life* (Frank Capra, 1946),

All about Eve (1950). I have discussed the last two of these titles in "L'interruption, l'instant" (Bellour 1990, 113), which also includes a detailed analysis of *La macchina ammazzacativi*.

10 Other than the page cited in Daney, Biette, Crimail 1993, see Daney 1982, and Bellour, "La dernière image," in *Passages de l'image* 1990, 57–60.

11 This is Peter Wollen's hypothesis in Wollen 1984, 19. The Capa photograph is *Death of a Republican Soldier*.

12 David Rodowick picks up on this by immediately taking *La Jetée* as the emblem of the contrast between the Deleuzian visions of the movement-image and the time-image (1997, 4–5).

13 There remains a tape considered lost to this day, *La Rejetée* (1975). On the fruitfulness of Marker's film for Kutzel's research, see the catalog of his exhibition at the Galérie nationale du Jeu de Paume, 1993, 32–37.

14 "Passages de l'image," Centre Georges Pompidou, September 12–November 18, 1990, curated by Raymond Bellour, Catherine David, Christine Van Assche.

15 The extracts made up the chosen range—we might call it "the trailer"—of a program of 148 films projected in the museum's main cinema, which was difficult to integrate within the exhibition space, and 93 videotapes shown in this same space.

16 Two of the most significant of which might be "Art and Film since 1945: Hall of Mirrors," organized by Kerry Brougher at the Museum of Contemporary Arts, Los Angeles, in 1996, and "Still/Moving: Contemporary Photography, Film and Video from the Netherlands," organized by Shinji Kohmoto and Frits Gierstberg, with Chris Dercon, at the Museum of Contemporary Art in Kyoto in 2000. These words of Frits Gierstberg are worth recalling: "One of the most striking results of the digital revolution is the dwindling of the once quantifiable gap between fixed and mobile images. . . . Whereas the photographic image had always drawn movement to a halt it now starts to move. Fixed images that start to move, moving images that become almost immobile or endlessly repeat" (18). Among the selected works, *Nudes/To See or Not to See* by the filmmaker-photographer Johan van der Keuken was intimately concerned with the states in between mobility and immobility.

I should at least mention, in addition to the two exhibitions above, one organized by Dominique Païni, "Projections: les transports de l'image," Le Fresnoy, Studio national des arts contemporains, November 1997–January 1998 as well as those organized by Phillipe Dubois, "L'effet film—figures, matières et formes du cinéma en photographies," Galerie Le Réverbère, Lyon, May 4–June 30, 1999; and "Movimentos improvaeis—o efeito cinema na arte contemporanea," Centro Cultural Banco do Brasil, May 19–July 13, 2003.

17 In this sense, Snow's "film" illuminates, and is illuminated by, the difficult pages of the "Perception in the Fold" in Deleuze 1988, in particular 124–25.

18 Also, with more or less subtlety, in *Ruurlo, Bocurloschweg*, (1910); *Kindergarten, Antonio Sant'Elia* (1932), and *Boom*.

19 A short, anonymous account of *Erwartung* in the pages of *Aden* ends as follows: "A quite obscure but highly sensual experience, touching the heart of the materiality of film: Dream matter" (March 10–13, 2001).

20 For unforeseen reasons, *Partial Account* was not able to be part of the final choice of Jeff Wall's images. Its unique character in Wall's oeuvre (comparable to that of *Eviction Struggle* in its double photo/video version in "Passages de l'image"), and its own conceptual value, justify its being mentioned here.

21 "He started a series of shots based on a memory of how he found himself when he emerged from unconsciousness."

22 Jean-Louis Boissier, "La perspective relationnelle," in the catalog *Invisibile*, published for the exhibition at the Palazzo delle Papese Centre Arte Contemporanea de Sienne, autumn 2004 (119).

23 See the text by Masaki Fujihata, "Field-Work/Alsace," in Shaw and Weibel 2003, 416–25; or that by Jean-Louis Boissier on Fujihata's work in the same publication.

24 In the second part, entitled "Réalité de l'image," of the film by Teri Wehn-Damisch *Photographie et Société: D'après Gisèle Freund*, TF1, 1983. The same double proof is demonstrated with the no less celebrated image, in both film and photography, of the self-immolating Buddhist monk in a Saigon street.

25 This formulation is given by Rosalind Krauss when, in an essay devoted to the photo-animated work of James Coleman, she reports these words of Gisèle Freund bought to mind by Teri When-Damisch before encouraging her to come and see the films that Cartier-Besson made from his photographs (2003b, 163).

26 Roland Barthes, "Le troisième sens" (1972), in Barthes 1982b. I have insisted on this notion of "the filmic" in "L'interruption et l'instant" (Bellour 1990) as well as in the "Livre d'images" devoted to Jean-Louis Boissier's interactive CD-ROM, *Moments de Jean-Jacques Rousseau* (Paris: Editions Gallimard;/Geneva: Centre pour l'image contemporaine, 2000) and Bellour and Boyd 2001. The "filmic" is also retained by Rosalind Krauss in her approach to James Coleman (165).

27 This forty-minute film consists of a projection of a transparency accompanied by a commentary.

28 This was at FIAC in Paris, autumn 2004, on the stand for the Marion Goodman Gallery.

29 Lumière 1994, 373, wherein Louis Lumière recalls to Henri Langlois "the insurmountable difficulties presented by the installation of an auditorium for the Photorama projections."

Abe-Nornes, Mark, and Yeh Yueh-yu. 1998 [1995]. "Narrating National Sadness: Cinematic Mapping and Hypertextual Dispersion." http://cinemaspace.berkeley.edu (accessed 6 April, 2002).

Acevedo-Muñoz, Ernesto R. 2003. *Buñuel in Mexico: The Crisis of National Cinema.* Berkeley: University of California Press.

Adorno, T. W. 1991. "The Essay as Form." *Notes to Literature,* volume. 1. New York: Columbia University Press. 3–23.

Albright, Daniel, ed. 2004. *Modernism and Music.* Chicago: University of Chicago Press.

Alexander, Darsie. 2005. *Slide Show: Projected Images in Contemporary Art.* University Park: Pennsylvania State University Press.

Alter, Nora. 1997. "Documentary as Simulacrum: *Tokyo-Ga.*" In *The Cinema of Wim Wenders: Image, Narrative, and the Postmodern Condition,* ed. Roger Cook and Gerd Gemunden. Detroit: Wayne State University Press. 136–62.

———. 2006. *Chris Marker.* Urbana: University of Illinois Press.

Alvarez, Santiago. 1965. *Now.* Cuba: Institutio Cubano del Arte e Industrie Cinematograficos (ICAIC).

Anderson, Benedict. 1991. *Imagined Communities.* New York: Verso.

———. 1998. *The Spectre of Comparisons: Nationalism, Southeast Asia, and the World.* New York: Verso.

Andrew, Dudley, ed. 1997. *The Image in Dispute: Art and Cinema in the Age of Photography.* Austin: University of Texas Press.

Arnheim, Rudolph. 1963. "Melancholy Unshaped." *Journal of Aesthetics and Art Criticism* 21.3: 181–91.

Arthur, Paul. 1978. "Structural Film: Revisions, New Versions, and the Artifact." *Millennium Film Journal,* no. 2: 5–13.

———. 1979. "Structural Film: Revisions, New Versions, and the Artifact. Part Two," *Millennium Film Journal*, no. 4–5: 122–34.

———. 2003. "Essay Questions." *Film Comment* 39.1 (January–February): 53–62.

———. 2005. *A Line of Sight: American Avant-Garde Film since 1965*. Minneapolis: University of Minnesota Press.

Askari, Kaveh. 2005. "From 'The Horse in Motion' to 'Man in Motion': Alexander Black's Detective Lectures." *Early Popular Visual Cultures* 3.1 (May): 59–76.

Astruc, Alexandre. 1999. "The Birth of a New Avant-Garde: Le Camera-Stylo." In *Film and Literature: An Introduction and Reader*, ed. Timothy Corrigan. Saddle River, N.J.: Prentice-Hall. 158–62.

Attali, Jacques. 1985. *Noise: The Political Economy of Music*. Trans. Brian Massumi. Minneapolis: University of Minnesota Press.

Baker, George. 1996. "Photography between Narrativity and Stasis: August Sander, Degeneration, and the Decay of the Portrait." *October* 76: 73–113.

———. 2003a. *James Coleman*. Cambridge, Mass.: MIT Press.

———. 2003b. "Reanimations (I)." *October* 104: 28–70.

———. 2003c. "The Storyteller: Notes on the Work of Gerard Byrne." *Gerard Byrne: Books, Magazines, and Newspapers*. New York: Lukas and Sternberg Press.

Barthes, Roland. 1972. *Critical Essays*. Trans. Richard Howard. Evanston, Ill.: Northwestern University Press.

———. 1975. *Roland Barthes by Roland Barthes*. Paris: Seuil.

———. 1977. *Image Music Text*. Ed. and trans. Stephen Heath. New York: Hill and Wang.

———. 1981. *Camera Lucida: Reflections on Photography*. Trans. Richard Howard. New York: Hill and Wang.

———. 1982a. *Empire of Signs*. Trans. Richard Howard. New York: Hill and Wang.

———. 1982b. *L'Obvie et l'Obtus*. Paris: Editions du Seuil.

———. 1991 [1985]. *The Responsibilty of Forms: New Critical Essays on Music, Art, and Representation*. Trans. Richard Howard. New York: Hill and Wang.

Batchen, Geoffrey. 2002. *Each Wild Idea: Writing Photography History*. Cambridge, Mass.: MIT Press.

Baume, Nicholas, ed. 2002. *Sol Lewitt: Incomplete Open Cubes*. Cambridge, Mass.: MIT Press.

Bazin, André. 1967. *What Is Cinema?* Trans. Hugh Gray. Volume 1. Berkeley: University of California Press.

———. 1985. "The Myth of Stalin in the Soviet Cinema." In *Movies and Methods*, vol. 2, ed. Bill Nichols. Berkeley: University of California Press. 29–39.

———. 2003. "Bazin on Marker." *Film Comment* 39.4 (July–August): 43–44.

Bellour, Raymond. 1990. *L'Entre-Images: Photo, cinéma, video*. Paris: Editions de la Différence.

Bellour, Raymond, and Jeffrey Boyd. 2001. ". . . rait: Signe d'utopie." *Yale Journal of Criticism* 14.2: 477–85.

Belting, Hans. 2005. "Image, Medium, Body: A New Approach to Iconology." *Critical Inquiry* 31.2: 302–19.

Benjamin, Walter. 1968. *Illuminations*. Ed. Hannah Arendt. New York: Schocken.

Bensamaia, Reda. 1987. *The Barthes Effect*. Minneapolis: University of Minnesota Press.

Berman, Tosh. 1992. "Wallace and his Film." In *Support the Revolution*, ed. Berman. Amsterdam: Institute of Contemporary Art. 73–77.

Berman, Wallace, ed. 1978. *Wallace Berman Retrospective*. Los Angeles: Fellows of Contemporary Art.

Bertillon, Alphonse. 1896. *Signaletic Instructions, including the Theory and Practice of Anthropometric Identification*. Ed. R.W. McClaughly. Chicago: Werner Co.

Biale, David. 1987. "Gershon Sholem's Ten Unhistorical Aphorisms on Kabbalah: Text and Commentary." In *Gershon Sholem*, ed. Harold Bloom. New York: Chelsea House. 99–123.

Blanchot, Maurice. 1995. *The Writing of Disaster*. Trans. Ann Smock. Lincoln: University of Nebraska Press.

Boon, Marcus. 2002. *The Road of Excess: A History of Writers on Drugs*. Cambridge, Mass.: Harvard University Press.

Bordwell, David, Janet Staiger, and Kristin Thompson. 1985. *The Classical Hollywood Cinema: Film Style and Mode of Production to 1960*. New York: Columbia University Press.

Bordwell, David, and Noël Carroll, eds. 1996. *Post-Theory: Reconstructing Film Studies*. Madison: University of Wisconsin Press.

Boucicault, Dion. 1984. *Plays by Dion Boucicault*. Ed. Peter Thompson. Cambridge: Cambridge University Press.

Bourneville, Désiré Magloire, and Paul Régnard. 1877–80. *Iconographie photographique de la Salpêtrière*. Volume 2. Paris: Progrès médical.

Braun, Marta. 1992. *Picturing Time: The Work of Etienne-Jules Marey, 1830–1904*. Chicago: University of Chicago Press.

Breuer, Josef, and Sigmund Freud. 1982. *Studies on Hysteria*. Trans. and ed. James Strachey. New York: Basic Books.

Bronfen, Elisabeth, and Misha Kavka, eds. 2001. *Feminist Consequences: Theory for the New Century*. New York: Columbia University Press.

Brown, Bill. 1999. "The Secret Life of Things (Virginia Woolf and the Matter of Modernism." *Modernism/Modernity* 6.2: 1–28.

———. 2001. "Thing Theory." *Critical Inquiry* 28: 1–16.

Burch, Noël. 1990. *Life to Those Shadows*. Trans. Ben Brewster. Berkeley: University of California Press.

Burnham, John Chynoweth. 1967. *Psychoanalysis and American Medicine: 1894–1918*. New York: International Universities Press Inc.

Burrow, Trigant. 1958. *A Search for Man's Sanity: The Selected Letters of Trigant Burrow*. New York: Oxford University Press.

Butler, Alison. 2005. "Feminist Film in the Gallery: *If 6 Was 9*." *Camera Obscura: Feminism, Culture, and Media Studies* 58: 1–32.

Cage, John. 1966. "The Future of Music: Credo." *Silence*. Cambridge, Mass.: MIT Press.

Campany, David, ed. 2007. *The Cinematic*. Cambridge, Mass.: MIT Press.

Camplis, Francisco X. 1992. "Towards the Development of a Raza Cinema." In *Chicanos and Film: Representation and Resistance*, ed. Chon Noriega. Minneapolis: University of Minnesota Press. 284–303.

Carroll, Lewis. n.d. *Alice's Adventures in Wonderland*. Illustrations by John Tenniel. New York: Books.

Carroll, Noël. 1988. "Film." In *The Postmodern Moment*, ed. Stanley Trachtenberg. Westport, Conn.: Greenwood Press. 101–33.

———. 1996. *Theorizing the Moving Image*. Cambridge: Cambridge University Press.

———. 2003. *Engaging the Moving Image*. New Haven, Conn.: Yale University Press.

Castaneda, Carlos. 1968. *Teachings of Don Juan: A Yaqui Way of Knowledge*. Berkeley: University of California Press.

Chanan, Michael. 1985. *The Cuban Image: Cinema and Cultural Politics in Cuba*. London: BFI.

Charcot, Jean Martin. 1888–94. *Oeuvres Completes*, volume 9. Paris: Bureaux du Progrès Médical.

Charney, Leo. 1998. *Empty Moments: Cinema, Modernity, and Drift*. Durham, N.C.: Duke University Press.

Charney, Leo, and Vanessa R. Schwartz, eds. 1995. *Cinema and the Invention of Modern Life*. Berkeley: University of California Press.

Chion, Michel. 1993. *La Audiovisión: Análisis conjunto de la imagen y el sonido*. Barcelona: Paidós. Spanish translation of *L'Audiovision*. Paris: Nathan, 1990. English translation: *Audio-Vision: Sound on Screen*, trans. C. Gorbman. New York: Columbia University Press, 1994.

Clark, L. Pierce. 1926. "The Objective and Subjective Development of the Ego." *Archives of Psychoanalysis*, Volume I (October): 1-22.

———. 1931. "Child Analysis: A Motion-Picture Dramatization." *Journal of Psycho Asthenics Proceedings* 36: 111–17.

———. 1932. "On Child Analysis." *Medical Journal and Record* 136: 115–18.

———. n.d. *An Experimental Study in Mental Therapeutics*. Reprinted from the *Medical Record*, February 21, 1920.

Conrad, Tony. 1966a. "On *The Flicker*." *Film Culture* 41: 1–3.

———. 1966b. "Inside the Dream Syndicate." *Film Culture* 41: 5–8.

Corrigan, Timothy. 1997. "Immediate History: Videotape Interventions and Narrative Film." In *The Image in Dispute: Art and Cinema in the Age of Photography*, ed. Dudley Andrew. Austin: University of Texas Press. 309–28.

Crary, Jonathan. 1990. *Techniques of the Observer: On Vision and Modernity in the Nineteenth Century*. Cambridge, Mass.: MIT Press.

———. 1999. *Suspensions of Perception: Attention, Spectacle, and Modern Culture*. Cambridge, Mass.: MIT Press.

Crimp, Douglas. 1984 [1979]. "Pictures." In *Art after Modernism: Rethinking Representation*, ed. Brian Wallis. New York: New Museum of Contemporary Art. 175–88. Originally published in *October* 8 (spring): 75–88.

———. 1993. *On the Museum's Ruins*. Cambridge, Mass.: MIT Press.

Curtis, Scott. 2004. "Still/Moving: Digital Imaging and Medical Hermeneutics." In *Memory Bites: History, Technology, and Digital Culture*, ed. Lauren Rabinovitz and Abraham Geil. Durham, N.C.: Duke University Press. 218–54.

Daney, Serge. 1982. Response to "Questions sur: Photo et Cinéma." *Photogénies* 5, n.p.

Daney, Serge, Jean-Claude Biette, and Emmanuel Crimail. 1993. *L'exercise a été profitable monsieur*. Paris: P.O.L.

de Baecque, Antoine. 1990. "Le Temps Suspendu." *Cahiers du Cinéma* 438: 24–28.

Deleuze, Gilles. 1986. *Cinema 1: The Movement-Image*. Trans. Hugh Tomlinson and Barbara Habberjam. Minneapolis: University of Minnesota Press.

———. 1988. *Le pli: Leibniz et le Baroque*. Paris: Editions de Minuit.

———. 1989. *Cinema 2: The Time-Image*. Trans. Hugh Tomlinson and Robert Galeta. Minneapolis: University of Minnesota Press.

———. 1993. *Difference and Repetition*. New York: Columbia University Press.

Derrida, Jacques. 1993. *Aporias*. Trans. Thomas Dutoit. Stanford, Calif.: Stanford University Press.

Didi-Huberman, Georges. 2003. *Invention of Hysteria: Charcot and the Photographic Iconography of the Salpêtrière*. Trans. Alisa Hartz. Cambridge, Mass.: MIT Press.

Doane, Mary Ann. 2002. *The Emergence of Cinematic Time: Modernity, Contingency, and the Archive*. Cambridge, Mass.: Harvard University Press, 2002.

———, ed. 2007. "Indexicality: Trace and Sign." Special issue, *differences* 18.1.

Donald, James, Anne Freidberg, and Laura Marcus, eds. 1998. *Close Up, 1927–1933: Cinema and Modernism*. Princeton, N.J.: Princeton University Press.

Doyle, Jennifer, Jonathan Flatley, and José Esteban Muñoz, eds. 1996. *Pop Out: Queer Warhol*. Durham, N.C.: Duke University Press.

Duckworth, William, and Richard Fleming, eds. 1996. *Sound and Light: La Monte Young and Marian Zazeela*. Lewisburg, Pa.: Bucknell University Press.

Duncan, Michael, and Kristine McKenna, eds. 2005. *Semina Culture: Wallace Berman and His Circle*. New York: DAP.

Durcum, F. X. 1914. "An Evaluation of the Psychogenic Factors in the Etiology of Mental Disease." *Journal of the American Medical Association* 63: 751–56.

Ellenberger, Henri F. 1970. *The Discovery of the Unconscious: The History and Evolution of Dynamic Psychiatry*. New York: Basic Books.

Ernst, Max. 1970 [1937]. "Beyond Painting." In *Surrealists on Art*, ed. Lucy Lippard. Englewood Cliffs, N.J.: Prentice-Hall.

Falzeder, Ernst, and Eva Brabant, eds. 2000. *The Correspondence of Sigmund Freud and Sándor Ferenczi*, volume 3 (1920–33). Cambridge, Mass.: Belknap Press of Harvard University Press.

Fischer, Lucy. 2004. "'Dancing through the Minefield': Passion, Pedagogy, Politics, and Production in *The Tango Lesson*." *Cinema Journal* 43.3 (spring): 28–70.

Foster, Hal. 1984. "Re: Post." In *Art after Modernism: Rethinking Representation*, ed. Brian Wallis. New York: New Museum of Contemporary Art. 189–203.

———. 1995. *Compulsive Beauty*. Cambridge, Mass.: MIT Press.

———. 1996. "Death in America." *October* 75: 37–59.

———. 2002. *Design and Crime (and Other Diatribes)*. New York: Verso.

REFERENCES

Foucault, Michel. 1980. *The History of Sexuality, Volume I: An Introduction.* New York: Vintage.

Frampton, Hollis. 1983. *Circles of Confusion: Film, Photography, Video, Texts 1968–1980.* Rochester, N.Y.: Visual Studies Workshop Press, 1983.

———. 2004. "An Invention without a Future." *October* 109: 64–75.

Franco, Jean. 1988. "Beyond Ethnocentrism: Gender, Power, and the Third World Intelligensia." In *Marxism and the Interpretation of Culture,* ed. Cary Nelson and Lawrence Grossberrg. Urbana: University of Illinois Press. 503–15.

Fregoso, Rosa Linda. 1993. *The Bronze Screen: Chicana and Chicano Film Culture.* Minneapolis: University of Minnesota Press.

Freud, Sigmund. 1953–74. *The Standard Edition of the Complete Psychological Works of Sigmund Freud.* Translated from the German under the general editorship of James Strachey in collaboration with Anna Freud, assisted by Alix Strachey and Alan Tyson, 24 volumes. London: Hogarth.

Fried, Michael. 1998. *Art and Objecthood.* Chicago: University of Chicago Press.

Friedberg, Anne. 1993. *Window Shopping: Cinema and the Postmodern.* Berkeley: University of California Press.

Frizot, Michel. 1986. "Un instant, s'il vous plaît . . ." In *Le Temps d'un mouvement.* Exhibition catalog. Paris: Centre nationale de la photographie.

Fuss, Diana. 1995. *Identification Papers.* New York: Routledge.

Galison, Peter. 1998. "Judgment against Objectivity." In *Picturing Science, Producing Art,* ed. Caroline A. Jones, Peter Galison, and Amy E. Slaton. New York: Routledge. 327–59.

Gardner, Colin. 1992. "The Influence of Wallace Berman on the Visual Arts." In *Support the Revolution,* ed. T. Berman. Amsterdam: Institute of Contemporary Art. 78–88.

Garibay, Lisa Y. 2003. "Border Punks." *Filmmaker:* 44–45.

Gaudréault, André, and Philippe Marion. 2005. "A Medium is Always Born Twice." *Early Popular Visual Culture* 3.1 (May): 3–15.

Gauld, Alan. 1996. "Notes on the Career of the Sommambule Léonie." *Journal of the Society for Psychical Research* 61 (July): 141–51.

Gibson, Ross. 1988. "What Do I Know? Chris Marker and the Essayist Mode of Cinema." *Filmviews* (summer 1988): 26–32.

Gidal, Peter, ed. 1978a. *Structural Film Anthology,* 2nd ed. London: BFI.

———. 1978b. "Theory and Definition of Structural/Materialist Film." In *Structural Film Anthology,* ed. Gidal, 1–21.

———. 1978c. "Notes on La Région centrale." In *Structural Film Anthology,* ed. Gidal, 52–55.

———. 1989. *Materialist Film.* London: Routledge.

Gilman, Sander L. 1996. *Seeing the Insane.* Lincoln: University of Nebraska Press.

Godard, Jean-Luc. 1972. *Godard on Godard.* New York: Viking.

Goldin, Nan, David Armstrong, and Hans Werner Holzwarth, eds. 1989. *The Ballad of Sexual Dependency.* New York: Aperture.

———. 1996. *I'll Be Your Mirror.* New York: Whitney Museum of American Art.

González, Jennifer A. 1995a. "Autotopographies" In *Prosthetic Territories: Politics and*

Hypertechnologies, ed. Bage Brahm and Mark Driscoll. Boulder, Colo.: Westview Press. 133–50.

———. 1995b. "Negotiated Frontiers: Contemporary Chicano Photography." In *From the West: Chicano Narrative Photography*, ed. Chon Noriega. Seattle: University of Washington Press and the Mexican Museum. 17–22.

González, Rita, and Jessie Lerner. 1998. *Mexperimental: 60 Years of Avant-Garde Media Arts from Mexico*. Mexico: Cine Mexperimental / Mexperimental Cinema.

Good, Graham. 1988. *The Observing Self: A Study of the Essay*. London: Routledge.

Gordon, Rae Beth. 2001. *Why the French Love Jerry Lewis: From Cabaret to Early Cinema*. Stanford, Calif.: Stanford University Press.

Greene, Merrill. 1975. "Wallace Berman." In *Art as a Muscular Principle / Ten Artists and San Francisco, 1950–1965*, ed. Merrill Greene. Exhibition catalog. South Hadley, Mass.: Mount Holyoke College. 50–53.

Guneratne, Anthony R., and Wimal Dissanayake, eds. 2003. *Rethinking Third Cinema*. New York: Routledge.

Gunning, Tom. 1990 [1986]. "The Cinema of Attraction: Early Film, Its Spectator, and the Avant-Garde." In *Early Cinema: Space, Frame, Narrative*, ed. Thomas Elsaesser. London: BFI. 56–62.

———. 1995a [1989]. "An Aesthetic of Astonishment: Early Film and the (In)credulous Spectator." In *Viewing Positions: Ways of Seeing Film*, ed. Linda Williams. New Brunswick. N.J.: Rutgers University Press. 114–33.

———. 1995b. "Phantom Images and Modern Manifestations: Spirit Photography, Magic Theater, Trick Films and Photography's Uncanny." In *Fugitive Images: From Photography to Video*, ed. Patrice Petro. Bloomington: Indiana University Press.

Habell-Pallán, Michelle. 2005. *Loca-Motion: The Travels of Chicana and Latina Popular Culture*. New York: New York University Press.

Hale, Nathan Jr. 1971. *Freud and the Americans: The Beginnings of Psychoanalysis in the United States, 1876–1917*. New York: Oxford University Press.

Hansen, Miriam Bratu. 1991. *Babel and Babylon: Spectatorship in American Silent Film*. Cambridge, Mass.: Harvard University Press.

———. 1997 [1960]. "Introduction." *Theory of Film: The Redemption of Physical Reality*. Princeton, N.J.: Princeton University Press.

———. 1999. "Benjamin and Cinema: Not a One-Way Street." *Critical Inquiry* 25.2 (winter): 306–44.

Heath, Stephen. 1976. "Screen Images, Film Memory." *Edinburgh '76 Magazine* 1: 3–42.

———. 1981. *Questions of Cinema*. Bloomington: Indiana University Press.

Hirschman, Jack. 1969. *Black Alephs*. London: Trigram Press.

———. 1972. *Kabbala Surrealism*. Venice, Calif.: Bayrock.

Hollander, Anne. 1989. *Moving Pictures*. New York: Knopf.

Holmes, Oliver Wendell. 1980 [1859]. "The Stereoscope and the Stereograph." In *Classic Essays on Photography*, ed. Alan Trachtenberg. New Haven, Conn.: Leete's Island Books. 71–82.

Holmes, Thomas. 2002 [1985]. *Electronic and Experimental Music*, 2nd ed. London: Routledge.

Hou, Hsiao-hsien. 1990. "Entretien," with Michel Ciment, trans. Marco Müller. *Positif*, no. 358: 6–10.

Huhtamo, Erkki. 1994. "From Kaleidoscomaniac to Cybernerd: Towards an Archeology of the Media." In *Inter-Society for the Electronic Arts '94* catalog, ed. Minna Tarkka. Helsinki: University of Art and Design. 130–135.

Huyssen, 2003. Andreas. *Present Pasts: Urban Palimpsests and the Politics of Memory*. Stanford, Calif.: Stanford University Press.

Idel, Moshe. 1989. *The Mystical Experience in Abraham Abulafia*. Albany: State University of New York Press.

Iles, Chrissie. 2001. *Into the Light: The Projected Image in Contemporary Art, 1964–1977*. New York: Whitney Museum of Art.

James, David. 1989. *Allegories of Cinema: American Film in the Sixties*. Princeton, N.J.: Princeton University Press.

Jameson, Fredric. 1991. *Postmodernism, or, The Cultural Logic of Late Capitalism*. Durham, N.C.: Duke University Press.

———. 1992. *The Geopolitical Aesthetic: Cinema and Space in the World System*. Bloomington: Indiana University Press.

Janet, Pierre. 1965. *The Major Symptoms of Hysteria*. New York: Hafner.

Jones, Caroline A., Peter Galison, and Amy E. Slaton, eds. 1998. *Picturing Science, Producing Art*. New York: Routledge.

Joseph, Branden W. 2002. "'My Mind Split Open': Andy Warhol's Exploding Plastic Inevitable." *Grey Room* 8: 80–107.

Kahn, Douglas. 1999. *Noise Water Meat: A History of Sound in the Arts*. Cambridge, Mass.: MIT Press.

Kaplan, Louis. 2001. "Photography and the Exposure of Community: Sharing Nan Goldin and Jean-Luc Nancy." *Angelaki: Journal of the Theoretical Humanities* 6.3 (December): 7–18.

———. 2005. *American Exposures: Photography and Community in the Twentieth Century*. Minneapolis: University of Minnesota Press.

Keller, Gary D., ed. 1985. *Chicano Cinema: Research, Reviews, and Resources*. Binghamton, N.Y.: Bilingual Review.

King, David. 1997. *The Commissar Vanishes: The Falsification of Photographs and Art in Stalin's Russia*. New York: Henry Holt.

Kirby, Lynne. 1997. *Parallel Tracks: The Railroad and Silent Cinema*. Durham, N.C.: Duke University Press.

Knight, Christopher. 1992. "Instant Artifacts: The Art of Wallace Berman." In *Support the Revolution*, ed. T. Berman. Amsterdam: Institute of Contemporary Art. 33–46.

Koch, Stephen. 1985. *Stargazer: Andy Warhol's World and His Films*. New York: Marion Boyars.

Kracauer, Siegfried. 1995. *The Mass Ornament: Weimar Essays*. Trans. Thomas Y. Levin. Cambridge, Mass.: Harvard University Press.

————. 1997 [1960]. *Theory of Film: The Redemption of Physical Reality.* Princeton, N.J.: Princeton University Press.

Krauss, Rosalind. 1985 [1979]. "Sculpture in the Expanded Field." *The Originality of the Avant-Garde and Other Modernist Myths.* Cambridge, Mass.: MIT Press.

————. 1999. *"A Voyage on the North Sea": Art in the Age of the Post-Medium Condition.* New York: Thames and Hudson.

————. 2003a [1999]. "Reinventing the Medium: Introduction to *Photograph.*" In *James Coleman,* ed. George Baker. Cambridge, Mass.: MIT Press. 185–210.

————. 2003b [1997]. ". . . And Then Turn Away." In *James Coleman,* ed. George Baker. Cambridge, Mass,: MIT Press. 157–84.

Kunzle, David. 1997. *Che Guevara: Icon, Myth, and Message.* Los Angeles: UCLA Fowler Museum of Cultural History in collaboration with the Center for the Study of Political Graphics.

Laderman, David. 2002. *Driving Visions: Exploring the Road Movie.* Austin: University of Texas Press.

Lai, Tse-han, Ramon H. Myers, and Wei Wou. 1991. *A Tragic Beginning: The Taiwan Uprising of February 28, 1947.* Stanford, Calif.: Stanford University Press.

Landsberg, Alison. 2004. *Prosthetic Memory: The Transformation of American Remembrance in the Age of Mass Culture.* New York: Columbia University Press.

Langford, Martha. 2001. *Suspended Conversations: The Afterlife of Memory in Photographic Albums.* Montreal: McGill-Queen's University Press.

Lee, Pamela M. 2001. "Phase Piece." In *Sol Lewitt: Incomplete Open Cubes,* ed. Nicholas Baume. Cambridge, Mass.: MIT Press. 49–58.

LeGrice, M. 1977. *Abstract Film and Beyond.* Cambridge, Mass.: MIT Press.

Leyda, Jay, ed. 1983. *Kino: A History of the Russian and Soviet Film,* 3rd ed. Princeton, N.J.: Princeton University Press.

Li, Tuo. 1993. "Narratives of History in the Cinematography of Hou Xiaoxian." *Positions* 1.3: 805–15.

Liao, Ping-hui. 1993. "Rewriting Taiwanese National History: The February 28 Incident as Spectacle." *Public Culture* 5: 281–96.

Lippit, Akira Mizuta. 2000. *Electric Animal: Toward a Rhetoric of Wildlife.* Minneapolis: University of Minnesota Press.

Lister, Martin, ed. 1995. *The Photographic Image in Digital Culture.* New York: Routledge.

Londe, Albert. 1893. "Photochronography in the Medical Sciences." *Scientific American,* December 30, 424.

López, Ana, and Chon Noriega, eds. 1996. *The Ethnic Eye: Latino Media Arts.* Minneapolis: University of Minnesota Press.

Luce, Henry. 1937. "The Camera as Essayist." *Life,* April 26, 60–61.

Lu, Tonglin. 2002. *Confronting Modernity in the Cinemas of Taiwan and Mainland China.* New York: Cambridge University Press.

Lukács, Georg. 1978. "On the Nature and Form of the Essay." *Soul and Form.* Cambridge, Mass.: MIT Press: 1–19.

Lumière, Auguste, and Louis Lumière. 1994. *Correspondances, 1890–1953*. Ed. Jacques Rittaud-Hutinet. Paris: Cahiers du Cinéma.

Lupton, Catherine. 2005. *Chris Marker: Memories of the Future*. London: Reaktion.

MacDonald, S., ed. 1992. *A Critical Cinema 2: Interviews with Independent Filmmakers*. Berkeley: University of California Press.

———. 1993. *Avant-Garde Film: Motion Studies*. Cambridge: Cambridge University Press.

———, ed. 1998. *A Critical Cinema 3: Interviews with Independent Filmmakers*. Berkeley: University of California Press.

———. 2001. *The Garden in the Machine: A Field Guide to Independent Films about Place*. Berkeley: University of California Press.

———. 2002. *Cinema 16: Documents Towards a History of the Film Society*. Philadelphia: Temple University Press.

Malcolm, Derek. 1999. "Santiago Alvarez: LBJ." *Guardian Unlimited*, June 17. http://film.guardian.co.uk/Century_Of_Films/Story/0,,59010,00.html.

Malraux, André. 1946. *Esquisse d'une psychologie du cinéma*. Paris: Gallimard.

Mannoni, Laurent. 1994. *Le Grand art de la lumière et de l'ombre—archéologie du cinema*. Paris: Nathan Université.

———. 1996. *Le Mouvement Continué*. Paris: Cinématheque Française-Mazzotta.

Marker, Chris. 1952. *Giraudoux par lui-meme*. Paris: Editions du Seuil.

———. 1959. *Coréennes*. Paris: Editions du Seuil.

Marks, Laura U. 2000. *The Skin of the Film: Intercultural Cinema, Embodiment, and the Senses*. Durham, N.C.: Duke University Press.

———. 2002. *Touch: Sensuous Theory and Multisensory Media*. Minneapolis: University of Minnesota Press.

Mast, Gerald, and Marshall Cohen, eds. 1979. *Film Theory and Criticism: Introductory Readings*. 2nd ed. New York: Oxford University Press.

McClary, Susan. 1998. *Rap, Minimalism, and Structures of Time in Late Twentieth Century Culture*. Geske Lectures Series. Lincoln: College of the Performing Arts/University of Nebraska.

McKenna, Kristine, and Michael Duncan. 2005. *Semina: Wallace Berman and his Circle*. New York: DAP.

Mellencamp, Patricia. 1990. *Indiscretions: Avant-Garde Film, Video, and Feminism*. Indianapolis: Indiana University Press.

Meltzer, David. 1978. "The Door of Heaven, the Path of Letters." In *Wallace Berman Retrospective*, ed. Wallace Berman. Los Angeles: Fellows of Contemporary Art. 1–101.

———. 1992. "The Secret Text Lost in the Processor." In *Support the Revolution*, ed. T. Berman. Amsterdam: Institute of Contemporary Art. 54–59.

Mendiola, Jim. 2005. Personal correspondence with Rita Gonzalez (July 12).

———. 2004. Class presentation at UCLA (November 16).

Mertens, Wim. 1983. *American Minimal Music*. London: Kahn and Averill.

Michaud, Philippe-Alain. 2004. *Aby Warburg and the Image in Motion*. Trans. Sophie Hawkes. New York: Zone.

Michelson, Annette. 1973. "L'Homme à la camera. De la Magie à l'Epistémologie." In *Cinéma: Théorie, Lectures*, ed. Dominique Noguez. Paris: Klincksieck. 295–310.

———. 1978 [1971]. "Toward Snow." In *Structural Film Anthology*, 2nd ed., ed. Peter Gidal. London: BFI. 38–44.

———. 1985. "Frampton's Sieve." *October* 32: 151–66.

Miller, J. Hillis. 1992. *Illustration*. Cambridge, Mass.: Harvard University Press.

Milne, Tom, ed. 1972. *Godard on Godard*. New York: Viking.

Minh-ha, Trinh T. 2005. *The Digital Film Event*. New York: Routledge.

Mitchell, W. J. T. 2005. *What Do Pictures Want?* Chicago: University of Chicago Press.

———. 1994. *Picture Theory*. Chicago: University of Chicago Press.

Monte, James. 1968. "Wallace Berman and Collage Verité." In *Wallace Berman: Verifax Collages*. New York: Jewish Museum. N.p.

Morgan, Daniel. 2006. "Rethinking Bazin: Ontology and Realist Aesthetics." *Critical Inquiry* 32.3 (spring): 443–81.

Mulvey, Laura. 1999 [1976]. "Visual Pleasure and Narrative Cinema." In *Film Theory and Criticism*. 5th ed., ed. Leo Braudy and Marshall Cohen. New York: Oxford University Press. 833–44.

———. 2006. *Death 24x a Second*. London: Reaktion.

Musil, Robert. 1995. *The Man without Qualities*. Volume 1. New York: Knopf.

Musser, Charles. 1990. *The Emergence of Cinema: The American Screen to 1907*. New York: Maxwell Macmillan International.

Mussman, Toby. 1966. "An Interview with Tony Conrad." *Film Culture* 41: 3–5.

Nancy, Jean-Luc. 2003. "Concealed Thinking." In *A Finite Thinking*, ed. Simon Sparks. Stanford, Calif.: Stanford University Press. 31–47.

Nichols, Bill. 1994. *Blurred Boundaries: Questions of Meaning in Contemporary Culture*. Bloomington: Indiana University Press.

Noguez, Dominique, ed. 1973. *Cinéma: Théorie, Lectures*. Paris: Klincksieck.

Nora, Pierre. 1989. "Between Memory and History: *Les Lieux De Mémoire*." *Representations* 26: 7–24.

Noriega, Chon, ed. 1992. *Chicanos and Film: Representation and Resistance*. Minneapolis: University of Minnesota Press.

———, ed. 1995. *From the West: Chicano Narrative Photography*. Seattle: University of Washington Press and the Mexican Museum.

———. 2000. *Shot in America: Television, the State, and the Rise of Chicano Cinema*. Minneapolis: University of Minnesota Press.

———. 2004. "Race and Independent Media Research Group." Paper presented at the Race and Independent Media Research Group Meeting, Los Angeles (February 13).

Nyman, Michael. 1999 [1974]. *Experimental Music: Cage and Beyond*. New York: Cambridge University Press.

Ofrat, Gideon. 2001. *The Jewish Derrida*. Trans. Peretz Kidron. Syracuse, N.Y.: Syracuse University Press.

Païni, Dominique. 2004. "Should We Put an End to Projection?" Trans. Rosalind E. Krauss. *October* 110 (fall): 23–48.

Passages de l'image. 1990. Exhibition catalog. Paris: Editions du Centre Pompidou.

Petro, Patrice, ed. 1995. *Fugitive Images: From Photography to Video.* Bloomington: Indiana University Press.

———. 2002. *Aftershocks of the New: Feminism and Film History.* New Brunswick, N.J.: Rutgers University Press.

Phillips, Christopher, ed. 1989. *Photography in the Modern Era: European Documents and Critical Writings, 1913–1940.* New York: Metropolitan Museum of Art and Aperture.

Ponce, Charles. 1973. *Kabbalah: An Introduction and Illumination for the World Today.* Wheaton, Ill: Quest.

Porcile, François. 1965. *Défense du Court Métrage.* Paris: Les Editions du Cerf.

Projections: Les transports de l'image. 1997. Exhibition catalog. Paris: Editions Hazan.

Proust, Marcel. 1987. *A la Recherche du Temps Perdu.* Edition Bibliothèque de la Pléiade. Paris: Gallimard.

———. 2002. *In Search of Lost Time.* Trans. C. K. Scott Moncrieff and Terence Kilmartin, rev. D. J. Enright. London: Vintage.

Rabinovitz, Lauren, and Abraham Geil, eds. 2004. *Memory Bites: History, Technology and Digital Culture.* Durham, N.C.: Duke University Press.

Ragona, Melissa. 2004. "Hidden Noise: Strategies of Sound Montage in the Films of Hollis Frampton." *October* 109: 96–118.

Rainer, Yvonne. 1995 [1965]. "Interview with Ann Halprin." In *Happening and Other Acts,* ed. Mariellen R. Sanford. New York: Routledge. 137–59.

Ray, Robert. 1995. *The Avant-Garde Finds Andy-Hardy.* Cambridge, Mass.: Harvard University Press.

Redfield, Marc. 2003. "Imagi-nation: The Imagined Community and the Aesthetics of Mourning." In *Grounds of Comparison: Around the Work of Benedict Anderson,* ed. Pheng Cheah and Jonathan Culler. New York: Routledge. 75–105.

Renov, Michael. 1992. "*Lost, Lost, Lost*: Mekas as Essayist." In *To Free the Cinema: Jonas Mekas and the New York Underground,* ed. David James. Princeton, N.J.: Princeton University Press. 215–239.

Ricciardi, Alessia. 2003. *The Ends of Mourning: Psychoanalysis, Literature, Film.* Stanford, Calif.: Stanford University Press.

Richter, Hans. 1992. "Der Filmessay: Eine neue Form des Dokumentarfilms." In *Schreiben Bilder Sprechen: Texte zum essayistischen Film,* ed. Christa Blumlinger and Constantin Wulff. Vienna: Sonderzahl. 195–98.

Riley, Terry. 1996. "La Monte and Marian, 1967." In *Sound and Light: La Monte Young and Marian Zazeela,* ed. William Duckworth and Richard Fleming. Lewisburg, Pa.: Bucknell University Press. 21–24.

Roach, Joseph R. 1993. *The Player's Passion: Studies in the Science of Acting.* Ann Arbor: University of Michigan Press.

Rodowick, D. N. 1988. *The Crisis of Political Modernism: Criticism and Ideology in Contemporary Film Theory.* Urbana: University of Illinois Press.

———. 1997. *Gilles Deleuze's Time Machine*. Durham, N.C.: Duke University Press.

Rosen, Philip, ed. 1986. *Narrative, Apparatus, Ideology*. New York: Columbia University Press.

———. 2001. *Change Mummified: Cinema, Historicity, Theory*. Minneapolis: University of Minnesota Press.

Roud, Richard. 1962–63. "The Left Bank." *Sight and Sound* (winter): 24–27.

Russell, Catherine. 1995. *Narrative Mortality: Death, Closure, and New Wave Cinemas*. Minneapolis: University of Minnesota Press.

———. 1999. *Experimental Ethnography: The Work of Film in the Age of Video*. Durham, N.C.: Duke University Press.

Russolo, Luigi. 2004 [1913]. "The Art of Noises." In *Modernism and Music*, ed. Daniel Albright. Chicago: University of Chicago Press. 177–83.

Saldivar, José David. 1997. *Border Matters: Remapping American Cultural Studies*. Berkeley: University of California Press.

Sanford, Mariellen R., ed. 1995. *Happening and Other Acts*. New York: Routledge.

Sarig, Roni. 1998. *The Secret History of Rock: The Most Influential Bands that You Have Never Heard*. New York: Billboard Books.

Sayers, Janet. 1991. *Mothering Psychoanalysis*. London: Hamish Hamilton.

Schaeffer, Claudia. 2003. *Bored to Distraction: Cinema of Excess in End of the Century Mexico and Spain*. Albany: State University of New York Press.

Schivelbusch, Wolfgang. 1986 [1977]. *The Railway Journey*. Berkeley: University of California Press.

Schnitzer, Luda, and Jean Schnitzer. 1966. *Alexandre Dovjenko*. Paris: Éditions universitaires.

Serres, Michel. 1972. *Hermès II, L'Interférence*. Paris: Editions de Minuit.

Sharits, Paul. 1978a [1966]. "Notes on Films." In *Structural Film Anthology*, 2nd ed., ed. Peter Gidal. London: BFI. 1978. Originally published as "Notes on Films/1966–68," *Film Culture*. 47 (summer 1969).

———. 1978b. "Hearing: Seeing." *Film Culture* 65–66: 70–72.

Shaw, Jeffrey, and Peter Weibel, eds. 2003. *Future Cinema: The Cinematic Imagination after Film*. Cambridge, Mass.: MIT Press.

Sholem, Gershon. 1945. "Chapters from the Book of *Sulam Ha'Aliya* of Rabbi Yehuda Albotini." *Kirjath Sefer* 22: 161–71.

———. 1946. "Abulafia and the Doctrine of Prophetic Kabbalism." *Major Trends in Jewish Mysticism*. New York: Schocken. 135–136.

Sitney, P. Adams, ed. 1970a. *Film Culture Reader*. New York: Praeger.

———. 1970b. "Structural Cinema." In *Film Culture Reader*, ed. Sitney. 326–48.

———. 1979. *Visionary Film: The American Avant-Garde, 1943–1978*. New York: Oxford University Press.

Slater, Don. 1995. "Domestic Photography and Digital Culture." In *The Photographic Image in Digital Culture*, ed. Martin Lister. New York: Routledge. 129–46.

Smith, Paul. 2003. *Amores Perros*. London: BFI.

Snow, Michael. 1967. "A Statement on *Wavelength* for the Experimental Film Festival of Knokke-le-Zoute." *Film Culture* 46: 1–2.

———. 1978 [1969]. "Ten Questions to Michael Snow." In *Structural Film Anthology*, 2nd ed., ed. Peter Gidal. London: BFI. 36–37.

Snyder, Joel. 1998. "Visualization and Visibility." In *Picturing Science, Producing Art*, ed. Caroline A. Jones, Peter Galison, and Amy E. Slaton. New York: Routledge. 379–97.

Sobchack, Vivian. 1992. *The Address of the Eye: A Phenomenology of Film Experience*. Princeton, N.J.: Princeton University Press.

———. 2004. *Carnal Thoughts: Embodiment and Moving Image Culture*. Berkeley: University of California Press.

Sobieszek, Robert. 1996. "A Silent Language of Juxtaposition." *Ports of Entry: William S. Burroughs and the Arts*. Los Angeles: Los Angeles County Museum of Art and Thames and Hudson. 38–44.

Solnit, Rebecca. 1990. *Secret Exhibition: California Artists of the Cold War Era*. San Francisco: City Lights Books.

———. 1995. "Heretical Constellations: Notes on California, 1946–1961." In *Beat Culture and the New America, 1950–1965*, ed. Lisa Phillips. New York: Whitney Museum of Art: 69–87.

Solomon-Godeau, Abigail. 1984. "Photography after Art Photography." In *Art after Modernism: Rethinking Representation*, ed. Brian Wallis. New York: New Museum of Contemporary Art.

Sontag, Susan. 1971. *On Photography*. London: Penguin.

Spies, Werner. 1991. *Max Ernst Collages: The Invention of the Surrealist Universe*. Trans. John William Gabriel. New York: Harry N. Abrams.

———. 2003. *Regarding the Pain of Others*. New York: Farrar, Straus and Giroux.

Spivak, Gayatri Chakravorty. 2003. *Death of a Discipline*. New York: Columbia University Press.

Stewart, Garrett. 1999. *Between Film and Screen: Modernism's Photo-Synthesis*. Chicago: University of Chicago Press.

Strickland, Edward. 2000 [1993]. *Minimalism: Origins*, 2nd ed. Bloomington: Indiana University Press.

Sturken, Marita. 1997. *Tangled Memories: The Vietnam War, the AIDS Epidemic, and the Politics of Remembering*. Berkeley: University of California Press.

Suarès, Carlo. 1970. *The Cipher of Genesis: The Original Code of the Qabala as Applied to the Scriptures*. Berkeley: Shambala Publications.

Suárez, Juan. 1996. *Bike Boys, Drag Queens, and Superstars: Avant-garde, Mass Culture, and Gay Identities in the 1960s Underground Cinema*. Bloomington: Indiana University Press.

Taub, Morris. 2004. "¡Guevararama!" *Print* (May/June): 66–69.

Toop, David. 1995. *Ocean of Sound: Ambient Noise, Ether Talk, and Imaginary Worlds*. London: Serpent's Tail.

———. 2004. *Haunted Weather: Music, Silence, and Memory*. London: Serpent's Tail.

Trachtenberg, Alan, ed. 1980. *Classic Essays on Photography*. New Haven, Conn.: Leete's Island Books.

Trachtenberg, Stanley, ed. 1988. *The Postmodern Moment*. Westport, Conn.: Greenwood Press.

Treviño, Jesus S. 1985. "Form and Technique in Chicano Cinema." In *Chicano Cinema: Research, Reviews, and Resources*, ed. Gary D. Keller. Binghamton, N. Y.: Bilingual Review. 109–15.

Usai, Paolo Cherchi. 2001. *The Death of Cinema: History, Cultural Memory and the Digital Dark Age*. London: BFI.

Vidler, Anthony. 2004. "Architecture's Expanded Field." *Artforum* 42.8: 142–47.

Virilio, Paul. 2003. *Unknown Quantity*. New York: Thames and Hudson.

"Visual Culture Questionnaire." 1996. *October* 77 (summer): 25–70.

Wagner, Anne. 2004. "Splitting and Doubling: Architecture and the Body of Sculpture." *Grey Room* 14 (winter): 26–45.

Wallace Berman: Support the Revolution. 1992. Amsterdam: Institute of Contemporary Art.

Wallis, Brian, ed. 1984. *Art after Modernism: Rethinking Representation*. New York: New Museum of Contemporary Art.

Wees, William C. 1992. *Light Moving in Time: Studies in the Visual Aesthetics of Avant-Garde Cinema*. Berkeley: University of California Press.

Wheeler, Thomas H. 2002. *Phototruth or Photofiction: Ethics and Media Imagery in the Digital Age*. Mahwah, N.J.: Lawrence Erlbaum.

Wholey, Cornelius C. 1914. "Psychoanalysis." *Journal of the American Medical Association* 63: 1036.

———. 1933. "A Case of Multiple Personality." *American Journal of Psychiatry*. 12.4 (January): 670.

Williams, Linda. 1986. "Film Body: An Implantation of Perversions." In *Narrative, Apparatus, Ideology*, ed. Philip Rosen. New York: Columbia University Press.

———. 1989. *Hardcore: Power, Pleasure, and the Frenzy of the Visible*. Berkeley: University of California Press.

Wolfe, Charles. 1987. "Introduction." *Wide Angle* 9.1: 1–11.

Wollen, Peter. 1969. *Signs and Meaning in the Cinema*. Bloomington: Indiana University Press.

———. 1982. *Readings and Writings: Semiotic Counter-Strategies*. London: Verso.

———. 1984. "Feu et Glace." *Photographies* 4: 16–21.

Young, La Monte. 1995 [1963]. "Lecture 1960." In *Happening and Other Acts*, ed. Mariellen R. Sanford. New York: Routledge. 72–81.

GEORGE BAKER is an assistant professor of art history at UCLA. His work explores the critical lessons of modernism for current cultural problems and phenomena, focusing on the European avant-gardes of the early twentieth century, as well as contemporary art, film, and the history and theory of photography. His publications include: *James Coleman: Drei Filmarbeiten* (2002) and *James Coleman* (2003), an edited anthology on Coleman's work. He is currently working on two books: a revisionist history of Dada entitled, *The Artwork Caught by the Tail: Francis Picabia and Dada in Paris* and a collection of essays on contemporary art entitled, *Reanimations*. A longstanding critic for *Artforum* magazine, Baker is also an editor of *October* magazine and October books.

REBECCA BARON is a Los Angeles-based filmmaker. Her most recent film is *How Little We Know of Our Neighbours* about the Mass Observation Movement. She is on the faculty at the CalArts School of Film and Video. Her award-winning experimental and documentary films have been screened extensively in the United States and abroad (including at the Cinémathèque Française in Paris, the International Film Festival Rotterdam, the New York Film Festival, the Oberhausen Film Festival, and the Vienna International Film Festival). Her film *okay bye-bye* was included in the 2000 Whitney Biennial. She has also worked as a documentary film editor, most notably for Pennebaker and Associates. She holds a BA from Brown University and an MFA from the University of California, San Diego. She is the recipient of a 2002 Guggenheim Fellowship.

KAREN BECKMAN is the Elliot and Rosyln Jaffe Associate Professor of Film Studies and History of Art at the University of Pennsylvania. She is the au-

thor of *Vanishing Women: Magic, Film, and Feminism* (2003), and has recently published articles on feminism and terrorism, J. G. Ballard's *Crash*, and death penalty photography.

RAYMOND BELLOUR has written extensively on literature, cinema, film theory, and contemporary video art. He has also curated several major exhibitions. The first volume of his collected essays on film and video, *L'entre-Image, Photo Cinema, Video*, was published in 1990; the second volume, *L'entre-Images 2, Mots, Images*, was published in 1999. Professor at the Centre Universitaire Américan de Cinéma in Paris from 1973 to the present, he has also been a visiting professor at New York University and the University of California, Berkeley. He is currently director of research at the Centre Nationale de la Recherche Scientifique, Paris. Bellour is also the co-editor of the cinema journal *Trafic*.

ZOE BELOFF is a moving image artist who works with a variety of cinematic imagery: film, stereoscopic projection performance, interactive media, and installation. Her projects are philosophical toys, objects to think with. Beloff's work has been exhibited internationally. Venues include the Museum of Modern Art, the Whitney Museum of American Art, the New York Film Festival, the International Film Festival Rotterdam, the Pacific Film Archives, and the Pompidou Center.

TIMOTHY CORRIGAN is a professor of English and cinema studies at the University of Pennsylvania. His books include *New German Film: The Displaced Image* (1983); *The Films of Werner Herzog: Between Mirage and History* (1986); *A Cinema without Walls: Movies and Culture after Vietnam* (1991); *Writing about Film* (1994); *Film and Literature: An Introduction and Reader* (1998); and *The Film Experience* (co-authored with Patricia White, 2004). He is presently concluding research on a book-length study entitled *The Essay Film*, which examines the films of Chris Marker, Derek Jarman, and Trinh T. Minh-ha.

NANCY DAVENPORT is represented by the Nicole Klagsbrun Gallery in New York. Her work has been exhibited at a variety of venues including the Gardener Art Centre (Brighton, UK), the 25th Bienal de São Paulo, the MIT List Arts Center (Cambridge, Mass.), the First Triennial of Photography and Video at the International Center of Photography (New York), the De Singel International Kunstcentrum (Antwerp), and will be included in the tenth International Istanbul Biennial. She has written for numerous publications including the *New York Times*, *Artforum*, *Art in America*, *October*, *Frieze*, *Vogue* (UK) and *Vitamin Ph: New Perspectives in Photography* (2006). She is a member of the MFA faculty at the School of Visual Arts and at ICP-Bard in New York, and has taught and lectured at many other MFA programs, including Yale

University, Milton Avery Graduate School of the Arts at Bard College, Hunter
College, and Purchase College.

ATOM EGOYAN has produced a body of work in film, television, and the-
ater. He has won numerous prizes at international film festivals, including the
Grand Prix and International Critics Awards from the Cannes Film Festi-
val and two Academy Award® nominations. His films have been presented
in major retrospectives around the world and a number of books have been
written about his work. Egoyan's installations have been exhibited at museums
and galleries in Canada and abroad, including the Venice Biennale. Egoyan
was president of the jury at the 2003 Berlin International Film Festival. His
latest film, *Where The Truth Lies*, had its world premiere in the 2005 Cannes
International Film Festival's Official Competition, and its North American
premiere as a gala screening at the 2005 Toronto International Film Festival.
On the occasion of Samuel Beckett's Centenary Celebration in April 2006,
Egoyan's critically acclaimed interpretation of Beckett's *Eh Joe* was presented
by the Gate Theatre in Dublin, and later remounted in London's West End.
His production of Wagner's *Die Walküre* was performed by the Canadian
Opera Company in April 2004 and remounted with the full *Ring Cycle* for
the opening of the Four Seasons Centre for the Performing Arts in Toronto
in September 2006.

RITA GONZALEZ is a video maker, independent curator, and writer. Her
work has appeared in a number of venues, including the *Spectator*, *Wide Angle*,
Aztlán, and the *Independent*. Her video work has been shown at the Canal
Isabel II (Madrid), the Armand Hammer Museum (Los Angeles), the Bronx
Museum, the Center on Contemporary Art (Seattle), and elsewhere. Her co-
curated collaboration, "Mexperimental Cinema," the first survey of experimen-
tal and avant-garde work from Mexico, traveled to the Pacific Film Archives,
Berkeley; the Museum of Contemporary Art, San Diego; the Guggenheim
Museums (New York and Bilbao); and other places. Currently, Gonzalez is
Assistant for Special Exhibitions at the Los Angeles County Museum of Art.

TOM GUNNING is a professor of art history and cinema and media studies
at the University of Chicago. He is the author of *D. W. Griffith and the Origins
of American Narrative Film* (1991) and *The Films of Fritz Lang: Allegories of
Vision and Modernity* (2000), and he has written on a wide range of subjects
related to cinema and photography in numerous journals, including *American
Film*, *Camera Obscura*, *Cinema Journal*, *Discourse*, *Film Quarterly*, and *Wide
Angle*.

LOUIS KAPLAN is an associate professor of history and theory of photog-
raphy and new media in the Graduate Department of Art at the University
of Toronto and the Director of the Institute of Communication and Culture

at the University of Toronto, Mississauga. He is the author of *Laszlo Moholy-Nagy: Biographical Writings* (1995), *American Exposures: Photography and Community in the Twentieth Century* (2005) and the co-author with Scott Michaelsen of *Gumby: The Authorized Biography of the World's Favorite Clayboy* (1986). Kaplan has published widely in the fields of art history, visual culture, photography studies, and Jewish studies in pursuit of interdisciplinarity. Kaplan is currently editing a source book on William Mumler and the contested discourse around the origins of spirit photography in the United States. His webpage can be found at http://www.fineart.utoronto.ca/faculty/kaplan.html.

JEAN MA is an assistant professor in the Department of Art and Art History at Stanford University, where she teaches in the Film and Media Studies Program. She is currently working on a manuscript on contemporary Chinese-language art cinema entitled *Melancholy Drift: Marking Time in Chinese Cinema*.

JANET SARBANES teaches critical theory and creative writing at the CalArts School of Film and Video. Her interests include theories of embodiment, spatiality, and aesthetics. In addition to writing short fiction and a novel in manuscript, for which she won the Shirley Collier Fiction Prize, she has written nonfiction works on William Burroughs, David Wojnarowicz, and others.

JUAN A. SUÁREZ is an associate professor of American studies and English at the University of Murcia (Spain). He is the author of *Bike Boys, Drag Queens, and Superstars* (1996); *Pop Modernism: Noise and the Reinvention of the Everyday* (2007); *Jim Jarmusch* (2007); and numerous articles and book chapters.

Page numbers in italics refer to illustrations

KAREN BECKMAN is the Elliot and Rosyln Jaffe Associate Professor of Film Studies and History of Art at the University of Pennsylvania.

JEAN MA is an assistant professor in the Department of Art and Art History at Stanford University, where she teaches in the Film and Media Studies Program.

Library of Congress Cataloging-in-Publication Data

Still moving : between cinema and photography /
Karen Beckman and Jean Ma, editors.
p. cm.
Includes bibliographical references and index.
ISBN 978-0-8223-4131-4 (cloth : alk. paper) —
ISBN 978-0-8223-4155-0 (pbk. : alk. paper)
1. Motion pictures. 2. Photography. 3. Installations (Art)
I. Beckman, Karen Redrobe, 1971– II. Ma, Jean
PN1995.S728 2008
791.4301—dc22
2008013491